OUT OF CONTEXT

Recent Titles in
Contributions to the Study of Art and Architecture

The Craftsperson Speaks: Artists in Varied Media Discuss Their Crafts
Joan Jeffri, editor

The Painter Speaks: Artists Discuss Their Experiences and Careers
Joan Jeffri, editor

Text, Image, Message: Saints in Medieval Manuscript Illustrations
Leslie Ross

Van Gogh 100
Joseph D. Masheck, editor

Women in the Nineteenth-Century Art World: Schools of Art and Design for
Women in London and Philadelphia
F. Graeme Chalmers

Architectural Excursions: Frank Lloyd Wright, Holland and Europe
Donald Langmead and Donald Leslie Johnson

Imaging Her Selves: Frida Kahlo's Poetics and Identity and Fragmentation
Gannit Ankori

OUT OF CONTEXT

American Artists Abroad

**Edited by Laura Felleman Fattal
and Carol Salus**

Contributions to the Study of Art and Architecture, Number 8

Westport, Connecticut
London

Library of Congress Cataloging-in-Publication Data

Out of context: American artists abroad / edited by Laura Felleman Fattal and Carol Salus.
 p. cm. — (Contributions to the study of art and architecture, ISSN 1058–9120 ; no. 8)
 Includes bibliographical references and index.
 ISBN 0–313–31649–X (alk. paper)
 1. Art, American—Europe—19th century. 2. Art, American—Europe—20th century. 3.
Expatriate artists—Europe—Biography. 4. Artists—United States—Biography. I. Fattal,
Laura Rachel Felleman. II. Salus, Carol, 1947– III. Series.
N6757 .O93 2004
704.03'1304—dc21 2002024478

British Library Cataloguing in Publication Data is available.

Library of Congress Catalog Card Number: 2002024478
ISBN: 0–313–31649–X
ISSN: 1058–9120

First published in 2004

Praeger Publishers, 88 Post Road West, Westport, CT 06881
An imprint of Greenwood Publishing Group, Inc.
www.praeger.com

Printed in the United States of America

The paper used in this book complies with the
Permanent Paper Standard issued by the National
Information Standards Organization (Z39.48–1984).

10 9 8 7 6 5 4 3 2 1

Copyright Acknowledgments

The editors and publisher gratefully acknowledge permission to excerpt material from the following sources:

M. Elizabeth Boone, "Bullfights and Balconies: Flirtation and *Majismo* in the Spanish Paintings of Mary Cassatt, 1872-1873," *American Art* 9: 1 (Summer 1995): 54-71. Reprinted by permission.

Britta C. Dwyer, "Bridging the Gap of Difference: Anna Klumpke's Union with Rosa Bonheur," Henry Krawitz, ed., Rosa Bonheur, *All Nature's Children*. New York: The Dahesh Museum, 1998, pp. 63-78. Copyright 2000. Reprinted by permission.

William H. Gerdts, "The American Artists in Grez," Toru Arayashiki, curator, *The Painters in Grez-sur-Loing*. The Japan Association of Art Museums, pp. 266-277. Copyright 2000-2001. Reprinted by permission of the author.

Theresa Leininger-Miller, *New Negro Artists in Paris: African American Painters and Sculptors in the City of Light, 1922-1934*. Rutgers University Press, 2001. Reprinted by permission of the publisher.

To the memory of my parents, Dr. Karl and Rose Salus

Contents

Preface xi

Acknowledgments xv

Introduction 1
Laura Felleman Fattal and Carol Salus

1. Whistler's Paintings in Valparaiso: *Carpe Diem* 11
 Robert H. Getscher

2. Bullfights and Balconies: Flirtation and *Majismo* in
 Mary Cassatt's Spanish Paintings of 1872–1873 23
 M. Elizabeth Boone

3. The American Artists in Grez 35
 William H. Gerdts

4. Bridging the Gap of Difference: Anna Klumpke's
 "Union" with Rosa Bonheur 69
 Britta C. Dwyer

5. John Singer Sargent: Accidental Heir to the
 American Expatriate Tradition 81
 Kathleen L. Butler

6. "Heads of Thought and Reflection": Busts of African Warriors
 by Nancy Elizabeth Prophet and Augusta Savage, African American
 Sculptors in Paris, 1922–1934 93
 Theresa Leininger-Miller

7. The Mexican Murals of Marion and Grace Greenwood 113
 James Oles

8. Fashioning Nationality: Sam Francis, Joan Mitchell, and
 American Expatriate Artists in Paris in the 1950s 135
 Michael Plante

9. R. B. Kitaj: Painting as Personal Voyage 147
 Carol Salus

10. Global Citizen: Beverly Pepper 161
 Laura Felleman Fattal

 Index 169

 About the Editors and Contributors 173

Photo essay follows Chapter 4.

Preface

This anthology addresses the issues of expatriation and what that vast term encompasses in American art through an examination of select artists. Designed to be a handbook for students of art history and American studies at both undergraduate and graduates level, the text is of interest to any serious follower of American art and culture. It supplements, highlights, and adds depth to general histories and classroom discussions of American art and related topics. Arranged in chronological order, this sampling of expatriate artists starts with the mid-nineteenth century and progresses to the contemporary period. We have tried to ask what made each of the chosen artists leave the United States and what they found in their new lands. In this text there is coverage of both more renowned expatriates such as Whistler, Cassatt, and Sargent and less familiar ones to show the range of artists seeking to leave this country and, in some cases, reject it permanently. Ironically, of these three famous expatriate painters, it is Sargent, the only artist in this anthology who was born overseas, who was the most popular and had the most financially successful career here. Unlike Sargent, who became the leading, most fashionable portraitist of the American social elite, the other artists left America for a variety of fascinating reasons. Europe meant for some exposure to the great ateliers, museums, and frescoes overseas; expatriation, for others, whether to Mexico or Europe, involved not only greater professional, social, and political freedom, but also more psychological fulfillment.

A number of the authors bring in more than visual analysis and biography, to include documentation regarding subjectivity of an author will lead to the viewer's involvement and interpretation. In particular, of the new theoretical approaches to the history of art, there is emphasis here on feminism. A high number of women are mentioned; various gender and racial issues led some of the artists

discussed to find better opportunities for professional development outside American borders.

The decisions to work abroad provide valuable insights into the well-documented limitations for women and African Americans in our country. From the Revolutionary era into the twentieth century women were primarily part of the domestic realm of motherhood and care for the whole family. Like African Americans, women's political rights were ignored in the Declaration of Independence and the U.S. Constitution. But during the twelve-year Reconstruction Period (1865–1877) that followed the Civil War, the U.S. Congress, dominated by radical Republicans from the North, set a strict set of Reconstruction policies that forced Southern states to recognize the civil and political rights of black citizens. Aided by numerous "carpetbaggers," or newly arriving teachers, businessmen, and retired Union soldiers from the North, former African American slaves were finally able to vote in elections. Still, suffrage, both for white and African American women, took place after World War I in 1920.

After Reconstruction ended in 1877, the U.S. government withdrew oversight of Southern states' political affairs, thereby allowing the return of a racist legal system and giving free rein to terrorist organizations such as the Ku Klux Klan. While racism in twentieth-century America is a well-documented history, prejudiced regarding women are not as well known, especially in the arts.

In 1848 the first women's rights convention was held in Seneca Falls, New York. The leader, Margaret Foley, was one of many unmarried daughters of New England farmers who had been working in a textile mill factory. She also had a career as a sculptor. By 1860 she moved to Rome and joined other American women artists in producing neoclassical marble sculptures. Along with Harriet Hosmer, who created a renowned statue of Senator Thomas Hart Benton, Foley and other American women sculptors were referred to later in the century by the American expatriate novelist Henry James as the "white marmorean flock." This derisive label came from the group's collective preference for the non-classical medium of marble rather than bronze, the malleable material favored by more naturalistic sculptors after the Civil War.

Americans had since Jefferson's time held the general belief that Italy lay at the center of western civilization. While these women were part of a large colony of American artists in Rome, there were also studios of American Impressionists in Venice for whom France had meant so much. In the nineteenth century there was even an American colony of sculptors in Florence. Florence was much closer than Rome to the marble quarries along the coast, those at Carrara and Seravezza from which the sculptors drew the materials for their marmorean works. These were within relatively easy access; there they could personally select the blocks of marble that would subsequently be transported to their Florentine studios at less cost than shipping the heavy blocks to Rome. The American presence in Italy continued into the twentieth century as highlighted in these pages in the study of sculptor Beverly Pepper.

The gathering of American women artists in Italy in the nineteenth century raises curiosity as to why they left America. perhaps it had to do with prejudice about the capacities of women to be serious artists. The masculine visions of Eakins, Homer, and Anshutz implicitly express the notion, argued by many artists and critics, that the art profession should be the preserve of men. Though he taught many young women at the Pennsylvania Academy, Eakins wrote to a friend in 1886 that he did not believe a woman could produce art works that were great. Significantly, Mary Cassatt was unable to study at the École des Beauz-Arts because of her sex and then moved from traditional academic styles and joined the male-dominated Impressionist group. In our era, it is not surprising that during the 1970s numbers of women collectively and individually protested the dominance of male artists in gallery and museum exhibitions. African American artists like Bettye Saar and Faith Ringgold confronted racist imagery in the 1970s. Yet the African American expatriate female artists we discuss, Nancy Prophet and Augusta Savage, left the United States when there were restrictions, long before the days of the civil rights and black power movements. With their multiple identities, the courage and creativity of these artists who chose to leave the United States can only be admired.

There is a great demand today in academia for cultural diversity. Questions of nationhood and their arts matter. The complex issues and identities some of these artists faced as a result of the expatriate experience—feelings of acceptance, sense of outsider status, success, ambivalence, or greater appreciation for their art—all found it in other cities and towns abroad are addressed here. It is most interesting to discover how their status as Americans was often welcomed in foreign countries.

The frontier-like courage to explore associated with our country is part of the expatriate artist's quest. Whatever frustrations or limitations, absence of democratic ideals, parochial tastes, a number of these artists felt in America, it is important to understand their experiences elsewhere as they sought better careers, greater freedoms, or more sophisticated training.

Further, the question of American artists overseas and over the border adds to the wide and fluid nature of American art. The characteristics that comprise American art are impossible to clarify in terms of geography, subject matter, or style. The study of American art is forever shifting as the composition of our immigrant population changes. The expatriate experience only amplifies the plurality of societies forming our American art—not only the well-established European, but also Mexican, Native American, African, Asian art and others, and a number of these influences are addressed in this anthology. The question of American artists abroad adds to the ever-expanding question of what comprises or is identifiable as American art.

We would have liked to discuss even more artists to further represent the diversity of the expatriate experience, but this would result in an unwieldy task. American artists in the nineteenth century became active in Europe in rural artists' colonies, finding natural beauty and fascination that led them to become part of often international communities overseas. It is interesting to note that

during the approximate time period 1860–1910, as Cassatt, Whistler, Sargent and Anna Klumpke, another American whose bond with the famous French painter Rosa Bonnheur is discussed in these pages, flourished, their colleagues came to live in rural artists' colonies in Europe. These were communities primarily of painters who came to work and live in a village for a period of time. Citizens of the United States even started a number of artists' communities in France and the Netherlands. American artists were present in substantial numbers in many of these colonies in France, the Netherlands, and some in England. In fact, the chronology of the Americans at Grez on the Loing River in the forest of Fontainebleau is documented here. Rural artists' colonies existed for most of the nineteenth century until approximately 1910, and turned many of these sites into picturesque tourists attractions. The simultaneous emergence of major expatriate artists in this anthology around the later part of the nineteenth century and the peak period of development of these rural artists' communities is linked to the rise in the overall number of training and practicing artists in this period. The number of permanent versus temporary American residents varied in individual communities as these artists became part of a mass cultural movement from traditional urban centers of art to the less industrialized countryside, but their involvement in these villages adds to the complexity of understanding the totality of the expatriate artists' experience, a task that is beyond the perimeters of this text.

Due to the limitations of space and other factors, certain works of art could not be reproduced. But obviously the number or variety of reproductions of their works does not determine the significance of the artists selected and their particular ideas.

Hopefully, the biographies and incidents in the travels of the artists and their art in this anthology will spotlight the interests, contradictions, tensions, and, in some cases, ideological struggles of their experiences as a foreigner abroad. Some experienced war, political unrest, and signs of extermination, while others lived graciously in both American and foreign communities. The interpretations of their sculptures and paintings presented here are mean to both inform and raise open-ended thoughts and questions about how an outsider sees and creates from his or her imagination, training, and experience. American art, of the past or the current century, is much better understood with knowledge of the expatriate's works and his or her experiences, whether seamless or rough, found and still to find abroad.

Carol Salus and Laura Felleman Fattal

Acknowledgments

Laura Fattal would like to thank the Center for the Critical Analysis of Contemporary Culture (CCACC) at Rutgers University for jump-starting my thinking on national borders, cultural identities, and gender issues that are so evident in the development of American art. Coinciding with my unofficial participation in the transnationalism seminar at CCACC, I organized the session *Out of Context: American Artists Abroad* for the College Art Association conference, which was my introduction to the writers and co-editor of what has become this anthology.

Carol Salus would like to acknowledge the Division of Research and Graduate Studies, Kent State University, for the generous support of this project. Special thanks are also extended to Professor William Quinn, director of the School of Art, Kent State University, for his support, not only for this anthology, but many other times in my career. My greatest gratitude is given to Dr. Robert Getscher for his expertise and sound advice in many aspects of the construction of this text. To Lisa Binder, M.A., the Denver Museum of Art, thank you so much for your help in collating and working out various problems involved in these essays. To Joan Marold, your time, patience and dedicated assistance with so many aspects of this project are greatly appreciated. Also I want to thank Louis Adrian, M.L.S., associate librarian for Public Services, the Cleveland Museum of Art, for his willingness to help with frequent reference questions and Jenna Bates for her help with the technical aspects of preparing the manuscript for publication.

The co-editors want to acknowledge the intellectual pleasure it has been to have had the opportunity to work with the contributing authors and with each other. We want especially to thank Eric Levy, acquisitions editor, Greenwood Press, for his encouragement and excellent guidance as an editor.

Introduction

Laura Felleman Fattal and Carol Salus

The trajectory of the lives and art of American expatriate artists is reflective of the political concept of a nation as well as the personal identity of an individual. An analysis of the works of art by expatriate visual artists reveals three overlapping, yet at times distinct thematic categorizations. They are the implicit and explicit imagery of the work of art, the autobiographical and personal circumstance of the artist, and pervasive ideas related to the national ethos defining expatriate artists' work. Regardless of their residence, American artists in the nineteenth and twentieth centuries have viewed their destinies as linked to the United States. Nationhood as aligned with language, formative education, and familial ties is manifest in a strong allegiance to the United States. Duplicitous associations with expatriatism have forwarded polarities of exile and cosmopolitanism with a middle ground represented by tourists, sojourners, and globetrotters. The ten essays presented in this anthology explore specific artists, their context, and their work in order to understand, in part, what is American about American art.

The established academies of England, France, and Italy provided ambitious American artists with techniques and models that were unavailable in the colonial United States. As the nineteenth century progressed, artists such as Thomas Cole and Harriet Hosmer, the first American woman to make her career in Italy as a sculptor, continued to study and work in European cities with commissions primarily from American patrons. However, the class structure in European society was antithetical to the progressive democratic ideas of the growing United States. During his travels in Europe, the American writer Mark Twain felt uneasiness with the constraints of established traditions and cultural indebtedness to an aristocracy apparent in the works of art, in particular, and

life, in general.[1] For Twain could not separate art and a "social system repugnant to any right-thinking democrat." The miles of paintings in the great museums in Paris such as the Louvre were beautiful according to Twain, but their aesthetic was spoiled for him by the social structures of a "cringing populace who adulated princely patrons."

Many American artists looked back further to a classical past. The antiquity of Greece and Rome represented by archaeological remnants scattered across continually inhabited landscapes was frequently incorporated into American artists' paintings, offering a "vicariously realized antiquity" unlike the "ever-fugitive" American past. The Italian countryside became a theatrical backdrop in the portraits and historical paintings of many nineteenth-century American artists so as to underscore their part in the history of western civilization.[2] American artists studying French and English works of art from the Neoclassical period of the seventeenth and eighteenth centuries were confronted with an earlier appropriation of the evidence of Classicism. Barbara Novak, the art historian, sees the American expatriate tradition as a dialectical foil against the indigenous aspects of the American vision. She emphasizes the saliency of the shaping factors in the American experience as a more vital paradigm for viewing American art than an emulation of the European tradition. The cultivated antiquity of the European continent stands in marked contrast to the "raw" American frontier and wilderness. Although, at times, the natural history of the United States was regarded as emblematic of a pristine and, therefore, divine type of antiquity. The vastness of the American Badlands, the deep and unending Appalachian forests, and the volatile force of the changing west Texas sky suggest a linkage with the world before the existence of mankind. New interpretative approaches to public and private issues such as societal reform, feminism, and racial and ethnic equality provided the crucible for many American artists. In this way, American expatriate artists can be seen as cultural arbiters between natural and civilized histories within and outside of the United States.

European travel in the nineteenth century was a highly conventional activity, controlled at one level by the layout of transportation networks and a list of canonical sights, at another level by the socially sanctioned purposes of travel, and at a third, most intimate level by the appropriate responses to individual sights suggested (and repeated) by cultural authorities and previous visitors. It was, in other words, a kind of secular ritual complete with prescribed actions, promised rewards, and a set of quasi-scriptural writings.[3]

The number of American travelers in Italy grew steadily from 1825 to the end of the century. By the 1830s, and especially in subsequent decades, there were active communities of American artists in Florence, Rome, and Venice. Ironically, American artists were drawn to Italian cities because American tourists were more likely to buy a painting in Italy than in their native land. It appeared that American taste, with its traditional moral and aesthetic standards, was more flexible abroad than within the United States. American tourists—

prospective patrons—invariably visited both Florence and Rome, where there were special guidebooks to artists' studios. However, they stayed longer in Rome, allowing more social interaction and the potential of commissions.[4] More recently Rome has been the permanent residence of the American painter Cy Twombly since 1957.

As the nineteenth century progressed, American artists increasingly came from all classes and many parts of the United States. Their trips were often paid for by their families, by wealthy patrons, or by groups who believed in their promise. At times, the artists helped one another by giving and/or lending funds. For instance, Sanford Gifford describes in his journal entry July 16, 1857: "At dinner we had a call from Eugene Warburg, a Negro sculptor from New Orleans, on his way to Florence and out of money. His manner was prepossessing. He had letters from people we knew. He was modest, and full of hope and confidence." Gifford and his friends in Venice raised money enough for Warburg to resume his travels.[5] There were guidebooks—*Studying Art Abroad: How to Do It Cheaply* (1879) by May Alcott Nieriker (William Gerdts' essay makes note that May Alcott, Amy in her sister's *Little Women,* as a single woman artist visited the American art colony in Grez, France in 1877) and *European Travel for Women* (1900) by Mary Cadwalader Jones (the sister of Edith Wharton)—intended for women travelers who were preparing to study art. Both guidebooks assume female independence and a matter-of-fact acceptance of European customs and conditions.[6]

Even before our country was united, American artists, such as Benjamin West and John Singleton Copley traveled to Europe and sustained successful careers abroad. Thomas Sully, Gilbert Stuart, John Trumbull, and Charles Wilson Peale were at West's London studio. Washington Allston, America's first truly Romantic painter, studied in London at the Royal Academy under West. In 1805 he became part of the Caffé Greco circle in Rome, which included his friends John Vanderlyn, Washington Irving, Coleridge, and Thorvaldsen, as well as such famous figures as Keats, Shelley, Turner, von Humboldt, and Madame de Staël. John Vanderlyn broke the string of American artists in West's studio and studied in Paris. Countless American artists worked in Paris: Thomas Eakins, Thomas Dewing, Robert Henri, William Glackens, Charles Demuth, Max Weber, Gerald Murphy, Alexander Calder, Man Ray, Robert Rauschenberg, and hundreds of others. George Inness was influenced by Corot and the Barbizon School. There were Americans reacting to Impressionism such as Theodore Robinson, Childe Hassam, John Twachtman, William Merritt Chase, and Alden Weir.

There were American students who went to Düsseldorf to work under the tutelage of Emanuel Leutze after 1847, when Americans were introduced to German painting with the opening of the Düsseldorf gallery in New York. Munich was an important art center in the late nineteenth and early twentieth centuries. In the late 1870s Frank Duveneck set up his own school where he taught American art students. Such painters as George Luks and William

Merritt Chase also adopted the dark palette of the Munich School. Marsden Hartley was also a part of the German art scene. He exhibited in the Blaue Reiter group in the First German Autumn Salon. From the Civil War until the end of the century such American painters as Samuel Colman, George Henry Hall, John Singer Sargent, William Merritt Chase, and Mary Cassatt visited Spain and painted subjects based on their travels. Most of these artists followed a prescribed itinerary, spending a brief period of time in Madrid in order to view the Old Master paintings in the Prado before continuing south to either Seville or Granada, where bullfights, flamenco, gypsies, and Moors provided colorful subjects for their own pictures. It is the intent of the following multi-layered nineteenth-and-twentieth century art historical studies to examine select works from various well-known expatriate artists as well as to introduce those less well-known, and to address a number of the complex aesthetic and cultural issues surrounding expatriatism.

Influential for much of his career, John McNeill Whistler (1834–1903) was born in Lowell, Massachusetts, but spent most of his adult life in England and France. Robert Getscher details and analyzes important aspects of Whistler's oeuvre. Whistler had received his secondary education in St. Petersburg, Russia, where his father was employed by Czar Nicholas I to construct a railroad between Moscow and St. Petersburg for Czar Nicholas I. Later he was educated at West Point, then under the leadership of Robert E. Lee. At age 21, Whistler went to Paris and did not return to the United States, though he had strong ties with the Southern cause during the Civil War. His military-educated family as well as his own experience at West Point provoked a needed expression of nationalistic pride, which was realized in the Chilean conflict in the 1860s. Envisioning himself, perhaps, as an American frontiersman enduring physical hardship, Whistler took up the call of an adventurer in assisting the English cause in Chile. The aesthetic legacy of the Chilean conflict for Whistler appeared in the carefully nuanced Nocturnes that foreshadow Impressionist ideas. Getscher demonstrates that the Nocturne was born in Valparaiso.

In M. Elizabeth Boone's essay, the paintings of Mary Cassatt (1845–1926) executed in 1872–1873 in Seville, Spain, mark a critical departure from the subjects of her long and productive career. Anecdotal flirtation is evident in these works by the inclusion of a prominent male figure enveloping an adjacent female figure with a compelling gaze that is in striking contrast to her familial intimacies between mother and child. Influenced by the paintings of Murillo, Goya, and Manet, Mary Cassatt established a voyeuristic approach, based on her acknowledged position of a tourist, that relishes the behavior of the provocative female figures situated in the intermediary space of a balcony. The warm and affectionate behavior between family members that distinguishes Cassatt's paintings in France after 1875 is purposefully absent in these Spanish works. Cassatt visited Spain after several months in Italy. She describes her travels as a search for subjects. One can only suspect the exoticism of the Mediterranean distinction between public and private gender-related customs as manifest in

these works. The mandatory covering of a woman's face and expectation of downcast eyes when appearing in public were foreign modes of conduct to Cassatt as was the bravado of the toreador's posture, elaborate costume, and expectant adulation. In the Spanish paintings, Cassatt excels at evoking a sense of detachment that allows her to investigate the intrigue represented by sequestered women and the *machismo* of the toreadors of the ever-popular bullfight.

William H. Gerdts chronicles the art colony of Grez, France, from the late 1870s through its vital years of the early 1890s and into the early part of the twentieth century. He documents the fluid aesthetic and romantic relationships in the expatriate community of American, British, Scandanavian, and other European artists. The American expatriate painters at Grez focused on the town's picturesque landscape with its old bridge and meandering river inhabited by the local peasantry through seasonal changes. The peasants were paid models for many of the artists. Gerdts details the nuanced evolution from the Barbizon painters to the grey tonal mode of painting indicative of work from Grez, to the development of Impressionism that comes to fruition in Giverny in the late 1880s. This essay details numerous painters who stayed at Grez: Willard Metcalf, Will Low, Theodore Robinson, Thad Welch, Frank Fowler, Kenyon Cox, Augustus Heaton, Milne Ramsey, Frederick Arthur Bridgman, William Baird, Harry Bispham, Hiram Bloomer, Alexander and Birg Harrison (brothers), Robert Vonnoh, as well as many others. Though an art colony of expatriates who lived in two or three main hotels during their prolonged stays, there was a collegiality with the townspeople and each other. The artists played the piano in the hotels, competed in billiards and took boating trips along the river. Many of the artists were accompanied by their wives, aiding the easy friendships, a diluted bohemianism, between many members of the art colony.

Britta C. Dwyer constructs the historically conflicting currents of feminist thought and activity in France and the preeminence of American feminism in the last decade of the nineteenth century. The professional relationship between the celebrated painters Rosa Bonheur (1822–1899) and Anna Elizabeth Klumpke (1856–1942) symbolized the promise of individual versus relational feminist thought that supported women's accomplishments in the arts. Representing aspects of French feminism is the painter Rosa Bonheur, who was inspired by the literary and confrontational attitudes of George Sand and a curiosity for the American West. Bonheur garnered an initial taste for the New World, perhaps from the very public appearance of George Catlin, the painter, and his accompanying group of Native Americans, as well as an exhibition of Catlin's work and performances of Native songs and dances in 1845 in Paris. Bonheur's most well known work *Horse Fair* (1853) and the portrait of *William S. Cody,* alias Buffalo Bill (1889), can be linked with a fascination for the freedom of the American West. Anna Klumpke, though born in San Francisco, spent much of her youth in Germany and Switzerland. When she was in her mid twenties, she moved with her siblings and mother to study in France. Klumpke

was awarded numerous prizes in France and the United States leading to a successful career as a portrait painter in Boston in the 1890s. The two women painters admired each other and, in fact, corresponded during Klumpke's many years in the United States. The intimate relationship between Klumpke and Bonheur began at Klumpke's request to paint Bonheur's portrait. The resulting realistic portrait depicts both the person and her profession. In turn, Bonheur seemed to have admired Klumpke, both as an American and an artist, since in her opinion the United States led the Western world in the emancipation of women in the development of their talent.

Kathleen Butler carefully documents varying degrees of psychological distance in Sargent's watercolors. John Singer Sargent (1856–1925) was born in Italy, studied art in Paris, and settled in London, thereby inheriting his expatriatism. His family had come to Italy to recover from a family tragedy and restore their health. His mother felt a greater degree of domestic, artistic, and intellectual freedom in Europe than in Philadelphia, so she convinced her husband to stay abroad. Though wanting to return to the United States because of his strong allegiance to his native country, he obliged his wife's wishes. Sargent's father subconsciously manifested an inherent conflict associated with exile—a fear of losing the world that has shaped him, everything that once seemed fixed is uprooted, and everything known becomes strange.[7] John Singer Sargent did not feel a sense of dislocation from his native language, familiar customs, and community because of his father's outward unabated sense of patriotism. Sargent's portraits reveal degrees of involvement with his subjects. When family members or close friends of the family are depicted, there is a casualness and spontaneity to the work. In the architectural renderings in watercolor of Venice, the focus on portals and entrances suggests a beckoning that does not include a penetration into the space. During Sargent's travels to the Near East, illustrative renderings of Bedouins provide a psychological distancing, ensuring that the artist remains a stranger. Acting as a screen, travel creates a comfort level based on a desired proximity with those in the foreign or new environment. Sargent's graduated approaches to intimacy with his subjects form a critique on degrees of expatriatism.

The destination of American expatriate artists shifted from Florence, to Rome, to Düsseldorf. By the 1870s with the passing of Rome and Düsseldorf as popular centers of study, artists flocked to Munich—as many as 270 at that time—but Paris ultimately became the most important center, a position it held until the start of World War II in the 1930s.[8] Artists' interest in a historical antiquity was usurped by the vitality of the modern city of Paris with its experimental atmosphere. Theresa Leininger-Miller investigates the work of Augusta Savage and Nancy Elizabeth Prophet, two African American sculptors working in Paris in the late 1920s and early 1930s. The geographical and psychological distance from racial and sexual discrimination in the United States encouraged the sculptors' evolution from traditional academic studies of white European women to distinctive busts of Black men and nude figures of

Black women. Mobilizing their yearnings and curiosity, these women had a metabolic need to make art overcoming the scarcity of commissions and the erratic nature of the art market in the United States. A conflation of influences such as modern anthropological studies on "primitivism," the rediscovery of the history and art history of Africa by Black scholars, and the development of a racially representative art and individual self-discovery intertwined in both Prophet's and Savage's work. Though some of their most distinctive sculptures are racially and sexually ambiguous, their work is most acclaimed for a unique discernment of racial qualities. Both Prophet and Savage used materials such as cherrywood, pearwood, teakwood, ebony, and bronze as a way to express the variety and beauty of Black skin tones, especially those of female nudes. As the first group of African American and African/Native American art educators at traditional Black institutions of higher learning, Savage and Prophet's stylistic and thematic advances presage the work of future generations.

Marion Greenwood (1909–1970) was the first woman artist to be commissioned to create a public mural and add to the creation of the formative Mexican aesthetic of the 1930s. Her sister Grace (1902–1979) worked with her, but never achieved Marion's recognition. Marion's murals in Taxco, Morelia, and Mexico City exhibit a distinguished stylistic and political evolution. James Oles notes in Greenwood's murals a reconciling of Mexican folklore with the political demands of public art that moves beyond the tourist emphasis on superficial surfaces to societal inequities. The depiction of the communal (Taxco) marketplace situated in opposition to individualist capitalism in Greenwood's mural parallels Diego Rivera's paintings and watercolors and similar indictments of economic distinctions among various other American writers and artists' work during the Depression. The "rhetorical function of muralism" can be seen in Greenwood's painting at the university at Morelia, which portrays the unidealized importance of labor—fishing, agriculture, and folk art production. In her murals for the large urban marketplace in Mexico City, Greenwood's Marxist content is revealed in the struggle between workers and capitalists. The overtly left-wing content of Greenwood's evolving murals in Mexico and the birth of mural commissions in the United States—partially explained by the association with socialist and communist ideals and the inherent plebeian method of exhibiting art—have been decided factors in the lack of interest in the artist's work. The Greenwoods returned to the United States in the summer of 1936. Later in the decade Marion succeeded in working on all four major New Deal mural projects, fulfilling her hope that her Mexican mural expertise could be employed "at home." Both sisters worked, but by the end of the 1940s, Grace, who had a less productive oeuvre, faded from the art scene, while Marion continued a prolific career.

In the twentieth century, American expatriate artists often sought to immerse themselves in their adopted environs. Michael Plante's essay on the American Abstract Expressionists Joan Mitchell and Sam Francis, who lived in Paris during the 1950s, presents an orientation, partly French and partly American, or

in other words as *demi-française*. Even in the nationalistic climate of post-World War II France, Francis had great success in exhibiting his canvases to French audiences, as he managed to create an interest in his work by capturing the light and winter-gray sky of Paris, and later the brilliant hues of Matisse and the revival of an admiration of Monet's late work. The saturated coloration, loose abstraction, and large scale of Monet's late paintings can easily be recognized as precursors to Mitchell's and Francis' work. Although there were affinities in Mitchell's art to nonobjective French art of the 1950s, Mitchell distanced herself from the Parisian art scene and remained rooted in landscape. The American artists needed to show that they were working in a French tradition, even though it is evident that both artists were mirroring concerns of the Abstract Expressionist movement in the United States.

Divergent expressions of exile are realized in the paintings of R.B. Kitaj. Carol Salus in her essay reflects on the idea of travel as intrinsic to the life and art of the contemporary artist R.B. Kitaj. For Kitaj, who lived in London almost 40 years and traveled in Europe as well as lived for periods in the United States, ideas are the baggage of artists. He travels into the past and present, simultaneously disclosing parts of his identity as an American and as a Jew. His paintings show a deep attachment to place that is perhaps ironic considering his peripatetic nature. Cinematic references and fragments, as well as real and imagined sites portrayed in his paintings, are keys to his search for roots and artistic growth. Through reenactments of fantasized historical episodes and analogies to ageless themes, Kitaj travels with the viewer back and forth through time. His paintings, therefore, provide a unique coupling of veracity and ambivalence.

Laura Fattal describes the various cities of residence and monumental site-specific sculptures of Beverly Pepper. Beverly Pepper, born in 1924 in Brooklyn, New York, sees the idea of expatriatism as an anachronism. The exigencies of everyday life as a young wife and mother necessitated that Pepper locate in a place where she could work and raise children. Since the 1950s, Beverly Pepper has worked professionally as a sculptor in Rome and Todi, Italy, and New York City. Explicating her American aesthetic, Pepper states that she feels more American when she leaves the country. Modernist, in the ideology of the collectivity of a spiritual aesthetic, Pepper's sculptures seek pictorial equivalents of universal experiences. Dramatizing space, Pepper strategically places her cast iron and bronze sculptures to evoke a heroic present, concomitantly engaging the viewer into participating in a theatrical historical setting. Memory and a sense of continuity with the past are omnipresent in her work. An early awareness of an eco-aesthetic is pervasive in her environmental installations intending, in part, to be a meditation on time. Pepper's work bridges stylistic moments, not movements. She recognizes that she is the ever-present factor in each sculpture, not affected by nationality or geography.

Expatriates have been recognized as insightful critics of American society. Francine Prose writes that some (artists) who travel to distant places seem not to

have left home but rather, to have come home. Others are able to see a foreign culture more clearly than their own, or are suddenly able to see their own more clearly from a distance. Astonishing sights, unfamiliar sounds and smells, and uncategorizable sensations may work in mysterious ways to evoke critical memories or to stir the imagination. The sounds of other languages may intensify our fondness—and longing—for our own.[9] It can be suggested that expatriate artists delight in an explicit marginality and who then create an inchoate definition of an American aesthetic. The psychological needs of expatriate artists, perhaps, thrive on the unpredictability of experience and a continual search for absolute freedom. The essays in this anthology expand upon individual incidents of expatriatism to explore the cultural constructs of social class aspirations, chronicling an artists' colony, the metaphoric meaning of travel, feminist comradery, the didactic impulse of public art, politics of the Diaspora, and cosmopolitanism.

NOTES

1. William W. Stowe, *Going Abroad, European Travel in Nineteenth Century American Culture* (Princeton, NJ: Princeton University Press, 1994), p. 157.

2. Barbara Novak, *American Painting of the Nineteenth Century: Realism, Idealism, and the American Experience* (New York: Praeger Publishers, 1969), p. 74.

3. Stowe, *Going Abroad,* pp. 18–19.

4. Theodore E. Stebbins, Jr. *The Lure of Italy: American Artists and Italian Experience 1760–1914* (New York: Museum of Fine Arts, Boston and Harry N. Abrams, Inc., 1992), p. 50.

5. Ibid., p. 24.

6. Stowe, *Going Abroad,* p. 37.

7. Suzanne Berne, "Remembering Babylon," *New York Times* (October 17, 1993).

8. Matthew Baigell, *Concise History of American Painting and Sculpture* (New York: Harper and Row, 1984), p. 123.

9. Francine Prose, "Expatriate Games," *New York Times* (Sunday, March 3, 1996): 33.

1

Whistler's Paintings in Valparaiso: *Carpe Diem*

Robert H. Getscher

While born in New England, in Lowell, Massachusetts, with his youth spent in England and Russia, where his father was railroad engineer to Czar Nicholas I, and his student days in Paris, James McNeill Whistler (1834–1903) had strong Southern roots. His father, Major George Washington Whistler, came from Kentucky, while the major's second wife, Anna Matilda McNeill, grew up in North Carolina. The artist, christened James Abbot, added his mother's maiden name to his as a young adult. After he settled in England, Joanna Hiffernan became Whistler's chief mistress and model. We see her in *The White Girl,* painted in Paris in the winter of 1861. It first was rejected at the British Royal Academy exhibition, and then became one of the most talked-about paintings in the Salon des Refusés in Paris in 1863.[1] That same winter his mother, ailing, came to London to stay with James to escape the American Civil War, sailing on a confederate ship that had evaded the blockade at Wilmington, North Carolina, her home. Then, in April 1865 Whistler's brother, William, who had been a physician in the Confederate Army, came to live in London, reuniting the two brothers and their half-sister Deborah, wife of Francis Seymour Haden, a famous surgeon and budding etcher.

How difficult. Whistler clearly loved his mother, but he could not conveniently sleep with Jo while living with his Bible-quoting parent. The two brothers were also close, but his younger brother came to London as a hero from the war, while Whistler had had little commercial success as an artist. Although Anna remained fiercely proud of both her boys, how do you explain to your extremely pious mother the virtues of your depiction of your mistress that became a *succès de scandale* in the Salon des Refusés? West Point helped; Whistler often joked about his time there, in part to make certain that his acquaintances knew of his attendance. His father had also been a West Point man. Whistler's erect bearing must have been as much due to his military

training as to his short stature. While we cannot assume that he longed for a war of his own, he soon found one—Chile's fight against Spain. Although not the magnet that the Spanish Civil War became in the 1930s, it drew him. Long in gestation, short on action, the conflict went back to 1824 when Peru drove out the Spanish troops and declared independence, which Spain never recognized. In 1864 she sent a fleet to the Pacific, officially to protect the interests of Basque immigrants there, but in reality to reestablish domination over her former colony. Out of its own self-interest, Chile joined in Peru's defense. When a Chilean steamship captured a Spanish gunboat November 1865, South American pride and Spanish ire both escalated. The Spaniards then blockaded Valparaiso, and Whistler had a cause.[2] On January 31, 1866, he signed a will making Jo, not his mother, his sole beneficiary, with power of attorney to dispose of his paintings while he was gone. He left that night. On March 12 he arrived in Valparaiso, where he spent his time keeping a spotty journal of naval and military developments, while avoiding any actual involvement with the troops. He also painted a few seascapes. Whistler did not return to England until that September, perhaps too poor to do so earlier. But this handful of works gave birth to two of his most original contributions as a painter: the *Nocturne* and an understanding of Japanese design.

Whistler's friends and most tenacious biographers, Joseph and Elizabeth Pennell, transcribed in detail the story as Whistler gave it to them:

It was a time when many of the adventurers the war had made of many Southerners were knocking about London, hunting for something to do, and I hardly know how, but the something resolved itself into an expedition to go out to help the Chileans, and, I cannot say why, the Peruvians too. Anyhow, there were South Americans to be helped against the Spaniards. Some of these people came to me as a West Point man, and asked me to join, and it was all done in an afternoon. I was off at once in a steamer from Southampton to Panama. We crossed the Isthmus, and it was all very awful—earthquakes and things—and I vowed, once I got home, nothing would ever bring me back again. I found myself at Valparaiso, and in Santiago, and I called on the President or whoever the person in authority was. After that, came the bombardment. There was the beautiful bay with its curving shores, the town of Valparaiso on one side, on the other the long line of hills. And there, just at the entrance to the bay, was the Spanish fleet, and, in between, the English fleet and the French fleet and the American fleet, and all the other fleets. And when the morning came, with great circles and sweeps, they sailed out into the open sea, until the Spanish fleet alone remained. It drew up right into the front of the town, and bang went a shell, and the bombardment began. The Chileans didn't pretend to defend themselves. The people all got out of the way, and I and the officials rode to the opposite hills where we could look on. The Spaniards conducted the performance in the most gentlemanly fashion; they just set fire to a few of the houses, and once, with some sense of fun, sent a shell whizzing over toward our hills. And then I knew what a panic was. I and the officers turned and rode as hard as we could, anyhow, anywhere. The riding was splendid and I, as a West Point man, was head of the procession. By noon the performance was over. The Spanish fleet sailed again into position, and the other fleets sailed in, sailors landed to help put out the fires, and I and the officials rode back to Valparaiso. All the little girls of the town had turned out, waiting for us, and, as we rode in called us Cowards! The *Henriquetta,* the ship fitted up in London, did not appear until Whistler's Paintings in long after, and then we breakfasted, and that was the end of it.

But I made good use of my time, I painted the three Valparaiso pictures that are known—and two others that have disappeared. I gave them to a steward or purser to bring home and the purser kept them. They were once seen in his house or rooms in London by someone who knew me and my work. As soon as he saw them, he said, "Why these must be by Whistler." "Who's Whistler?" said the purser. "An artist," said the other. "Oh no," said the purser, "they were painted by a gentleman." Then the purser started back for South America and took them with him. And, you know, a tidal wave met the ship and swept off purser, cabin, and Whistlers.[3]

While Santiago might have held some interest, for much of Whistler's life had been shaped in capitals (St. Petersburg, Washington, Paris, London), he spent most of his time in the international port of Valparaiso,[4] where the large British enclave would have met his social needs. As a Southerner, Whistler also would have been comfortable with a Chilean society that sharply divided landowners and merchants from laborers, with no middle class. As a Southerner, he felt right at home. In his very long tale, Whistler clearly specified the number of paintings that he made in Valparaiso, three plus two, or five. The authors of the catalog raisonné of his oils suggest six.[5] But, since nothing in the paintings depicts anything specific to this site, not even the magnificent bay he could recall so clearly more than 30 years later, we must rely on the titles to these works to identify them. How strange that he traveled thousands of miles to paint water, ships and wharves that he could have seen in London.

The first painting that the authors of the catalog raisonné associated with this trip, *Nocturne: The Solent,* they did so because Whistler sailed on the *Solent* from Panama to South America, according to his Valparaiso diary.[6] However, I find the three ships depicted in the painting co-equal in color and size, so that it would be difficult to pick out the *Solent.* More surprisingly, Whistler made the central vessel a sailboat, the two on the left, sailing ships, either of which could be the *Solent.* However, if we read the title as: "Nocturne: from the 'Solent,'" the painting could have been done from the ship during its trip down the coast of South America, looking seaward. That would explain why land plays such a little part in this composition, whereas the sky and water fuse into one broad field of blue-green. Young et al. can clearly justify relating this painting to Whistler's Chilean adventure, even though Whistler might not call it a "Valparaiso picture."

Still, they also mention in the catalog raisonné that a strait called the Solent lies between the Isle of Wight and the mainland at Southampton, an area Whistler visited as a child. In the summer of 1847 Deborah, some years Whistler's senior, married the surgeon Francis Seymour Haden, and the boy stayed with them, sketching the scenery on the Isle of Wight while on holiday there the following summer, when he could have first visited the Strait of Solent.[7] He might have visited there again either before or after his voyage to Valparaiso. When crossing a strait, the water spreads out on either side of a ship. The definite article serves as well for a strait ("the" Strait of Hormuz) as for a ship. In the catalog raisonné they also mention a sketch on the back of the canvas that they relate to the "Six Projects," a series of decorative figure paintings often thought to be for Frederick Leyland, for whom he created the

Peacock Room.[8] The sketch on the back of the *Nocturne: The Solent,* indeed resembles this series. In her catalog raisonné of the drawings, Margaret McDonald illustrates several drawings related to the idea for the "Six Projects" that she dates before the trip to Valparaiso, and more after, but the swayback, undulating pose found on the back of the painting best corresponds to images made after the trip.[9] More important, I cannot imagine Whistler traveling thousands of miles, to a distant continent, accompanied by a used canvas, in case there might be something to paint. He certainly brought his paints across the Atlantic, not trusting new, unfamiliar mixtures, and he probably brought stretchers and canvas, for all the dimensions in the Valparaiso paintings correspond to others made earlier. Further, the stretchers used for the *Nocturne: Valparaiso* discussed below (now removed from the original canvas at the Freer but still preserved), appear smooth, professionally cut, pine, with their keys still in the corners, very typical of the ones found on many other Whistlers of the sixties. But the pattern of tack holes indicates that these stretchers had been used before. Just because Whistler had difficulty finishing canvases in these days did not mean that he could afford to discard perfectly good wooden stretchers after a single use. On the other hand—while the designs on old canvas often spur creativity frozen by the blankness of new cloth—by turning it over, Whistler removed this advantage. These reasons led me to conclude that the *Nocturne: The Solent* must date from after his trip, and therefore is not one of the Valparaiso paintings, or one of his first painted nocturnes.[10]

The intriguing *Symphony in Grey and Green: The Ocean* presents a different problem. Young et al. reproduce an early photograph of this painting, signed and inscribed by Whistler about 1881, "Arrangement in Grey & Green—The Pacific." While this early inscription clearly identifies this painting as being from the trip, the photograph shows neither the spray of foliage nor the cartouche that so attract us today. They both must have been added about 1872, when exhibited in the Dudley Gallery, as *Symphony in Grey and Green—the Ocean.* The critic in *The Times* correctly found "the presence of the monogram and leafed twig in the foreground in Japanese fashion intrusive as well as imaginative."[11] Therefore Whistler returned from South America with a seascape with European conventions rather than the pioneering example of Japonisme it now might appear. His later additions obscured the rolling, peaceful waters of the Pacific that lap against a bit of quay and the implied shore, flattening the sculptured, translucent waves. Whistler created the sky and distant ocean with thin washes of paint. He formed the moving water with thicker, more broken passages, gently scumbled to suggest transparent waves.[12] In none of his other paintings from Valparaiso does the water rise up to greet us; instead it remains a flattened, more opaque sheet flowing from us. While not necessarily executed in Valparaiso, it could have been the first of his paintings done there, while Whistler, faced with new stimuli, remained under the influence of old solutions.

These first two paintings, *Nocturne: The Solent* and *Symphony in Grey and Green: The Ocean,* turned towards the ocean. The next four, one horizontal and three vertical ones, focus on Valparaiso's harbor. He certainly painted the

beautiful *Crepuscule in Flesh Color and Green: Valparaiso* there, for the *Athenaeum* described it the following year at an exhibition at the French Gallery in London, as a painting of "dusk in a harbor of the great ocean, probably the pool of Valparaiso, although there is not enough of land represented to enable one to identify the locality. The painter's theme was rather the grayish green of twilight sinking on the sea, and ships becalmed, at anchor, or gently moving."[13]

While not in the printed catalog, no other painting exhibited at the gallery fits this description. And certainly it had some title with "Valparaiso" in it (although not necessarily the present poetic one), for the *Athenaeum*'s critic to identify the scene, unless the gallery so informed him privately. This, one of the most finished of these South American paintings, has a thin sea, while Whistler painted the sky with such thick paint, wet on wet, whites and lavenders sliding into pale blues, that we can almost feel its ridges. Creamier strokes of white define the sails and skiffs as pigment crowds the edge of the stroke, while the bristles of the brush swept the center clean.

The final three paintings: *The Morning after the Revolution, Valparaiso,* the *Nocturne in Blue and Gold: Valparaiso Bay,* and the *Sketch for "Nocturne in Blue and Gold: Valparaiso Bay,"* are all vertical, and, surprisingly, all depict the same dock from the same station point. *The Morning after the Revolution, Valparaiso*[14] depicts another time of day, not dusk, but the end of dawn. We look over the rust-colored wharf to distant hills of the same color, with rich blue water dividing them. The cloud cover is bright white. Since Whistler's executrix Rosalind Birnie Philip, his youthful sister-in-law (1873–1958), the youngest sister of his wife, Beatrix (1857–1896), presented it to Glasgow, we can be fairly certain of the title. The Spanish bombarded the city for three hours on March 31, 1866, one of the most dramatic events of this protracted conflict. Here people crowd the dock gazing at the Spanish fleet, now silent, before the other ships returned, if we can trust Whistler's description, quoted above by the Pennells. The painting as a whole has less substance than *Crepuscule,* having been worked over repeatedly with thin washes or glazes of color, rather than with the creamy directness of the previous painting. This "morning," which he witnessed, came but once, specifically, ironically, April 1, April Fool's Day, but the effect took Whistler days to achieve, as each glaze needed to dry before the next film of pigment could be run over it.

Perhaps this very time lag led to the final two paintings: the *Nocturne in Blue and Gold* and its so-called *Sketch.* The dark, greenish blue, almost monochromatic *Nocturne in Blue and Gold: Valparaiso Bay*[15] certainly represents night (Figure 1). Since Whistler used this title when he exhibited it in 1887 at the Royal Society of British Artists, we can again be certain that this painting depicts Valparaiso. But why did Whistler paint the *Sketch for "Nocturne in Blue and Gold: Valparaiso Bay"* (Figure 2)? It could not have functioned as a sketch for the other painting, even though the Pennells identified it that way in 1908; their title came from T. R. Way, Whistler's lithographer, whose father had owned it since the painter's bankruptcy in 1879.[16] We must conclude that Whistler himself told the Ways that their painting was a sketch. The terms "sketch" and "study" often appear in the catalog raisonné of paintings

but, except for this painting, all others depict figures. With human beings, the slightest irregularity can suggest deformity, so that sketches help define form, but landscapes have few predetermined shapes. To find another nocturnal landscape "study," we have to turn to prints, specifically the study for the early etching *A Street at Saverne*. The preparatory watercolor for the print, while not very dark, clearly indicates the lamp on the wall.[17] Whistler needed to see the linear structure of the scene while working and inking the plate; to be as dark as the printed image would have defeated his purpose. But the painted "*Sketch*" indicates no lights or other objects associated with darkness, and, when seen by itself, seems to depict daylight. The few ships in the "*Sketch*" cluster in the center; many more spread across the horizon in the Valparaiso *Nocturne*. In the *Nocturne* the crowd avoids the water. In the "*Sketch*" they push to the upper edge of the wharf. Between these two paintings everything changes, except for the outlines of the distant mountains, and the wharf itself. One can rightly wonder, how did the "*Sketch*" help Whistler paint his Nocturne, what information did it fix for him? Perhaps none.

While art in series is common enough, Whistler had been aware of art made in series even as a boy, in works by Hogarth. He had to spend several months in London, recuperating from rheumatic fever. In February 1847, while recovering, he received a volume of Hogarth's prints. His mother wrote in her diary:

He is now enjoying a huge volume of Hogarth's engravings so famous in the Gallery of Artists. We put the immense book on the bed, and draw the great easy chair close up, so that he can feast upon it, without fatigue, he said while so engaged yesterday "Oh! how I wish I were well, I want so to show these engravings to my drawings master, it is not everyone who has a chance to see Hogarth's own engravings of his originals," and then added in his own happy way, and "if I had not been ill, Mother, perhaps no one would have thought of showing them to me."[18]

From then on, for Whistler, Hogarth remained England's greatest artist. Hogarth even produced one series centered on the *Four Times of Day*. This particular set might have attracted the 12-year-old, for it, unlike most prints by Hogarth, featured children.

Whistler's two paintings, with the same station point, could easily have been painted from his hotel room, or some other safe, convenient spot. The Pennells noted that "Mr. McQueen, a young Oxford undergraduate when we first knew him, told us that his father was in Valparaiso when Whistler was there, that he put Whistler up at his Club, and that it was from the Club window that the beautiful upright Valparaiso [Nocturne] was painted."[19] Wanting, waiting to paint, after day after day of being closeted in his rooms, Whistler might easily have observed the variations of light out over the harbor. He would not have needed Hogarth to suggest a set, for the "Four Times of Day" has a long history, but rarely do painters discover this theme at such a tender age.

Whistler often had trouble completing series of paintings, the "Six Projects" being merely one example. The idea for the series would not have occurred initially. The tentative *Morning after the Revolution* could have been first, the

more confident "*Sketch*" next, simple and abstract, followed by the experimental *Nocturne*. These last two paintings, the same size, confirm Whistler's concept of a set. The rough paint surface suggests that this time he achieved the sense of night with great difficulty, not with the fluidity Walter Greaves saw him use later. He often took Whistler out on the Thames in his boat so that he could study the night, and then would watch the master paint his "Nocturnes." The Pennells recorded what Greaves told them:

The nocturnes, moonlights, were painted on an absorbent canvas on a red ground, the red forcing the blues laid on it. He also says that Whistler worked with linseed oil only on these nocturnes mixing his colour on a big flat table large quantities of it with a great deal of oil, calling it "sauce," washing it on like a water colour [this Whistler always said he did] and often having to put the canvas flat on the floor to keep the whole thing from running off.[20]

The bracketed comment by Pennells—made as insiders, for Joseph was a well-known and accomplished artist—confirm Whistler's use of "sauce," extremely liquid passages of color. But they knew Whistler in the nineties, and Walter Greaves worked with Whistler in the seventies, not in 1866 in Valparaiso. Later Nocturnes do have smooth passages of liquid color,[21] but this *Nocturne* from Valparaiso, and other early ones, all use thicker paint that resists the stroke of the brush, recording its movement, with underlying paint swept bare by the stiffer brush, obscured by the spaces between the bristles that deposit the greatest amount of paint, obvious in early Nocturnes of the Thames, as well as this one from Valparaiso. Rather than the "soups" that Walter Greaves referred to, flowing as Whistler tilted his surface back and forth, the paint here seems more like thick gravy. The Gilcrease painting has a similar surface. The authors of the catalog raisonné tentatively link the nocturne of Valparaiso Bay to a letter Whistler wrote to Alfred Chapman of Liverpool on July 22, 1874, "I had once promised to let Grapel have the first chance at the Valparaiso [piece] if I ever finish it."[22] We often assume that Whistler habitually checked his image against the site, but clearly here he at least wrote of working on a Valparaiso painting years after he left Chile, and the surface of this Nocturne indicates that that is exactly what he did.

No other Valparaiso painting appears so worked; in none of the others had Whistler stretched so far. The letter to Chapman might suggest to some that the *Nocturne in Blue and Gold: Valparaiso Bay* did not leave Chile as a Nocturne, but became one only after Whistler returned to London, much as *The Ocean* received its leaves. Yet what other purpose might it serve? Whistler already had a morning, noon and dusk; why paint a fourth unless it showed night? He returned from Chile with disjointed fragments of the "Four Times of Day," one horizontal and three vertical, and, of these, one wide, two narrow. We must assume that he had started this work as a Nocturne in, but not finished it. By the time he did, probably in the mid-seventies, given the letter to Chapman, other Nocturnes had been painted, and the earlier idea of the "Times of Day" would have seemed less brilliant. Now we can understand why Whistler told the Pennells about three "known" paintings and two that had "disappeared," another

of his fabrications. Three of the paintings had been exhibited by the time he talked to them, thus "known." But he needed to mention a few more; he could not have created only three paintings in all that time. Yet why obscure the brilliance of his Nocturnes with a mere "Noon?" To avoid too many questions, two became conveniently lost, *Morning* and the "*Study.*" However, since Thomas Way purchased the latter in 1879 in Whistler's bankruptcy sale, it could only have been lost in his studio. "Suppressed" might be a better term. The Ways would not question the Master's title, coined for the moment to give their painting purpose. Whistler felt that "A picture is finished when all traces of the means used to bring about the end has disappeared."[23] If necessary, cut and regroup to that end.

But the Valparaiso Nocturne has another element not evident in the paintings that bracket it in time, such as the beach scene with Courbet,[24] and the previously mentioned early Nocturne of the Thames,[25] and the '*Sketch*'—*Noon* (Figure 2). In both of these Whistler painted the background first, and then completed the figures. He completed the largest areas first, then painted the smaller, closer objects on top. Using this traditional approach, he painted the figures in both the *Morning* and the "*Sketch*" last, on top of the wharf, although he made the latter figures with mere wisps of paint. But in the Valparaiso Nocturne, he brushed the blue sea around the darker wharf. He then created the figures on the wharf by painting around them, letting their silhouette define them. In other words, the figures closest to us, crowded in the cool, safe night, consist of a thin layer of paint further away, while the more distant sea, calm, mirror-like was painted with the thickest paint. Whistler painted the figures in the famous *Nocturne: Blue and Gold—Old Battersea Bridge*[26] and *The Falling Rocket.*[27] the same way, except that he used a far thinner 'sauce' for these paintings. This suggests that his letter to Chapman is correct. While this Nocturne began in Chile, the treatment of the objects suggests that he did indeed take years to solve these problems, and that while this must be the earliest painted Nocturne, it does not look like it did when Whistler arrived back in London. One can paint over offending areas, building up a thicker layer with each change. But the paint on *Nocturne: Valparaiso Bay* remains unusually thin. Whistler could have painted, then, dissatisfied, wiped off the still wet paint. But this surface, as best seen in the wharf, indicates that he scraped the paint off after it had begun to dry, for sharp white bits of canvas, deliberately retained, still show through. He must have done this numerous times over the years.[28] Why scrape down a surface? If he painted at night, rather than merely relying on memory of the effect, the illumination in his room would have to have been kept low not to blind him to the dark outdoors. Only later, in daylight, could he see what his paints said. So he scraped down, then started again, some other night. Back in London, freed from the motif, he could paint with ease, but what had he seen, how did it look? The "*Sketch*" would have been of little help, for it distinguished forms by juxtaposing cocoa browns and pale blues. In the *Nocturne* he used light and dark blue, variations in value, not warm and cool colors. Whistler's ultimate frustrations can be seen in his rough strokes down the distant pier. They fall like coarse straw, silhouetting his huddled masses, the

tired, the poor, and their battle over. This luminous Nocturne might more properly be seen as a sketch, a working surface, where Whistler worked out problems of light and suggestion. Later he would paint his Nocturnes from memory, during the day, having absorbed the scene the previous night. But he would not have thought to do that in Valparaiso, since at that time he painted every other scene from sight, not memory.

Whistler first called his nocturnal paintings "Moonlights,"[29] but quickly renamed them Nocturnes at Frederick Leyland's suggestion. The Irish composer John Field had first used the term for his piano pieces in 1814; Chopin followed. Not only did Whistler admire its musical associations and poetic sound, but it was closer to the truth. Artists had painted "by the light of the silvery moon," at least since seventeenth-century Holland. But for the others the moon clarified by its pale light. Whistler looked, not for bright moonlight, but for the magical transformations brought by enshrouding darkness, a time when "the tall chimneys become campanili."[30] How appropriate that he first watched this metamorphosis with a mere wharf.

This insignificant wharf became so important to Whistler that he painted it three times. Note that he narrowed these last two canvases and raised the angle at which we see it. He could have gone to a higher floor in the club to observe the scene this way, but I suggest that instead he made a conscious move to make his paintings more vertical, and the wharf within it more vertical, diminishing the sky, to approximate the flattened space found in Japanese prints. Again, to help flatten the image, Whistler used a single color for the wharf in the "*Sketch*" (Figure 2), and brushed the surface smooth, retaining only an echo of horizontal bands of color under this barely translucent glaze, and completely avoiding any long diagonal that would follow the planking. He also painted the wharf and the distant hills the same cocoa brown, uniting far and near. The white sky, overcast, has pale blue and brown streaks in it. I saw the painting in Washington during a similarly overcast noon, and a flat sky. Here Whistler used pale stripes of color, not as sunlit or shadowed clouds, but in imitation of the bands of color seen in the Japanese prints that he had painted earlier, in 1865, in *The Golden Screen*.[31] Later, in reworking its companion, he overlaid the distant wharf with diagonal strokes and lighter paint than found this side of the figures, suggesting a recession into space. Still, here in these Valparaiso paintings Whistler first used Japanese formal elements, rather than merely Eastern artifacts, like the costumes found in *The Golden Screen,* posed for by Jo. In the "*Sketch,*" the great vertical thrust of the wharf helps squeeze the hills between the blue of the sky and the sea, while boats and people become lost in the soft, moist mist. Another element flattens the *Nocturne,* a clear wave-like pattern that unites the blue of the sky and the water. As he introduced oriental artifacts as artifice, make-believe, to European painting in the 1860s, these landscapes now introduced its thought, its space, its essence, rather than its surface. Whistler finally understood the East, uncovered by Admiral Perry, in a new way, although straying no closer to it than Chile.

As Americans still do, Whistler went to Chile willing to risk his life for strangers. But, once in Valparaiso, instead of war, he discovered a theme that

affirmed life, the cycle of the day: night and day, dawn and dusk—*Nocturne in Blue and Gold: Valparaiso Bay* and its *"Sketch," The Morning after the Revolution* and *Crepuscule in Flesh Color and Green.* Fortunately we still have the results of his quiet struggle.

NOTES

1. *The White Girl.* National Gallery of Art, DC. See the catalog raisonné by Andrew McLaren Young, Margaret MacDonald, Robin Spencer and Hamish Miles, *The Paintings of James McNeill Whistler* (London: Yale University Press, 1980), no. 38.

2. Ronald Anderson and Anne Koval, in *James McNeill Whistler: Beyond the Myth* (New York: Carroll & Graf, 1994), intriguingly suggest that Whistler fled England in 1866 because he feared being connected with the Irish separatists then being imprisoned there, pp. 152–156. This motive does not explain why he went to Chile however; France would have protected him from the police just as well.

3. E. R. and J. Pennell, *The Whistler Journal* (Philadelphia: J. D. Lippincott, 1921), pp. 42–43. Related to the Pennells on June 3, 1900. Their *Journal* documents when they learned of the events presented chronologically in their *Life* of Whistler (1908).

4. Katherine Emma Manthorne, in her *Tropical Renaissance: North American Artists Exploring Latin America, 1939–1879* (Washington, DC: Smithsonian Institution Press, 1989), "The Syncretism of South and East: James Whistler in Chile," pp. 159–176, provides the most extensive, detailed study of this period and its paintings. However, she relates their sequence and purpose to the work of other painters in South America, whereas I see Whistler's development as more internal. More recently, Margaret MacDonald dealt with the personal aspects of this period, as well as with the special nature of the paintings, as part of "Whistler in Crisis," a lecture, National Gallery, Washington, DC, May 28, 1995.

5. Young et al., nos. 71–76.

6. *Nocturne: The Solent,* canvas, 19 3/4" x 36". Gilcrease Institute of American Art History and Art, Tulsa, OK, Young et al., no. 71. Not exhibited in Whistler's lifetime. "Valparaiso Diary," pp. 1–2, Glasgow University Library. Also see Margaret F. MacDonald, *James McNeill Whistler: Drawings, Pastels, and Watercolours; a Catalogue Raisonné* (New Haven: Yale University Press, 1995), no. 340, for his sketches in this diary.

7. For the Strait of Solent, see Young et al., no. 71. Richard Dorment omitted reference to this option in the recent retrospective catalog on Whistler: Richard Dorment and Margaret F. MacDonald (who dealt only with the works on paper), James McNeill Whistler (London: Tate Fallery, Paris: Musée d'Orsay, and Washington, DC: National Gallery of Art, 1994–1995), no. 43.

8. The Peacock Room. Freer Gallery of Art, Washington, DC, Young et al., no. 178.

9. For the sketches for the "Six Projects" made before 1866, see MacDonald, *Whistler Drawings,* nos. 314–315; for those made after, nos. 341–358.

10. In "Whistler in Crisis" Margaret MacDonald also concluded that the *Nocturne: The Solent* came after Whistler's trip to Valparaiso, for the same reason, the sketch on the back. She dates the painting to 1871 on the basis of its painting technique. Unfortunately, I did not have the opportunity to hear her lecture, and my ideas grew independently; later she kindly lent me a copy of her text. Here I have the opportunity to explore the case for the other options more fully than she had the time to do in Washington.

11. *Symphony in Grey and Green: The Ocean,* canvas, 31 3/4" x 40 1/4". Frick Collection, New York, Young et al., no. 72, and pl. 378 for the photograph without the

foliage. They quote *The Times* (November 11, 1872), which specifically mentioned foliage.

12. I am grateful that Roger A. Welchans discussed Whistler's painting practices with me. The *Symphony in Grey and Green: The Ocean* is a gentle variant of *Blue and Silver: Blue Wave, Biarritz,* 1862. Hill-Stead Museum, Farmington, CT, Young et al., no. 41.

13. *Crepuscule in Flesh Color and Green: Valparaiso,* canvas, 23" x 29 3/4". The Tate Gallery, London, Young et al., no. 73. Described in the *Athenaeum* (January 5, 1867): 22–23, quoted in Young et al.

14. *The Morning after the Revolution, Valparaiso,* canvas, 30" x 25 1/8". Hunterian Museum of Art, University of Glasgow, Young et al., no. 75. Not exhibited in Whistler's lifetime.

15. *Nocturne in Blue and Gold: Valparaiso Bay,* canvas, 29 3/4" x 19 3/4". Freer Gallery of Art, Washington, DC, Young et al., no. 76.

16. Sketch for "Nocturne in Blue and Gold: Valparaiso Bay," canvas, 30 1/4" x 20", National Museum of American Art, Washington, DC, Young et al., no. 74, where they use this title, as did E. R. and J. Pennell in *The Life of James McNeill Whistler,* 2 vols. (Philadelphia: J. B. Lippincott, 1908), p. i, facing p. 134.

17. The etching, *A Street at Saverne,* no. 19 in Edward G. Kennedy, *The Etched Work of Whistler* (New York: The Grolier Club, 1910). For the study *A Street at Saverne,* watercolor. Freer Gallery of Art, Washington, DC, see MacDonald, *Whistler Drawings,* no. 237.

18. Anna McNeill Whistler, "Diary," February 27, 1847, Manuscript Division, New York Public Library, no pagination.

19. Pennell, *The Whistler Journal,* p. 48.

20. Greaves's description comes from the Pennells' *Journal,* September 18, 1906, p. 116. For an extensive, sensitive treatment of Whistler's Nocturnes, see John Siewert's forthcoming study.

21. Such as *Nocturne in Blue and Silver—Chelsea,* 1871. The Tate Gallery, London, Young et al., no. 103. Purchased by C. W. Alexander in 1872 as Harmony in Blue-Green—Moonlight."

22. Whistler's letter to Alfred Chapman, Library of Congress, Pennell Collection, quoted in Young et al., no, 76, p. 44.

23. "A picture is finished," the opening statement of his "Propositions–No. 2," *The Gentle Art of Making Enemies,* 2nd ed. (London: William Heinemann, 1892), p. 115.

24. *Harmony in Blue and Silver: Trouville,* 1865. Isabella Stewart Gardner Museum, Boston, Young et al., no. 64. Called "Courbet—on sea shore—" by Whistler in 1886.

25. *Nocturne in Blue and Silver—Chelsea,* 1871. The Tate Gallery, London, Young et al., no. 103.

26. *Nocturne: Blue and Gold—Old Battersea Bridge,* 1872/73. Tate Gallery, London, Young et al., no. 140.

27. *The Falling Rocket,* c. 1875. Detroit Institute of Arts, Young et al., no. 170.

28. The paint on *Nocturne: Valparaiso Bay* resembles a similarly worked and reworked surface, where Whistler never completed the face, *Harmony in Blue and Gold: The Little Blue Girl* (from 1894 until his death, Freer, Young et al., no. 421), on similarly coarse canvas, but here he blanketed every bit of it with ultramarine blue before painting more. Had one simply guessed, one might have expected the figurative painting to have the canvas sparkling through, and the Nocturne to have the canvas hidden.

29. Whistler first called the *Nocturne in Blue and Silver—Chelsea* a "Moonlight," see above. Therefore, Manthorne appropriately uncovered several other American artists who painted moonlights in South America, but these fascinating connections obscure the

relationships between Whistler's single Valparaiso Nocturne and his other works painted there.

30. The chimneys become campanili in "Mr. Whistler's 'Ten O'Clock,'" his famous lecture first given in 1888. *The Gentle Art,* p. 144.

31. *The Gold Screen.* Freer Gallery of Art, Washington, DC, Young et al., no. 60

SELECTED BIBLIOGRAPHY

MacDonald, Margaret F. *James McNeill Whistler: Drawings, Pastels, and Watercolours; a Catalogue Raisonné.* New Haven: Yale University Press, 1995.

Pennell, E. R. and Pennell, J. *The Life of James McNeill Whistler,* 2 vols. Philadelphia: J. B. Lippincott, 1908.

————. *The Whistler Journal.* Philadelphia: J. B. Lippincott, 1921.

Whistler, Anna McNeill. "Diary." February 27, 1847. Manuscript Division, New York Public Library.

Whistler, James McNeill. *The Gentle Art of Making Enemies,* 2nd ed. London: William Heinemann, 1892.

Young, Andrew McLaren, Margaret MacDonald, Robin Spencer and Hamish Miles. *The Paintings of James McNeill Whistler.* London: Yale University Press, 1980.

2

Bullfights and Balconies: Flirtation and *Majismo* in Mary Cassatt's Spanish Paintings of 1872–1873

M. Elizabeth Boone

On New Year's Eve 1872, Mary Cassatt wrote to her good friend Emily Sartain: "My present effort is on a canvass [*sic*] of thirty and is three figures life size half way to the knees. All three heads are foreshortened and difficult to pose, so much so that my model asked me if the people who pose for me live long. I have one man's figure the first time I have introduced a man's head into any of my pictures." The painting to which Cassatt (1844–1926) was referring is *On the Balcony* (Figure 3), the first of several paintings she would complete during her six-month sojourn in Spain. During the visit she also painted *Toreador* (The Art Institute of Chicago) and the closely related *Offering the Panale to the Bullfighter* (Figure 4), two paintings inspired by the bullfight. Pleased with her results, Cassatt sent *On the Balcony* to New York's National Academy of Design in 1874 and *Offering the Panale* to both the Paris Salon of 1873 and the National Academy in 1874. Then an artist in her late twenties, she had yet to meet Edgar Degas or the impressionist painters with whom she would become associated later in the decade; nor had she begun to specialize in themes relating to feminine life. In these Spanish paintings, she wrote Sartain, she was introducing the male figure.[1] This was a new venture and one that would rarely be repeated in the course of her career.

Scholars have remarked upon—and even offered reasons for—infrequency of the male figure in Cassatt's oeuvre. It has been observed that women painters studying in Philadelphia and Paris, the two cities where Cassatt received her education, had little access to the male nude and that the female realm of the domestic interior was considered at the time a more appropriate subject for women of Cassatt's class than the public space of the modern city.[2] But in Spain things were different. There Cassatt was a tourist, a visitor who could

watch Spanish society without fully participating in it. Being a tourist seems to have offered her the freedom to move beyond the themes generally deemed suitable for a female painter. In fact, a careful consideration of her Spanish paintings, bringing together an understanding of nineteenth-century Spanish life and Cassatt's innovative use of Spanish art, reveals that these works possess a particularly modern approach to social relations. It was a modernity permitted Cassatt by virtue of her distance from Spanish society and one she would pursue differently in he later work, in which the mores of nineteenth-century society kept female and male painters working in clearly circumscribed spheres.

Cassatt went to Spain during her second extended stay in Europe, traveling first to the Italian city of Parma with Sartain and then alone by train to Madrid and Seville. She arrived in Madrid on Saturday, October 5, 1872, and registered at the Hotel de Paris, one of the city's newest hotels, on the Puerta del Sol in the center of town. It was a short distance from the Prado, which she visited that very morning.[3]

Like many nineteenth-century artists, Cassatt went to Spain to study the old masters, especially Diego Velázquez and Bartolomé Murillo. To Sartain, she wrote that Murillo's *Immaculate Conception of the Escorial* (ca. 1660–1665, Museo del Prado) was "lovely most lovely" and proclaimed, "I sincerely think it is the most wonderful painting that ever was seen, this of the Spanish school." While at the Prado, Cassatt made a copy of Velázquez's portrait of the child prince, Don Baltasar Carlos,[4] and the gentleness of Murillo's madonnas, prescient choices in light of her later portrayals of mothers and children.

But Cassatt also went to Spain to find subjects of her own, so after almost three weeks in Madrid, she went to Seville. Again she traveled alone, taking a seat in the "Dames Seules" section of the train. Arriving on Tuesday, October 26, she settled in for a stay of five months. Cassatt described the landscape between Madrid and the south as "immensely sad, vast, and dreary," but Seville, she noted, was "full of color, gay lively, the Cathedral magnificent, orange trees growing in the streets and squares." In the hospitable climate of Andalusia, she hoped to paint outdoors, and soon she was able to situate herself in a studio at the Casa de Pilatos, a sixteenth-century palace belonging to the ducal family of Medinaceli.[5]

Cassatt's evocative new surroundings undoubtedly fostered her enthusiasm for Spanish life. An eclectic mixture of Spanish and Moorish architectural elements, the Casa de Pilatos had become a tourist site during the nineteenth century, and most guidebooks listed it among Seville's many attractions. Commissioned by the first duke of Tarifa after a pilgrimage to the Holy Lands, the palace was popularly believed to be an extra replica of the house belonging to Pontius Pilate in Jerusalem. This splendid building combined shady Spanish patios with classical sculpture, brilliant Moorish tile work, and various allusions to Christ's passion such as a model of the True Cross and a copy of the table on which the thirty pieces of silver were counted.

Here Cassatt commenced work on her Spanish subject paintings, and by New Year's Eve she had begun *On the Balcony,* the picture she described to Sartain. In the painting, three Spaniards stand together on a window balcony. The two brightly lit women in the foreground lean casually against the railing, one looking down toward the street, the other over her shoulder toward their male companion, who is just emerging from the shadowy interior of a room beyond.

The window balcony is a common feature of Spanish architecture, long used for privately viewing the street below. Foreign travelers sometimes constructed elaborate fantasies, ranging from amorous to illicit, involving women on balconies and passerby. Washington Irving in *The Alhambra* (1832), for example, recorded watching a pretty brunette carry on "a mysterious correspondence with a handsome, dark, well-whiskered cavalier." Initially Irving supposed a romantic liaison in the marking, but when he discovered that the cavalier was, in fact, the lady's husband, he substituted smuggling for love as the reason for the communications.[6]

French poets explicitly associated *The Balcony* with love. In Charles Baudelaire's "*Le balcon*" (1857), the balcony is the setting for a passionate encounter between two lovers. Ten years later, Paul Verlaine's "Sur *Le balcon*" envisions an unmade bed behind an amorous couple (in this case lesbians) standing on the balcony. To circumvent the censors, Verlaine published his small book of erotic poetry under a fictitious Spanish-sounding name, "Pablo de Herlagnes," with Sergovia as its place of publication.[7]

American writers were generally more restrained in the comments. George Lathrop, for example, observed that within the balcony's protective confines, Spanish women behaved in a less inhibited, more casual way. "Although [Spanish] women avoid meeting male glances when on the sidewalk," Lathrop reported, "they enjoy full license to stand at their high windows, which are called *mirodores* or *lookers,* and contemplate with entire freedom all things or persons that pass."[8]

In Spain, as in the United States, a woman's role was in the home, and public activity was generally discouraged. Spanish guides to deportment stressed the importance of "domestic competence [and] social *savoir faire,* especially modesty" in women of the middle and upper classes.[9] The balcony's position allowed it to function as the intersection between public and private space, and its elevated placement removed its occupant from the street while offering her an unobstructed view of the world below.

Window and balcony scenes are common in Spanish painting, and Cassatt's *On the Balcony* can be connected to several artistic precedents. The most famous balcony painting of the time was *Majas on a Balcony* (Metropolitan Museum of Art, New York) by Francisco de Goya. Nineteenth-century scholars recorded several versions of this painting, and Cassatt brought one of them to the attention of Louisine and Harry Havemeyer in 1901, when the three traveled together to Spain in search of paintings for the couple's art collection. Cassatt remembered the *Majas* from an earlier visit, and while the Havemeyers made a side trip to Granada, she stayed in Madrid to find it with the help of Joseph

Wicht, a dealer familiar with the private collections of Spanish nobility. Eventually, the Havemeyers purchased the painting.[10]

Like Goya's painting, Cassatt's *On the Balcony* features two women in the foreground, learning against a railing placed parallel to the picture plane. Behind, and in the shadows, stands the man. Cassatt maintained the Spanishness of Goya's work by dressing her Andalusian models in traditional costume, complete with flowers, shawls, and fans. In Goya's painting the men are cloaked in dark mantles, while in Cassatt's, the single cavalier is less heavily clad and wears a broad-brimmed hat. Cassatt elaborated upon the anecdotal quality of Goya's canvas by establishing a casual conversation between her young Spaniard and the woman in front of him, who coyly lowers her fan in response to his advance.

Goya scholar Nigel Glendinning claims that *Majas on a Balcony* was Goya's most frequently imitated painting. Charles Yriarte published a full-page reproduction of the original in his 1867 monograph on the artist, and Edouard Manet produced his well-known adaptation, *Le balcon* (Musée d'Orsay, Paris), in 1868–1869, three years before Cassatt's *On the Balcony*.[11] Cassatt probably made a point of seeing Manet's painting at the 1869 Salon, for she was in Paris that spring and had also studied with Manet's former teacher, Thomas Couture, during the summer and fall of 1868.

Manet's Spanish subject paintings of the 1860s undoubtedly contributed to the popularity of Spain among late-nineteenth-century artists like Cassatt. Appreciation for Velázquez, in particular, brought Manet to Spain in the fall of 1865. Traveling alone, he had the good fortune to meet Théodore Duret at the Hotel de Paris in Madrid. Duret, well-traveled and interested in art, made the perfect companion, and the two men visited the Prado, Toledo, and a bullfight during Manet's weeklong stay.[12] In *The Balcony,* as in *The Execution of Maximilian* (1868–1869, Städtische Kunsthalle, Mannheim), Manet relied on Goya for is compositional format. In both works, however, the artist removed the overt Spanishness of Goya's original. *The Balcony,* for example, includes Manet's friends Berthe Morisot, Antoine Guillemet, and Fanny Claus, clearly recognizable in contemporary clothing. The painting is, moreover, devoid of the anecdotal element in Goya's *Majas,* a quality retained and exploited by Cassatt.

Cassatt's debts to both Manet and Goya eluded American critics; instead, they noticed the influence of a third painter, Bartolomé Murillo. "In one of the balcony groups," a critic at the National Academy of Design observed, "there is a leaning girl's head, full of somber power, and painted with the best traditions of Murillo." Indeed, it seems likely that Cassatt knew Murillo's *Two Women at a Window* (National Gallery of Art, Washington, DC). Murillo's painting was engraved several times during the eighteenth and nineteenth centuries—most notably in William Stirling-Maxwell's monumental text, *Annals of the Artists of Spain* (1848)—giving Cassatt ample opportunity to become familiar with the image.[13] Cassatt may have borrowed the shutter, on the left of her picture, from Murillo's work, and the hand of her cavalier, a particularly effective suggestion of three-dimensional depth, recalls the hand of Murillo's laughing figure.

Moreover, Cassatt seems to have reversed the diagonal placement of Murillo's figures, complicating it slightly with the inclusion of the male figure.

The connections between Cassatt's *On the Balcony* and her sources—Manet's *The Balcony,* Goya's *Majas on a Balcony,* and Murillo's *Two Women at a Window*—are provocative when we recall the nineteenth-century criticism of these works. During Cassatt's time, the two women in Murillo's painting were assumed to be prostitutes from the province of Galicia, offering an amorous solicitation to a passerby below. Stirling-Maxwell, with a reference to the biblical story of Rachel and Leah, explained:

Well-known at Madrid as *Las Gallegas,* [Murillo's painting] represents two women at a window, one still in the bloom of her teens, and leaning on the sill, the other declining into the "sere and yellow leaf" and half concealed by a shutter. These fair Galicians, says the tradition, were famous *amancebadas* [courtesans] of Seville; and the gallants who were lured to their dwelling by the beauty of the younger frail one, frequently became victims of that sort of deception which made the shepherd-patriarch [Jacob] the unwilling husband of the elder daughter of his maternal uncle [Laban].[14]

Goya's treatment of prostitution in his prints and paintings is widely recognized, and even in 1872 his *Majas* was described as depicting "two dubious beauties fishing for love." Finally, Morisot's discomfort with her image in Manet's *The Balcony* is significant. "I look strange, rather than ugly," Morisot wrote to her sister, Edma, after visiting the 1869 Salon. "It seems that the term *femme fatale* has been circulated among the curious."[15]

But what about Cassatt? Provocative behavior, to say nothing of prostitution, is not something we are accustomed to finding in the work of the genteel woman artist. Yet these themes, more commonly found in the work of male artists such as Manet and Degas, may have some relevance here. Indeed, when *On the Balcony* was shown in 1873 at the Cincinnati Industrial Exposition, it bore a far more explicit title—*The Flirtation: A Balcony in Seville.*[16]

Flirting seemed to fascinate Americans of the 1860s and 1870s. Cassatt's hometown newspaper, the *Daily Evening Bulletin,* reprinted an article on the subject from the popular magazine *Saturday Review* in 1869. It began in a playful tone:

There are certain things which can never be accurately described—things so shadowy, so fitful, and so dependent on the mood of the moment, both in the audience and the actor, that analysis and representation are equally at fault. And flirting is one of them. What is flirting? Who can define or determine? It is more serious than talking nonsense, and not so serious as making love; it is not chaff, and it is not feeling; it means something more than indifference, and yet something less than affection.[17]

Despite its elusiveness, flirting could cross the line between acceptable social behavior and immortality, and the article concluded with an earnest caution to young ladies who chose to flirt with male companions.

Victorian etiquette manuals emphatically stressed the importance of women confining themselves to the domestic sphere. Sexual forwardness, in particular, was discouraged, and party-going, dancing, and flirtation were viewed, in the

words of social historian Charles Rosenberg, "as part of a life-style demeaning to middle-class status." In this context, the behavior of the women in *On the Balcony* may be viewed as indicative of their working-class background. One critic commented, "The attitude and gestures are free and animated and give the impression of the class to which the people belong, a class unrestrained by reticence."[18] *On the Balcony,* then, was received as more than the production of an artist intent on incorporating the lessons of old master painters. Cassatt's painting also touched on class and social relations during the late nineteenth century.

The compositional structure of *On the Balcony* is also suggestive. Here, as in the paintings from which Cassatt's derives, the balcony is parallel to the picture plane, separating the figures from the painting's viewer. This arrangement differs markedly from the artist's later use of the balcony in, for example, *Susan on a Balcony Holding a Dog* (Corcoran Gallery of Art, Washington, DC). Griselda Pollock has pointed out that in these later works and in the works of Cassatt's colleague Morisot, the artist and viewer are aligned with the female subject and forced to experience the space from a feminine perspective.[19] On the balcony Susan maintains her protected (and sanctioned) position within the home. The artist and viewer share the balcony with her, cut off from the city of Paris beyond.

In *On The Balcony,* on the other hand, Cassatt's position—and the position of the viewer—is closer to that of a passerby on the street. Murillo and Goya clearly exploited this compositional structure, for in their works the women look toward the (implied male) viewer, making him the recipient of their proposals. Cassatt's women, however, ignore the viewer's gaze. Instead of being a participant in the action, the viewer is thus a voyeur, a tourist removed from the intricacies of Spanish life. Cassatt's American audience vicariously enjoyed the flirtation without becoming implicated in it.[20]

Upon finishing *On the Balcony,* Cassatt began *Toreador* and *Offering the Panale to the Bullfighter.* In the theme of the bullfight, Cassatt tackled a quintessential Spanish subject and a controversial one for American viewers. Cassatt had read descriptions of the *corrida de toros,*[21] but if she witnessed the spectacle, her reaction is unrecorded.

Many American found the bullfight repulsive. The sight of the dead and dying animals disgusted Isabella Stewart Gardner. Childe Hassam stated: "I thought it was frightful. Disagreeably frightful. The pageant was wonderful. But the other—I know it reacted on me the same as it would on any other person of high refinement."[22]

William Merritt Chase, on the other hand, enjoyed the color, excitement, and, to a degree, even the violence of the bullfight. In 1882 Chase traveled to Spain with Robert Blum, who described a bullfight to his patron, magazine publisher Alexander Drake: "At times [it seems] a horrible butchery making you swear never to see it again, at others fascinated, a sensation of enthusiasm at seeing some daring act of cool bravery, an elated feeling at others of human skill; you shout, curse, laugh with the rest and at last come to regard your personal feelings from a secondary point of view." Blum's splendid drawings of

bullfights were published in *Century Magazine* the following year, and many of them capture both the excitement and brutality of the event. Charles Dudley Warner's text, however, disavower any pleasure in the spectacle and derided the Spanish national pastime as one "that reveals and molds the character of a once powerful people."[23]

Perhaps because of this negative relation, and out of concern for finding American buyers for her work, Cassatt avoided depicting the fight itself. Instead, she portrayed the toreros in moments of relations, calmly lighting a cigarette or accepting the *panale,* a popular honeycombed treat that served in Spain as both beverage and sweet. As with *On the Balcony,* Cassatt appears to have synthesized a variety of sources in composing these paintings. Manet's Spanish paintings of the 1860s again provided inspiration. His *Matador* (Metropolitan Museum of Art, New York) similarly focuses on a single figure placed against an empty background, and his brushwork, like Cassatt's, developed from a careful study of Velázquez. In addition, Cassatt may have borrowed from *carte-de-visite* photographs of famous toreros, marketed as souvenirs during the 1860s and 1870s and collected the way baseball cards are today."[24]

But the paintings that Cassatt's most closely resemble in anecdotal content and picturesque detail are those created by the Spanish academic painters who congregated around Mariano Fortuny. Cassatt knew Fortuny's work from the W.H. Stewart Collection in Paris, and she mentioned her interest in it in letters to Sartain.[25] The same year that Cassatt painted *Offering the Panale,* one of Fortuny's associates, Germán Alvarez Algerciras, painted *Pelando la pava* (private collection). Both paintings feature the torero dressed in full costume, wearing the *traje de luces,* or "suit of lights," an elaborate silk jacket heavily ornamented with gold braid, a white ruffled shirt, and a black-winged *montera* (cap) covering the traditional braided pigtail on the back of the head. *Pelando la pava,* an expression that literally translates to "plucking the turkey," refers in colloquial Spanish to flirtation and courtship, making the activity of Alvarez Algecira's figures perfectly clear.

Hints of flirtation occur in other genre paintings relating to the bullfight. Nancy Mathews has pointed to the similarity between *Offering the Panale* and *La Bomba* (City of Aberdeen Art Gallery and Museums Collection) by John Phillip, a Scottish painter active in the Royal Academy in London.[26] In Phillip's tavern scene, a dashing torero flirts unabashedly with a smiling señorita. As with the comparison to Alvarez Algeciras, however, the similarity of Cassatt's work to John Phillip's suggests the prevalence of such themes rather than Cassatt's knowledge of specific works of art. Bullfighters, the paintings concur, were often found in flirtatious encounters.

Bullfighting and bulls, moreover, have long been associated with fertility rituals, and bull worship was practiced in ancient civilizations from Mesopotamia to Crete. The horns of the bull are often considered powerful phallic symbols, and the Spanish term *cornudo,* from the word for horn (*cuerno*), means both "horned" and "cuckolded." The association of bullfighting

with sexual prowess thus produced a whole mythology concerning the torero and women.

But the image of the torero is infused with more than sex. For example, Cassat's Philadelphia critics alluded to the issue of class in the painting. *Offering the Panale,* wrote a reviewer in the *Daily Evening Telegraph,* "is one of a class of subjects that Miss Cassatt is fond of painting. It is a very life-like study of a Spanish bull-fighter coquetting with a *tabernera,* who is offering him liquid refreshment." The barmaid's open reception of the torero's flirtation makes her working-class status clear. The bullfighter occupied the same social stratum. Originally an aristocratic pastime, by Cassatt's day bullfighting had become a professional sport dominated by toreros drawn from the ranks of cattlemen and butchers, who were familiar with the animal and knew how to kill it.[27]

This change in the bullfighter's status and the increased class fluidity it signaled contributed to tensions in Spanish society that became manifest in a subculture known as *majismo.* According to Timothy Mitchell, who perceptively analyzed *majismo*'s relationship to bullfighting, the term "has no direct equivalent in English. It can be defined initially as the personal presentation of style for both men and women of the lower classes of the eighteenth and nineteenth centuries; it was characterized by a bold, sexy, self-assured, and flippant manner of dressing, walking, and talking."[28] Eventually, nineteenth-century aristocrats began imitating the saucy style of the Spanish populace, again blurring class distinctions: Toreros born to the working class were practicing the aristocratic art of *tauromaquia,* while well-born noblemen were walking the streets of Spain acting and dressing like *majos.*

Both *Offering the Panale* and Cassatt's earlier *On the Balcony* capture the spirited essence of working-class Spanish life. The figures are "bold, sexy, self-assured, and flippant." Their manners do not derive from a privileged Victorian upbringing such as that upheld by Cassatt and her potential patrons, but reflect instead the style of the working class, the code of *majismo.*

Cassatt's trip to Spain and the paintings she created there mark an important transition in the artist's development. Spain—and Cassatt's attitude toward the Spanish—seems to have permitted greater license to experiment, and in *On the Balcony* and *Offering the Panale,* Cassatt took advantage of this freedom. Comparing her experience in Spain with her previous six months in Parma, Cassatt reported to Sartain that the Italians were much more refined than the Spanish. "The great thing [in Spain] is the odd types and peculiar rich dark coloring of the models, if it were not for that I should not stay, the artists here are perhaps more flattering than they were in Parma, but I think the Spaniards infinitely inferior in education and breeding to the Italians."[29]

Cassatt's stance was not unusual. While Old Spain evoked wealth, power, and empire, nineteenth-century Spain, in the opinion of many Americans, was a country in decline. Yet Cassatt appreciated both Spain's artistic past and its exuberant present. She visited museums and delighted in the local color. "I see the immense capital that can be drawn from Spain," she wrote to Sartain. "It has not been 'exploited' yet as it might be, and it is suggestive of pictures on all

sides." Balconies and bullfights became the subjects of her canvases, and the rare male figure made his debut in her art. But the country that offered these possibilities never became her own, and as she confided to Sartain after a few weeks, "I would not care to live here."[30] In Spain, Cassatt remained a tourist, and this "outsider" position allowed her to consider themes deemed inappropriate for nineteenth-century women. Settling in Paris in 1875, she adjusted to her adopted home and turned to painting more refined segments of society.

NOTES

1. Mary Cassatt to Emily Sartain, December 31, 1872, quoted in *Cassatt and Her Circle: Selected Letters,* ed. Nancy Mowll Mathews (New York: Abbeville Press, 1984), and p. 114. Cassatt began exploring maternal themes in 1881, and shortly thereafter critics began to associate her with such imagery. Her first biographer, Achille Segard, titled his book *Mary Cassatt: Peintre des enfants et des mères* (Paris: Libairie Paul Ollendorff, 1913). See also Nancy Mowll Mathews, "Mary Cassatt and the Modern Madonna of the Nineteenth Century," (Ph.D. diss., New York University, 1980), and Harriet Scott Chessman, "Mary Cassatt and the Maternal Body," in *American Iconology: New Approaches to Nineteenth-Century Art and Literature,* ed. David C. Miller (New Haven: Yale University Press, 1993), pp. 239–258.

2. See, for example, Griselda Pollock, *Mary Cassatt* (New York: Harper and Row, 1980), p 11.

3. Cassatt signed for a copyist permit at the Prado on October 5, 1982, as number 416, *Libro de registro: copistas, 18 marzo 1864–1918 octubre 1873,* box L–36, Prado Archives, Madrid.

4. Cassatt to Sartain, October 5, 13, and 27, 1872, quoted in *Cassatt and Her Circle,* pp. 103, 107, 110. The Prado registers do not indicate whether Cassatt copied Velázquez's *Baltasar Carlos on Horseback* (ca. 1633–1635) or *Baltasar Carlos as Hunter* (ca. 1634–1635). According to Elizabeth Ellis, who is studying American copyists at the Prado, both were popular choices with American copyists and easily accessible either in the long central gallery or in the Sala de Isabel. Correspondence with Ellis, November 12, 1932.

5. Cassatt to Sartain, October 27, 1973, quoted in *Cassatt and Her Circle,* p. 109. Manuel Barrerra, assistant to the administrator of the Casa de Pilatos and an amateur painter, offered Cassatt a room in the palace. On Barrera, see Joequín González Moreno, *Las Casa de Pilatos en el siglo XIX* (Seville: Puente-Genil, 1983), pp. 244, 300.

6. Washington Irving, *The Alhambra* (New York: MacMillan Company, 1911), pp. 138–139.

7. Charles Baudelaire, "Le balcon," in *The Flowers of Evil,* ed. Marthiel and Jackson Mathews (1857; reprint, New York: New Directions Books, 1955), pp. 46–47, 271–272; and Paul Verlaine [Pablo de Herlagnes, pseudonym], "Sur le balcon" (1867), *Royal Tastes: Erotic Writings: Paul Verlaine,* trans. Alan Stone (New York: Harmony Books, 1984), pp. 3, 102. Nigel Glendinning first mentioned these poems in "Variations on a Theme by Goya: *Majas on a Balcony,*" *Apollo,* n.s., 103 (January 1976): 47, n. 38.

8. George Parsons Lathrop, *Spanish Vistas* (New York: Harper & Bothers, 1883), p. 13.

9. Adrian Shubert, *A Social History of Modern Spain* (London: Unwin Hyman, 1990), pp. 32–43, quotation on p. 36.

10. The painting that the Havemeyers bought turned out to be an early copy after the original of ca. 1808–1812. See Gary Tinterow, "The Havemeyer Pictures," in *Splendid Legacy: The Havemeyer Collection* (New York: Metropolitan Museum of Art, 1993), p. 15; also Metropolitan Museum of Art European Paintings Department files. On Cassatt's discovery of the *Majas,* see Louisine Havemeyer, *Sixteen to Sixty: Memoirs of a Collector* (New York: privately printed, 1961), p. 153.

11. See Glendinning, pp. 40–47. A complete analysis of Manet's *The Balcony* appears in Françoise Cachin et al., *Manet, 1832–1883* (New York: Metropolitan Museum of Art, 1983), pp. 302–7.

12. Juliet Wilson-Bareau, ed., *Edouard Manet: Voyage en Espagne* (Cain: L'Echoppe, 1988).

13. "Fine Arts: The National Academy Exhibition, II," *Nation* 18 (May 14, 1874): 321. See William Stirling Maxwell, *Annals of the Artists of Spain,* 3 vols. (London: John C. Nimmo, 1891), 3:1092. See also Jonathan Brown and Richard Mann, *Spanish Paintings of the Fifteenth through Nineteenth Centuries* (Washington, DC: Smithsonian Institution Press for the National Galley of Art, 1990), pp. 105–9. Goya was probably referring to Murillo's *Two Women at a Window* in his *Majas on a Balcony.* See *Goya and the Spirit of Enlightenment* (Boston: Museum of Fine Arts, 1989), p. 160, n. 2.

14. Stirling-Maxwell, 3, pp. 1092–93.

15. J. Puggiari, quoted in Glendinning, p. 47, n. 30; and Berthe Morisot, quoted in *Manet, 1832–1883,* p. 304.

16. See James L. Yarnall and William H. Gerdts, *The National Museum of American Art's Index to American Art Exhibition Catalogues from the Beginning through the 1876 Centennial Year* (Boston: G.K. Hall & Co., 1986), 1, p. 609.

17. "Flirting," *Philadelphia Daily Evening Bulletin* (July 8, 1869): 2.

18. Charles E. Rosenberg, "Sexuality, Class, and Role in Nineteenth-Century America," *American Quarterly* 25 (May 1973): 143; and Elizabeth Luther Cary, "Recent Accessions of Modern Art in the Wilstach Collection," *International Studio* 35 (July 1908): xxxi. See also Shubert, pp. 32–43.

19. Griselda Pollock, "Modernity and the Spaces of Femininity," in *Vision and Difference: Femininity, Feminism and the Histories of Art* (London: Routledge, 1988), pp. 62–63.

20. On the psychological construct of viewing, see Laura Mulvey, "Visual Pleasure and Narrative Cinema," *Screen* 16 (Autumn 1976): 6–18.

21. Cassatt related having read Théophile Gautier's *Voyage en Espagne* (1843), which contains a colorful description of a bullfight, to Sartain, October 13, 1872, quoted in *Cassatt and Her Circle,* p. 107.

22. Interview with Childe Hassam, January 31, 1927, Dewitt McClellan Lockman Papers, Archives of American Art, Smithsonian Institution, reel 503. See also Louise Hall Thorp, *Mrs. Jack: A Biography of Isabella Stewart Gardner* (Boston: Little, Brown and Company, 1965), pp. 136–37.

23. Robert Frederick Blum to Alexander Drake, July 21, 1882, Alexander Drake Papers, Archives of American Art, Smithsonian Institution, reel 3582, frames 876–and Charles Dudley Warner, "The Bullfight," *Century Magazine* 27 (November 1883): 3–13, quotation on p. 13.

24. Manet and Degas, among other artists, used *carte-de-visite* photographs in composing their paintings. See Elizabeth Anne McCauley, *A.A.E. Disderi and the Carte de Visite Portrait Photograph* (New Haven: Yale University Press, 1985), pp. 137–203.

25. Cassatt to Sartain, October 13 and December 31, 1872, quoted in *Cassatt and Her Circle,* pp. 108, 114.

26. See Nancy Mathews, *Mary Cassatt* (New York: Harry N. Adams, 1987), p. 16. See also Margaret C. Conrads, *American Paintings and Sculpture at the Sterling and Francine Clark Art Institute* (New York: Hudson Hills Press, 1990), p. 28.

27. "The Spring Exhibition of the Academy of the Fine Arts," *Philadelphia Daily Evening Telegraph,* (April 25, 1878): 4. On bullfighting, see Timothy Mitchell, *Blood Sport: A Social History of Spanish Bullfighting* (Philadelphia: University of Pennsylvania Press, 1991).

28. Mitchell, p. 56.

29. Cassatt to Sartain, December 31, 1872, quoted in Mary *Cassatt and Her Circle,* p. 114.

30. Cassatt to Sartain, October 27, 1872, quoted in ibid., p. 109.

SELECTED BIBLIOGRAPHY

Baudelaire, Charles. *The Flowers of Evil.* 1857; trans. and ed. Marthiel and Jackson Mathews. New York: New Directions Books, 1955.

Brown, Jonathan and Richard Mann. *Spanish Paintings of the Fifteenth through Nineteenth Centuries.* Washington, DC: Smithsonian Institution Press for the National Gallery of Art, 1990.

Chessman, Harriet Scott. "Mary Cassatt and the Maternal Body" in *American Iconology: New Approaches to Nineteenth-Century Art and Literature,* ed. David C. Miller. New Haven: Yale University Press, 1993.

Cortada, James. *Two Nations Over Time: Spain and the United States, 1776–1976.* Westport, CT: Greenwood Press, 1978.

Dachin, Françoise et al. *Manet, 1832–1883.* New York: Metropolitan Museum of Art, 1983.

Glendinning, Nigel. "Variations on a Theme by Goya: *Majas on a Balcony.*" *Apollo,* n.s., 103 (January 1976): 40–7.

Havemeyer, Louisine. *Sixteen to Sixty: Memoirs of a Collector.* New York: privately printed, 1961.

Irving, Washington. *The Alhambra.* 1832; 1st illus. ed. 1851; repr. New York: Sleepy Hollow Press, 1982.

Lathrop, George Parsons. *Spanish Vistas.* New York: Harper & Brothers, 1883.

Mathews, Nancy Mowell, ed. *Cassatt and Her Circle: Selected Letters.* New York: Abbeville Press, 1984.

———. *Mary Cassatt.* New York: Harry N. Abrams, 1987.

McCauley, Elizabeth Anne. *A.A.E. Disdéri and the Carte de Visite Portrait Photograph.* New Haven: Yale University Press, 1985.

Mitchell, Timothy. *Blood Sport: A Social History of Spanish Bullfighting.* Philadelphia: University of Pennsylvania Press, 1991.

Mulvey, Laura. "Visual Pleasure and Narrative Cinema." *Screen* 16 (Autumn 1976): 6–18.

Pérez Sánchez, Alfonso E., and Eleanor A. Sayre. *Goya and the Spirit of Enlightenment.* Boston: Museum of Fine Arts, 1989.

Pollock, Griselda. *Mary Cassatt.* New York: Harper and Row. 1980.

———. "Modernity and the Spaces of Femininity" in *Vision and Difference: Femininity, Feminism and the Histories of Art.* London: Routedge, 1988.

Rosenberg, Charles E. "Sexuality, Class, and Role in Nineteenth-Century America." *American Quarterly* (May 25, 1973): 131–53.

Segard, Achille. *Mary Cassatt: Peintre des enfants de des mères.* Paris: Libairie Paul Ollendorff, 1913.

Shurbert, Adrian. *A Social History of Modern Spain.* London: Unwin Hyman, 1990.

Stirling-Maxwell, William. *Annals of the Artists of Spain.* 1848; repr. London: John C. Nimmo, 1891.

Tinterow, Gary et al. *Splendid Legacy: The Havemeyer Collection.* New York: Metropolitan Museum of Art, 1993.

Verlaine, Paul. *Royal Tastes: Erotic Writings: Paul Verlaine,* 1967; trans. Alan Stone. New York: Harmony Books, 1984.

Warner, Charles Dudley. "The Bullfight." *Century Magazine* (November 27, 1883): 3–13.

Wilson-Bareau, Juliet, ed. *Edouard Manet: Voyage en Espagne.* Caen: L'Echoppe, 1988.

3

The American Artists in Grez

William H. Gerdts

The American presence in Grez was formidable,[1] conditioned by three related factors.[2] First was the earlier involvement of American artists who began to visit, paint, and even reside in Barbizon, beginning in the late 1840s. Of importance also was the camaraderie formed in the atelier of Carolus-Duran, which transferred to the activity of these artists in Grez, beginning in the mid 1870s. And the third factor was the relationship of the earliest of the Americans there with the British contingent, especially with the two Robert Stevensons–the artist, Robert A.M. Stevenson ("Bob"), and his cousin, the writer, Robert Louis Stevenson.

Artists have always congregated together, presumably already back in ancient times and certainly from the Renaissance on. This was true of Americans, too, living in proximity to one another in the country's larger cities, and ensconced together in specially constructed studio buildings, beginning in the late 1850s. When abroad, they sought out one another to "keep each other warm," as Nathaniel Hawthorne wrote of the artists who congregated in Rome along the Via Margutta. But with the development of painting out-of-doors, artists' colonies grew up in the countryside, where painters might visit repeatedly during the summers and where some might live year-round.

The earliest of these was at Barbizon, on the northeast edge of the Forest of Fontainebleau. While the French landscape painter Camille Corot painted there as early as the 1820s, the American presence at Barbizon probably began with the Boston expatriate painter, William Babcock, who followed his friend, Jean-François Millet, to Barbizon in 1849, and remained there until after Millet's death, at which time he moved to a more secluded hamlet, Bois d'Arly, Fontainebleau, until he died in 1899.[3] The figure painter Millet, rather than the French landscape painters working in Barbizon, was the great draw for many

American artists, and Babcock, in turn, became the conduit for other Americans who wished to meet Millet and paint in this community, artists such as William Morris Hunt, who became a disciple of Millet on meeting him in 1852, settling in Barbizon for two years in 1853, and becoming the successful champion of Millet's painting among American collectors back in Boston.[4] Other American disciples of Millet included Edward Wheelwright, Wyatt Eaton, and Will Hickok Low, all of whom published important essays on Millet.[5]

Barbizon itself continued to be an important art colony through the 1870s, when Eaton and Low were there; ironically, the majority of American paintings actually created at Barbizon itself seem to date from after the village had ceased to enjoy its earlier significance.[6] In the decade of the 1870s, Barbizon attracted a large group of painters who had been students in the Parisian atelier of Charles Durand, who had changed his name to Emile Auguste Carolus-Duran, a name more in keeping with the successful and fashionable portraitist he had become.[7] Carolus-Duran began to offer private instruction in 1872 after being approached by the American art student Robert Hinckley, and within a year he had a dozen students, mostly Americans; John Singer Sargent, who was to become the most distinguished of Carolus-Duran's American students, joined the atelier in 1874.[8] Carolus-Duran offered a form of instruction in clear distinction to the academic methodology espoused by the E?cole des Beaux-Arts, which in turn may have led some of his students in the direction of Millet and Barbizon.[9]

One of these, who was to become the "ring leader" among the Grez colonists of the 1870s, was Robert Alan Mowbray Stevenson, who registered at the relatively newly opened Hotel Siron in Barbizon. Stevenson there became friendly with the American Will Hickok Low (1853–1932), who had rented a house in Barbizon in the summer of 1873 with the Canadian painter Wyatt Eaton, and through Babcock, had gotten an introduction to Millet. Also present that summer at the Hotel Siron, where Low and Eaton took their meals, were the American painters Henry Bacon and Daniel Ridgeway Knight.[10] In turn, during the following summer of 1874, Low introduced Stevenson to Millet, and when Stevenson returned to Barbizon in the summer of 1875, he and Low were joined by a group of art students, including the Englishman Henry Enfield, the Irishman Frank O'Meara, and the American Theodore Robinson, another pupil in Carolus-Duran's atelier, as well as by Stevenson's cousin, the writer Robert Louis Stevenson.[11] The company was good and the hijinks could become pretty wild; still, what the young artists missed most was the opportunity to indulge in water sports, which was provided by the Loing River at Grez.

Indeed, it was the river and the stone bridge over it, along with the old church, that constituted the glory of the village and offered the most enduring attractions to the art community, both for their visual pleasure and for their pictorial subject matter. This appears to have more than made up for the relative flatness of the landscape, as compared to the proximity of the dense Fontainebleau forest at Barbizon. The American painter Henry Bacon noted in 1881 that the American and English painters had deserted Barbizon for Grez, and that "they and their friends filled the small hotels at Grez. Grez has more advantages for the painters, as a picturesque stream runs through the town."[12]

Due to a lack of shops, basic merchandise was provided by traveling salesmen, who drove small stores on wheels where "they sell everything from a pitchfork to a needle," as reported by the American painter Howard Russell Butler in 1886.[13] As another American artist, Birge Harrison, was to write:

An ancient stone bridge spans the river, and away from the farther brim sweep miles of delicious meadows, softly wooded here and there. The crown and glory of Gretz [sic], however, is the river. Such a river! A river to dream of; to read of in fairy tales; a poem in reeds and water-lilies. Swathed deep in rushes, it idles down from mill to mill, now reflecting the open sky, and now lost in dusky lanes of foliage; with now a stretch of brightness struck by the wind, and now a glimpse of sunny meadow seen through the arches of the old bridge.[14]

To satisfy the need of water pleasures, one day late in August of that summer, the first group of artists, along with the writer, Stevenson, hired a carriage and went over to Grez, on the Loing River, a village that Corot had visited in 1863, and that was already home to the then well-known painter the Chevalier Giuseppe Palizzi, who had settled there in the 1860s. Grez is situated south of the Forest of Fontainebleau, and near Marlotte, a larger town. The usual route from the French capital was to leave the Gare de Lyons for a two-hour train trip, alighting at Bourron-Marlotte and walking through the harvest fields to the village itself.[15] The group also found a congenial resting place in the Hôtel Chevillon, which would become the headquarters of what developed as a new artists' colony, succeeding Barbizon in significance.[16] The Hôtel Chevillon had been purchased in 1860 by Jules Chevillon, and after his death in April 1881, his widow ran the hotel; Mme. Chevillon died in 1920, at which time their son, Paul, sold the establishment.[17]

With Will Low there, Grez enjoyed an American presence from the first, but in the next year, 1876, that presence was enhanced by Birge Harrison (1854–1929), Hiram Bloomer (1845–1911) from California, and Walter Launt Palmer (1854–1932) from Albany, all students of Carolus-Duran. Harrison left Philadelphia for France in late spring of 1876,[18] he would later pen a moving recollection of Grez and the Stevensons.[19] Harrison was there again in 1877 and every year through 1882 when, at the end of that year or in January of 1883, he married Eleanor Ritchie and left France. Two other Californians that year were the earliest women members of the Grez art colony, Fanny Osbourne (1840–1914) and her daughter, Isobel (1858–1953), both of whom were among the first students at the California School of Design in San Francisco, which had just opened in 1874. Female participation had been unknown in the art colony at Barbizon, and the appearance of women at Grez caused a great deal of concern and discussion among the male artists.[20] In her autobiography, Isobel Osbourne credits an American painter, "Mr. Pardessus," with directing them to Grez; no artist of that name is known; it is possible that this may have been James William Pattison, who seems to have settled in Paris in 1876 after three years in Düsseldorf.[21] When the Osbournes first arrived, they found only Palmer there, painting in the hotel garden.[22]

Palmer and Bloomer both made quite an impression on the Osbournes. Isobel recalled Palmer staying late in Grez on into the winters, to paint the snow scenes on which he made his reputation. This may be an error on her part, since there appears no documentation that Palmer returned to Grez after he had taken up this theme beginning in the late 1880s. On the other hand, Palmer, in a 1927 interview, mentioned meeting not only Englishmen and Swedes in Grez, but also Mr. Osborn [sic—possibly Lloyd Osbourne, Fanny's son], Robert Louis Stevenson, Low, and Birge Harrison, as well as Louis Dessar and Clifford Grayson.[23] However, Dessar (1867–1952) was far too young and was only in the Fontainebleau area in the late 1880s, while Grayson (1857–1951) was associated in Concarneau in Brittany during the 1880s. Since Grayson does not appear to have arrived in France until 1879, any visit to Grez, however brief, could not have occurred in 1876. Fernande Sadler states that Grayson was at the Hôtel Chevillon in Grez in the early 1880s (sometime in 1880/1881/1882), returning again in 1888, but he is, in any case, little remembered today.[24] Palmer, therefore, may have recalled a much later return visit to Grez, perhaps in the late 1880s. Likewise, Sadler appears to have identified the well–known American expatriate George Hitchock (1850–1913) as being at the Chevillon also in the early 1880s ("Georges Hitchcock, peintre canadien assez connu"),[25] but such a visit is not otherwise recorded; Hitchock is generally associated with paintings of tulip fields and the local peasantry in the Dutch fishing village of Egmond, a community he "discovered" at this time. However, since Hitchcock was also studying in Paris at the Académie Julian in the winters of 1881 and 1882, a visit to Grez is very likely.[26]

Isobel Osbourne characterized Hiram Bloomer as a "gentle, kindly man who painted innumerable pictures of the bridge, all more or less alike." She also noted that it was Bloomer's Parisian studio that served George du Maurier for the background of his 1894 novel of Bohemia, *Trilby*.[27] In 1878, Bloomer was informed that one of his paintings of the Grez bridge had been bought by the French government for 1,000 francs, but this appears to be apocryphal.[28] The Osbournes spent three summers in Grez, making a short visit to Barbizon before returning to America in 1878, with Robert Louis Stevenson soon following. Though Fanny Osbourne was to become the wife of Robert Louis Stevenson, and Isobel was later to marry the San Francisco painter Joseph Strong, neither woman achieved great significance as artists, and their work, including any done at Grez, is very difficult to locate.[29]

The Irishman, O'Meara, was to become one of the "big men" among the artists in Grez, and the village remained his base for 13 years, while he commingled extensively with the American contingent. In 1876 he was greatly drawn to Isobel Osbourne, and commissioned the small portrait of himself for her, painted by John Singer Sargent, who had been a fellow-student in Carolus-Duran's atelier. Whether this portrait was painted in Paris or in Grez is unclear, though Sargent did visit the village, probably in 1876, as Birge Harrison remembered him there; Sargent himself verified the sojourn in a later letter to Vernon Lee.[30]

Grez received the greatest amount of literary attention in the writings by and about the Stevensons, including R.A.M. Stevenson's classic description of the village and art colony. Stevenson noted that, in the 1870s,

Barbizon was deserted for places with water, buildings, boats, coloured costumes—places that offered definite planes to the eye. Grez was a halfway between the forest and the Seine. Lodged on a tributary with less formal banks than the big river, it showed a greater variety of view in a small length, slender and more elegant tree-forms, but narrower horizons and less evident construction in the distance. Barbizon, Marlotte, and Cernay remained French, while the colonies of Brittany and that of Grez became filled with Anglo-Saxons.[31]

And his cousin, Robert Louis Stevenson, listed the attractions of the village enjoyed and depicted by artists of all nationalities:

It lies out of the forest, a cluster of houses, with an old bridge, an old castle in ruin, and a quaint old church. The inn garden descends in terraces to the river; stable-yard, kail-yard, orchard, and a space of lawn, fringed with rushes and embellished with a green arbour. On the opposite bank there is a reach of English-looking plain, set thickly with willows and poplars. And between the two lies the river, clear and deep and full of reeds and floating lilies.[32]

Stevenson's original assessment of Grez, made on his first visit in August, 1875, captured the appeal the village had to many of its artist-colonists: a pretty and very melancholy village on the plain. A low bridge of many arches choked with sedge; great fields of white and yellow waterlilies; poplars and willows innumerable; and about it all such an atmosphere of sadness and slackness.[33]

One of the leading figures among the American colonists in the region at this time was Will Low, though few works by him can be securely designated as painted there. In the autumn of 1875, Low became the first of this early group of painters in Grez to marry. He was thus required to find a home for his wife, the former Berthe Eugenie Julienne. They took a house, not in Grez, where none was available, but in neighboring Montigny, a short distance from the railway stop at Marlotte and, like Grez, situated on the Loing River.[34] The house had a little studio, with a large window that overlooked the whole valley of the Loing River.[35] Just as Barbizon had its satellite villages such as Fleury and Chailly that attracted artists, so painters were also drawn to Montigny and Marlotte, both in the vicinity of Grez, the latter appealing especially to French painters, but also to American ones as well.[36] Low's home in Montigny was merely an attractive walk from Grez, though he recalled being in the latter village in 1877 only a couple of times.[37] However, the Lows were regularly visited by the artist's colleagues staying in Grez; as Low himself recalled: "Our house at Montigny was a convenient port of call by the waterway, and the route overland was scarcely longer, so that nearly every day we entertained our friends. Here, under the leafy trellis gathered round the sun-chequered table we held long symposiums, the subject of art ever uppermost."[38] But in the pursuit of his professional career, Low returned to the United States in 1877, and though he

was back in France frequently in subsequent years, revisiting Barbizon in 1886, and associating with the Impressionist art colony in Monet's home town of Giverny in 1892, he had terminated his association with Grez and Montigny.

Theodore Robinson (1852–1896) was in Grez in 1876, for two drawings by him in a sketchbook are so annotated, and he was back in late August of 1878 with his good friend, Kenyon Cox (1856–1919); a watercolor, *Garden Bench and Ferns,* is inscribed "Grez/18 August 1878/Th. Robinson." Robinson was there again in the spring of 1879.[39] His *Standing Peasant Girl* (Colby College Museum of Art, Waterville, Maine) is traditionally dated to 1879, and might have been painted in Grez, or in some other French village such as Barbizon. Indeed, from 1876 scarcely a year went by that more Americans did not appear. May Alcott (1840–1879), a friend of Fanny Osbourne, and a fellow student in Paris at the Académie Julian, was in Grez in 1877.[40] The summer of 1878 saw the appearance not only of Theodore Robinson and Kenyon Cox, but also of William B. Baird (b. 1847; fl. 1872–1899),[41] Harry Bispham (1841–1882), Augustus Heaton (1844–1931), Milne Ramsey (1847–1915), Frederick Arthur Bridgman (1847–1928), Thad Welch (1844–1919) from California, and Frank Fowler (1852–1910), a student of Carolus-Duran. Chicago-born Baird spent most of his career abroad in London and Paris, but his 1879 Salon entry was entitled *A Grez*—(Seine-et-Marne). In Grez, Welch met up with his fellow Californian Hiram Bloomer, who introduced Welch to Robert Louis Stevenson and Fanny Osbourne.[42] Mary Odenheimer (?–1898) from Philadelphia, daughter of a bishop, and another student of Carolus-Duran, was also in Grez that summer, and it was probably later that year that she married Fowler; as Mary Odenheimer-Fowler, she was again in Grez in 1888. In fact, a good many of the artists—Bispham, Ramsey, Heaton, and Bridgman among them—were in Grez with their wives.[43] (Thomas) Alexander Harrison (1853–1930) followed his brother, Birge, to Grez in 1879, and the future mural specialist Edward Emerson Simmons (1852–1931) was there in 1880. Seemingly inevitably, Simmons, too, celebrated "The bridge, built over the river Loing, which was so much like the Concord [in his native Massachusetts] that it was a constant delight to me, has been painted times innumerable, but it is so charming that we never tire of seeing it on canvas." Nevertheless, Simmons wrote a straightforward description of the village from the perspective of the local inhabitants, rather than the artist's.

There is one central street upon which the houses face so close together as to form a solid wall on either side. In the back of this phalanx of stone the whole life of the community goes on. Here are gardens, many of them sloping down to the river, where are the stones upon which they wash their clothes; here the children play, protected from all harm. The cultivated fields lie away up on the hillsides, as do the pastures, but in olden times, before the last ray of the sun had left the sky, every evening would see each inhabitant of the village back in his home, close to his neighbors, protected not only from the roaming wild animals, but from the lord upon the hill as well.[44]

Even during these early years, Grez was losing something of the Bohemian raffishness that had characterized it at the beginning, though the sense of artistic

fraternity remained. It was suggested, in fact, that the residence of increasing numbers of married couples, some with children, toned down the more spirited, free-wheeling life style that had characterized the colony in its first years. There was considerable intermingling of colonists and locals, though. Augustus Heaton wrote of the native peasantry who served as models, always grateful for that modest employment. Birge Harrison, on the other hand, noted that these locals were shrewd, though not unkind, suddenly called away to their agricultural pursuits in the middle of a modeling session unless a (relatively) substantial payment was made, and charging in general a higher price than elsewhere—from four to five francs a day.[45] Heaton also recalled that "Cheap wine with our plain meals stimulated sociability and we were all willing to retire early after the fresh-air activities of the day." And he directed a tone of mild disapproval at the then still-single Mary Odenheimer, "A decidedly prepossessing girl but of rather mannish temperament under the influence of the French bohemian life."[46]

Grez soon became so popular that a second inn was opened, the Hôtel Beauséjour, run by a Madame Laurent, and familiarly known as the Pension Laurent. Frederick Bridgman, who had already achieved considerable success as a painter of orientalist themes, stayed there with his wife, rather than at Chevillon's, because it was said to have more comfortable rooms, the best views, and a lovely formal garden.[47] It was also reported by some to be more "respectable," while the older Chevillon housed the freer, more bohemian spirits.[48] Laurent's probably opened in 1878, for the following year May Alcott wrote of "the auberge, where board was from four to five francs per day, but lately, since a hotel has been started, the rate is raised to six francs, I am told."[49] In Bridgman's case, the colony may not have appealed to him, since he visited only once, and no paintings done there are presently known, though he is known to have painted the hotel garden.[50]

With a group of fellow art school colleagues, Kenyon Cox had traveled over from Barbizon in January of 1878 for a brief visit to Grez, before moving on to Montigny and then back to Paris. Returning that August with Theodore Robinson to sketch and relax, before going on to Italy, Cox was there again in early June of 1879 for a longer stay, remaining until early October, but he initially found few other artists there, and even a month later reported that "the place is nearly empty."[51] Robinson may have been with him this time, for some years later he recalled their time together "in the spring of '79."[52] In fact, the most dramatic influx that summer was not of artists, but of a party of soldiers maneuvering somewhere near, and quartered in almost every village house as well as at Laurent's hotel. Cox himself stayed at Chevillon's, which he noted as a "rather bohemian place" as opposed to Laurent's—"the more swell of the two."[53] He was engaged in plein-air painting, both landscapes and figures painted in the out of doors. In June he confirmed, "The peculiar glory of Grez is the river," though its full splendor would not appear until later that season, when the lilies blossomed and the reeds turned.[54]

The American presence appears to have remained fairly low over the next year or two. It is probable that G. Rugero Donoho (1857–1916) was in Grez in

the summer of 1881, for here he painted *La Marcellerie* (The Brooklyn Museum), which he exhibited at the Paris Salon in the spring of 1882. In that year there was a renewed influx of American painters to Grez—the landscapist Bruce Crane (1857–1937), Francis Chadwick (1850–?), William Coffin (1855–1925), Frederick Judd Waugh (1861–1940), Frederick Dellenbaugh (1854–1935), and the brothers Birge and Alexander Harrison, along with Kenyon Cox, who returned in May and stayed through September. Writing to his mother in August, Cox mentioned several Norwegian children there with their mother, thus documenting the Scandinavian presence that had begun to appear in the artists' colony.[55] In his book *Landscape Painting,* Birge Harrison, too, mentioned his association with the Scandinavians, which presumably would have occurred sometime in 1882–1884.[56] Dellenbaugh, celebrated for his participation in the Powell expedition through the Grand Canyon, may not have remained in Grez long, and is better known for his activity in the Brittany artists' colony at Concarneau, about which he wrote.[57] Waugh, with Henry Rankin Poore, who had been a fellow student at the Pennsylvania Academy of the Fine Arts, was on a brief vacation in France. The two friends bicycled to Barbizon, Poore then going on to explore other parts of France, while Waugh resided for a while at the Hôtel Chevillon, painting landscapes in Grez; he would return for a longer stay two years later.[58]

Francis Chadwick was to become almost unique among the American colonists, for he, almost alone of all of them, remained in Grez. He interacted with the growing contingent of Scandinavian painters, marrying in 1882 the Swedish sculptor Emma Löwstadt, who had studied with Charles Cazin.[59] In 1885, Chadwick rented the studio at the Hôtel Chevillon formerly occupied by the Chevalier Palizzi, and later leased a house owned by the Marquis de Casaux, where still later the composer Frederick Delius would live and work. Chadwick and his wife purchased the former Hôtel Beauséjour in 1892, continuing to own it even when Grez was losing its appeal to the artistic community and the building no longer served as a hotel. The Chadwicks occasionally visited other artists' colonies—Concarneau in Brittany, St. Ives and Newlyn in Cornwall, England—but they lived for the rest of their lives in Grez.[60] In turn, the Chadwicks' daughter, Hilma, married the American painter Edward Brooks (?–?), who came to Grez about 1884. Brooks bought a house in the village and raised a family there, the Chadwicks and Brooks' thus carrying the American residency in Grez into the twentieth century.[61]

During the summer of 1882 that he spent in Grez, Bruce Crane reported that he was working alongside of his fellow Americans Kenyon Cox and the brothers Alexander and Birge Harrison.[62] In a letter to his father of July 14, Crane noted that he had decided not to go to Normandy. Instead he would leave Grez for England, where he would remain until returning home from Liverpool on August 8.[63] We have seen that the Harrison brothers had been in Grez earlier, but their presence was more substantially noted at this time, and it is probable that their best-known Grez canvases were painted in the first half of the 1880s. The length of the brothers' stays in Grez is not certain, nor is there any reason to believe that they remained there together; in any case, Alexander is far more

closely identified with the artists' colony in Concarneau than with Grez, but the paintings he exhibited at the Boston Art Club in 1883, *Studio in Grez* and *Grey Day,* were presumably painted there the previous year. Birge's paintings done that summer of 1882 were well received, several of them acquired by John A. Lowell of Boston.[64] Alexander was in the colony in the summer of 1883; that July he was reported to be in Grez along with his fellow American artist Eugene Vail (1857–1934).[65] Vail is documented as being in Grez in 1883, having visited there with the Irish painter John Lavery, the latter painter's first experience in a French art colony.[66]

An intimate view of the nonartistic pastimes enjoyed by the colonists at this time is afforded in William A. Coffin's *After Breakfast* (Berry-Hill Galleries, New York) painted in 1882 (formerly entitled *Après le Déjeuner* when it was first shown in the sixth annual exhibition of the Society of American Artists, held in New York in the spring of 1883). Originally owned by the great American collector Thomas B. Clarke, it was described in the Clarke auction sale in 1899 as: "A scene in the billiard room of a country home at Grez, near Fontainebleau."[67] As billiard rooms were not infrequent in hotels, this may be a room in one of the two inns at Grez. Chevillon's certainly had a billiard room. And this was probably true of Laurent's also; this scene may be a view at the latter hotel, since Coffin's name does not appear in Sadler's listing of artist-visitors to the Pension Chevillon.

Chevillon's is described at length in an important article that appeared in 1883 in an article on Grez from the *Studio,* one of the most significant American art publications of the time. The writer identified Grez as

familiar to artists from all corners of the world drawn thither by the delightful collection of old stone houses, odd-shaped trees, village roads whose flint pavements are always echoing back the clattering sabots of the blue-bloused peasants, old gardens flourishing behind vine-clad walls, orchards, vineyards, and water mills, stringing along the banks of the lazy river, and the rambling moss-grown bridge, wrapped in a delicate atmosphere which holds it together and tones down the noisy features.[68]

The salon of the Hôtel Chevillon where the artists ate also served as a forum for criticism of their work by their colleagues, while some two hundred paintings and sketches filled the panels above the wainscoting. The incorporation of these panels in the Chevillon salon had begun quite early; one by Will Low has survived from 1877, depicting one of the informal regattas on the River Loing, where the participants were required to paddle across the river in large wooden tubs. Few could manage the unwieldy craft, but among those who shone in the contest was the English painter Henry Enfield, a good comrade of Robert Louis Stevenson, whose exploits were commemorated in a sketch by Low (Robert Louis Stevenson Memorial Cottage, Saranac Lake, New York).[69] Bruce Crane mentioned in a letter to his father in the summer of 1882 that he had painted two of the panels, and that "the Artists have pronounced one of them 'the best landscape in the room."[70] The salon contained a piano, and the evening's entertainment usually took place there, or in the neighboring billiard room. The principal chambers opened onto a court, which contained artists'

studios, while the garden led down to the river's bank where several boats were available for guests, who could disrobe in an arbor close by.[71]

An American painter, almost totally forgotten today, who was in Grez at the beginning of 1883 was Robert M. Pennie from Albany, New York, about whom little is known after that year. Previously at Etretat, Pennie was reported to have returned to Grez early that year to complete his painting *The Weaver* (private collection), which was subsequently exhibited at the Paris Salon.[72] The picture is unusual among the figural images painted by Americans in Grez in that it is an indoor scene, rather than one set in a landscape, one that celebrates both the industrious peasant and traditional craftsmanship. The subjects are working on old hand machines for making linen,[73] but Pennie has gone beyond customary representations, identifying the workers as young adults rather than the more usual elderly artisans.[74] In the attractive male-female duo, he suggests, too, the domestic harmony resultant from honest labor. In addition, Pennie painted a now unlocated early springtime view of that classic subject, the bridge at Grez.[75]

Frederick Waugh was back in Grez in the summer of 1884, but this time for an extended stay at Chevillon's for about a year, returning to Philadelphia only because of his father's sudden death. Waugh found himself in the company of the Harrison brothers, and his association with Alexander Harrison may have influenced his eventual turn to marine painting, a theme with which Harrison became especially celebrated. He wore the native wooden sabots, and traveled around the countryside on a high-wheeled bicycle in search of landscape motifs. While Waugh would become one of the United States' leading marine specialists, he himself opined that he had never surpassed the work he had done at Grez.[76] Also in Grez during Waugh's visit was John White Alexander, who had returned to Europe for the first time that year since his studies in Munich, primarily to observe the work of Velásquez at the Prado and to visit the Paris Salon. Alexander visited Gilbraltar and Tangiers before going on to Madrid, from which he left for Paris on June 11; he wrote of joining his friend and colleague there, the illustrator Charles Stanley Reinhart (1844–1896), "who will be going to some artists' colony near Paris, in which case I may also go and paint a landscape or two before we start for Holland."[77] In Grez, probably at the end of June, Alexander "posed the tall Frederick Waugh in a rowing shell wherein the slightest move by the model would upset the boat."[78] Since Alexander was establishing himself primarily as a portrait and figure painter, his sojourn in Grez, though socially rewarding, may have offered him little in the way of artistic inspiration, and was probably of short duration before he left for Holland where he was by mid-July.[79] Reinhart, his companion, who spent most of the decade of the 1880s in France, worked primarily on the French coast at Tréport and Villerville, but his stay in Grez is attested to by his painting *Landscape, Grez, France* (either a watercolor or pastel), exhibited in his memorial sale in 1897.[80]

The little-known Charles Payne Sears (1864–1908), who had gone to Europe to study in 1883, was probably in Grez in 1884,[81] but the most significant painter to arrive in Grez in 1884 was Willard Metcalf, who had come to Europe in 1883 and made the rounds of artists' colonies during the next several years—

Walberswick in England, Pont-Aven in Brittany, Grez, and finally Giverny, where he was one of the founders of the Impressionist colony. In Grez in late 1884 and again in February 1885, he was welcomed by Chadwick and his Swedish wife and painted several works in their garden; Metcalf seems to have remained in the village for much of that year, for he was painting there in October.[82] That year, Metcalf was joined by the Danish-born Emil Carlsen, who had already established his reputation in the United States as a specialist in still-life painting, and had been sent to Paris in 1884 by the New York art dealer Theron J. Blakeslee, on condition that he guarantee the dealer one floral still life a month. But while attracted and inspired by the eighteenth-century still lives of Jean-Siméon Chardin, Carlsen shared sketching expeditions in the countryside at Grez with Metcalf.[83] Also in Grez that year was the independently wealthy American William Sullivant Vanderbilt Allen, and the Canadian painter William Blair Bruce. Bruce, who had arrived in Paris from Hamilton, Ontario, in 1881, had been a longtime resident in Barbizon beginning the next year. He appears to have first visited Grez in 1885, staying at the Hôtel Chevillon.[84] It was here that he met his future wife, the Swedish sculptor Caroline Benedicks, part of the large Scandinavian contingent of the artists' colony. Benedicks had arrived in Grez in the summer of 1883 with a group of her Swedish friends who were studying in Paris. Bruce went back home to Hamilton later that year, and soon after he returned to France, he, like Metcalf, became one of the founding members of the Giverny art colony in 1887, and one of the earliest Canadian Impressionists. Bruce married Caroline in Stockholm in December of 1888, and beginning in 1889, the two artists spent a good deal of time back in Grez for the next five years.

The artists of the Grez colony, the Americans included, shared both thematic and formal interests. The subjects upon which they chiefly concentrated were limited: pure landscapes, landscapes with figures, and figural compositions, almost always set in the out-of-doors, and in these last categories, the figures were invariably the peasants of the village who modeled for them. Primary among the favorite motifs of the artists of all nationalities was the River Loing itself, which had been the original attraction for the earliest group of painters, though the appeal there was originally recreational, not artistic. Other subjects included the distinct form and outline of the squat stone church, and above all, the gray stone bridge across the river, which painters such as the Irish artist John Lavery depicted over and over again. So did the Americans, judging by both contemporary accounts and exhibition records—we have noted that Hiram Bloomer is known to have painted the bridge many times, one of which appeared in the 1878 Paris Universal Exposition. But strangely, relatively few of the surviving, or at least located, paintings by the Americans feature either of these structures. Kenyon Cox's *Grez Seen Across an Open Field* (National Academy of Design, New York), Willard Metcalf's *Turkeys in a Field* (private collection), and his 1884 *Afternoon on the River at Grez* (Figure 5) (The Brooklyn Museum), which include the Grez church in the background, are exceptions. In a letter to his mother in 1878 on his first visit to Grez, Cox had described the church, inside and out, as simple and primitive, noting that it dated

from the 13th century.[85] Hopefully, more examples of these structures by American artists will surface in the future.

What unites the majority of paintings by the artists of the colony is not only their subject matter but also their formal strategies; the artists of the Grez School tended to paint gray pictures. That is, they often eschewed the sunlight, favoring an overall overcast atmosphere. Whether this was particularly the nature of the climate, or solely the preference of the painters is difficult to determine. This preference for "grayness" was not confined only to Grez; working in Fleury, near Barbizon, the American painter Charles Davis noted: "The succession of gray days is so continuous, in this dormant condition of all nature, that a *motif* remains about the same nearly four months."[86] Nor was it only the predilection of the foreign artists, for it was also associated with several of the leading French painters of the period—primarily the celebrated French artist of peasant themes Jules Bastien-Lepage, but also with Charles Cazin, much less renowned today, and a painter who tempered the strategies of Bastien with a muted, poetic light favored by many of the Grez colonists. For a time, Cazin resided in Recloses, a village in the vicinity of Grez (where Will Low had spent a short while early in his sojourn in the Barbizon region).[87] William Coffin, whom we have noted was in Grez about this time, later wrote about Cazin and his art, "A gray day is more in accord with his temperament," adding that "Few of his pictures found their way to the United States until 1884 or 1885."[88] Bruce Crane, in Grez in 1882, commented that the leader of the "Grez School" was "Cazan [*sic*] who took the Medal of Honour (highest award) in the last year Salon, for the best landscape. His method is entirely different from anything you have seen. Tone is the thing sought for–objects are never modeled–everything is treated as a flat mass. He detests realism & is the best teacher I could have had as I have been inclined toward realism." Typical for the preferred subject matter, Crane also reported that he had "a twilight—six foot-long,"[89] while in his 1882 *Farm Landscape* (Fine Arts Collection of The Hartford Steam Boiler Inspection and Insurance Company), Crane projects the silvery-gray atmosphere, reflected in the winding stream, so preferred in the landscapes by the Grez colonists.

Indeed, in his extremely simplified but fascinating summation of landscape tendencies of the late nineteenth century, the Indiana painter Otto Stark identified: "the so-called gray movement, brought mainly from France. This striving for grays was the result of the work carried on out of doors, or the 'plein air' movement, which was making itself felt about this period. Air and light were sought after as never before. The result of all of this was shown in pictures, beautiful in repose, harmonious in tone, generally without shrill notes of any kind; good in values, in a monotonous sense, but still lacking light and colors."[90]

Stark perceptively defined the objectives of the painters in Grez, creating landscapes of great harmony and tranquility. Perhaps the earliest colonists, drawing upon the examples of their Barbizon precedent, created somewhat more solidly rendered and more strongly illuminated scenes of greater breadth, which includes Walter Launt Palmer's 1876 *A View at Grez* (Brock & Co., Acton, Massachusetts). But increasingly, the painters generally rendered seemingly

casually chosen bits of pasture and field, rather than grandiose territory or forest interiors, such as Edward Simmons' 1880 *Landscape at Grez* (Berry-Hill Galleries, New York), which features orchard trees and a vegetable garden—a landscape of sustenance and produce, not at all decorative. Trees are usually thin vertical markers in the landscape, often almost leafless, as in Willard Metcalf's 1885 *Spring Landscape* (Graham Williford Collection). This remains characteristic even of those landscapes that abut the town itself, as in Frederick Waugh's rendering of *Grez* (Edwin A. Ulrich Museum of Art, Wichita State University, Kansas), a comprehensive, distinctive repertoire of the village. Here, the verticals of the thin, leafless trees punctuate the succeeding horizontal bands of scrubby landscape, stonewall, and massing of building walls and roofs, creating an especially dense composition.

When the American colonists painted figural scenes, they usually concentrated upon the local inhabitants, most often engaged in agricultural toil; only seldom are the activities as playful and casual as the children dispersed among the grasses outside the town in Kenyon Cox's monumental 1882 *Thistledown* (Washington County Museum of Fine Arts, Hagerstown, Maryland).[91] Among the finest of the more typical figural landscapes is Ruger Donoho's sizable *La Marcellerie* (The Brooklyn Museum), where a farmer, holding his scythe, is almost lost in the horizonless dense green landscape, with little suggestion of any sense of place.[92] In Willard Metcalf's slightly later *Sunset at Grez* (Hirschhorn Museum and Sculpture Garden, Washington, DC.), the careful pose and intense expression of the young peasant girl carrying a heavy pail away from the river, reveal a greater sense of real toil. The picture shows a clear debt to Bastien Lepage in the firm draftsmanship that defines both the figure and the fence, as well in the clearly rendered weeds and thistles. Yet, Metcalf's coloristic experimentation with effects of sunset are innovative for their time, so different from the somber twilights favored by many of the Grez artists, suggesting, perhaps, the influence of Karl Nordstrom and some of the other Scandinavians in Grez.[93]

In fact, when the Americans painted scenes in and around the village—country vistas, depictions of the village, and figurative landscapes featuring the local populace—they treated motifs very similar to those of their Scandinavian and British colleagues. But perhaps even more than their cohorts, their pure figure pieces tended to emphasize the French peasantry, and were less directed to the depiction of their fellow artists, perhaps because the Americans were a less cohesive group than the Scandinavians, for instance.[94] Theodore Robinson's *Peasant Girl* (Colby College Museum of Art, Waterville, Maine) is traditionally identified as a Grez image, though it may have been painted in any one of several French villages in which the artist worked; still, her contemplative pose among the grasses and before the lily pad-filled water could easily be a scene on the Loing River. Will Low's *Garden Scene* (New York State Museum, Albany) is also a generic picture of a peasant woman tending to a flowering tree in an orchard, with attention given to the baby in the pull-cart in the foreground; however, its 1877 date strongly suggests that it was, indeed, painted at Grez.

Ruger Donoho's 1884 *Shepherd* (National Museum of American Art, Smithsonian Institution, Washington, DC) is a more powerful image of a young peasant lad tending a flock of sheep, with the broad flat plain in the background reminiscent of many landscapes painted at Grez. Donoho gives careful attention to the young man's costume—his brown felt cap and lambswool coat—the latter matched by the active brushwork defining the wind-tossed grasses and bushes. The youth is depicted more vigorously than the figures by Robinson and Low, his weather-beaten face alerted, perhaps, to "shouting excitedly to his dog to gather in the sheep," as one contemporary reviewer suggested.[95] Frederick Waugh's 1889 *Family Resting Under a Tree* (Berry-Hill Galleries, New York) is a later image combining the high horizon, the carefully defined foreground grasses, and the close tonalities in this area, thereby projecting an overall lassitude reminiscent of Bastien-Lepage's 1878 *Haymakers* (Musée d'Orsay, Paris). But Waugh introduces a broader handling and an interest in effects of sunlight, Impressionist concerns that were beginning to be investigated by American painters in Grez and elsewhere in France in the late 1880s. Waugh's return to Grez at this time is not documented, but several of the artist's paintings of this year are signed "Paris," connoting a return trip to France, at which time his reappearance in the village to paint peasant subject matter seems likely.

As Waugh's painting suggests, it is likely that a good many Grez paintings, especially figurative imagery as opposed to landscapes painted out-of-doors and on site, were begun with models posed in a natural setting, but were then completed in the studio. That studio might have been in Grez or back in Paris, where many of the painters maintained professional quarters. This is very likely the case in at least some of the often-monumental figural pieces by the brothers Birge and Alexander Harrison, who produced the most ambitious figure paintings of any of the Americans in Grez. Several of Birge Harrison's paintings were created in 1881 and feature local villagers in somewhat claustrophobic settings. One such work, over eight feet long, is his *November* (Musée des Beaux-Arts et d'Archéologie de Rennes, France), an effectively melancholy image of a single young woman raking up dead leaves while gazing mournfully into the thick, leafless forest of birch trees, the "November" mood amplified by the sombre neutral tonality. *November* was one of the first paintings by an American artist to be purchased by the French government.[96] *The Appointment* (Musée des Beaux-Arts, Tournai, Belgium) further isolates a single, cheerless peasant woman, obviously spurned in an expected rendezvous, painted in muted tonalities and now isolated on a boat among the rushes and lily pads, a feature of the Loing River so often noted by commentators. Kenyon Cox had earlier noted that: "The peculiar glory of Grez is the river, but the lilies are not out yet, and it is not so interesting as it will be later. In autumn when the reeds turn it is said to be superb."[97] In both of Harrison's pictures, the high horizon and tilted space suggest the influence of Bastien-Lepage, and it is noteworthy that Henry Van Cutsem, who purchased *The Appointment* in 1882, was a Belgian collector who also owned three works by Bastien-Lepage.[98] Equally somber but less dour is the smaller, two-figure painting, *The Mirror* (The Haggin Museum, Stockton, California). The compact group of two contrasting young women—one

standing, the other kneeling in the grass—is juxtaposed with the bright lilies in the clear, reflective water. Here, the extreme verticality of the composition heightens the steep spatial incline, while the carefully painted foreground grasses and flowers again reflect Bastien's influence.[99] Even in Harrison's more sunlit *Jeune fille dans un pré* (Mairie de Grez-sur-Loing), the artist places his figure picking daisies stooped, with her back to the light and enveloped in the horizonless field.

Both Harrison brothers were in Grez in 1883. (Thomas) Alexander Harrison, older by one year, shared his brother Birge's Naturalist aesthetics, which derived from Bastien, who impacted more directly upon Alexander; indeed, Alexander was recognized as Bastien's disciple at the time. Alexander's subject matter, however, was often more light-hearted, as in the masterwork of his Grez years, his seven-and-a-half-foot *The Amateurs* (Brauer Museum of Art, Valparaiso University, Indiana). Again with a high horizon, set on a brighter and more spacious stretch of the Loing River, two youths, not at all idealized, and posed somewhat ungainly, are ostensibly fishing with a single line among the lily pads; their playful, amorous positions seem perilously close to capsizing their dory. Harrison constructed a barge to accommodate himself and his easel, anchored with two heavy stones, but had to finish the work in his studio, because of the motion of the water.[100] The work was under way in 1882 when it was reported that: "A. Harrison has had a summer-studio at Grez-par-Nemours, where he has made many studies and a couple of large pictures. One, a sunset subject, with children fishing from a boat in the foreground, is intended for the Salon."[101] As with Birge's work, Bastien's influence can be seen in Harrison's artistic strategies, though there is also the possibility of interaction with other members of the Grez colony, especially the English painter, William Stott. John Lavery's biographer noted the facetious discussion among the painters concerning Harrison and Stott: "Does Stott influence Alexander Harrison, or is Alexander Harrison influenced by Stott?"[102] And recently, Julia Rowland Myers has suggested Stott's influence on Birge Harrison's *The Appointment*.[103] An ever brighter, sunlit scene of casual amusement by Alexander Harrison features two boys playing in a rural setting in Grez, *Enfants jouant, Grez-sur-Loing* (Château-Musée, Nemours, France).

Alexander Harrison was also responsible for one of the most daring paintings by an American artist of this decade, *In Arcadia* (Musée d'Orsay, Paris), a plein-air work painted around 1886, wherein he posed a group of naked women in a dappled, sunlit forest interior, projecting overt sensual imagery, devoid of any allegorical or historic identification. The work is generally ascribed to Concarneau in Brittany, where Harrison was most active in this decade, but despite the artist's protestations that the work was fully painted in the out-of-doors, the painting actually derives from studies of the outdoor nude possibly painted in both Brittany and Grez.[104] As a picture more scandalous in the United States than in France, a petition was circulated objecting to its exhibition when it appeared at the annual show of the Pennsylvania Academy of the Fine Arts in 1891.[105] By this time, Harrison was turning away from figurative work to coastal scenes featuring waves breaking on broad expanses of

beach, a theme originally inspired by a walk along the Brittany shore with Bastien-Lepage in 1884, and a subject obviously incompatible with the land-locked environment around Barbizon and Grez. However, the nude appears again in *La Solitude* (Musée d'Orsay), an idyllic view of a distant single fe-male on a boat in the river, again a work painted in Grez on the Loing River.[106]

The year 1886 brought yet more American artists, including August Franzen and Howard Russell Butler.[107] Butler appears to have visited only briefly in late April, and painted few works, notably a spring landscape. Butler recalled: "I painted two or three pictures there, walked in the forest and lived with a crowd of artists, among them Roger [*sic*] Donoho, William Sullivant Allen and Mr. and Mrs. Frank Chadwick."[108] Franzen was a member of the Scandinavian contin-gent at Grez, a Swede who had gone to study in Paris in 1881, but on a visit to his brother in the United States, he stayed on to work on a panorama of Gettys-burg being painted outside Chicago. Franzen resumed his studies in Paris in 1885, while joining the Scandinavian and American artists in Grez the follow-ing summer, and becoming one of the early Impressionists in the colony. In 1890 he immigrated to the United States, settling in New York, and the following Feb-ruary he enjoyed a large, one-artist show and auction of his Grez pictures at Ort-gies Art Galleries on Fifth Avenue, selling out almost the entire collection, many to fellow artists.[109] That some of these were, indeed, Impressionist works is con-firmed by a reviewer who noted that Franzen "had been working under the in-fluence of Claude Monet, Pissarro, Renoir and the other leaders of the Impres-sionist School,"[110] while another writer, C. M. Fairbanks, described them as "done in the most daring and glaring of mid-summer sunlight effects."[111]

Not all the works in Franzen's show were Impressionist; Fairbanks noted that "Some of his gray November effects were more readily understood."[112] This in-troduces the question of just when Franzen, in the village for almost five years, began to adopt the strategies of Impressionism and lose, at least to some degree, the Tonal mode more traditionally associated with the Grez colony. One might presume that the gray November effects were painted earlier, and the more col-orful works later, though temporal considerations must surely be an element here: The late autumnal works *would* be more gray and neutral; the late spring and summer works more Impressionist. Still, Impressionism was making its in-roads into the art of the colony in the late 1880s. Franzen especially, himself a Swede, may well have been reacting to the growing coloristic interests of artists such as Nordstrom and others who had begun investigating those strategies in the mid-decade, and as we have seen, this may be one source of the coloristic effects of Metcalf's *Sunset at Grez.* But there were also other forces at work. Impressionism, by this time, was a common mode of artistic approach in France and would soon become so in the United States. It is more than coincidental that the art colony in Giverny, the home of Claude Monet, began to develop in 1887. And the Irish painter Roderic O'Conor, yet another student of Carolus-Duran, appears to have been instrumental in bringing full-blown Impressionism to Grez possibly in 1886 or 1887, perhaps introduced by John Lavery. O'Conor was staying at the Hôtel Laurent, or Beauséjour, in 1889,

before he left for Brittany, where his art became allied with the post-Impressionist artistic devices of Gauguin and Van Gogh.[113] In Grez he became associated with the American contingent there, as a close friend of Edward Brooks, and their connection was recalled by Brooks' son, Alden.[114]

Certainly, by the early 1890s the artistic character of Grez had changed radically. This was confirmed in an insightful article on the colony published in San Francisco in April of 1891. The author first described the village itself, giving great emphasis to the gardens, all sloping down toward the river, and to the picturesque sight of the village women, gossiping as they did their wash, this among many other scenes of traditional peasant life. The writer went on to describe the appearance and life of Lilli, one particularly winsome painter's model. He then noted:

The artists came down to Grez at all seasons of the year. Made ill from the bad air of the crowded class-rooms, anxious to put into practice the theories imbibed from their masters, or desirous of secluding themselves for serious work upon some canvas destined for the Salon—for one reason or another they come to Grez and stay months or years even, as mood or money permit. In the early spring the place is said to be incomparable. It is then that a silvery mist pervades the landscape, and those delicate luminous tones, like cobwebby veils over the grass in the early morning, give an exquisite softness and mystery to the earth that the poetic artist loves.

But the author then noted:

For a year or two Grez has been given up to a craze for 'Impressionism,' and Monet is the god of the young landscapists. The strongest of these followers of 'purple shadows' achieve some really wonderful results in color and light. To stay long in their company, listening to their enthusiastic talk and watching with them for the effects they love, is to become half converted to their views—at least, so far converted as to see a commendable reaction to the style of the 'Tonalists,' who have certainly carried their tendencies to extreme heaviness and blackness. The landscapists of the present time do all that is possible in their sketches out of doors. They keep a variety of canvases under way. Thus, if the day is gray, they are prepared to take advantage of that; if bright, they are ready to seize an hour or two of this joyous mood, and early morning and the last gleams have qualities so evanescent that they must be seized by the watchful, waiting painter, who is ready to catch nature 'by the fly,' as it were.[115]

Robert Vonnoh, the American painter best known for his exploration of Impressionist aesthetics, was in Grez in 1887. Vonnoh's art too conforms to the report of the writer cited above, for his pictures painted there range from more tonal depictions to the brilliantly colorful and sunlit views in and around the village for which he is best known.[116] Vonnoh had studied in Boston and began in 1879 to teach at the Massachusetts Normal Art School where he had previously studied. In 1881 he went to Paris to enroll in the Académie Julian, returning to Boston in 1883 to continue as an art instructor as well as to paint portraits. In 1885 he secured a position teaching at the Boston Museum School, and in 1886 he married, and may have gone to France on his honeymoon; his presence in Grez is first reported that year as a guest at the Hôtel Chevillon.[117]

He was back in France in 1887, having resigned from the Boston Museum School, spending the summer in Paris and enrolling again at Julian's, but probably not for long, for he was certainly in Grez that autumn.[118]

While Vonnoh's figural works painted in Paris during the next several years conform to standard academic practice as espoused at the Académie Julian, his work in Grez, some indoor scenes but primarily landscapes, some involving the figure, is far more experimental, but not all of his work is Impressionist. His well-known *November* (Pennsylvania Academy of the Fine Arts, Philadelphia) of 1890 is a vigorously painted scene of an elderly peasant woman raking leaves in her garden, with a background of the piled-up houses and other buildings of the village. While the paint is applied broadly, the color range is limited, and the work reflects the overall gray atmosphere traditionally associated with artists of the Grez School. But other paintings of the same year, such as *Spring in France* (Art Institute of Chicago), incorporate a brilliant palette of yellows, greens, blues, and vermilions, with a total absence of neutral tones, the flowering trees blossoming under the glistening sunlight. *Sunlit Hillside* (National Academy of Design, New York), also of 1890, brings the viewer right into the village, utilizing the flat, blank walls and sharp rooflines that Vonnoh preferred, for structural support, thus disallowing the bright sunlight and color to dissolve his composition. Even Vonnoh's *Winter Sun and Shadow* (North Carolina Museum of Art, Raleigh) of that year, with its strong emphasis upon the agrarian theme embodied in the grain stacks at the right, abjures the traditional gloom of winter for a contrast of brilliant whites and purples, the latter, the defining color of Impressionism. And this same aesthetic holds for such smaller Grez paintings as Vonnoh's *Edge of the Pond* (Spanierman Gallery, New York), one of the artist's most freely brushed paintings. Perhaps necessarily in a picture involving more traditional figural imagery, in this case a peasant mother and child, Vonnoh's handling is more meticulous in his 1890 *Jardin de Paysanne* (Terra Foundation for the Arts, Daniel J. Terra Collection, Chicago), but even here the lushness of the flowering garden and the sunlit back wall reflect Vonnoh's Impressionist concerns. The theme is a traditional one of the recognition of peasant maternal care, which is allied and rewarded with nature's abundance.

The sources for Vonnoh's "conversion" to Impressionism are probably several. While he probably crossed paths only briefly with those Scandinavian artists who had begun to adopt the strategies of this aesthetic, an association with Roderic O'Conor has been posited, and may well have played a part in Vonnoh's development. On the other hand, he was in Paris during these years when the work of the Impressionist artists was abundantly displayed—it would seem unlikely, for instance, that he would *not* have seen the great Monet-Rodin exhibition held at Galerie Georges Petit in 1889. Still, even if Vonnoh was attracted to Impressionism directly at its French source, O'Conor's presence, and perhaps that of other painters such as Franzen, may have been important in confirming Vonnoh in the direction his art was taking—a radical one both among American painters at the time and with regard to the prevailing gray Grez aesthetic.

Since there are few works by Vonnoh dated to 1887, there is no evidence to suggest that he had adopted Impressionist strategies his first year in Grez, but he had certainly done so in 1888, when he painted *Poppies* (Indianapolis Museum of Art) and *Poppies in France* (Terra Foundation for the Arts, Daniel J. Terra Collection, Chicago). These are among the most avant-garde pictures by any American painter at that time, the wild, flame-like red poppies flourishing on the canvas without outline drawing or traditional compositional enframent, and, in the case of the former, lacking even a horizon to indicate spatial disposition. These works especially illustrate Vonnoh's own recollections of his artistic development in Grez: "I gradually came to realize the value of first impression and the necessity of correct value, pure color, and higher key resulting in my soon becoming a devoted disciple of the new movement in painting."[119] The subject brings to mind Monet's paintings of poppy fields in the vicinity of his Giverny home, but the motif was a ubiquitous one among avant-garde artists of this time.[120]

These paintings of poppy fields, though complete in themselves, also would appear to function as preparatory thematic explorations that found full flowering in Vonnoh's greatest, largest, and most celebrated painting, *Coquelicots,* also known as *In Flanders Field* (1890) (Figure 6) (Butler Institute of American Art, Youngstown, Ohio). Here, a lovely and well-dressed young woman, posed for by Vonnoh's wife, Grace, accompanied by several children, is picking flowers in an incredibly vast field of poppies. At the far end of the field, a farmer in his horse-drawn cart makes his way across the landscape; in the distance is another field, a wall, and some farm buildings. The picture is tremendously rich in color and brilliant sunlight, the poppies painted as freely as his several earlier renderings of the subject, though the figures are, necessarily, more academically rendered. Though exhibited to acclaim, first at the Paris Salon of 1891, then in the International Exposition in Munich in 1892, and later in Vonnoh's one-artist exhibition held at the Durand-Ruel Gallery in New York in February of 1896, the picture failed to sell, perhaps because of its enormous (almost 10' long) size.[121] Many years later, the artist removed the 1890 date, and exhibited the work again in New York, San Francisco, St. Louis, and Rochester. He retitled the picture *In Flanders Field—Where Soldiers Sleep and Poppies Grow,* derived from the tragic 1915 poem *In Flanders Field,* by John McCrae, which memorialized the German invasion of Belgium in World War I, and though the joyous mood here is diametrically opposite to the tragic essence of the poem, the work was finally sold to the collector Joseph G. Butler, Jr., for the Butler Institute collection in Youngstown, Ohio.[122]

Vonnoh returned to the United States in 1891; it was not until 1907, long after the artists' colony had declined in significance, that he and his second wife, the sculptor Bessie Potter, rented a house in Grez and began summering there until the beginning of World War I; they were able to return again in 1922. A great many paintings created by Vonnoh in Grez from these later years are known, including several of the famous bridge (Metropolitan Museum of Art, New York; Corcoran Gallery of Art, Washington, DC).

Thus, by 1889, when there was a new influx of Americans to Grez, the dominant aesthetic there had turned predominantly to Impressionism. It was probably in that year that Edward Potthast was first in Grez. He had earlier studied in Antwerp and Munich beginning in 1882, but after several years back in his native Cincinnati, Potthast left for further study in Paris in 1887, remaining abroad for five years. Potthast may have met O'Conor and Vonnoh either there or in Grez; he credited both of them for introducing him to Impressionism.[123] Potthast is known to have painted some landscapes in Grez,[124] and though no pictures done there have been located, his *Sunshine* (also known as *A Breton Girl,* 1889; Cincinnati Art Museum), a young peasant girl holding a poppy in the out-of-doors, utilizes artistic strategies remarkably similar to Vonnoh's at this time.[125] This work was shown at the Universal Exposition in Paris in 1889, where it was one of the few Impressionist pictures on view. In addition to Vonnoh and Potthast, O'Conor may also have influenced the longtime resident painter Edward Brooks to adopt Impressionist strategies, though Brooks' paintings have, so far, not come to light.[126]

Wilbur Dean Hamilton also followed Vonnoh to Grez in 1889. Hamilton, a Boston artist who went to study in Paris that year, devoted a good deal of his career to portrait and figure painting as well as landscape. Judging by the works that have appeared from his stay in Grez, such as *Afternoon at Grez* (Terra Foundation for the Arts, Terra Museum of American Art, Chicago) and *Houses on a River Bank* (private collection), he seems to have painted scenes in and around the village much in the manner of the older and better-known Vonnoh, who may have had a strong impact upon Hamilton's painting at the time.[127] Indeed, *Houses on a River Bank* is especially close both in subject and in strategies to Vonnoh's *Sunlit Hillside.* Like Vonnoh's great *Coquelicots,* Hamilton's *Afternoon at Grez* features a stylishly dressed woman in a colorful flower garden, and discloses a further contrast between the earlier Naturalists and the later Impressionists in the Grez colony, beyond their formal distinctions. In their figural work, the former tended to emphasize the local peasantry, sometimes in humble surroundings, in keeping with the more subdued atmosphere; the latter tended to choose well-dressed family members or professional models in order to add a note of elegance to their brighter, colorful pictures. A considerable group of Grez paintings, including a number of blossom pictures and one of the famous bridges, appeared in Hamilton's exhibition at the J. Eastman Chase Gallery in Boston in April of 1892.[128]

Fernande Sadler also lists two American painters, "Ransdell, Colins," as staying at the Hôtel Chevillon, in 1889.[129] I am aware of no American artists of these names, but the former may refer to Frederick Winthrop Ramsdell (1865–1915), an artist from Manistee, Michigan, who was in France about this time, and was later associated with the important Impressionist art colony at Old Lyme, Connecticut, though there is no further record of a visit to Grez.[130] "Colins" may be the Boston painter Arthur George Collins, who attended the Académie Julian in 1889–1890 and later spent a good deal of time in Moret, near Grez, exhibiting *Le Loing at Moret* with the Société des Artistes

Indépendants in Paris in 1895, and in 1897 a painting, *Au Bord du Loing,* at the "New" Salon in Paris.[131]

Of greater artistic significance was the return of the Canadian William Blair Bruce to Grez in 1889, now married to the Swedish sculptor Caroline Benedicks. They were back by late May, joining their old friends, the Francis Chadwicks, and staying at the Hôtel Chevillon, where they occupied a small house within the garden of the hotel that had formerly been the residence first of the Chevalier Palizzi and then of the Swedish painter Carl Larsson and his wife, Karin.[132] Several months later, Bruce wrote to his mother that "Grèz [*sic*] is a great improvement on Barbizon, quite another country in fact."[133] By June that year, Bruce had sold several paintings to the successful American artist Walter Gay (1856–1937), who presumably was also visiting Grez. Another American there that summer was Albert Grantley Reinhart (1854–1926), younger brother of Charles Stanley Reinhart, who had been in Grez five years earlier.[134] The Bruces continued to spend time in the village part of each year through 1894. Having painted in an Impressionist mode in Giverny in 1887, Bruce became a major exponent of this aesthetic in Grez, as confirmed in such painterly, colorful landscapes as *Grez* (Gotlands Fornsal, Visby, Sweden) and *Garden in Grez* (Gotlands Fornsal, Visby, Sweden), both featuring blossoming fruit trees, which became one of his favorite themes.[135] Bruce also recorded the sun-dappled *Bridge in Grez* (Gotlands Fornsal, Visby, Sweden), devoted to one of the village's favorite motifs. Perhaps the most remarkable of Bruce's Grez paintings is his *Open-Air Studio* (National Museum, Stockholm), a view from the sunlit dining room of the Bruces' home picturing Caroline seated and working at etching through a diffusing sun screen, beyond which is a brilliant luminous landscape. Caroline Benedicks, therefore, is utilizing the light and color of the out-of-doors as is Bruce himself. This scene conforms to Bruce's description of Grez in April 1892, with its delightful spring weather and the blossoming fruit trees, when Caroline had made "some very good etchings."[136] The Bruces remained in Grez during 1893 and spent the summer, and probably the autumn, there in 1894. In 1895 they returned to Bruce's home in Hamilton, Ontario, Canada, and the following year settled more or less permanently in Sweden, where they built their home, "Brucebo," on the island of Gotland, and where the artist died in 1906.[137]

Probably related to the increased Boston awareness of Grez, with the activity there of Vonnoh and Hamilton, Frederic Porter Vinton (1846–1911), another major artist from that city, visited the colony in 1890 during an 18-month trip abroad. Though one of Boston's premier portraitists, who worked in a dramatically naturalist mode derived from that of his French teacher, Léon Bonnat, Vinton's nonportrait work, such as the naturalistic view of *The River Loing at Grez, France* (Museum of Fine Arts, Boston) and the colorful *La Blanchisseuse* (Museum of Fine Arts, Boston), both painted at Grez in 1890, reveal his selective adaptation of the strategies of his Impressionist colleagues. As his biographer Arlo Bates wrote: "When, however, during his stay in Europe in 1889–1890, he came in contact with Impressionism, then rising into full recognition, his whole method of painting nature altered. He embraced the new

gospel of sunlight and open air with the artistic enthusiasm which was characteristic of him."[138] Such works also testify to the frequent distinction among European-trained American painters of this time between their more formal, often commissioned portrait and academic presentations and their casual out-of-doors work. In the former, they almost necessarily retained the academic strategies they had struggled so dearly to learn in the academies; in the latter, especially since landscape was not a major consideration in their artistic education, they were free to explore more adventuresome, even avant-garde directions, so that often their art appears bifurcated. Vinton's stay in Grez appears to have been productive, judging by the works he showed along with seven other Impressionists at the St. Botolph Club in Boston in January 1894, and in those that appeared in the memorial exhibitions of his painting held in Boston and in Portland, Maine, in 1911.[139]

Yet, the glory days of the Grez colony were rapidly coming to a close. Most of the earlier artists had departed for Paris, other European art colonies, or had returned home, except for Chadwick and Brooks, who were permanent residents in Grez. Of the Impressionists, Franzen, Hamilton, Potthast, and Vinton were all back in the United States by 1891 and Vonnoh returned the following year, leaving only Bruce, whose last year in Grez was 1894. Artists did continue to visit of course. The printmaker and illustrator Albert Sterner was there in 1893,[140] and the following year Edward Rook, later a mainstay of the Old Lyme, Connecticut Impressionist art colony visited Grez, as probably did the New York painter Roswell Hill. Sadler notes of Rook's work, done in Grez, that he specialized in moonlight scenes, which conform to the artist's earliest known paintings. These represent a very individual interpretation of a Tonal aesthetic, Whistlerian in formal terms, but devoted to peasant village themes.[141] During the summer of 1894, two well-established landscape painters, the leading Cincinnati landscapist Lewis Henry Meakin (1850–1917) and William Lamb Picknell (1853–1897), were painting in nearby Moret, though there is no record of a visit to Grez; Picknell at the time painted a number of major river scenes, *Morning on the Loing at Moret* (Museum of Fine Arts, Boston) and *Borders of the Loing* (Metropolitan Museum of Art, New York), the former receiving a medal at the Salon, where both works were on view in 1896 and 1897.[142] Robert Van Vorst Sewell (1860–1924) from New York, as well as Cleveland's William J. Edmondson (1868–1966) were probably there in 1895, as was Boston's Sears Gallagher, who studied in Paris at the Académie Julian in 1895–1896, for whom "The town of Grez proved an attractive place," where he painted "many excellent pictures."[143] In this decade yet another American student of Carolus-Duran, Lucy Lee-Robbins, visited Grez and purchased the Saint Léger estate at Bourron, a few miles away.[144]

Vonnoh, of course, returned in 1907, continuing to visit during subsequent summers. Later American visitors included the venerable William Sartain (1869–1914) from Philadelphia, who first visited Grez in 1906 and painted a good many works in Grez during his next three years abroad, 1907–1910.[145] C. Harry Allis (1877–1938), a Detroit painter also associated with the artists' colony in Etaples and later resident in Long Beach, California, was in Grez in

this decade.[146] And in 1910, one of the most celebrated of the American Impressionists, Childe Hassam, was in Grez in late summer, where he painted a good many versions of the celebrated Bridge at Grez in both oil and watercolor.[147] Sadler also references an American painter, "Taylor," as active in Grez in these later years, but the candidates here are too numerous for positive identification.[148] It is tempting to recognize this artist as either the painter-illustrator William Ladd Taylor (1854–1926) or Henry Fitch Taylor (1853–1925), who, early in his career, was one of the original art colonists in Giverny in 1887, and was later involved in organizing the historic Armory Show in New York in 1913, but whose experiences in the years between remain obscure. As late as 1912, the American artist Guy Maynard (1856–1936), who had visited Grez as early as 1886, was back to renew his friendship with the longtime resident Francis Chadwick; on this better-documented visit, Maynard was accompanied by the English artist Matthew Smith and Katharine McCausland, the Irish painter with whom he had established a close relationship.[149]

So, artists continued to visit Grez well into the twentieth century, but the question of the colony's fading in the early 1890s is worth pondering. What led to the decline of Grez as a significant artistic community, for American artists as well as for others? Partly, at least, this must be due to the decline in popularity of the naturalist aesthetic identified with the work of Bastien-Lepage, along with the peasant subject matter with which it was associated, in favor of the more colorful mode of Impressionism. Around 1890, some aspects of the "Grez aesthetic"—the "gray" aesthetic—flourished in America, absorbed into the less naturalistic, more poetic form of Tonalism, itself dependent upon French and American Barbizon landscape practice. Impressionism, of course, was practiced in Grez, but in Giverny, Claude Monet's home, superceded it in attraction for young artists, beginning in 1887—just at the time of the decline of the earlier mode in Grez. And while few American, or other foreign artists actually became intimate with Monet, his presence gave an identity to Giverny, which Grez lacked. Also, about the time of Grez's decline, out-of-doors painting, Impressionism, in particular, was gaining ever-increasing popularity back in the United States, becoming there the most favored artistic system. It may not be just coincidence that William Merritt Chase's famous Shinnecock School of Art opened in Southampton, New York, in 1891, the final year of Grez's real importance. And by the very nature of the artistic strategies associated with Impressionism, academic training generally, in Paris, in Munich, or elsewhere in Europe, became a less decisive factor in professional artistic development, particularly as American academies successfully replicated the teaching offered at the École des Beaux-Arts and the Académie Julian. However, in its decade and a half of prominence, Grez offered to American, European, and Japanese artists a tremendously stimulating and distinctive environment for artistic creativity.

NOTES

1. For assistance in preparing this essay, I would especially like to thank my colleague Toru Arayashiki; May Brawley Hill, whose estimable work on Grez has been invaluable, and who allowed me to consult her ongoing research and files on the Grez artists; and my graduate assistant, Zachary Ross, who provided a great deal of important research, beyond what was requested of him.

2. While there is considerable publication on the Scandinavians in Grez, no previous studies of the American colonists there have been published. The finest report to give emphasis to the Americans is that by May Brawley Hill, "Grez-sur-Loing As an Artists' Colony 1875–1890," seminar paper, Graduate School of the City University of New York, 1983. Hill published some of her findings in *Grez Days: Robert Vonnoh in France* (New York: Berry-Hill Galleries, Inc., 1987). For Grez, generally, see Fernande Sadler, *L'Hotel Chevillon et les Artistes de Gres-sur-Loing* (Fontainebleau: L'Informateur de Seine-et-Marne, 1938), the chapter on Barbizon and Grez in Michael Jacobs, *The Good & Simple Life Artist Colonies in Europe and America* (Oxford, England: Phaidon Press, 1985, pp. 17–41); and, in Julian Campbell, *Frank O'Meara 1853–1888* (Dublin: Hugh Lane Municipal Gallery of Modern Art, 1989), pp. 16–30.

3. "William P. Babcock's Pictures," *Boston Evening Transcript* (April 23, 1903): 13. Laura Meixner, in a letter to the author, suggests that Babcock might even have been in Barbizon a year earlier, Meixner to Gerdts, July 16, 1986, but see below. Babcock remains one of the more intriguing but least studied figures in nineteenth-century American art history. For a later glimpse of him at Barbizon in the 1870s, see Edward Simmons, *From Seven to Seventy Memories of a Painter and a Yankee* (New York and London: Harper & Brothers, 1922), p. 190. One of the more exhaustive treatments of Barbizon written by an American artist was that published by the sculptor Truman Bartlett, "Barbizon and Jean-François Millet," for *Scribner's Magazine* 7 (May 1890): 530–556; and (June 1890): 735–755. There is fairly extensive literature on the impact of Barbizon painting on American art and the collecting of French Barbizon pictures in America. Among the most significant works are Peter Bermingham, *American Art in the Barbizon Mood* (Washington, DC: Smithsonian Institution Press, for the National Collection of Fine Arts, 1975) based on the author's Ph.D. dissertation, "Barbizon Art in America: A Study of the Role of the Barbizon School in the Development of American Painting, 1850–1895," Ann Arbor, University of Michigan, 1972; and Laura Meixner, *An International Episode: Millet, Monet and their North American Counterparts* (Memphis, TN: The Dixon Gallery and Gardens, 1982). See also the section on "The Artists at Barbizon," in Lois Marie Fink, "The Role of France in American Art 1850–1870" (Ph.D. dissertation, University of Chicago, 1970), pp. 151–172. None of these or other publications devoted to Barizon-American interrelationships list or detail the American artists who visited, painted, and/or stayed in Barbizon.

4. Thomas Hicks was probably also in Barbizon in 1849 while studying with Thomas Couture in Paris, for he displayed a *Cottage in Barbison* [*sic*] at the American Art-Union (a lottery organization) in New York in 1850, perhaps the earliest exhibition of a Barbizon scene by an American painter. Worthington Whittredge of Cincinnati, on his way to Düsseldorf in 1849, stopped in Barbizon where he "had heard had congregated several young landscape painters" but only recalled meeting Virgile Narcisse Diaz de la Peña, so presumably Babcock was not yet in residence. See Whittredge's manuscript "Autobiography" (Washington, DC: Archives of American Art, Smithsonian Institution), p. 39. Hicks also copied a work by Diaz during his stay in France; see George A. Hicks,

"Thomas Hicks, Artist, a Native of Newtown," *Bucks County Historical Society Papers* 4 (1917): 91.

5. Edward Wheelwright, "Personal Recollections of Jean-François Millet," *Atlantic Monthly* 38 (September 1876): 257–276; Wyatt Eaton, "Recollections of Jean-François Millet," *Century Magazine* 38 (May 1889): 90–104; Will H. Low, "A Century of Painting," *McClure's Magazine,* 6 (May 1896): 497–512. Ednah Cheney and her artist-husband, Seth Cheney, visited Babcock at Barbizon in 1854, and she, too, later wrote about Millet: Ednah D. Cheney, "Jean-François Millet," *The Radical: A Monthly Magazine Devoted to Religion* 1 (October, 1867): 667–672. Also, see Bartlett, op. cit.

6. This conclusion is based upon the located pictures documented by the Inventory of American Painting, Smithsonian Institution, Washington, DC, which included paintings by Elizabeth Nourse, Edward Potthast, Charles Harold Davis, and Alexis Jean Fournier. Davis lived for nine years, 1881–1890, in Fleury, a small village west of Barbizon, where a number of other Americans painted during this decade: Walter Griffin, G. Rugero Donoho, Charles H. Hayden, and John Austin Sands Monks. Probably the most celebrated American paintings of Barbizon itself were the series of eventually 20 works by Fournier, collectively identified and exhibited as *The Homes and Haunts of the Barbizon Masters.* The series was begun in France in 1907 and was first shown at the Schaus Art Galleries in New York in March of 1910, before going on tour. See Rena Neumann Coen, *In the Mainstream: The Art of Alexis Jean Fournier* (1865–1948) (St. Cloud, MN: North Star Press, 1985), pp. 63–76. At the time of the initial exhibit, Fournier produced an accompanying book, *The Homes of the Men of 1830* (New York: William Schaus Galleries, 1910).

7. For a discussion of the variations on Carolus-Duran's name, see Mary Jo Viola, "American Students of Carolus-Duran," unpublished seminar paper, Graduate School of the City University of New York, 1977.

8. Henry Bacon, *A Parisian Year* (Boston: Roberts Brothers, 19882), pp. 59–60.

9. I know of no listing of Carolus-Duran's pupils; for an excellent discussion of his life and career, and his teaching with regard to some of his American students, see H. Barbara Weinberg, *The Lure of Paris* (New York, Abbeville Press, 1991), pp. 189–220.

10. Low's initial appearance in Barbizon in 1873, after a week in a miserable inn in the little hamlet of Recloses, is described in Will H. Low, *A Chronicle of Friendships 1873–1900* (New York: Charles Scribner's Sons, 1908) p. 32. Low's discussion of Barbizon, Grez, and Montigny is the most thorough presentation by an American painter of the nature and development of the artistic activities in the region..

11. Robert Louis Stevenson wrote to his mother from the Hotel Siron in Barbizon in August of 1875 that he had spent three days in Grez. Stevenson to Mrs. Thomas Stevenson, August 1875, Sidney Colvin, editor, *The Letters of Robert Louis Stevenson* (New York: Charles Scribner's Sons, 1899), pp. 1, 119.

12. Bacon, *A Parisian Year,* p. 98.

13. Howard Russell Butler to his mother, April 25, 1886, Howard Russell Butler Papers, Archives of American Art, Smithsonian Institution, Washington, DC.

14. Birge L. Harrison, "In Search of Paradise with Camera and Palette," *Outing Magazine* 21 (July 1893): 310.

15. Harrison, "In Search of Paradise," p. 310.

16. The initial trip to Grez is recounted in some detail in Low, *A Chronicle of Friendships 1873–1900,* pp. 134–136.

17. Letter to May Brawley Hill from Gérard Ermisse, Directeur des Services d'Archives de Seine-et-Marne, July 22, 1982, courtesy of Ms. Hill.

18. My tremendous thanks to Andrea Husby, who is writing a dissertation on Birge Harrison and has supplied me with information both about Harrison's presence in Grez and the location of some of his major works painted there.

19. Birge Harrison, "With Stevenson at Grez," *Century Magazine* 93 (December 1916): 306–314.

20. This is detailed at great length in Will H. Low, "The Primrose Way," typescript, pp. 129–132, Library, Albany Institute of History and Art, Albany, New York, 1930.

21. Isobel Field, *This Life I've Loved* (New York, Toronto: Longmans, Green and Co., 1937), pp. 98–99. Pattison, however, would shortly become associated with the art colony in Ecouen.

22. Nellie Van de Grift Sanchez, *The Life of Mrs. Robert Louis Stevenson* (New York: Charles Scribner's Sons, 1920), p. 46.

23. Interview with De Witt Lockman, typescript, November 23, 1925, New York Historical Society.

24. Sadler, p. 11. For Grayon, see *Arts for America* 5 (Midsummer, 1896): 239; Julia Rowland Myers, "The American expatriate painters of the French peasantry, 1863–1893." (Ph.D. dissertation, College Park, University of Maryland, 1989), pp. 311–313. Grayson's *Effet de Soleil* of 1882, sold in 1954 at Sotheby Parke Bernet, New York, auction sale, No. 1556, lot 227, might have been painted either at Grez or Concarneau.

25. Sadler, p. 11.

26. Annette Stott, "American Painters Who Worked in the Netherlands, 1880–1914" (Ph.D. dissertation, Boston University, 1986), p. 121.

27. Isobel Field, p. 111. Field's description of Grez in her autobiography is one of the most complete for the period, see pp. 98–114.

28. Bloomer's recollections of 1878 as "the year of years in which the history of my struggles amounted almost to a climax" are found in the *San Francisco Call* (February 13, 1898): 23, courtesy of Alfred C. Harrison, Jr., director, North Point Gallery, San Francisco.

29. Among the many narratives concerning the Stevenson cousins and the Osbournes, mother and daughter, see James Pope Hennessey, *Robert Louis Stevenson, A Biography* (New York: Simon & Schuster, 1974), pp. 96–105.

30. Harrison, "In Search of Paradise," p. 311; Sargent's letter to Vernon Lee, August 16, 1881, Ormond family archives, cited in: Richard Ormond and Elaine Kilmurray, *John Singer Sargent: The Early Portraits* (New Haven and London: Yale University Press, 1998), pp. 27–28.

31. R.A.M. Stevenson, "Grez," p. 31.

32. R(obert) L(ouis) (Stevenson), "Forest Notes, *Cornhill Magazine,* 3 (May, 1876): 553. By 1884, Stevenson noted changes that had occurred in the village, see his: "Fontainebleau: Village Communities of Painters—IV," *Magazine of Art* 7 (1884): 342.

33. Stevenson to his mother, August, 1875, in: Colvin, p. 119.

34. Robert Louis Stevenson wrote poems celebrating both Low and his wife. See "To Will H. Low" and "To Mrs. Will H. Low" in: *Robert Louis Stevenson,* Underwoods. (London: Chatto & Windus, 1899), pp. 21–25.

35. Will H. Low, "The Primrose Way," p. 127.

36. Walter Launt Palmer, for instance, painted *Twilight at Montigny* while he was staying in Grez, possibly while visiting Low; the picture was included in a one-artist auction held in his native Albany in 1881. See Annesley and Vint Gallery, *Catalogue of Paintings of Walter L. Palmer* (Albany, 1881), #20. Two other American artists, George H. Bogert and Ernest Lee Major, also painted in Montigny. In 1879, Kenyon Cox mentioned going to Marlotte to visit the French painter Armand Charnay, and then to

painting the forest there. Cox to his father, September 5, 1879, and to his mother, September 7, 1879, in H. Wayne Morgan, *An American Art Student in Paris* (Kent, OH and London: Kent State University Press, 1986), pp. 173 and 174. Painters occasionally also painted at the larger towns of Moret, northeast of Grez, and Nemours, south of the art village; Montigny, Moret, and Nemours all offered the attraction of the Loing River, along with Grez. Numerous artists visited Moret since it was the nearest major stop to Grez on the main rail line. Kenyon Cox, traveling to Italy with Theodore Robinson, wrote in late August 1878 of the charms of the town, while waiting to travel to Italy after visiting Grez. Morgan, p. 111. Other American painters who worked in Moret include George Yewell, Joseph Foxcroft Cole, William Lamb Picknell, H. Bolton Jones, Alfred Vance Churchill, George Inness, Jr., Dodge MacKnight, George Oberteuffer, Robert Henri, Ernest Lawson, George Elmer Browne, and the California painter Jules Pages. The Pennsylvania painter Peter Alfred Gross made numerous visits to paint Nemours in the first decade of the twentieth century.

37. Caroline Ticknor, *May Alcott: A Memoir* (Boston: Little, Brown and Company, 1928), p. 221.

38. Low, *A Chronicle of Friendships 1873–1900,* p. 179.

39. Richard H. Love, *Theodore Robinson Sketchbook Drawings* (Chicago: R. H. Love Galleries, 1991). My gratitude to Sona Johnston, senior curator of Painting and Sculpture, Baltimore Museum of Art, and the authority on Robinson, for her help in identifying Robinson's presence in Grez.

40. Ticknor, pp. 211–225.

41. Baird's *À Grez* was shown in the 1879 Salon. His death date is not documented.

42. Helen V. Brockhoff, *Thad Welch Pioneer and Painter* (Oakland, CA: Oakland Art Museum, 1966), p. 26.

43. For an account of that summer in Grez, see Augustus G. Heaton, "My Artist Life, 1878," *The Nutshell* 11 (April–June, 1925): 4–6.

44. Simmons, pp. 196–197.

45. Harrison, "In Search of Paradise," p. 312

46. Heaton, p. 5.

47. For Bridgman's visit to Grez, otherwise little unrecorded, see Ilene Susan Fort, "Frederick Arthur Bridgman and the American Fascination with the Exotic Near East" (Ph.D. dissertation, Graduate School of the City University of New York, 1990): pp. 80–82.

48. Harrison, "In Search of Paradise," p. 311.

49. May Alcott Nieriker, *Studying Art Abroad, and How to Do it Cheaply* (Boston: Roberts Brothers, 1879), p. 60. Will Low recalled that there were "two Inns at Grez, Chevillon's, where we, the Stevensons and our band stayed, and the other, whose name I forget, and which I fancy was considered the most respectable, though that may be because it was slightly more expensive," Ticknor, p. 223.

50. Bridgman exhibited *Garden at Grez* in New York: American Art Gallery, Exhibition of Pictures and Studies by F. A. Bridgman, 1881, no. 216.

51. Cox to his father, July 1, 1879, quoted in H. Wayne Morgan, editor, *An American Art Student in Paris,* p. 165. See also H. Wayne Morgan, *Kenyon Cox, 1856–1919: A Life in American Art* (Kent, OH and London: Kent State University Press, 1994), pp. 54–57.

52. Robinson to Cox, May 31, 1883, Kenyon Cox Papers, Avery Library, Columbia University, New York; thanks to Sona Johnston for bringing this letter to my attention.

53. Cox to his father from Grez, September 5, 1879, quoted in Morgan, *An American Art Student in Paris,* p. 173.

54. Cox to his mother from Grez, June 2, 1879, quoted in Morgan, *An American Art Student in Paris,* pp. 159–160.

55. Cox to his mother from Grez, August 24, 1882, quoted in Morgan, *An American Art Student in Paris,* p. 211.

56. Birge Harrison, *Landscape Painting* (New York: Charles Scribner's Sons), p. 138.

57. For Dellanbaugh's presence in Grez in the summer of 1882, which he devoted entirely to drawing, see "Americans in Paris," *Studio* 1 (January 6, 1883): 3. For his article on Concarneau, see Dellenbaugh, "Concarneau," *Studio* 2 (December 22, 1883): 282–289.

58. George B. Havens, *Frederick H. Waugh, American Marine Painter* (Orono, University of Maine Press, 1969), p. 15.

59. Though Swedish, Emma Löwstadt Chadwick exhibited two works in New York with the Society of American Artists in 1886, the same year her husband showed *A Portrait* in that show.

60. Tom Cross, *The Shining Sands. Artists in Newlyn and St. Ives 1880–1930* (Cambridge, England: Lutterworth Press, 1994), pp. 97–98.

61. Letter to the author from Malcolm Yorke, October 28, 1994; Yorke is the authority on the British painter Matthew Smith. American artists continued to sojourn in Grez well past its years of greatest importance—not only the regular visits of Robert Vonnoh, but also painters such as Guy Maynard, William Sartain, and others who were there in the twentieth century

62. Crane's stay in Grez in the summer of 1882 was noted in "The Illustrations," *Studio* 1 (February 3, 1883): 36, where his painting *The Bridge at Grez* was reproduced.

63. Crane to his father, Solomon Bruce Crane, Grez, July 14, 1882, letter in possession of Anne Crane Irwin; quoted in part in Charles Teaze Clark, "The Touch of Man: The Landscapes of Bruce Crane," in Florence Griswold Museum, *Bruce Crane (1857–1937): American Tonalist* (Old Lyme, CT, 1984), p. 7. My thanks also to Jack Becker, curator, Florence Griswold Museum, Old Lyme, Connecticut, for a photocopy of this letter. See also Crane interview with De Witt Lockman, March 8, 1926, pp. 19–21, New York Historical Society.

64. "Americans in Paris," *Studio* 1 (January 6, 1883): 3.

65. "Americans in Paris" *Studio* 1 (January 6, 1883): 3; "Paris Notes," *Studio* 2 (July, 1883): 31.

66. Sadler, p. 14.

67. Catalogue of the Private Art Collection of Thomas B. Clarke, New York (New York: Chickering Hall, 1899), p. 36. My thanks to Dr. Bruce Weber for the information on this painting.

68. "Tnel" [pseudonym]. "Grez," par Nemours," *Studio* 2 (July, 1883): pp. 15–18. The unidentified author was one of the company of artists whom he described here, presumably staying at the Chevillon in the summer of 1882

69. This sketch was found on the wall of the Hôtel Chevillon in 1927 by John Percival Jefferson, who purchased it and presented it to the Stevenson Society of America. My thanks to Mike Delahant, curator of the Robert Louis Stevenson Memorial Cottage, Saranac Lake, New York.

70. Crane to his father, July 14, 1882.

71. "Tnel" [pseudonym]. *Studio* 2 (July 1883): 15–18.

72. Pennie later exhibited this picture in New York with the Society of American Artists, the only time he showed with this organization.

73. "Paris Notes," *Studio* 1 (March 3, 1883): 70

74. See, for instance, Walter Gay's *The Weaver* (1886; Museum of Fine Arts, Boston).

75. "Studio Notes," *Studio* 2 (September 22, 1883): 133. The Albany Institute of History and Art has a Pennie sketchbook with sketches dated 1881 and 1882. Included are three sketches labeled "Grez." My thanks to Tammis K. Groft, chief curator, of the Institute.

76. Havens, pp. 26–30.

77. Letter from Alexander to Colonel Edward J. Allen, June 10, Madrid, Archives of American Art, Smithsonian Institution, Washington, DC, reel 1728, frame 322.

78. *Memorial Exhibition: Paintings of the Sea by Frederick Judd Waugh, N.A. (1861–1940)* (New York: Grand Central Art Galleries, 1943), unpaginated

79. Sandra Leff, in *John White Alexander 1856–1915 Fin-de-Sie?cle American* (New York: Graham, 1980), p. 8, notes Alexander's travels that summer to North Africa, Madrid, Paris, Dordrecht and London, but does not mention Grez. See also the detailed discussion of the impact of Velásquez on Alexander at this time in Sarah J. Moore, "John White Alexander (1856–1915): In Search of the Decorative" (Ph.D. dissertation, Graduate School of the City University of New York, 1992), pp. 73–74. Another colleague reported to be in Grez with Waugh was Thomas Anschutz, his former instructor at the Pennsylvania Academy, but there is no record of Anschutz traveling abroad until 1892. See "An Artist of Our Time Frederick J. Waugh, 1861–," *Public Ledger* (Philadelphia), June 5, 1932, Society Section, p. 7.

80. American Art Galleries, *Collection of the Late Charles Stanley Reinhart Oil Paintings, Water Colors, Original Drawings* (New York, 1897), p. 21, #336.

81. Sears exhibited a charcoal *A Study in Grez, France* at the Art Institute of Chicago in 1888, but he had returned to America by 1886 when he was living in New York, and subsequently in Atlantic Highlands, NJ.

82. Elizabeth de Veer and Richard J. Boyle, *Sunlight and Shadow. The Life and Art of Willard L. Metcalf* (New York: Abbeville Press, 1987), pp. 35–36, 188–194, 265–266.

83. F. Newlin Price, "Emil Carlsen—Painter, Teacher," *International Studio* 75 (July, 1922): 308; Ulrich W. Hiesinger, *Quiet Magic: The Still-Life Paintings of Emil Carlsen* (New York: Vance Jordan Fine Art Inc., 1999), p. 17.

84. See Bruce's letters to his father written August 26 and 30, 1885, in Joan Murray, editor, *Letters Home: 1859–1906 The Letters of William Blair Bruce* (Moonbeam, ONT, Canada: Penumbra Press, 1982), pp. 112–114.

85. Cox to his mother, January 6, 1878, in Morgan, *An American Art Student in Paris*, p. 54

86. Charles H. Davis, "Notes Upon Out-of-Door Life by One of Our Students in France," *Art Student* 1 (December, 1884): n.p. Davis is not otherwise included here because he was actively painting in the villages of Barbizon and Fleury rather than Grez and its neighboring communities. This is also true of the American painter Walter Griffin, who established an art school in Fleury. See Toru Arayshiki, "Seiki Kuroda, Jean-François Millet, and Walter Griffin: Admiration and Influence" in *J. F. Millet, the Barbizon Artists and the Renewal of the Rural Tradition* (Yamanashi Prefectural Museum of Art, 1998), pp. 369–372.

87. Julian Campbell, *The Irish Impressionists: Irish Artists in France and Belgium 1850–1914* (Dublin: National Gallery of Ireland, 1984), pp. 44, 225. In addition, Campbell states that Cazin visited both Grez and Marlotte, and also notes that the celebrated French specialist in peasant imagery, Leon L'Hermitte, visited Grez in 1880.

88. William A. Coffin, "Jean-Charles Cazin," *Century* 55 (January, 1898): 395, 397.

89. Crane to his father, July 14, 1882.

90. Otto Stark, "The Evolution of Impressionism," *Modern Art* 3 (Spring, 1895): 53–54.

91. Refused at the Paris Salon of 1883, the picture was exhibited at the annual exhibition of the Pennsylvania Academy of the Fine Arts in 1883, and illustrated in the catalogue, and then in New York in 1884 at the annual exhibition of the Society of American Artists. See Morgan, *Kenyon Cox, 1856–1919: A Life in American Art,* p. 67.

92. *La Marcellerie* won for Donoho a silver medal at the International Exposition held in Paris in 1889.

93. Nordstrom visited Grez in 1882, though he returned to Sweden later that year. He was back in 1884 and remained there until 1886; thus, he and Metcalf would have been in the village at the same time.

94. For a study of American peasant imagery painted at Grez, see Myers, pp. 246–280.

95. "The Paris Salon," *Art Amateur* 11 (June, 1884): 5; cited by Victoria J. Beck in René Paul Barilleaux and Victoria J. Beck, *G. Ruger Donoho: A Painter's Path* (Jackson, Mississippi Museum of Art, 1995), p. 31.

96. Harrison detailed the creation of November and the assistance he received from a Scandinavian painter in the creation of the picture in his important volume, *Landscape Painting* (New York: Charles Scribner's Sons, 1910), pp. 137–140.

97. Cox to his mother, June 2, 1878, in Morgan, *An American Art Student in Paris,* p. 160.

98. Jennifer A. Martin Bienenstock, *The Forgotten Episode: Nineteenth Century American Art in Belgian Public Collections* (Brussels: American Cultural Center, 1987), p. 40.

99. Birge Harrison, an artist-teacher-writer, authored two articles on Grez: "In Search of Paradise with Camera and Palette," pp. 310–317, and "With Stevenson at Grez," pp. 306–314.

100. Charles Louis Borgmeyer, "Alexander Harrison," *Fine Arts Journal* 29 (September, 1913): 531.

101. "Americans in Paris," *Studio* 1 (January 6, 1883): 3.

102. Walter Shaw-Sparrow, *John Lavery and His Work* (London: Kegan Paul, Trench, Trübner & Co., 1911), p. 44.

103. Myers, pp. 311–313.

104. For Harrison's own discussion of the problems involved in painting the nude out-of-doors, see "Ishmael," "Through the New York Studios," *Illustrated American* 5 (January 3, 1891): 238.

105. Archives of the Pennsylvania Academy of the Fine Arts, Philadelphia. See the entry on Harrison by Karen Zukowski in: Annette Blaugrund, *Paris 1889: American Artists at the Universal Exposition* (Philadelphia: Pennsylvania Academy of the Fine Arts, 1989), pp. 160–161, 164.

106. Borgmeyer, p. 538.

107. Another American artist who may have been in Grez around 1885 or 1886 was Jesse Leach France (1862–?). France's death date is not documented. France was studying at the Académie Julian in 1885, and probably painted his small, somewhat tonal *Old Bridge at Grez* (private collection) at that time.

108. Howard Russell Butler, "Biographical Notes," typescript, p. 165; Howard Russell Butler Papers, Archives of American Art, Smithsonian Institution, Washington, DC.

109. Franzen interview with De Witt Lockman, pp. 7–12, typescript, March, 1927, The New York Historical Society.

110. "Pictures by Augustus Franzen," *Studio* 6 (March 28, 1891): p. 161.

111. C.M. Fairbanks, "New York as an Art Center," *Chautauquan* 13 (January, 1891): 331.

112. Fairbanks, p. 331.

113. Jonathan Benington, "Roderic O'Conor (1860–1940), The Development of His Art up to 1918" (M.A. thesis, Courtauld Institute of London University, 1982), p. 3; Campbell, *The Irish Impressionists,* pp. 96–103; Benington, "From Realism to Expressionism: The Early Career of Roderic O'Conor," *Apollo* 121 (April, 1985): 253–254.

114. Denys Sutton, "Roderic O'Conor," *Studio Magazine* 160 (October, 1960): 172, drawn from a letter from Brooks' son, Alden, to Sutton, July 12, 1956, Topanga, California, Archives, Tate Gallery, London. My thanks to Jonathan Benington for a copy of this letter.

115. "The Village of Grez, France" *San Francisco Call* (April 26, 1891): 13. I am tremendously indebted to Alfred C. Harrison, Jr., my good friend and a great scholar, for locating this important article and sending it to me.

116. Vonnoh's experiences in Grez are the best studied of any American painter, thanks to the noteworthy essay by May Brawley Hill, *Grez Days: Robert Vonnoh in France* (New York: Berry-Hill Galleries, 1987). Much of the following discussion is based upon Hill's findings.

117. Sadler, p. 14.

118. *National Cyclopedia of American Biography* 7 (1897): 462.

119. Ibid.

120. Just a few years earlier, the American and British painters John Singer Sargent, Frank Millet, Edwin Blashfield, Edward Austin Abbey, Alfred Parsons, and Robert Williams were all painting a poppy garden at the artists' colony in Broadway in the West of England, and by 1890, Childe Hassam was beginning a series of paintings of the poppies in Celia Thaxter's garden on the island of Appledore, off the coast of Maine and New Hampshire. See Elaine Kilmurray and Richard Ormond, editors, *John Singer Sargent* (London: Tate Publishing, 1998), p. 118; David Park Curry, *Childe Hassam An Island Garden Revisited* (Denver, CO: Denver Art Museum, 1990), esp. pp. 81–113; William H. Gerdts, Down Garden Paths: *The Floral Environment in American Art* (Rutherford, Madison, Teaneck, NJ: Fairleigh Dickinson University Press), 1983, pp. 67–79.

121. After the picture was shown in Munich, the great German art historian Richard Muther declared: "Never yet was war so boldly declared against the conventional usages of the studio; never yet were such barbaric means employed to attain an astounding effect of light." Richard Muther, *The History of Modern Painting,* 3 volumes (London: Henry and Co., 1896), p. 491.

122. See the present author's essay on this picture in Irene S. Sweetkind, editor, *Paintings from the Butler Institute of American Art* (New York: Harry N. Abrams, 1994), pp. 159–163.

123. "In Studio and Gallery," unidentified clipping, Edward Potthast Papers, roll N738, frame 428, Archives of American Art, Smithsonian Institution, Washington, DC.

124. One critic recalled a landscape near Grez, exhibited in Cincinnati in 1892, as an "arrangement in blue and yellow" and a "greenery-yallery affair." "Some Notable Pictures by Cincinnati Artists" *Cincinnati Commercial Gazette* (June 19, 1892): 17. The same writer identified Potthast as a member of the Impressionist school and commented upon the "rankly hot" color of *Sunshine.*

125. For Potthast in Grez, see Ellen Ann Hinckley, "Edward Henry Potthast: Cincinnati's First Impressionist" (M.A. thesis, University of Cincinnati, 1989), pp. 16–24; and John Wilson, *Edward Henry Potthast: American Impressionist* (New York: Gerald Peters Gallery, 1998), pp. 8–11.

126. Sadler, p. 13, writes of Brooks' inspiration toward Impressionism.

127. For Hamilton, see Erica E. Hirshler's biography of the artist in: Trevor Fairbrother, *The Bostonians. Painters of an Elegant Age, 1870–1930* (Boston: Museum of Fine Arts, 1986), pp. 211–212.

128. *Catalogue of Paintings by Edward W. D. Hamilton on Exhibition and Sale at the Gallery of J. Eastman Chase, 7 Hamilton Place,* Boston, 1892

129. Sadler, p. 14.

130. Information on Ramsdell, courtesy of Jack Becker, curator, Florence Griswold Museum, Old Lyme, Connecticut, citing several articles by John H. Perschbacher of Manistee, Michigan. Ramsdell's work was well known in his native state, and he enjoyed several one-artist shows at the Art Association of Grand Rapids, Michigan.

131. Collins later joined the Impressionist colony in Giverny in 1898, becoming a resident of that village and marrying a young woman from nearby Vernon in 1905.

132. See the typescript of letters from Caroline Benedicks Bruce from the Hôtel Chevillon to her mother-in-law in Canada, May 24, June 17, July 28, September 1, 1889, William Blair Bruce Papers, Robert McLaughlin Gallery, Oshawa, ONT, Canada, courtesy of Joan Murray.

133. Murray, *Letters Home,* p. 173.

134. Letters from Caroline Benedicks Bruce, June 17, July 28, 1889.

135. One of the works, which figured in the artist's memorial show held in Paris in 1907, was titled *Le pommier en fleur, Grèz (Seine-et-Marne). Exposition Rétrospective W. Blair Bruce* (Paris: Galeries Georges Petit, 1907), p. 38.

136. Bruce's letter to his mother from Grez on April 7, 1892, Murray, p. 181.

137. See the "Chronology" in the catalogue, *William Blair Bruce 1859–1906* (Oshawa, ONT, Canada: Robert McLaughlin Gallery, 1975) along with the letters sent to his family in Murray, Letters Home, passim.

138. Arlo Bates, "Frederic Porter Vinton," in *Memorial Exhibition of the Works of Frederic Porter Vinton* (Boston: Museum of Fine Arts, 1911), p. 14.

139. *An Exhibition of Paintings* (Boston: St. Botolph Club, 1894), which included a painting of *The Old Bridge at Grez;* Memorial Exhibition, in which both *La Blanchisseuse* and *The River Loing at Grez, France* appeared, along with renderings of the bridge and the church at Grez.

140. Sterner's *Landscape at Grez,* dated 1893, was sold at Christie's, New York, January 26, 1983, Sale #5261, and is now in a private collection.

141. Sadler, p. 16. A painting such as Rook's *Moonlight* (ca. 1890–1900; private collection) may have been painted in Grez. See Diane Petrucha Fischer, *Edward F. Rook 1870–1960: American Impressionist* (Old Lyme, CT: Lyme Historical Society, 1987), p. 9.

142. For Meakin, see Richard J. Boyle, *Lewis Henry Meakin 1850–1917: An American Landscape Painter Rediscovered* (Cincinnati, OH, 1987), p. 13. For Picknell, see David Sellin, "The Art of William Lamb Picknell," in *William Lamb Picknell 1853–1897* (Washington, DC: Taggart & Jorgenson Gallery, 1991), p. 26.

143. Lucius E. Ladd, Jr., "Boston Artists and Their Work," *New England Home Magazine* 11 (May 13, 1900): 325.

144. Sadler, p. 17. Both Edmundson and Hill painted pastels near Grez, which they exhibited at the Annual Exhibition at the Art Institute of Chicago in, respectively, 1895 and 1896.

145. [Autobiography], mss., pp. 57–58; and, "Appraisal of Pictures Property of Mr. Sartain," mss., both documents with the Sartain Family Papers, Archives of American Art, Smithsonian Institution, Washington, DC. Sartain's *On the Plain at Grez* was formerly in the collection of The Raydon Gallery, New York.

146. "Pictures by Allis" *Los Angeles Times* (December 1, 1912): section 2, p. 14. There was some crossover among American artists who visited Grez and were also integral to the important but as-yet unstudied art colony in Etaples. One such painter was Augustus Koopman (1869–1914) who painted a view of the *Bridge at Grez-sur-Loir* [*sic*] (private collection).

147. Hassam's large oil of *The Bridge at Grez*, presently unlocated, is illustrated in Adeline Adams, *Childe Hassam* (New York: American Academy of Arts and Letters, 1938), opp. p. 56. Two smaller versions of this subject in oil are also known, one unlocated, the other in a private collection in New Jersey. The Corcoran Gallery of Art, Washington, DC, has a two-sided watercolor of *The Bridge at Grez*, dated 1904. Hassam was not abroad that year, and this is very likely a misreading of the date. See Linda Crocker Simmons, *American Drawings, Watercolors, Pastels and Collages in the Collection of the Corcoran Gallery of Art* (Washington, DC: Corcoran Gallery of Art, 1983), p. 121. In addition, *Moonlight, Cottage and Cats* (private collection) appeared in an inventory list with the American Academy of Arts and Letters in 1935 as *Moonlight, Grez, France*. My thanks for all this information to Kathleen Burnside.

148. Sadler, p. 18.

149. Diary of Alden Brooks [son of the painter, Edward Brooks], September 15, 1912, quoted in Alice Keene, *The Two Mr. Smiths The Life and Work of Sir Matthew Smith 1879–1959* (London: Lund Humphries, 1995), p. 34.

SELECTED BIBLIOGRAPHY

Gerdts. William H. "The American Artists in Grez." Toru Ayashiki, curator, *The Painters in Grez-sur-Loing*. October 2000-June 2001, The Japan Association of Art Museums, 2000.

Harrison, Birge. "With Stevenson in Grez." *Century Magazine* 93 (December 1916): 306–14.

Hill, May Brawley. *Grez Days, Robert Vonnoh in France*. New York: Berry-Hill Galleries, 1987.

Jacobs, Michael. *The Good and Simple Life: Artist Colonies in Europe and America*. Oxford, England: Phaidon Press, 1985, pp. 17–41.

Low, Will Hickok. *A Chronicle of a Friendship*. New York: Charles Scribner's Sons, 1908.

Lübbren, Nina. *Rural Artists' Colonies in Europe, 1870–1910*. New Brunswick, NJ: Rutgers University Press, 2001.

Sadler, Fernande. *L'Chevillon et let Artists de Gres-sur-Loing*. Fountainebleau, Informateur de Seine-et-Marne, 1938.

Stevenson, Robert A. Mowbray. "Grez." *Magazine of Art* 17 (1894): 27–32.

Wright, Margaret Bertha. "Bohemian Days." *Scribner's Monthly* 16 (May 1878): 121–30.

4

Bridging the Gap of Difference: Anna Klumpke's "Union" with Rosa Bonheur

Britta C. Dwyer

By 1898, the French animal painter Rosa Bonheur (1822–1899) had received all the accolades a woman painter could have wished for, including unprecedented international fame for her art. Yet, a simple laurel wreath placed on her head by her American companion–artist Anna Klumpke (1856–1942) became, she said, her most treasured prize. To commemorate this important and intimate moment, Klumpke photographed the artist wearing her crown of laurels.[1] Expressing her gratitude, Bonheur said: "It is not only a personal affection [that I have for you] but a sympathy for the country to which you belong. You are for me the symbolic alliance of old Europe with young America"[2] (Figure 7).

In the photograph of this "union" the French artist is the center of attention. She is the subject of Klumpke's image and, essentially, of its attendant narrative. Klumpke takes on the role of the passive enabler, referred to but not part of the image per se.[3] If one were to read symbolic significance into this event, certainly Klumpke's secondary position may be read as a traditional mark of reverence and respect toward "old Europe" by "young America." Yet, her role could also be interpreted more positively as a mediator of new ideas, inspiration, and knowledge. Such an interpretation is especially valid given Bonheur's faith in America and its women as harbingers of a new and better future.

Interpreting the event in 1898 from this latter perspective provides an interesting parallel between Klumpke's relationship with Bonheur and the history of French feminism. Though international congresses had laid the foundation for a collaborative feminist program, feminists in France and in America had tended to focus upon their own particular agenda. However, during the 1890s, French feminist activism fell into a temporary remission. In part as a result of this situation, an alliance between the two nations was established,

providing French feminism with a new momentum under the guidance and inspiration of American contacts.

This study claims Klumpke's "union" with Bonheur as an exemplar of transnational feminist relations. It proposes Rosa Bonheur as the doyenne of French feminism and the young American Klumpke as representative of encouragement for her contemporaries in "old Europe." My approach in this chapter is twofold. The first part is biographical, drawing primarily upon Klumpke's text *Rosa Bonheur, sa vie et son oeuvre* (1908).[4] It uses Bonheur's "voice" to tell the stories of two historical figures. The second half provides a political analysis of *fin–de–siècle* French feminism that supports the interpretation of an American artist "not out of context" but "united" with the adopted nation.

ROSA BONHEUR—A DOYENNE OF FRENCH FEMINISM

> Of all movements, political, social and religious, of past ages there is, I think, not one so unmistakably tide like in its extension and the uniformity of its impulse, as that which has taken place within living memory among the women of almost that of every race on the globe.[5]

Although the author writing the introduction to Theodore Stanton's 1884 book on *The Woman Question in Europe* does not refer to a specific instance in French history when "this movement" began to "stir an entire sex," the editor "credited the Saint–Simonian men and women of the 1830s for the birth of an autonomous women's movement in France. United by a utopian social vision, the Saint-Simonians wished to create a new world order where women would have a special role in transforming society. They believed in a female Messiah who would usher in a peaceful society, advocated equality of women and men, and supported the enfranchisement of women, including the abolition of the Napoleonic code of inheritance."[6]

Bonheur's childhood experiences are closely linked to the politics of the Saint-Simonians and the reform movement that laid the founding blocks to a feminist ideology in France. Born the first of four children to the painter Raimond Bonheur and Sophie Marquis in 1822, she was the daughter of an ardent disciple of this socialist movement. When her father left the family to join a pseudomonastic fellowship at Ménilmontant (a commune located in northeastern Paris), her mother took the children to visit him regularly, sharing with him a commitment to the movement's credo. During this time Sophie had not only to look after the four children, but also to earn enough by giving piano lessons to support the household. Remembering her mother's struggles, Rosa wrote: "As for my mother, there was no longer any question of something for her, aside from taking care of her children."[7] When the group was disbanded, her father returned to the family and his work as art instructor.[8] Shortly thereafter her mother died. Rosa was then 11 years old. Two years later she was working in her father's studio. At 14 she took up painting in earnest, going to the Louvre regularly to make copies of the Old Masters. By the end of the 1830s, when Rai-

mond had become head of a drawing school, she exhibited her first works in the annual Salon. Bonheur would later credit her father for developing in her the feminist ideals that she espoused, saying: "To his doctrines I owe my great and glorious ambition for the sex to which I proudly belong and whose independence I shall defend until my dying day."[9] She would also, however, recall her mother's fatal, conflicting commitments to family and husband, adding: "They were considerable influence in my decision to remain single."[10]

As is apparent from the above permutations of argument, virtually any arguments Bonheur made to assert her rights would be complicated and contentious. At stake was a struggle to remain independent. Not surprisingly she professed total admiration for her sister of the pen George Sand. Eighteen years older than Bonheur, Sand was a central figure in the mainstream of the literary world of the time.[11] A radical in her utopian ideas and in her attempt to break through the conventions of narrative writing, Sand never expressed a feminist agenda per se. Yet many of her novels, especially of the 1840s, encapsulated a vision of the future that announced a new social order similar in many ways to the Saint-Simonians' beliefs with which Bonheur had been raised.

In addition to "embracing" the work of Sand, Bonheur may also have taken courage from the writer to defy bourgeois norms, adopting male attire and smoking cigarettes. As she forged her role as a nineteenth-century painter, Bonheur—like Sand—helped to shift the meaning of "woman" to express the double emergence of the woman as artist and the artist as woman. Determined to compete with her male peers on their own terms, by the end of the 1850s Bonheur had paved her way for an independent career in the arts. Her enormous success with her 1853 painting of *The Horse Fair* (The Metropolitan Museum, New York) enabled her to buy her own château (i.e., a seventeenth–century hunting lodge bordering the Fontainebleau forest) in By, near Paris. Joined by Natalie Micas, she lived and worked with her childhood companion until Micas died in 1889.

ANNA ELIZABETH KLUMPKE—AN AMERICAN WOMAN

Klumpke entered the French painter's life in the last decade of the nineteenth century, the period that is the focal point of this discussion. The following discussion provides a biographical sketch of her unique status as an American expatriate in Paris. Born in 1856 in the frontier settlement of San Francisco, Anna Klumpke was the eldest daughter of German immigrant parents. John Gerald, a Roman Catholic, and Dorothea, a Protestant, had six children, five girls and twin boys–one of whom died in infancy. Starting as a cobbler, her father soon turned to the real estate business and the family prospered with the growth of the city on the bay.

The first major disruption in Anna's life was an accident that occurred at the age of about two. Caused by a fall from a chair, the injury dislocated her right knee and left her lame. She was too young to recall the event. She remembers, however, that it was about this time that her mother bought her a doll, explaining

that its name Rosa Bonheur meant "a happy hour" and "Rosa Happiness."[12] While American critics nationwide at the time shared in the artist's extraordinary success, claiming that "By birth, Rosa Bonheur belongs to France; by genius, to the world," for the young Anna the doll (dressed after the fashion seen in a 1857 portrait of the artist by Edouard-Louis Dubufe) was a nursery treasure brought alive by stories from her mother about a great and unusual woman.[13]

The second disruption in Anna's life occurred with the separation of her parents. Though the exact circumstances remain uncertain, religious differences were said to have been the cause of their discord. Seeking legal advice, Anna's mother was granted a divorce in 1872 with the entire care, custody, and control of the children and alimony consisting of one half of her husband's possessions.

With a determination typical of her character, Anna's mother decided to return with her children to Europe. Foremost in her mind was to provide for each of her children an education that would enable them to become financially independent. After a number of years, living in Germany and Switzerland, the family moved to Paris, a city notorious among other things for its educational institutions.[14] Here Anna's oldest sister Augusta (1859–1927) started her premedical studies and Dorothea (1861–1942) her work in mathematics. Impervious to conventional expectations, they overcame numerous hurdles to prove to their skeptical professors that "science had no sex." After finishing the lycée, Anna's two youngest sisters, Mathilda (1863–1894) and Julia (1871–1961), studied music, the former gaining competitions at the Paris Conservatory in piano, the latter teaching the violin and composing music. Wilhelm (1869–1917), who was not academically inclined, received an education in the mechanical trade. Supported in their individual endeavors by an ambitious mother, they would all later lovingly recall her admonition: "Remember that the word *can't* does not exist in the dictionary."[15]

For Anna, living in Paris meant a chance to pursue her lifelong dream to study art. As with most artists at that time, she started her training by making copies of the Old Masters at the Louvre and also at the Luxembourg museum, where the works of contemporary painters were exhibited. One of her first exercises included copying Bonheur's 1849 painting *Ploughing at Nivernais* (Musée d'Orsay, Paris). With the money she received from selling her copy (two hundred dollars), she decided to begin her formal training at the Académie Julian, then the most progressive and popular art institution in the city.

The young artist's talent and skill caught the attention of her masters Rodolphe Julian and Toni Robert-Fleury. Barely a year into her training, Klumpke was encouraged to prepare a painting for the Paris Salon. The picture was accepted by the jury, it was well hung, and led to a number of portrait commissions. In 1885, the Salon jury awarded her an "Honorable Mention" for her portrait of her sister Augusta (unlocated). Three years later, she was the first woman to win the coveted Temple Gold Medal at the Pennsylvania Academy of the Fine Arts for her large, academically inspired painting *In The Wash-House* (1888, The Philadelphia Academy of the Fine Arts, Philadelphia). More accolades followed with the exhibition of a fine Salon portrait of her mother

(private collection) and a "Bronze Medal" at the Exposition Universelle, the 1889 World's Fair. Summarizing her accomplishments, a compatriate chronicler, William G. Sheldon, pronounced Klumpke one of the most successful American women in Paris.[16]

A meeting that year between Klumpke and Bonheur allows us now to interweave the stories of these two women. The encounter took place at the *château* on October 5, 1889, when Klumpke, accompanied by an American horse dealer wishing to visit Bonheur, acted as an interpreter. The discussion in the studio is revealing of Bonheur's attraction to Klumpke at this early stage of their relationship. While looking at the works on display, Klumpke writes that she was somewhat surprised when Bonheur had turned to her for artistic criticism. Flattered, to be sure, that the century's most illustrious woman painter sought her opinion, she heard Bonheur exclaim: "But yes, but yes, I do know of your talent and I have seen [the] fine portrait [of your mother at the Salon]. I have also heard of the success of two of your sisters, one as an *interne* of Paris hospitals, and the other preparing her theses mathématique for the Sorbonne. All three of you have proven that women can be as intelligent and as talented as men and sometimes even more."[17] Bonheur concluded: "The foolish prejudice that girls are exclusively destined for marriage does not exist in your country, as it does in mine."[18] Expressing her admiration for the American ideas that she thought Klumpke represented, Bonheur began to form a romantic attachment to her new friend. With a sense of regret, she later discovered that Klumpke was planning to leave for the United States and work in Boston. Wishing her success, she hoped that she would not forget her *vieille amie* at By.

Klumpke's popularity in Boston, a city well known for its Francophile patronage, was almost instant. A busy exhibition schedule with shows in public galleries, in museums, and in her own studio earned her recognition and financial independence. Before the end of her first year, she had painted about 17 portraits and earned the respectable sum of $5,000, an amount equivalent to the salary of a professor at Harvard University at the time. As her reputation as Salon painter spread beyond Boston, she was invited to show her work across the country. During her years in America, Klumpke and Bonheur kept in touch. A request by Bonheur for specimens of weeds and sagebrush for a painting she was planning, representing wild horses fleeing a prairie fire, laid the foundation to an epistolary friendship. Letters and packages concerning "the quest of the sage brush" continued to cross the Atlantic because, as Klumpke writes: "Sagebrush surely did not grow on Boston Common, nor was it so easily procured as the French artist seemed to imagine."[19] One letter, dated September 14, 1897, came with a request from Klumpke to Bonheur. Written with the encouragement from one of her many female patrons, it asked Bonheur for the permission to paint her portrait.[20] On 16 June 1898, Bonheur welcomed Klumpke to her "château."

To paint a portrait of the famous artist was an experience fraught with apprehension and anxiety, as Klumpke openly admits in her biography. Yet Bonheur's confidence and sympathy in her as an artist spurred Klumpke to her highest achievement. In the finished portrait, Bonheur is sitting at her easel

holding a study in her left hand. A *portrait d'apparat,* the image presents both the person and her profession. She is attired in her "feminine" outfit, with the Cross of the Legion of Honor pinned to the left side of her jacket.[21] Her short hair is sharply highlighted, drawing the viewer's attention to her clearly articulated facial features. A careful modeling of forms and a limited palette of earthy colors and fleshy tones reveal the formative influence of late-nineteenth-century French portrait painting. A forceful realistic style produces an image of an almost iconic power.[22]

The composition, slightly off-center, is balanced on the left by the partial view of an unfinished sketch of three horses, a painting within a painting that probably refers to the subject of "wild horses" that first brought them together in the fall of 1889.[23] The rhythmic movement of the racing animals leads the eye across a negative empty space to the image of Bonheur. A keen and serious gaze with a shadow of a smile gives the portrait an expression that hovers between the pensive and the provocative.[24]

BONHEUR'S COMPANION–ARTIST

Reflecting upon that summer in 1898, Bonheur later remarked that it was while painting the portrait that their affection and sympathy developed and finally manifested itself on August 1898 in "the sacred marriage of two souls."[25] Though Bonheur's allegiance to her former companion, Micas, remained steadfast, Klumpke was an American and the status she shared with Bonheur as a professional woman and as an artist gave their "union" a different meaning.[26] Comparing her first and her second love, Bonheur expressed her recognition of this difference: "Nathalie was my childhood companion, she witnessed my trials and tribulations, she shared my joy and my pain. As for you, my dear Anna, you've taken hold of my heart like the daughter I would declare my own in front of an assembly of the Muses."[27] A formal photograph, taken during a visit to Monsieur Gambart in Nice, provides a commemorative document of their *fin-de-siècle* "union" (Figure 8).

For Bonheur, Klumpke was the quintessential intelligent American woman. She imagined the United States as the epitome of modern society and attributed its position *en tête de la civilization* to the manner in which American women were educated. Criticizing the customs of her own country, Bonheur explained: "Our timid beauties of old Europe let themselves be led too easily to the altar." As a result they "become subordinate, the leader's companion, not his equal, but his help–mate, [in short] no more than a pale reflection of what they were before."[28] Based on such an interpretation, Bonheur's relationship with Klumpke was both affectionate and professional.

Aware of the bias against women, their subordinate role in society, and the need for emancipation and equality between the sexes, Bonheur envisioned her "union" with Klumpke to serve as an example to encourage and promote women in their quest for independence and autonomy. Committed to a common cause, she "hoped to abolish at least some of the prejudice against women, especially where her intelligence and her talent rendered her equal to man."[29] Speaking for

them both, Bonheur said: "We'll work hard, we'll earn a living, each one inde-
pendently."[30] Indeed, the unbridled development of talent—rather than the sub-
ordination to another—was the goal of Bonheur's "union" with Klumpke.
Though Klumpke was not young at 43, Bonheur, 34 years her senior, saw in her
American companion the promise of a woman who would continue to foster and
encourage women in the arts in a supportive context of production and promo-
tion. In praise of America and its women, she said to Klumpke shortly before her
sudden death, in May: "I am convinced that to us belongs the future." What did
Bonheur mean?

POLITICAL PERSPECTIVE AND PERSONAL ASPIRATIONS

The following discussion examines Bonheur's wishful words in political
terms. Or, more to the point, it tries to interpret the "crowning" event in 1898
with Klumpke as agent and even catalyst for change in the context of a French
feminist *rapprochement* with America. Toward this end, it is appropriate to re-
turn to the Saint-Simonians and the feminist consciousness of Bonheur's early
childhood days. Representing the first organization in the Western world that
challenged women's actual status—legal, social, religious, and economic—it
envisaged a harmonious association of differentiated classes and sexual equal-
ity.[31] But, the utopian vision of the early century developed over time in di-
vergent directions to form two camps: relational feminism and individualist
feminism.[32]

The program of relational feminists, by some scholars referred to as famil-
ial feminists, linked the emancipation of women to the welfare of the family
and of the Republic.[33] Focusing upon the primacy of the family, relational fem-
inists designed a program of educational, legal, and economic reforms for the
benefit of the family. They celebrated the uniqueness of womanhood and ac-
cepted a sexual division of labor in the family and in society, which they re-
ferred to as "equality in difference." Motherhood, *patrie,* and *pot-au-feu* were
the banners rallied around by these French feminists in their campaign for re-
form during the 1890s.

The political platform of the individualist feminists (also referred to as the
integrational feminists) made total political equality for women its goal. Hu-
bertine Auclert, who is generally considered the founder of the modern French
suffrage movement, and her followers repudiated all concepts of woman's spe-
cial nature and insisted upon an end to sexism. In contrast to family–centered
values, the rhetoric of this group focused upon the individual's autonomy, with
no reference to societal purpose.[34]

These political controversies caused a major rift in the feminist body politic.
Relational feminists objected to the uncompromising individualism espoused
by their contemporaries. They argued that it was socially destructive to place
personal needs ahead of the family and the welfare of the nation and considered
the demands "unwomanly." Many branded this kind of feminism as un-French,
insisting that it was an imported movement, American and English in origin,
that threatened French culture. Indeed, to privilege the individual rather than the

family and the welfare of France was considered by many as a peculiar American mutation of French feminism.

The political split among French feminists that emerged at the end of the century severely undermined a movement that had once been the most advanced of all in the Western world. "Floundering" and "helpless," to use Moses' expressions, French feminists in the 1890s turned to America and England for guidance and inspiration.[35] As a result, new contacts were formed. The increased interest in the political activities in America by French feminists pointed to the development of a political alignment that was novel in the relationship between the two nations.

In the 1890s, this collaborative climate between America and France provided French feminists with new ideas and inspiration for reform; it allowed them to discuss, debate, and decide on a program that ultimately was widely endorsed and that made possible the organizing of women into a mass movement. Partly as a result of this Franco–American "alliance," French feminism emerged in 1900 on a note of optimism. In hindsight, we know that the program that was eventually adopted by French feminists advocated putting motherhood ahead of individual and personal needs in the name of national solidarity. Indeed, from 1900 until the fall of the Third Republic in 1940, the role of woman as mother— not the individual—continued to compose the core unit in French feminist thinking.[36] In the crucial period of the 1890s the question whether to adopt a program advocating relational feminism or individual feminism remained largely unanswered. How far should feminist action be related to the quest for individual autonomy? How far should the French feminists align themselves with the American ideas of autonomy and freedom of the individual?

The slogans of the relational feminists, stressing "equality in difference" and the politics of pronatalism, were not anathema to Bonheur's way of thinking. While she maintained that matrimony was a sacrament essential to society, she sought for herself an alternative lifestyle: an autonomous identity outside of the family. Throughout her life, but especially towards the end of the century, Bonheur's personal choices underscored her political thinking. It is in the climate of potential change for women and their role in *fin-de-siècle* society that we should understand Bonheur's optimistic vision of an "alliance of old Europe with young America." In her "union" with Bonheur as companion-artist, Klumpke bridged the gap of difference.

ADDENDUM

Shortly after the event described at the beginning of this chapter, Bonheur made Klumpke sole legatee of her estate, providing the American artist (and her family) with a permanent home in France. Julia Kristeva offers a psychological theory of immigration, read "expatriation," that proposes that the immigrant remains an outsider.[37] The foreigner, she argues, usually loses his mother tongue and the acquired one is never perfect, nor natural. Thus between two languages, the immigrant's realm remains solitary and estranged. For the foreign woman

the problem of finding "a public voice" is amplified and problematized. Klumpke's experience as an expatriate contradicts such an interpretation. Her decision in 1898 to live and work in France did not estrange her. She and her sisters were multilingual. Nor did expatriation require her to "reinvent" herself. Klumpke was an American artist at home in France.

NOTES

A version of this chapter appeared in the 1998 Dahesh Museum of Art's exhibition catalogue *Rosa Bonheur, All Nature's Children*. I thank David Farmer for granting me permission to present it here.

1. A still unidentified early painting by Bonheur of a pair of riders (women?) on horseback may have been placed on the easel for the occasion to underscore the idea of companionship.

2. Anna Klumpke, *Rosa Bonheur, sa vie et son oeuvre* (Paris: Ernest Flammarion, 1908), p. 326.

3. Though Celine, Bonheur's faithful domestic help, was in the house, she was only called for after the event, when Bonheur made her promise that the wreath would be buried together with her.

4. Another source used is Klumpke's *Memoirs of an Artist* (Boston: Wright & Potter Printing Co., 1940), which was largely written by the painter's Boston friend Lilian Whiting with commentaries provided by Klumpke. For a translation of Klumpke's biography of Bonheur, see Gretchen van Slyke, *The Artist's (Auto)Biography. Rosa Bonheur by Anna Klumpke* (Ann Arbor: University of Michigan Press, 1997). The 1908 publication does not follow the traditional biographical format in that both Bonheur and Klumpke told their stories. The narrative is divided into three parts: Klumpke's narration of how she came to know and love Bonheur, Bonheur's story of her life as compiled by Klumpke, and Klumpke's narration of Bonheur's final days and death.

5. Frances Power Cobbe in Theodore Stanton, ed., *Selections From The Woman Question in Europe* (New York: MSS Information Corporation, 1974), p. 7.

6. See Claire Goldberg Moses, *French Feminism in the 19th Century* (Albany: State University of New York Press, 1984), especially her chapter "The Saint-Simonian Vision: Creating a New World Order," pp. 41–60. See also, Jane Rendall, *The Origins of Modern Feminism, Women in Britain, France, and the United States, 1780–1860* (Chicago: Lyceum Books Inc, 1985) for entries on Saint-Simonianism.

7. Klumpke, *Bonheur,* p. 146.

8. For Bonheur and Saint-Simonianism, see Dore Ashton and Denise Browne Hare, *Rosa Bonheur, A Life and a Legend* (New York: The Viking Press, 1981), pp. 18–23, and Rosalia Shriver, *Rosa Bonheur* (Philadelphia: The Art Alliance Press, 1982), p. 23. The society ceased to exist in 1832, as the radical doctrines of the sect were viewed as a political threat to Louis-Philippe's new government.

9. Klumpke, *Memoirs,* p. 311.

10. Ibid., p. 152.

11. For a study of George Sand as a co-equal of Balzac, Hugo, and Flaubert, see Isabelle Hoog Naginski, *George Sand, Writing for Her Life* (New Brunswick: Rutgers University Press, 1991).

12. Klumpke, *Memoirs,* p. 13.

13. Ibid., pp. 12–13; Klumpke writes that after the exhibition of *The Horse Fair* in New York, the press soon made the name of the painter a familiar household word. She

adds: "San Francisco was by no means behind in the popular furore [sic]; reproductions of all degrees of excellence and prices from the crudest print to a more pretentious rendering, made the great painting family in many homes."

14. Ibid., pp. 11–27; for a more detailed discussion, see Britta C. Dwyer, *Anna Klumpke, A Turn-of-the-Century Painter and Her World* (Boston: Northeastern University Press, 1998), especially the chapter "Sisters Mounting the Ladder of Science and Art."

15. Bessie Van Voorst, "The Klumpke Sisters," *The Critic* 3 (September 1900): 224–225.

16. William G. Sheldon, *Recent Ideals of American Art* [c. 1890] (rpt. New York: Garland Press, 1977), p. 147.

17. Klumpke, *Bonheur,* p. 10.

18. Ibid.

19. Klumpke, *Memoirs,* p. 32; See also the chapter "The Quest of the Sagebrush," pp. 34–39.

20. See Klumpke, *Memoirs,* p. 36, for her visit to the summer residence of George Douglas and Anna Miller at Alexandria Bay, Deer Island, New York, and also Klumpke, *Bonheur,* pp. 44–48, for more on her patron's discussion with Klumpke on the topic of Bonheur.

21. See Klumpke, *Bonheur,* p. 53, for a discussion on the type of dress Bonheur wanted to wear in this portrait. See also, Shane Adler Davis, "Rosa Bonheur's 'Feminine Costume,'" *Antiques West Newspaper* (July 1986): 12–15, and Gretchen van Slyke, "Does Genius Have a Sex? Rosa Bonheur's Reply," *The French American Review,* vol. 63, no. 2, (Winter 1992): 12–23, esp. pp. 18–23, a section entitled "Skirting the Dress Issue."

22. The portrait was donated by Klumpke to The Metropolitan Museum, New York, in 1922. She painted two more portraits: *Rosa Bonheur* with her dog Charley, Salon 1899 (Musée de Fontainebleau, Fontainebleau), and *Rosa Bonheur* standing at her easel in her working clothes, Salon 1902 (Musée de Rosa Bonheur, By). For the latter, Klumpke used the pose in the photograph (Figure 7) that shows Bonheur wearing the laurel wreath.

23. Klumpke, *Bonheur,* p. 392; a comment by Bonheur affirms this symbolic reading of the sketch on the easel. Shortly before her death, Bonheur told Klumpke that she planned to make a bas–relief for their new studio depicting *des chevaux sauvages.* She added that her work would be in memory of the wild horses, which had providentially brought them together.

24. The portrait received its first public exposure at the First Carnegie Annual Exhibition (today referred to as the Carnegie International) in Pittsburgh in November 1898.

25. Klumpke, *Bonheur,* p. 112.

26. I am grateful to Gretchen van Slyke for her insightful discussion and analysis of this relationship in "Reinventing Matrimony: Rosa Bonheur, Her Mother, and Her Friends," *Women's Studies Quarterly* 3 & 4, (1991): 59–76.

27. Klumpke, *Bonheur,* p. 361.

28. Ibid., p. 312.

29. Ibid., p. 308.

30. Ibid., p. 110.

31. See Moses, *French Feminism,* pp. 42–59, for a discussion of the contradiction between Saint-Simonian theory and practice regarding sexual equality.

32. Ibid., pp. 151–172. In her discussion of *La querelle des Femmes* of the Second Empire, Moses argues that a class bias emerged with the revolution in 1848 that was in sharp contrast to the commitment of the earlier feminists who fought for an association across class lines. With its emphasis upon individual rights and individual equality, the feminist program that reemerged was bourgeois in interest.

33. See Karen Offen, "Depopulation, Nationalism, and Feminism in Fin–de–Siècle France," *American Historical Review* 89 (1984): 648–676, for a discussion of republican politics and the promotion of natality as a means to prevent the decline of France's role as world power after the Franco-Prussian war.

34. While Auclert cooperated with Maria Dreams and Leon Richer, the leaders of the relational feminists, in the demand for changes in the Napoleonic code and in education, she was not willing to compromise the individual's political rights.

35. Moses, *French Feminism,* pp. 226–229. In her overview of a feminist development in nineteenth-century France, Moses describes a history that is discontinuous, tied in important ways to the political fluctuations in French history. The recurring stop-and-go cycles and the frequency with which an entire generation of experienced leaders was silenced, she argues, contrast dramatically with the largely continuous history of American feminism.

36. Ibid., p. 229. Moses notes that a suffrage bill passed the Chamber of Deputies in 1919, but the political climate changed dramatically at that point and the bill was held up by the Senate until 1944.

37. Julia Kristeva, *Strangers to Ourselves* (New York: Columbia University Press, 1991), pp. 7–18.

SELECTED BIBLIOGRAPHY

Blaugrund, Annette. *Paris, 1889: American Artists at the Universal Exposition.* New York: Harry N. Abrams, 1989.

Blumenthal, Henry. *American and French Culture, 1800–1900: Interchange in Art, Science, Literature, and Society.* Baton Rouge: Louisiana State University Press, 1975.

Fink, Lois. *American Art at the Nineteenth-Century Paris Salons.* Cambridge: Cambridge University Press, 1990.

Marlais, Michael, and Marianne Doezema. *Americans and Paris.* Waterville, ME: Colby College Museum of Art, 1900.

Morton, Brian N. *Americans in Paris.* New York: Quill, 1986.

Offen, Karen, Ruth Roach Pierson, and Jane Rendall, eds. *Writing Women's History: International Perspectives.* Bloomington: Indiana University Press, 1991.

Shirley–Fox, John. *An American Student's Reminiscences of Paris in the Eighties.* London: Mills and Boon, 1909.

Solomon, Barbara. *In the Company of Educated Women: A History of Women and Higher Education in America.* New Haven: Yale University Press, 1985.

Turner, Elizabeth Hutton. *American Artists in Paris, 1919–1929.* Ann Arbor, MI.: UMI Research Press, 1988.

Weinberg, Barbara. *The Lure of Paris: Nineteenth-Century American Painters and Their French Teachers.* New York: Abbeville Press, 1991.

Wiesenger, Veronique. *Paris Bound: Americans in Art Schools, 1868–1918.* Dossiers du Musée de Blérancourt, no. 1. Paris: Réunion des musées nationaux, 1990.

Wiser, William. *The Great Good Place: American Expatriate Women in Paris.* New York: W. W. Norton, 1991.

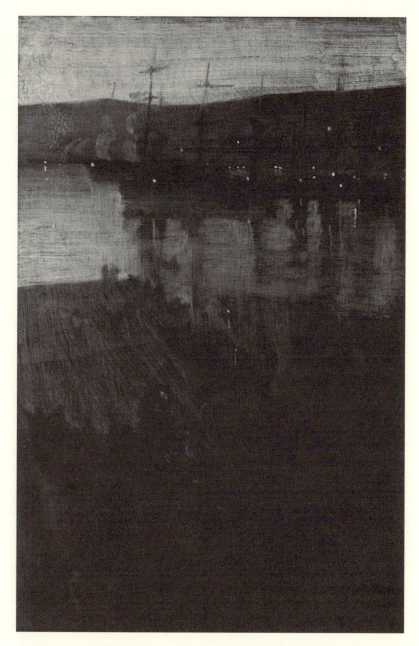

Figure 1. J. M. Whistler, *Nocturne in Blue and Gold: Valparaiso Bay.* 1866. Courtesy of the Freer Gallery of Art, Washington, DC/Smithsonian, Accession number F109.127.

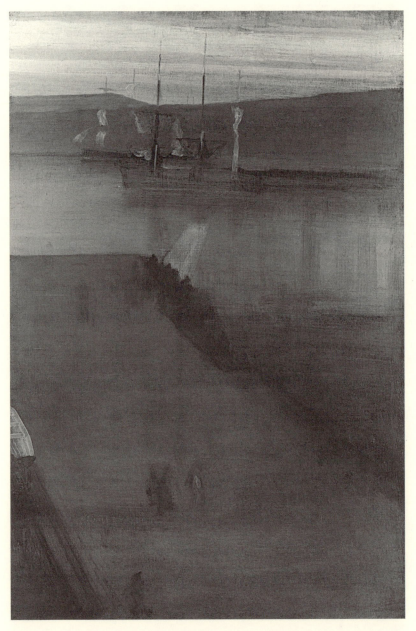

Figure 2. J. M. Whistler, *Sketch for Nocturne in Blue and Gold: Valparaiso Bay or Noon.* 1866. Courtesy of the Smithsonian American Art Museum, Gift of John Gellatly.

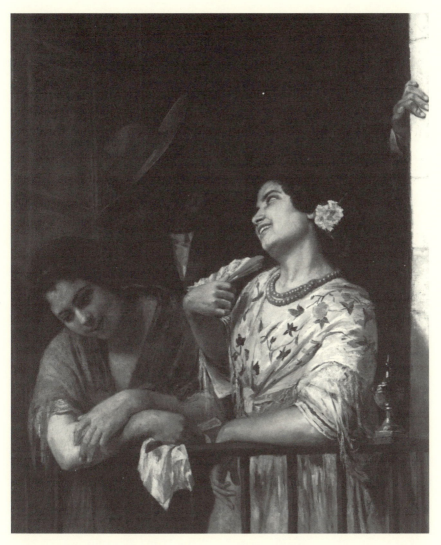

Figure 3. Mary Cassatt, *On the Balcony*. 1872. Philadelphia Museum of Art: The W. P. Wilstach Collection.

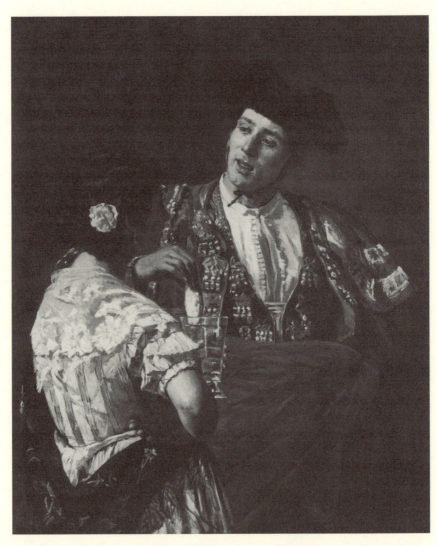

Figure 4. Mary Cassatt, *Offering the Panale to the Bullfighter.* 1873. Courtesy of the Sterling and Francine Clark Art Institute, Williamstown, MA.

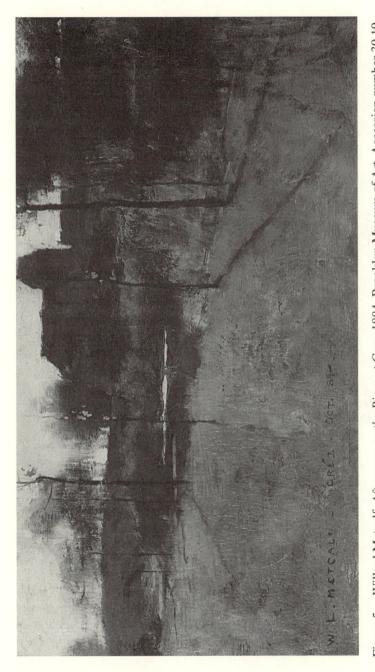

Figure 5. Willard Metcalf, *Afternoon on the River at Grez*. 1884. Brooklyn Museum of Art, Accession number 39.19, Gift of Wickersham June.

Figure 6. Robert William Vonnoh, *In Flanders Field—Where Soldiers Sleep and Poppies Grow.* 1890. Courtesy of the Butler Institute of American Art, Youngstown, Ohio.

Figure 7. Anna Klumpke, *Old Europe Crowned by Young America.* 1898.

Figure 8. Photograph of Anna Klumpke and Rosa Bonheur, Nice, 1899.

Figure 9. J. S. Sargent, *Simplon Pass: The Tease.* 1911. Courtesy of the Museum of Fine Arts, Boston, Massachusetts.

Figure 10. J. S. Sargent, *Bedouin Camp*, ca. 1905–1906. The Brooklyn Museum, Accession number 09.811. Purchased by special subscription.

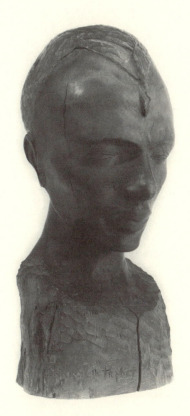

Figure 11. Nancy Elizabeth Prophet, *Congolais,* ca. 1931. Photograph copyright © 2001: Whitney Museum of American Art, New York, NY.

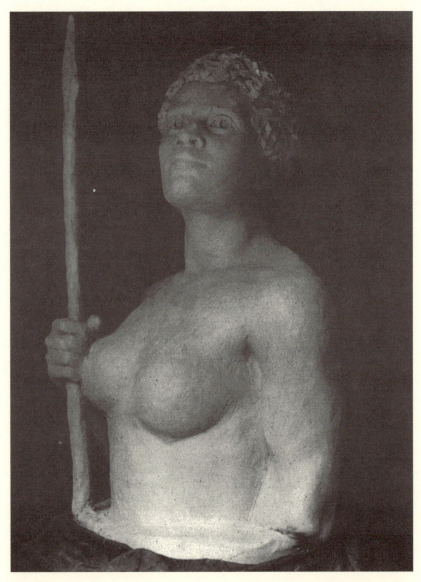

Figure 12. Augusta Savage, *The Amazon,* ca. 1930. Courtesy of Special Collections, Fisk University Library.

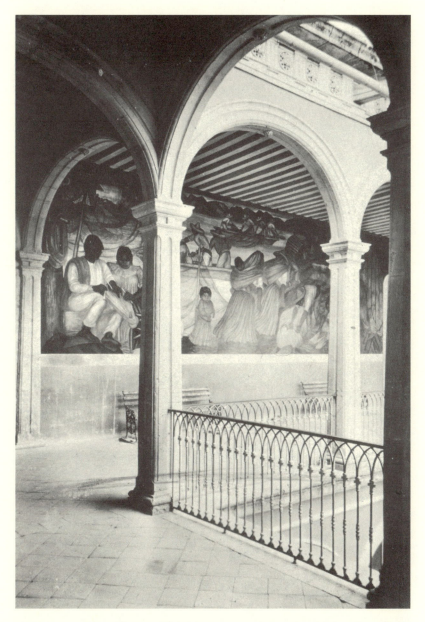

Figure 13. Marion Greenwood, *Landscape and Economy of Michoacán* (detail). 1933–34. Courtesy of Robert Plate (Marion Greenwood archive).

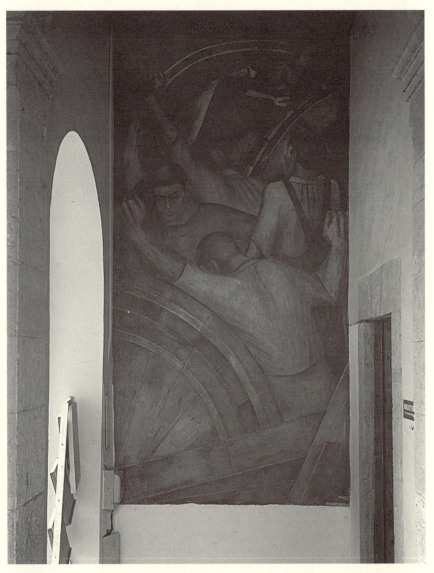

Figure 14. Grace Greenwood, *Men and Machines*. 1934. Courtesy of Elsa Chabaud.

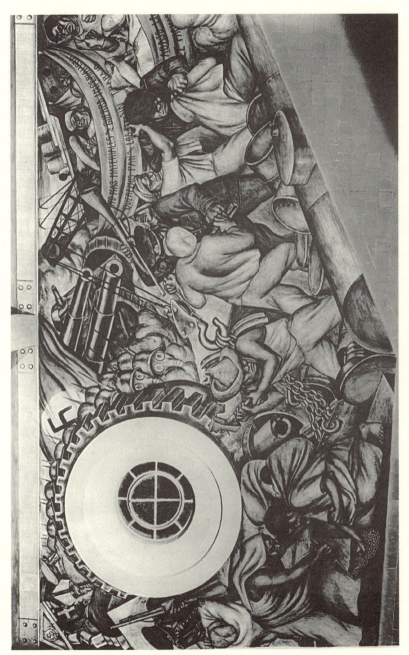

Figure 16. Marion Greenwood, *The Industrialization of the Countryside* (west wall). 1935. Courtesy of Robert Plate (Marion Greenwood archive).

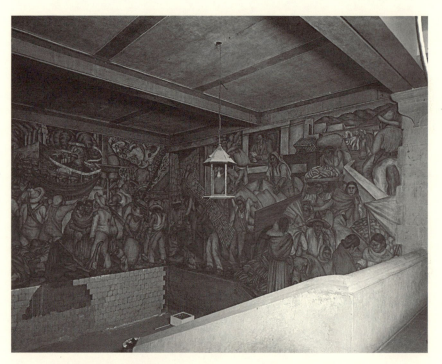

Figure 15. Marion Greenwood, *The Industrialization of the Countryside* (east and landing walls). 1935. Courtesy of Robert Plate (Marion Greenwood archive).

Figure 17. Grace Greenwood, *Mining* (east and landing walls). 1935. Courtesy of Elsa Chabaud.

Figure 18. Sam Francis, *Red and Pink*. 1951. Courtesy of the San Francisco Museum of Modern Art, a partial gift of Mrs. Wellington S. Henderson.

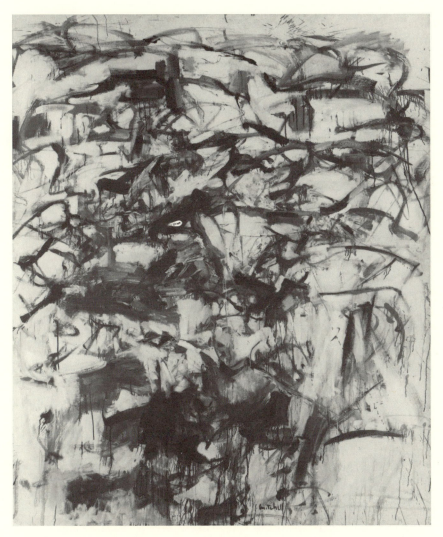

Figure 19. Joan Mitchell, *August, Rue Daguerre*. 1956. Courtesy of the Phillips
Collection, Washington, DC.

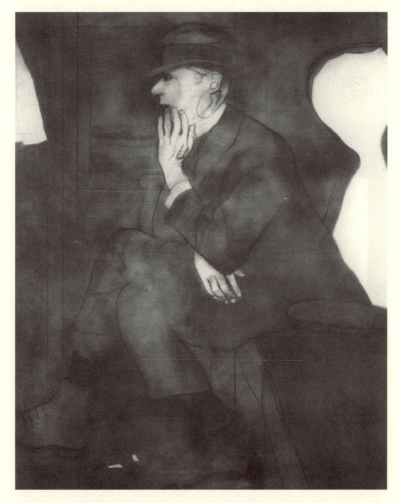

Figure 20. R. B. Kitaj, *The Jew*. 1976–79. © R. B. Kitaj. Courtesy of the Marlborough Gallery, New York.

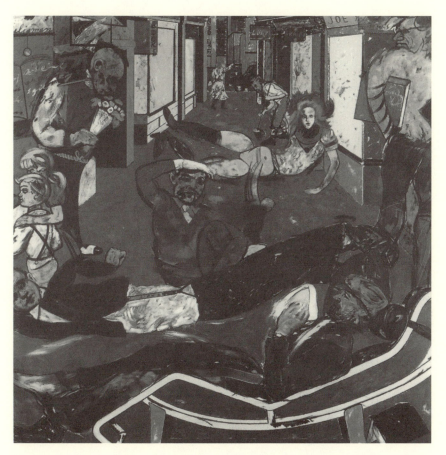

Figure 21. R. B. Kitaj, *Cecil Court, London WC2 (The Refugees).* 1983–84.
© R. B. Kitaj. Courtesy of the Marlborough Gallery, New York.

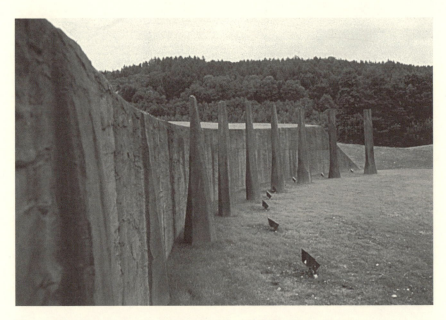

Figure 22. Beverly Pepper, *Palingenesis.* 1992–94. Site-specific cast iron sculpture. © Beverly Pepper. Courtesy of the Marlborough Gallery, New York.

Figure 23. Beverly Pepper, *Palingenesis* (detail). 1992–94.
© Beverly Pepper. Courtesy of the Marlborough Gallery, New
York.

5

John Singer Sargent: Accidental Heir to the American Expatriate Tradition

Kathleen L. Butler

John Singer Sargent (1856–1925) is consistently linked to his American near-contemporaries Mary Cassatt (1844–1926) and James McNeill Whistler (1834–1903) because like them, he spent much of his professional career in Europe. The implication has been that he, like them, consciously withdrew from mid-and late-nineteenth-century America in favor of Europe. The choices that each made, however, resulted from their individual experiences and expectations. While Cassatt and Whistler were both born and received much or all of their early education in the United States, Sargent was born in Italy and raised on the European continent, wintering and summering in various healthful places with his strong-willed, but apparently weak-constitutioned family. Cassatt and Whistler both received their artistic education in the United States prior to their European experience, while Sargent's artistic education, with the important exception of instruction from his mother, was exclusively European.

Sargent's first visit to the United States did not occur until 1876 when he traveled to Philadelphia with his mother Mary (1826–1906) and his sister Emily (1857–1936), in order to claim his American citizenship, attend the Centennial Exposition, and meet his extended family. Knowing this, one might ask what form Sargent's expatriatism takes, and, if he can even be considered an expatriate in the sense of one who is exiled from his or her native land, or who purposely withdraws for short or extended periods of time.

While Sargent was not born in the United States, and he was not sent to American schools abroad where he might have been raised with other American children or taught by American teachers he did however, consider himself an American, and in later life, went out of his way to identify himself as an American. Given that he was born in Europe, and never lived in or even traveled to the United States before adulthood, one might ask how Sargent acquired his sense of himself as an American. How could he hope to define himself as an

American if he apparently had no frame of reference for what America was, physically or intellectually? Finally, if Sargent's experience with America did not begin until he was 20 years old, by which time he had already chosen and embarked upon his profession, what was the source of his perception of himself as an American artist, and can he be considered an expatriate in the tradition of Cassatt, Whistler, and his supporter Henry James (1843–1916)?

For Cassatt, Whistler, and James, an expatriate life was the one that each chose as an adult while for Sargent, at least as a child and young adult, it was the life that was chosen by his parents. Perhaps we might better comprehend Sargent's place within the tradition of American expatriate artists if we begin with his parents Mary and FitzWilliam Sargent and their motivation for leaving the United States and for never permanently returning.

Sargent, and his sisters Emily and Violet (1870–1955), inherited their parents' expatriate status and their mother's insatiable wanderlust. The family's patriarch, Dr. FitzWilliam Sargent (1820–1889), was not an expatriate by choice, but, powerless to exercise his will over his family, acquiesced to his wife's desire to remain abroad rather than live the stifling life of a wife and mother in mid- and late-nineteenth century Philadelphia. Unable to find his way home, FitzWilliam Sargent created a community of Americans around him through his children in whom he instilled their sense of themselves as Americans.

FitzWilliam and Mary Sargent left for Europe in 1854 with Mary's mother after the death of the couple's first child. The purpose of their travel was to take Mary to a restorative European climate where she could regain her health, and then return to Philadelphia. Much to FitzWilliam's disappointment, the Sargent family never returned to the United States to live. Births, careers, marriages, and ultimately deaths all took place in European lands. Mary Sargent was the dominant partner in the relationship, both temperamentally and financially, and it was she who chose to locate her family in Europe. It was very likely the anticipation of living a life of traditional female domesticity, in which, as one nineteenth-century observer asserted, a "woman's intellect is confined, her morals crushed, her health ruined, her weaknesses encouraged and her strength punished," that motivated Mary Sargent to leave the United States, and to consistently delay her family's return to Philadelphia.[1] Women of Mary Sargent's generation were rarely offered the opportunity to be educated outside of their homes. They were expected to become wives and mothers, and to limit their ambitions to their husbands, children, homes, and perhaps a quiet accomplishment. Mary Sargent was not willing to accept this fate.

Touring Europe was one avenue of escape as it could be interpreted as having practical ends. In Mary Sargent's case, travel, particularly in pursuit of health and for the purpose of mourning, served as a socially acceptable means of breaking loose from the rigid expectations of nineteenth-century domestic life. She was not alone in her flight to Europe. Examples of such escapees abound during this period, Washington Irving (1783–1859) being one of the most notable. Mary Sargent was a model for her children in many ways, not the least

of which was her desire to create a life for herself in which she was able to at once meet and avoid traditional expectations. She managed this dichotomy by locating herself in places where there were others like her, namely, the spas of Europe, where her habits were perfectly normal. Her example was crucial to forming her children's decisions as adults to remain in Europe rather than permanently taking up residence in the United States.[2]

Though it was Mary Sargent who was at the root for their decision to remain in Europe, her husband was the primary source for their children's comprehension of America and their understanding of themselves as Americans. The English author Vernon Lee (née Violet Paget, 1857–1935), a life-long acquaintance of John and his sisters, begins her 1925 essay, "J.S.S. *In Memoriam*," by discussing "the matter of John Sargent's heredity, and the respective parts played by his parents."[3] What Lee believed Sargent inherited from his father was "the deep-seated character, the austere, self-denying strength that smelted and tempered talent into genius."[4] She viewed "the puritan heredity of John Sargent's New England father" as the source of his nationality, the nationality that Sargent's father held dear and sustained through his children.[5]

Throughout his life abroad, FitzWilliam Sargent maintained strong ties to his family in Philadelphia and to the events taking place in the United States, particularly during the Civil War. He received American periodicals and newspapers while abroad, and closely followed and reflected upon American politics. A staunch supporter of President Lincoln and the Union, FitzWilliam wrote a tract in 1864 explaining the issues at the center of the American conflict that was published in London for British audiences. In 1864 he wrote to his mother about the war that: "to me, although I am so far away from it, it is a very engrossing subject and I watch the mails as they come, with great anxiety. Besides I have frequent bloodless contests with our English cousins about the causes and probable results of the contest, so that my patriotism is kept bright."[6]

Again to his mother, he wrote in November 1864 that he and his family had kept Thanksgiving Day as President Grant had suggested.[7] In 1865, Thanksgiving Day was spent aboard the American ship, the *Colorado,* with other Americans abroad.[8] It is no coincidence that FitzWilliam would have observed Thanksgiving Day, a uniquely American holiday, with his family, or that he would have written home to acknowledge the significance of the day.

FitzWilliam's observations were not limited to politics—he also paid attention to the work of American artists, particularly after his son began to exhibit a prodigious talent, and in an 1867 letter to his mother commented on several works exhibited in the Paris Exposition that while in

all the elegant arts we are of course behind the older European nations I must say, that some of the pictures which have been sent from the United States, are equal to any in the exhibition—such as Bierstadt's "Rocky Mountains," Church's "Clearing Up after a Storm in the Tropics," etc. The English and French have, of course, sent the most numerous and most remarkable contributions.[9]

Five months later, again to his mother, FitzWilliam wrote that John is "old enough to enjoy the beauties of nature and art, which are so lavishly displayed in these old lands."[10] FitzWilliam neglected neither the productions of Americans nor the offerings of Europe in terms of how each might enhance his son's education. Talented American artists were to be noted, particularly since his only son had the ambition to enter their ranks, but Europe offered the opportunities his son needed to study works of art and nature in person. Moreover, his son's educational needs served Mary and FitzWilliam with an additional justification for putting off their return to Philadelphia.

FitzWilliam Sargent, though unable to exercise his will, was clearly unwilling to allow himself or his family to be completely cut off from events at home. The importance of FitzWilliam's home and nationality is evident in 30 years of correspondence with his family in the United States. One may infer from the tone and content of his letters that he shared his devotion to the United States with his children. Writing to his sister-in-law, Mrs. Thomas Sargent, from Brittany in August of approximately 1868, FitzWilliam Sargent indicated that he fervently hoped his children would visit the United States: "Such a trip costs a great deal of money, and unfortunately we must live after the trip shall be over; but they [the children] are all very anxious to go 'home,' as they say, although the only home the children have ever known has been on this side of the ocean."[11] The dearly hoped-for journey did not occur in 1868, and writing to his sister in the United States from Brittany eight years later, FitzWilliam Sargent repeated his longing for his children to know their country:

I hope that the American visit will not fail to be accomplished, for, apart from Mary's desire to see her friends and family, we are desirous that the children should have a glimpse of their native land, so called. Although they will not see much of it after all; but, they ought, by this time, to be able to say and to feel that, being Americans, they have seen America.[12]

It was in 1876 that John and Emily traveled for the first time to the country that, since their birth, had been described to them by their parents, represented by letters emblematic of "home," and personified by other Americans inhabiting Anglo-American communities abroad. It is not surprising that FitzWilliam was so anxious for his children to see the United States and equally to *feel* that they had a place in their country, a sense he was himself unable to develop for Europe.

By celebrating Thanksgiving Day, or taking them to see American paintings, he proclaimed to his children that they belonged to their country, that the United States was their "home" or "native land," and gave them a firm belief in their nationality, even if they had never set foot in the United States. "Setting foot" on American soil became doubly important in 1876 when John turned 20, because he had reached the age at which it was necessary for him to go to the United States to claim his American citizenship, or lose his right to patrimony. The trip that had been put off repeatedly over the preceding 20 years finally occurred as FitzWilliam hoped, in 1876, the year of the nation's centennial.

Sargent's sense of himself as an American was absorbed from his father and others, and from them he acquired expectations of America as a place and of American character, even if what "America" was exactly was not familiar to him from first-hand experience. What is most critical to Sargent's own expatriatism is what did come from first-hand experience, namely, his parents' perception of themselves as expatriates and, in particular, his mother's desire to escape from confining social mores and his father's sense of exile from his home. Sargent, then, was a second-generation expatriate for whom living outside of the country of his birth was *the* natural state of being.

As has often been pointed out, an individual who chooses to live outside of his or her native country often maintains citizenship in it and remains or even becomes patriotic. Unlike Henry James who gave up his American citizenship for political reasons, and Whistler who did not return to the United States after he left in 1855, Sargent established ties to the United States, and returned to work and live there for short or extended periods of time.

Perhaps what these three share is the separation from a homeland that, in spite of their citizenship in it, could not provide them with a community or an absolute sense of belonging in the larger society. A sense of belonging is an undeniably attractive feature, and European cities such as Paris, Rome, and Düsseldorf offered the potential to be part of a close community that was desired by many American artists. Neil Harris notes in *The Artist in American Society* (1982) that artistic communities sought by American artists did not exist in early nineteenth-century America. He writes that: "Few artists felt the interdependence which isolation in the artist districts of great European cities, or in the ateliers of successful artists, might have produced. There was little to differentiate the artist from other men; no particular dress or habit, or neighborhood, or institutions, or status attached itself to him."[13]

No means existed to bring artists together, or to single them out as a group with special abilities within American society. American artists who left the United States for the studios and academies of Europe sought such identification. They sought the "native land" that FitzWilliam Sargent lost.

Like her contemporaries James, Cassatt, Whistler, and Sargent, the American writer and expatriate Edith Wharton (1862–1937) went in search of a place in which she felt she belonged. Physically, she found Italy and France. Intellectually, she found the profession that sustained her with the sense of belonging that eluded her in the United States. In her 1933 autobiography, *A Backward Glance,* Edith Wharton writes of her desire to belong when she relates her decision to become a "professional" author: "I felt like some homeless waif who, after trying for years to take out naturalization papers, and being rejected by every country, has finally acquired a nationality. The Land of Letters was henceforth to be my country, and I gloried in my new citizenship."[14] Having discovered her vocation, Wharton went in search of her "spiritual kin." She and her fellow expatriates found others like themselves in the Anglo-American artist communities of European cities. These communities, formed around academies, museums, and individuals, offered a source of

professional and personal identity as well as the means of becoming a part of the place in which the community itself existed. Belonging to a community enabled one to become an insider. The sense of being an outsider in one's own land, which resulted from a general lack of understanding of one's personal and professional goals, was partially resolved in countries where both art and its creators were held in high esteem.[15]

Until early adulthood Sargent's national and even artistic "community" was centered on his family. Upon embarking on his professional training he made the transition from his family to the Paris atelier of the fashionable French portrait painter Émile Auguste Carolus-Duran. It seemed, based upon his early success in the Paris Salon, that he would establish himself in the Parisian-American artistic community. As an American in Paris, however, Sargent's sense of belonging was short lived with "exile" coming not from home but from abroad.

It is well known that for much of Sargent's career he painted portraits commissioned by wealthy individuals in New York, Boston, and London, but not from Paris. One of Sargent's most famous, and seminal portraits, *Madame X (Madame Pierre Gautreau)* (1884, Metropolitan Museum of Art), was one whose sitter *he* sought out, and convinced to pose for him. It was a portrait that he and his sitter presumably hoped would result in the triumphant celebration of skill and beauty, thus strengthening their individual claims to positions in Parisian society. The portrait, however, was reviled. It dramatically and very publicly revealed that though the two Americans were countenanced by French society and even welcomed in some quarters, they did not belong.

Virginie Gautreau was an American-born woman of renowned beauty and charm. It was her stunning appearance that gained her entrée into Parisian society, and rendered her company so highly desirable to gentlemen in Parisian social circles. Her beauty, however, was artificially enhanced. She used lavender-colored body powder that gave her skin an unusual glow; she rouged the tips of her ears, and often wore a small, crescent moon in her henna-dyed hair. She did not attempt to conceal these enhancements but highlighted them further by wearing simple, elegant jewelry that would not distract from her own artful creation.

Sargent represented Virginie Gautreau as she often presented herself publicly, in full makeup and formal dress. He painted her in a full-length, frontal position with her head turned in profile. The strained effect is striking, but served to heighten the artificiality of his subject's beauty. She appears to be on view, rather than portrayed. In the original portrait she was depicted with the strap of her dress pushed off her right shoulder, and this detail, combined with the others, led critics, both privately and in the press, to accuse both the artist and the sitter of bad taste. It has been argued that it was not merely the arrogance of the portrait that caused offense to French viewers, but that, as skillful Americans, the artist and sitter symbolized the decline of French dominance on a global scale.[16] Following the bitter reaction to the portrait, Sargent left Paris and took up residence in London at the suggestion and with the social support of his compatriot Henry James.[17]

One might have thought that the upset in Parisian society over Sargent's portrait of Virginie Gautreau would have caused the somewhat staid Bostonians to withhold patronage from Sargent as a potential chronicler of Boston society; however, this was not the case. Sargent's patrons enjoyed his cosmopolitanism and saw their support of him as a reflection of their own worldliness. His patrons were, after all, among those whose political and economic skills so worried the French. In the late 1880s Sargent's portrait commissions from New Yorkers and Bostonians increased, and the tinge of scandal appeared to be a source of pride to his subjects. Here was an American artist from a distinguished New England family whose portraits had the power to provoke modern Parisians. The combination of Sargent's American pedigree and international reputation appealed to his American patrons, and important Boston collectors such as Isabella Stewart Gardner seemed to find his ability to provoke particularly alluring. When she commissioned Sargent to paint her portrait in 1888, it was to be in a manner that echoed his earlier image of Madame Gautreau.[18] Gardner's own portrait apparently provoked sufficient comment upon its first showing, such that her husband had it withdrawn from exhibition, and it was not displayed again publicly during her lifetime.[19]

Sargent's portrait of Isabella Stewart Gardner marks an important moment in his career, and one that might not have occurred had he and Virginie Gautreau not been Americans in Paris who clearly demonstrated that they intended to stay. In 1884 Sargent sought out Virginie Gautreau as the subject for his submission to the Paris Salon. She agreed to his request, and the result was a work that is one of the masterpieces of American painting. It is also a portrait that could not fail to trouble its Parisian audience. An American, an outsider to French culture, had captured brilliantly on canvas an all too real image of what some interpreted as the decline of Parisian society in the late nineteenth century. Gardner's portrait, in contrast, depicts a powerful woman, one who would not settle for a conventional representation of herself, and who would willingly take on Boston society if necessary to champion the painter who deeply disturbed the Paris art establishment.[20] While *Madame X* resulted in Sargent's loss of French patronage, and an initial wariness on the part of the English, the portrait induced his American patrons to recognize him as both a compatriot and an artist with the capacity to elevate American art to international prominence. In Boston in 1888, it was Isabella Stewart Gardner who sought out Sargent, and it was she who would become one of Sargent's major supporters.

During his lifetime, Sargent's portraits of individuals such as Virginie Gautreau and Isabella Stewart Gardner generally brought him his greatest celebrity. It may be through his watercolors, however, works that tend to be more intimate, that the form of his expatriatism can be most fruitfully explored.

While Vernon Lee wrote that Sargent inherited his national identity from his father, she asserted that although John's sisters believed he also inherited his talent from their father's side (the American painter Henry Sargent was after all their paternal ancestor), she believed that his artistic skill was as much due to his mother's influence. Lee describes seeing "Mrs. Sargent painting, painting,

painting away, always with an open paint-box in front of her to me the painting gift of John Sargent is all from his mother."[21] Whether his "gift" came all or only in part from her, Sargent's mother was his first teacher, and when he was a child she had already established the basis for the artistic routine he would follow as an adult. Mary Sargent taught John and his sister Emily as children to draw and to paint in watercolor. John used the medium continuously throughout his life, and as a result hundreds of paintings of sites in Italy, Switzerland, the Near East, Spain, Florida, and World War I France, exist in public collections. From their various perspectives, Sargent's watercolors invite his viewers to see into a place as he does, and suggest a personal vision that is not as freely described in his commissioned portraits.

Sargent's watercolors offer us distinct observations of his life abroad. His images of the Simplon Pass in the Swiss Alps such as *Simplon Pass: The Tease* (1911) focus primarily upon family members in a pastoral landscape (Figure 9). Those of Venetian domestic architecture such as *Doorway of a Venetian Palace* (Westmoreland Museum of Art, Greensburg Pennsylvania, c. 1906–1910) position the artist and viewer outside the vacant entrance to a dwelling. Near-Eastern watercolors such as *Bedouin Camp* (c. 1905–1906) place the artist and viewer in yet a third position, that of an outsider, in relationship to a tightly knit group of individuals (Figure 10).

The artist's position as either alien or intimate changes with his relationship to each subject. Sargent's Simplon Pass images such as *Simplon Pass: The Tease, Simplon Pass: The Green Parasol* (1911, Museum of Fine Arts, Boston) and *Simplon Pass: The Lesson* (1911, Museum of Fine Arts, Boston) form a set of intimate family views. *Simplon Pass: The Tease,* for example, pictures his niece Rose Marie Ormond and a family friend, Polly Barnard. The perspective is close, and the figures' casual pose fills the page. They are near the artist yet do not engage him, suggesting they are not self-conscious about being watched as is likely to be true of a family group traveling together. While the location is noted in the title, it would not be possible to identify the site based upon the details of the landscape. The title might give the viewer a sense of expectation of place; however, what is pictured here is "the tease," a brief moment within a group of intimates, a group to which the artist clearly belongs.

Sargent's paintings of his family members in the Swiss Alps are not unlike Mary Cassatt's images of her own family members in or near Paris, such as her 1880 oil painting of her sister entitled, *Lydia Crocheting in the Garden at Marly* (Metropolitan Museum of Art). Like Sargent, Cassatt's family members, alone or in intimate groups, were frequently her subjects. Her perspective in *Lydia Crocheting in the Garden at Marly* is close-up; the figure fills the foreground in an unselfconscious manner similar to the figures in Sargent's Simplon Pass watercolors. In each artist's image there is a sense of intimacy that comes from belonging in their subjects' company, if not in the place in which they are pictured.

Watercolors such as *Doorway of a Venetian Palace* locate the viewer in a very different position in reference to the site pictured than do his images of the

Simplon Pass. Sargent's perspective in images such as this is from the outside, probably the canal, looking toward the entrance of a Venetian palace and to the daily life to which the artist and viewer are not privy. There are no figures to either welcome or repel the viewer. Here the artist does not belong, but he has the potential. Admittance into the exclusive realm of the domestic interior implies a degree of belonging, and as a foreigner, the desire to be let in or to experience the living space of a native is ever present. One who is outside of the intimate space of another yearns to look behind the dwelling's facade, to see the private places to which one does not ordinarily have access, to which one does not belong.[22]

Sargent's paintings of Venetian entrances such as *Doorway of a Venetian Palace, Venetian Doorway* (n.d., Metropolitan Museum of Art), and *Grand Canal, Venice* (1907, National Gallery of Art, Washington, DC), concentrate on the threshold between the canal, or the public, and the doorway, or the private. They focus on the potential of being "inside." This potential is particularly appealing to one who desires entry into a foreign culture, whether it is a country or a community of artists. Sargent's focus on the doorway symbolizes possible entry into an interior, private space that would enable the foreigner to acquire the status of insider.[23]

As in his images of the Simplon Pass and Venice, Sargent paints from a close perspective in the majority of his watercolors of Near-Eastern subjects, but with a very different effect. In images such as *Bedouin Camp, Arab Gypsies in a Tent* (c. 1905–1906, The Brooklyn Museum of Art), and *Mending a Sail* (c. 1905–1906, The Brooklyn Museum of Art), the figures reside in the foreground. Some look out from the group toward the outside, and several even engage the viewer; however, their gaze does not welcome in the viewer. Given the group's lack of interest or invitation in *Bedouin Camp,* for example, the observer's proximity to the interior of the Bedouin domestic space and its occupants seem unusual. By foregrounding the figures, using the paper's edge to cut the figures, and filling the middle and background with the tent, the cultural distance between the viewer and the subject is heightened. Sargent's approach to his figures is effective in creating a claustrophobic closeness that pushes the viewer back, reminding him or her that, like the artist, he or she is not, and cannot be part of this group. There is no freedom of movement, and the viewer's nearness to the figures heightens his or her inability to participate as a member of the group. Unlike Sargent's watercolors of Italian domestic architecture, in which the potential to enter the interior is present, the observer of the Bedouin camp finds that even while practically inside the intimate space of the tent, he or she is locked into the position of outsider.[24]

In the guise of the traveler-artist, rather than of expatriate-artist, Sargent created watercolors that offer a glimpse into his view of himself in relation to the places he lived and worked. These are the images that define his place. In one instance, he is a member of the group he pictures; in the others he belongs neither to the group nor to the place he paints. His images represent degrees in the distance from the center to the edge of belonging.

Painting as the traveler-artist Sargent disarms his viewer because he does not merely paint a picture of a place. Instead he explores his position as an insider or outsider in relation to his subjects. The traveler is a role familiar to many, and by stepping into it, Sargent challenged his audience to recognize part of their own experience in his work. The result may be the necessity to acknowledge that they are not, and probably cannot be, "insiders" in the foreign culture experienced for brief, or prolonged periods. Or it may be that like Sargent, they are able to make the place their own by creating, as Sargent and his father did, a community to which they belonged regardless of its physical location.

Considering Sargent's biography alongside his paintings offers insight into the root and result of his experience as an American expatriate artist. Belonging in Sargent's case was not based upon the place, but the people in that place. Each group of Sargent's watercolors and some of his most important commissioned portraits resulted from his experience as an American artist abroad. They reveal the private and public components of his professional life, a life developed in Europe, but formed under the influence of his parents who defined his sense of himself as an American, and set the stage for his artistic production. As a second-generation expatriate, it was not the cause of his leaving, but the cause of his staying that defined Sargent's expatriatism.

ACKNOWLEDGMENTS

I would like to thank Margaretta M. Lovell for reading this essay and, as always, for her thoughtful insights. I would also like to thank Carol Salus for her gracious support, and the Kent State University Research Council whose generosity made possible the illustration of this essay.

NOTES

1. Harriet Martineau, *Society in America* (New York: Saunders and Otley, 1837), p. 226.
2. Kathleen L. Butler, *Tradition and Discovery: The Watercolors of John Singer Sargent* (Ann Arbor, MI: University Microfilms International, 1994), Chapters 1 and 2.
3. Vernon Lee, "J.S.S.: In Memoriam," pp. 235–255, in Evan Charteris, *John Sargent* (London: William Heinemann Ltd, 1927), p. 235.
4. Lee, p. 235.
5. Lee, p. 236.
6. FitzWilliam Sargent Papers, Archives of American Art/Smithsonian Institution, FitzWilliam Sargent to Mother, May 27, 1864, Roll D317.
7. FitzWilliam Sargent Papers, Archives of American Art/Smithsonian Institution, FitzWilliam Sargent to Mother, November 28, 1864, Roll D317, Archives of American Art.
8. FitzWilliam Sargent Papers, Archives of American Art/Smithsonian Institution, FitzWilliam Sargent to Father, January 1, 1866, Roll D317.

9. FitzWilliam Sargent Papers, Archives of American Art/Smithsonian Institution, FitzWilliam Sargent to Mother, June 12, 1867(?), Roll D317.

10. FitzWilliam Sargent Papers, Archives of American Art/Smithsonian Institution, FitzWilliam Sargent to Mother, October 20, 1867, Roll D317, Archives of American Art.

11. FitzWilliam Sargent Papers, Archives of American Art/Smithsonian Institution, FitzWilliam Sargent to Mrs. Thomas Sargent, August 31, 1868 (?), Roll D317.

12. FitzWilliam Sargent Papers, Archives of American Art/Smithsonian Institution, FitzWilliam Sargent to Sister, January 9, 1876, Roll D317.

13. Neil Harris, *The Artist in American Society: The Formative Years, 1790–1860* (Chicago: The University of Chicago Press, 1982), p. 65.

14. Edith Wharton, *A Backward Glance* (New York: Charles Scribner's Sons, 1933), p. 119.

15. Butler, Chapter 3.

16. See Albert Boime, "Sargent in Paris and London: A Portrait of the Artist as Dorian Gray," in Patricia Hills, ed., *John Singer Sargent* (New York: Harry N. Abrams, Publishers, 1986), p. 91.

17. The portrait of Virginie Gautreau remained in Sargent's studio until 1916 when it was purchased by the Metropolitan Museum of Art.

18. Isabella Stewart Gardner's attraction to Sargent's portrait of Virginie Gautreau was underscored in 1919 when she purchased a small oil entitled, *Madame Gautreau Drinking a Toast* (1884), for her collection.

19. Philip Hendy, *European and American Paintings in the Isabella Stewart Gardner Museum* (Boston: The Isabella Stewart Gardner Museum, 1974), p. 224. Sargent's portrait of Isabella Stewart Gardner is now on public view in the Isabella Stewart Gardner Museum in Boston.

20. Ibid. Isabella Stewart Gardner is said to have rejected Sargent's first eight attempts to complete her portrait. The ninth and final image she felt was one of Sargent's finest portraits, p. 224.

21. Lee, p. 235.

22. Dean MacCannell offers an in-depth analysis of the tourist as an outsider in his book *The Tourist: A New Theory of the Leisure Class* (New York: Schocken Books, 1976).

23. Sargent's watercolors of Venetian palaces represent only a small example of his images of Venice. For an in-depth discussion of Sargent's work in Venice, see Margaretta M. Lovell, *A Visitable Past: Views of Venice by American Artists, 1860–1915* (Chicago: The University of Chicago Press, 1989).

24. Butler, Chapter 4.

SELECTED BIBLIOGRAPHY

Butler, Kathleen L. *Tradition and Discovery: The Watercolors of John Singer Sargent.* Ann Arbor, MI: University Microfilms International, 1994.

Charteris, Evan. *John Sargent.* London: William Heinemann Ltd., 1927.

Harris, Neil. *The Artist in American Society: The Formative Years, 1790–1860.* Chicago: The University of Chicago Press, 1982.

Hendy, Philip. *European and American Paintings in the Isabella Stewart Gardner Museum.* Boston: The Isabella Stewart Gardner Museum, 1974.

Hills, Patricia ed. *John Singer Sargent.* New York: Harry N. Abrams, Publishers, 1986.

Lovell, Margaretta M. *A Visitable Past: Views of Venice by American Artists, 1860–1915*. Chicago: The University of Chicago Press, 1989.

MacCannell, Dean. *The Tourist: A New Theory of the Leisure Class*. New York: Schocken Books, 1976.

Martineau, Harriet. *Society in America*. New York: Saunders and Otley, 1837.

Wharton, Edith. *A Backward Glance*. New York: Charles Scribner's Sons, 1933.

6

"Heads of Thought and Reflection": Busts of African Warriors by Nancy Elizabeth Prophet and Augusta Savage, African American Sculptors in Paris, 1922–1934

Theresa Leininger-Miller

Augusta Savage (1892–1962) and Nancy Elizabeth Prophet (1890–1960) are two of the three women and the only sculptors out of 10 known African American artists who worked in Paris between 1922 and 1934. They expanded the tradition of working in the City of Light that was begun by the first documented African American women sculptors, Mary Edmonia Lewis (who expatriated to Rome in the 1860s) and Meta Vaux Warrick Fuller (who studied in Paris, 1899–1902). In Paris, their work evolved from conventional, academic studies of white women to dignified busts of Black men and nude figures of Black women, to personifications and abstract representations of spiritual and emotional states.[1] The most striking work Prophet and Savage produced abroad can be characterized by two groups—Black, female nudes and androgynous, racially ambiguous figures and heads.

In this chapter, I will focus on two of those sculptures, Prophet's *Congolais* (ca. 1931) and Savage's *The Amazon* (ca. 1930), both of which are romanticized busts of apparent African warriors. I shall briefly contextualize the pieces in terms of each artist's work abroad and the cultural climates in France and the United States. My argument is that these images with their allusions to gender boundaries and a proud, independent African history—and possible self-portraits—are among the most daring, unconventional, and complex works produced by African American artists in Paris between the wars. This kind of sculpture brought them international acclaim and won them significant teaching positions upon their return to the U.S.

Aside from expatriate painters Henry Ossawa Tanner (1859–1937) and Albert Alexander Smith (1896–1940), Prophet spent more time in Paris, from 1922 to 1934, than all other African American artists who were there after World War I until the effects of the Great Depression reached France. (Most of them spent one to three years in the late 1920s and early 1930s.) Like her predecessors

and colleagues, she went to France in search of greater sociopolitical and artistic freedom, serious attention to her work, and study and exhibition opportunities at prestigious academies and salons. After graduating from the Rhode Island School of Design in 1918, Prophet tried to earn a living by making portraits, but to no avail. Frustrated with the lack of artistic opportunities in Providence and an unsatisfying marriage, Prophet fled to Paris where she stayed in bed for the first two months from nervous exhaustion.

Without funding, Prophet struggled for years to find inexpensive room and board, yet she managed to maintain a rigorous work schedule. After a year's study at L'École Nationale des Beaux Arts, one of her wooden busts was exhibited at the Salon d'Automne in 1924.[2] The same year, Prophet supported herself by making and selling batik items, none of which has survived.[3] Although she received two thousand francs for sculpting materials from a sympathetic patron, Prophet continued to have serious monetary difficulties. Close to starvation, she was finally admitted to the American Hospital in Paris in the summer of 1925. Upon noting her emaciated condition, administrators there accused Prophet of drug abuse and cautioned her not to exert herself for a year lest a relapse occur. Within three weeks, however, she was back at work.

The titles of the first works Prophet made abroad express her physical and emotional discomfort, financially poor and alone in a foreign land; she maintained that every one of her works embodied "an experience, something I have lived—or its result."[4] *Bitter Laughter* (a white, abstract marble also known as *The Laughing Man*) and *La volonté* (translated "will" or "wish"), both ca. 1925–1926, no longer exist; the artist smashed the latter work, her first lifesize piece, in 1926 because of her perceived lack of progress. *Discontent* (before 1930), a shrouded head with furrowed brow in painted pear wood (first prize winner at the 21st Newport Art Association Annual Exhibition in 1932), and *Prayer* (1926), a lifesize plaster figure in supplication, reflect Prophet's continuing battle against destitution. That bitter struggle is also evident in her 1928 application to the Harmon Foundation, which lists her high school as "the college of serious thought and bitter experience, situated on the campus of Poverty and Ambition."[5]

Other works, such as the painted wooden bas-relief *Peace* and the lifesize plaster *Le pélerin* or *The Pilgrim,* both ca. 1925–1929 (known only by photographs in the James P. Adams Library at Rhode Island College; hereafter RIC), reflect her search for inward calm, as do the marble heads *Poise* (ca. 1926–1929) and *Silence* (before 1930). Prophet sculpted the latter woman's head (perhaps her own) after months of solitary living in her cramped Montparnasse studio. One of the verses that she wrote about the piece concludes, "Silence—the unifying quality of the body, mind and soul."[6] *Poise,* a man's head with a calm brow, tensed throat muscles, and squared chin, embodies the "inner intensity and outer calm"[7] that Prophet said necessarily compounded the quality of poise. She believed that "abstract qualities, some of which are poise and courage, are factors which no civilized man who aspires to be educated can live successfully without attaining."[8]

Black and white critics and patrons in both the U.S. and France received these sculptures well. Like her colleagues, Prophet sought recognition not only in France but also in her homeland, and frequently shipped works back to the United States for exhibition and sale. Two white women immediately purchased her work. Ellen D. Sharpe, of a prominent Rhode Island family, bought *Silence,* as well as an apparently untitled black man's head carved in wood. A friend of hers, Eleanor Burgess Green (founder of the Providence District Nursing Association and first lady of Rhode Island when her brother was governor), acquired *Head of a Negro* (ca. 1926–1927). This imposing piece, carved from a column of wood, portrays a Black man with a firm gaze, slightly flared nostrils, and a set mouth. Green wrote to Prophet that the work "has called forth high praise from my family and relations."[9] Both *Head* and *Silence* were exhibited at the Rhode Island School of Design in 1928. Upon viewing the work, Providence-based critic Nell Occomy declared Prophet to be "the only artist of the colored group who is doing note worthy [*sic*] [work] in Paris."[10] Renowned painter Henry O. Tanner concurred: "Of the many, many students over here either white or black I know of none with such promise as Mrs. Prophet."[11] W.E.B. Du Bois (1869–1963), founder of the NAACP and editor of *Crisis* magazine, called Prophet "our greatest Negro sculptor."[12] He kept a bronze version of *Silence* in his office and often commented on it in his correspondence to Prophet.[13] French art critic Jean Patézon declared *in Le rayonnement intellectuel,* "Elizabeth Prophet has a broad and grand vision, which is a guarantee of the quality of her work. Her vision follows her thought which is original and with no outward influences and this is what makes her work so strong and expressive."[14]

Like the work of Rodin's student Antoine Bourdelle (who died in 1929), many of Prophet's figures and busts of the mid- to late 1920s have an androgynous quality with their slender build, small breasts, and narrow hips. (The locations of these untitled works are unknown, but photographs of them are located at RIC.) Their close-cropped or covered hair, heavy-lidded eyes, medium-sized noses, and enigmatic smiles also make them racially ambiguous and may reflect Prophet's ambivalence about her heritage.

Prophet was of Narragansett-Pequod Indian and African American descent. In the 1920s she seems to have embraced her African heritage (writing "I too have my race pride"), but later she fiercely denied it, stating unequivocally that "I am not a negro."[15] While most of Prophet's work was racially ambiguous, writers insisted it contained racial evidence. One French critic declared, "Elizabeth Prophet is a sculptor of race; one feels it in everything, in her work, in the firmness of her will, in her independence."[16] African American poet Countee Cullen asserted that "If her work lacks ostensible racial distinctions, by which I mean if there is nothing in it which can evoke a comparison with primitive African art, there is still something of the Negro in it, something unweaned from her Negro inheritance, especially to be found in her abstract pieces."[17]

Although Prophet insisted that her work was "distinctly unracial," it was her carved, wooden busts of Black men that won her the most fame. *Head of a*

Negro (or *Bust of Roland Hayes*), ca. 1926–1927, won the $250 Otto Kahn Prize from the Harmon Foundation in 1929 and was exhibited at the International House in New York the following year along with *Silence.* Prophet quickly realized the demand for "racially representative" art called for by Alain Locke, professor at Howard University, in his seminal anthology, *The New Negro* (1925),[18] and promoted by the Harmon Foundation, the first (and virtually only) institution that offered both monetary awards and traveling exhibition opportunities for African American artists.

In October 1929, one month after the arrival of Savage in Paris, Prophet traveled to the United States to collect her Harmon award and to promote her work. She had several exhibitions in New York and Rhode Island, but sold few works and sailed back to France in the summer of 1930 with just $500. Soon she produced *Head in Ebony* (ca. 1926–1929), a fairly banal piece. It, along with *Poise,* was exhibited by the Harmon Foundation in 1931. The following year, the Société des Artistes Français exhibited the work as *Buste ébène.* Still, Prophet was unable to sell the piece and complained about the lack of African American patronage to Du Bois, her most ardent supporter. He tactfully acknowledged her frustration and responded, "Do not blame me and do not blame the colored people of the United States. We are still curiously helpless. When eventually you triumph, as I am sure you will, it will not be altogether wrong to give people of colored blood here a part of the glory. They are a kindred-hearted and sympathetic folk but they are ignorant and inexperienced."[19]

While Prophet might not have admitted to being an American "Negro," she admired the glory of African culture. In the summer of 1931, she attended the Exposition Coloniale in Paris. This enormous exhibition was designed to garner public support for the colonial conquests of France. In an almost Disneyesque fashion, it imported art, artifacts, and people to decorate and perform in purportedly authentic architectural environments. Prophet wrote an enthusiastic letter to Du Bois about the African sculpture on view, describing "heads that are of such a mental development that are rarely seen among Europeans. Heads of thought and reflection, types of great beauty and dignity of carriage. I believe it is the first time that this type of African has been brought to the attention of the world of modern times. Am I right? People are seeing the aristocracy of Africa."[20]

Inspired by the display of African art and culture, Prophet soon produced *Congolais* (Figure 11), a cherry wood head of an African, possibly a Masai warrior. With its smooth, expansive brow, closed lips, and heavy eyelids, the work imparts a sense of majesty and dignity. Nevertheless, like Prophet's other work, such as the remarkable plaster nude bust, *Head of a Negro* (ca. 1925–1929), *Congolais* depicts a type rather than a portrait of an individual. Masai men, from Kenya and Tanzania in East Africa, were known as cattle herders, lion hunters, and fierce warriors with distinctive coiffures that often included a single plait of beaded hair on the forehead. This apparent Masai, however, is depicted bodiless and weaponless, with eyes half-closed, head slightly bowed, without elaborate war makeup and earrings, appearing to a white audience as a

nonthreatening, rather romantic symbol of exoticism. For Prophet, however, the significance was probably deeper. She may have been familiar with Joseph Thomson's popular account of his exploration through East Africa called *Through Masai Land* (1885), available commercially and in libraries. Thomson extolled the Masai for their bravery, their disdain for menial labor, and their tall, slender bodies, and thin lips, which the British saw as hallmarks of aristocracy. But why would Prophet choose to name as Congolese—in other words, from the west of the continent—her depiction of an East African? It is unlikely that the Masai were represented in the French colonial exposition since Kenya and Tanzania were British mandates. Prophet may simply have grafted the term onto the image out of ignorance. In truth, between the lack of decent publications on Africa and the vogue for the mere surface qualities of West African art at the time, she probably knew little about Africa, like most people in the early twentieth century. Writer Countee Cullen eloquently addressed the dilemma in his poem "Heritage," in which he ponders the gulf of three centuries between his life and that of his ancestors, asking at the end of each stanza, "What is Africa to me?"[21]

Congolais, as Judith Wilson has succinctly written, is an iconographic pastiche in several ways: "Its title refers to Central Africa—today's People's Republic of the Congo and the Democratic Republic of Congo—while its one culturally specific visual element—a Masai warrior's plaited forelock—points to East Africa."[22] Prophet's treatment of the wood reflects the influence of Rodin. Carving from a single piece of cherry wood, she created a rough-hewn surface at the cubic base of the neck to imply "the form's emergence from the wood block and to reveal the artist's 'touch.'"[23] Further, although the slit-like eyes are somewhat abstract and lifeless, the facial features of *Congolais* resemble Prophet's own, her high cheekbones accentuated by her usual coiffure of a tight bun. Since the artist could not often afford models, it is likely that she sculpted the piece in front of a mirror, or from memory or imagination.[24] The conflation of fragments from various sources, both real and imaginary, recalls turn-of-the-century Symbolist aesthetics and the style's moderate abstraction.

It is exactly this hodgepodge of disparate elements—and the psychological intensity of the contemplative head—that likely appealed to both French and American viewers. Director of the Academy of France in Rome and sculptor Paul Landowski (1875–1961) was particularly impressed with *Congolais,* as were editor Edouard Champion (1882–1938), author of a multivolume anthology of French comedy, and government architect Francis Jacques (b. 1887). Champion and his wife supported Prophet by paying her room and board occasionally, and he, Landowski, and Jacques all wrote letters of recommendation for her to the Guggenheim Foundation. Jacques declared that the "serious, profound subject" of *Congolais* appeals "to the imagination of the spectator."[25]

Similarly, sculptor Gertrude Vanderbilt Payne Whitney (1875–1942)—as well as some of the highest society members in New England, including Mrs. William Vanderbilt, Mrs. William Randolph Hearst, Mrs. Vincent Astor, the

countess Cocini, and the Sterners—was attracted to the piece when it was ex-
hibited at the 21st Art Association of Newport Annual Exhibition in the sum-
mer of 1932. She privately viewed *Congolais* three times, then purchased it for
the Whitney Museum of American Art. Whitney then loaned the bust to the
Robert C. Vose Galleries in Boston that fall. Upon reviewing the show, a critic
for the *Boston Evening Transcript* suggested that *Congolais* is a self-portrait.[26]
Perhaps Prophet longed for the control and bravery of Masai warriors, or the
esteem in which the British held them. While the distinctive coiffure marks the
bust as male—Masai women never wore their hair this way—the visage is an-
drogynous and the work is sometimes called *Congolaise,* making it unclear
what Prophet really named the piece. Prophet may have been interested in the
concept of androgyny for several years by then—as evident in the early figures
and busts described before—or at least in the creation of her own identity and
the control of her destiny. In the Salon d'Automne catalogue of 1927 she listed
herself by (or was mistakenly listed as ?) a man's name, Eli.[27]

Prophet's last year abroad was full of privation and disappointment. In No-
vember 1933, the police hounded her for avoiding payment of import taxes and
threatened to seize her belongings. She relied on the generosity of her
concierge and Champion's wife for credit on heating and food. In 1934 she re-
activated her 1930 application to the Guggenheim Foundation, but without
success. Finally, through the intervention of Du Bois, John Hope (president of
Atlanta University) invited Prophet to teach at Spelman College. She remained
on the faculty there for 10 years, her initial salary of two thousand dollars paid
by the Carnegie Corporation.

Augusta Savage also produced original and intriguing images of apparent
Africans while abroad. A 1924 graduate of Cooper Union, Savage first gained
recognition for her portrait busts of African American male leaders, such as
Frederick Douglass, Marcus Garvey, and Du Bois, in the early 1920s. She took
Locke's call for racially representative art to heart and, in 1927, she symbol-
ized the birth of *The New Negro* (location unknown) as a young man with
folded arms, kneeling in fetal position. She also produced genre scenes of
Black boys such as the figure in *Green Apples* (1926), of a youth jackknifed in
pain after having eaten unripe fruit, and the bust of *Gamin* (1929), a street
urchin. The latter work, exhibited at the Harmon Foundation in 1930, won the
acclaim that helped Savage get Rosenwald and Carnegie Fellowships for study
in Paris.

The sculptor had been thwarted twice in her attempts to study abroad. First,
in 1923, an American committee of seven white men would not allow her to
accept a scholarship from the French government to study at the Palace of
Fontainebleau because two white Alabama women refused to travel and room
with a "colored girl."[28] Then, in 1925, the countess Irene Di Robilant of the
Italian American Society gave Savage a scholarship to pay for materials and
tuition at the Royal Academy of Fine Arts in Rome, Italy. The artist, however,
was unable to raise the travel and living expenses because the wages she earned

at a laundry helped support her parents who had emigrated from Florida to live with her after a hurricane destroyed their home and killed her brother.[29]

Savage's grant money, supplemented twice, allowed her to stay abroad just two years. Du Bois encouraged her to learned from Prophet's thriftiness.[30] When Savage arrived in Paris in fall 1929, Prophet set Savage up in her former atelier, then left France for an 11-month sojourn in the U.S. Savage studied privately for a couple of months with a professor at l'Académie de la Grande Chaumière. Her first artistic efforts in France seem to have been realistic figurative works in clay and plaster, such as *Bathing (or Laughing) Boy* (ca. 1929) and *Bust of a Woman* (ca. 1929; locations of both works unknown). She soon tired of such academic exercises, however, and was eager to develop her own style.[31]

Unlike Prophet, Savage was no destitute, melancholic loner abroad. She frequently had dinner and played cards with painters Hale Woodruff (1900–1980), Palmer Hayden (1890–1973), and Aaron Douglas (1899–1979), and writer Countee Cullen (1903–1946), and she produced a witty pair of bronze bookends of men at French urinals for Cullen (ca. 1930–1931). Delighted with the freedom she found in Paris, Savage also expressed her exuberance in a small figurine, *La Citadelle—Freedom* (ca. 1930). Here, she has personified the City of Light, her fortress, as a racially ambiguous dancing young woman with stylish bobbed hair standing on tiptoe with her arms outstretched. With its fluid movement and loose gown, the figure evokes the energy, grace, and typical costume of American dancer Isadora Duncan (1878–1927). Its arclike silhouette, however, suggests a ship's masthead or even, given its small size (14½ in. h.), an automobile-hood ornament. The work's title, as well as the figure's gesture and tunic, also evokes Delacroix's painting *Liberty Leading the People* (1830). Rather than a call to arms, though, Savage's dancing statue may express an exuberant welcome to France.

Savage produced another sculpture of a dancing woman that is now known only by its title, *Danseur nu* (ca. 1930). Along with a bronze nude, *Nu*, it may have been among the first sculptures of nude Black female bodies by an African American artist. The celebration of Josephine Baker's body in Paris since her first appearance there in 1925 with La Revue Nègre must have contributed to Savage's desire to depict beautiful, strong Black women. But it was also the presence of Black models willing to pose nude in Paris that allowed Savage to depict them with confidence. Savage informed one French writer that in New York, "people of color and in particular black models, refused to pose for her."[32]

In fact, Savage's primary model for these nudes may have been Martinican. Savage exhibited two works called *Martiniquaise,* or *Woman of Martinique* (ca. 1930), in Paris, one in black marble at the Salon d'Automne and another, in plaster, at the Société des Artistes Français in 1931. While both are now missing, her portrait study of a Martinican boy's head in black Belgian marble (ca. 1930, location unknown; see photograph in Bearden and Henderson) may give us an indication of what the works looked like.

The most striking works Savage produced abroad, three clay pieces, all ca. 1930 (which I call the Amazon series), are based on a female model who seems to be of African descent, as seen in *Tête de jeune fille*. This is a bust of a young woman, head turned to side, with short, curly hair, a flat, broad nose, and full lips. This woman also appears as *Amazon* (Figure 12), a bust of a topless female warrior holding a spear, and in *Mourning Victory*, as a weaponless, standing nude who gazes at a severed head on the ground. Like Prophet's *Congolais*, Savage's *Amazon* is an enigma—a depiction of an African (although it is possible that the bust portrays a woman from elsewhere in the African diaspora) with a title that doesn't quite jibe. This *Amazon* seems to be a fully endowed female African woman, but Amazons were typically thought of as mythological Greek women who cut off one of their own breasts in order to more readily throw javelins. Perhaps Savage knew about Archibald Dalzel's book *The History of Dahomey, an Inland Kingdom of Africa* (1793), in which the explorer described the Dahomean king's female warriors, and was the first to call them Amazons.[33] The volume contains illustrations of the troop. One, titled "Armed Women, with the King at their head, going to War," depicts the guards nude save for loose loincloths.[34] The defenders were, in fact, the only thoroughly documented Amazons in world history. European visitors first referred to the women soldiers as Amazons in the 1840s.[35] The defenders of royalty and the palace had existed since at least the eighteenth century.[36] The West African kingdom was once called a "small black Sparta" because residents of Dahomey also cultivated an intense militarism and sense of collectivism.[37] Moreover, both Spartan and Dahomean women prided themselves on bodies toughened from childhood by rigorous physical exercise. Yet Spartan females were raised to breed male warriors whereas these African Amazons were trained to kill them. Originally elite bodyguards to the king, the Dahomeans developed into a force six thousand strong and were granted semi-sacred status.[38] They fought valiantly until the kingdom's final defeat by France in 1892.

Unlike the fantasized Amazons of antiquity, the Amazons of Dahomey never rode horses or any other animal, rarely used shields, and did not cut off their breasts. They vowed celibacy, and thus did not produce children. Like their ancient forerunners, they lived by themselves, but in royal palaces, within larger settlements. Further, they fought in an army with a male majority and were ultimately ruled by men.[39] The Amazons were recognized for their fierce, intrepid battle skills.

Savage's *Amazon* is a half-nude figure, truncated at the waist. Her expression is similar to that of *Tête de jeune fille,* and her head is turned to the left, but with chin slightly uplifted. The warrior appears to be listening while standing at attention. Her breasts are full and round, but have no indication of nipples. Her left arm hangs at rest, yet she seems to have strong biceps. The soldier grasps a roughly modeled spear or pointed stick in her right hand. Dahomean Amazons mainly fought with muskets, clubs, and machetes, but did occasionally carry spears, lances, or assegais, which were light wooden javelins tipped with iron.[40] Savage's spear-wielding warrior is a far cry from typical French allegories of

Africa, such as Carpeaux's *Les quatre parties du monde soutenant la sphère* (1872) in the Luxembourg Gardens. In that work, the personified continent—whose features are not caricatured as are those of Blacks found in most European sculpture—is distinguished from her European, Chinese, and American Indian sisters by a broken chain on one ankle, a reminder of slavery as well as a signal of liberation. Savage's Amazon never would have been a slave. Savage herself might have identified with the subject personally as an independent woman who was characterized by strength, boldness, perseverance, and nonreliance on men.

Contemporary scholars view the Greek myth of Amazons as an elaborate cautionary tale. In their patriarchal society, Greek men ruled, fought, hunted, farmed, and controlled marriage and reproduction. They saw their roles as natural, orderly, and civilized. Women were expected to obey, marry, keep house, rear children, and be modest and tame. Amazon society turned the status quo upside down, and appeared unnatural, disorderly, uncivilized, barbaric—and therefore doomed. It was a warning of what could happen if gender roles and values were reversed and women took charge.[41]

One wonders what other aspects of West African Amazons Savage found intriguing. Clearly she, too, was challenging gender roles in a number of ways. She left home at an early age to pursue a career of which her father disapproved,[42] attended college, allowed others to care for her daughter while she traveled abroad alone as a widow, and enjoyed the company of male friends. Further, she worked in sculpture, a field largely dominated by men. Yet the artist was not as stoic as the Amazons.

Mourning Victory may express Savage's discomfort with violence and anguish over death and separation. By the time she came to Paris, she had lost three husbands, several siblings, an infant daughter, and her father, and she left behind her first child. But the depiction of a nude woman standing in *contrapposto* staring down at a severed adult male head gives few clues to its identity. Could the woman in *Mourning Victory* represent Salome, the New Testament figure who danced for the head of John the Baptist? Or is she Judith of the Apocrypha, who saved the city of Bethulia by cutting off the head of Holofernes? Could she be an Amazon reckoning with the violence and destruction of hand-to-hand combat? A possible source for this image is an illustration that appears in Frederick E. Forbes' *Dahomey and Dahomans* (London, 1851). Here a barefoot but clothed Amazon musketeer, a club and dagger tucked in her belt, holds a gun in one hand and a severed head by the hair in the other.

Beheading was the usual method of execution in Dahomey. Moreover, Amazons frequently decapitated and emasculated their victims with machetes or large, powerful razors. They either presented the enemies' heads and genitals to their leaders, or stuck the trophies on wooden stakes, iron spikes, hooks, or forks.[43] Some outer palace walls were adorned with the skulls of slain enemy soldiers.

The woman in Savage's *Mourning Victory* hardly appears to be a bloodthirsty or cruel warrior, however. She bears no arms and wears no battle

gear. Head hung in apparent sorrow as she gazes at the face of the severed head, she seems weary and vulnerable. Her shoulders are slumped, her arms hang limply, her hips are tucked under, and her right leg is bent under the weight of her body and the moment of reckoning. Was the struggle worth the sacrifice? Was this truly a triumph?

The Amazon series represents a significant aspect of West African history. Images of Amazons became widely familiar in France through Dahomean ethnographic exhibitions at the Jardin d'Acclimation in 1891 and 1893 and when "100 Dahomeans and 25 Amazons" appeared at the 1892 Casino de Paris. Given this history, it is not surprising that the French would have responded to Savage's works with interest. Savage apparently received a gold medallion for an "African figure" displayed at the Colonial Exposition; however, there is no evidence that her work was exhibited in the fine arts section.[44] Most likely, her sculpture was part of a natural history diorama. Could one of Savage's "Amazons" conveniently have been viewed as generically African for the purposes of the exhibition? Or had Savage brought along her now-lost sculpture *African Savage,* which she had created in New York in the mid-1920s in the hopes of exhibiting it in Paris? At any rate, sculptures of the woman are notable for their bold originality, their implied violence, and their mysterious significance.

As proof of her progress in art, Savage sent photographs of the Amazon series and *The Call,* a clay figure of a seated, nearly nude, young Black man leaning sideways as he listens intently—perhaps a direct response to Locke's call for racially representative art—to the Rosenwald Foundation. Approvingly, George Arthur, an African American administrator of the Rosenwald Foundation, wrote to Savage "as brother in the bond," in 1930 asking her to continue depicting Black people:

I hope you will continue to work primarily with negro models. I hope also that you will try to develop something original, born out of a deep spirituality which you, as a Negro woman, must feel in depicting modern Negro subjects. I even hope that you will not become too much imbued with European standards of technique, if they are going to kill the other something which in my opinion some Negro will eventually give to American art, maybe in sculpture, maybe in music, painting or literature. At any rate, *know* the culture and technique of other races, but do not simply be a copy of them at the expense of originality of your own. In my opinion there is just one field in which the Negro has an equal chance with the white man in American life and that field is art. If he follows standards of even the white Americans, which in turn have copied them from Europe, then the Negro can at best be but a bad copy of the copy. Maybe that is the reason why so much bad work is put out by our men.[45] Savage wrote back that she was "glad that you are of my way of thinking."[46]

But she also informed Arthur that she was timid about showing her latest piece because she was working in a "quite different" style and was concerned about its reception. Nevertheless, she considered it her "best effort so far" because

several artists had been "almost unanimous in their praise." They urged her to have the piece cast in bronze and exhibited. Savage explained, "It is African in feeling but modern in design, but whatever else might be said it *is* original."[47] Savage may have been referring to her *Divinité négre,* a small figurine with a four-sided woman's head, four folded legs that make a X, and four uplifted arms sustaining a globe. The work may evoke an African power figure that Savage might have seen at the Musée de l'homme, but it does not seem to be a copy of a single work. Instead, it is "a black divinity born of an imagination nourished by legends and readings about Africans."[48] Aside from Palmer Hayden's well-known painting *Fétiche et fleurs* (ca. 1931–1932), itself little more than an acknowledgment of the vogue for things African according to Hayden, *Divinité négre* is one of the few works an African American artist produced as a literal response to Locke's directive to "look to the art of the ancestors" for inspiration.[49]

Photographs of *Divinité négre, Tête de jeune fille,* and *Gamin* accompanied a feature article on Savage, "Une femme sculpteur noire," in *La dépêche africaine* (1930), a French periodical about the Black world. Just as writers had discerned "racial" qualities in Prophet's work, the West Indian editor Paulette Nadral found them in Savage's: "Her inspiration is of a racial order before all, something fairly rare among conquered and uprooted races. That is why she easily succeeds in the modern genre which is so imbued with Negro art."[50] Nadral was particularly taken with the irony of *Green Apples,* deciding that "Savage wouldn't be truly Negro if she didn't have a sharp sense of humor."

Savage's good humor regarding the directives for "racial" art may have begun to flag when she felt its limitations. By January 1931 she was sculpting directly on wood and marble, and her work was becoming more abstract. *Fern Frond* (ca. 1930–1931), for instance, is a small, abstracted figure (10 in. h.) of a standing woman in richly glowing black walnut gently unfurling herself, as if awakening. Her long arms are pressed to the sides of her slightly S-shaped body as she slightly bows her near-spherical head, devoid of features. In concept, *Fern Frond* evokes Fuller's *Ethiopia Awakening* (ca. 1914), perhaps the first work by an African American to blend together the growing awareness of women's potential and Pan-Africanist ideals. Savage's piece, however, is utterly modern and, in its abstraction, evokes a more universal idea of consciousness.

By 1931, after two years in Paris, Savage ran out of grant money. Through the aid of Frederick Keppel of the Carnegie Corporation, she received the position of teacher of sculpture at the Boykin Art School in Greenwich Village. She sustained herself in various teaching jobs throughout the 1930s—as founder and director of the Savage Studio of Arts and Crafts; instructor for an adult education project of the State University of New York; assistant supervisor for the Works Progress Administration Federal Art Project in the Uptown Art Laboratory; and director of the Harlem Community Art Center. Many of Savage's students became well-known artists, including Jacob Lawrence, Gwendolyn Knight, Norman Lewis, William Artis, and Ernest Crichlow. Savage continued to exhibit her work, too, at various galleries and museums in New

York and New Jersey, and received a commission to sculpt a large piece for the New York World's Fair in 1939.

What Savage and Prophet experienced in Paris was liberating in many ways. For the first time, in their late thirties (in 1929, Savage was 37 years old and Prophet 39), they were no longer mere students, but mature artists, and their work duly received acknowledgment in the form of awards and numerous exhibitions, both in France and in the United States. While the experiences of Savage and Prophet differed dramatically and the two were little more than acquaintances, both were committed to developing their artistic education, intellectual growth, and racial pride. In Paris, they learned more about other Black peoples by socializing with West Indians on occasion, depicting Africans and Martinicans, reading Black periodicals, and studying African art and the French and American responses to it. These personal encounters affirmed a sense of shared community and history in ways that the United States could not offer between the world wars.

Study abroad provided the impetus for Prophet and Savage to become pioneers in numerous ways. They were among the first African American artists to create images that celebrated their allegiance to and pride in their African heritage. They used materials such as cherry wood, pear wood, teakwood, ebony, and bronze, rather than traditional white marble, to express the variety and beauty of Black skin tones. Savage and Prophet also created both androgynous and racially ambiguous figures, even abstracted figures, desiring, perhaps, a common, universal visual language. Yet these daring works have been largely ignored until today. Perhaps that is why Savage and Prophet virtually ceased to produce such work after returning to the U.S., and each spent over a decade teaching—Savage at various art centers in Harlem and Prophet at Spelman College in Atlanta—before fading out of the art world.

Paris gave Prophet and Savage the freedom they needed to produce works that reflected their African heritage (albeit in a nondirect, romanticized way), explored the boundaries of race and gender, and alluded to emotional states of being, particularly in *Congolais* and *Amazon,* respectively. Savage's *Amazon* lacks the aesthetic finesse of Prophet's *Congolais,* with its "exquisite mastery of physiognomy and psychological nuance with an anti-naturalistic emphasis on the artist's touch."[51] It was likely never exhibited (although perhaps at the Colonial Exposition of 1931) or cast in a more permanent medium than clay, and it did not seem to receive the wide acclaim of Prophet's *Congolais.* However, her sculpture is equally sophisticated in its pastiche-like references to Greek and African history and it did win the admiration of the administrators at the Rosenwald Foundation, as well as West Indian writers of a Black French periodical. Both *Amazon* and *Congolais,* with their lack of clothing and headdresses, coupled with their intense expressions, have a timeless, psychological quality. Each explodes stereotypes about traditional warriors by associating Black women (or at least, a sexually ambiguous portrait in *Congolais/Congolaise*) with bellicosity through visual elements, that is, the spear in *Amazon* and the Masai's forelock in *Congolais.* Yet, these "soldiers" are not

physically fighting or even in motion. They seem, rather, to be deeply contemplative, waging inner battles perhaps, as they give serious consideration to some thought or reflection.

Congolais and *The Amazon* are unique among works produced by African American artists in Paris between the wars as the only sculptures of apparent warriors, and the only depictions of Africans as solemn thinkers. They serve to combat generations' worth of offensive and racist stereotypes of Black people in both fine art and material culture. Painters Hale Woodruff, Aaron Douglas, and William Henry Johnson did not depict Africans at all while abroad, although the influence of African art is apparent in at least one of Woodruff's paintings, *The Card Players* (1930), whose figures have Fang sculpture-like heads.[52] Archibald J. Motley, Jr. executed portraits of contemporary West Indians and African, for example, *Martinique Dancer, Martinique Youth,* and *Senegalese* (all 1930).[53] However, these seem to have been fairly straightforward portraits of real people and more about studies in light and color rather than thoughtful or romantic explorations of the history of the African diaspora. Palmer Hayden completed a watercolor series of African dancers, possible the Dogon people, at the Colonial Exposition, but these are in his characteristic caricature-like style and seem to appropriate some racist imagery.[54] Only Albert Alexander Smith (1896–1940) approached anything like what Prophet and Savage were doing in redeeming the African visage, with his images of Ethiopian musicians.[55] These include the painting *Ethiopian Music* (ca. 1928), which, in a naturalistic manner, depicts performers gathered to celebrate a religious feast, most likely the Christian Festival of Palms in Askum, the sacred city of Ethiopia. Smith based his representations on historical information gleaned from the Bibliothèque Nationale. Yet even with references to real places and cultural icons (such as colossal architecture and engraved stone tablets from Askum), he succumbed to admitted distortions of the truth, as in his pen-and-ink illustration *A Fantasy Ethiopia* (1928) for the cover of *Opportunity* magazine.

African American artists faced complex and often contradictory directives about racial imagery from Black and white jurors, critics, and patrons, both in France and in the U.S., and many responded in ways that they thought would strike a chord with their various audiences. While Prophet and Savage wrestled with those issues, they seem to have been more willing to take a chance on creating unique images that broke conventions and were not immediately or easily "read." In short, they created a black visual modernism, necessarily creolized. Living and working in Paris gave them the freedom and milieu in which to explore artistic directions they likely would not have considered in the U.S. For these "femmes sculpteurs noires," the City of Light was irresistible as an unequivocal muse, and as a place of pivotal significance.

NOTES

1. For a fuller treatment of the work Prophet and Savage produced abroad, as well as reproductions of all the works mentioned in this essay, see the chapters on each of

the artists in my book, *New Negro Artists in Paris: African American Painters and Sculptors in the City of Light*, 1922–1934 (New Brunswick, NJ: Rutgers University Press, 2001).

2. Nancy Elizabeth Prophet's diary (hereafter Prophet diary) (entry dated August 11, 1922). John Hay Library, Special Collections, Brown University, Providence, not paginated.

3. Prophet diary (August 11, 1922).

4. Ibid.

5. Nancy Elizabeth Prophet, Harmon Nomination Blank (1929), Harmon Foundation Paper, Library of Congress (hereafter HFP/LC).

6. As quoted in "Nancy Prophet Wins Success As Sculptress," *Providence Evening Bulletin* (July 8, 1932): 10.

7. Ibid.

8. Ibid.

9. Letter of recommendation to the Harmon Foundation (October 4, 1930), HFP/LC.

10. From "Art Corner," publisher date, and page unknown. As quoted in Blossom S. Kirschenbaum, "Nancy Elizabeth Prophet, Sculptor," *SAGE* 4:1 (1987): 46.

11. Letter of recommendation to the Harmon Foundation (October 22, 1928), HFP/LC.

12. As quoted in Kirschenbaum, p. 51.

13. For instance, Du Bois to Prophet (December 18, 1935), Du Bois Papers, Library of Congress (hereafter DP/LC).

14. As quoted in "Along the Color Line," *Crisis* 38 (September 1931): 308. This seems to come from *Chronique familiale du rayonnement intellectuel* (July–August 1931). From a clipping in the collection of George Proffitt.

15. Letter to Cedric Dover (July 6, 1959). In the collection of George Proffitt.

16. Author, title, date, and page unknown, *L'Art contemporain*. From a translation by Prophet, HFP/LC.

17. Countee Cullen, "Elizabeth Prophet: Sculptress," *Opportunity* 8 (July, 1930): 204.

18. Alain Locke, "The Legacy of the Ancestral Arts," *The New Negro* (New York: Atheneum, 1968), p. 266.

19. Du Bois to Prophet (May 18, 1931), DP/LC.

20. Prophet to Du Bois (August 20, 1931), DP/LC.

21. Countee Cullen, "Heritage," *The New Negro* (New York: Atheneum, 1968), pp. 250–253.

22. Judith Wilson, "Sargent Johnson: Afro-California Modernist," in *Sargent Johnson, African-American Modernist* (San Francisco: San Francisco Museum of Art, 1998), pp. 33–34.

23. Ibid., p. 34.

24. Ibid.

25. Francis Jacques to Guggenheim Memorial Foundation, 1934, Guggenheim Memorial Foundation.

26. Albert Franz Cochrane, "A Sculptress Who Carves Her Own at Vose's," *Boston Evening Transcript* (November 2, 1932): 4.

27. "Prophet (Eli), né à Providence, Rhode Island, U.S.A., Américain—147, rue Broca. 1778.—Tête de jeune fille." *Société du Salon d'Automne: Catalogue des Ouvrages de Peinture, Sculpture, Dessin, Gravure, Architecture et Art Décorative* (Paris: Imprimerie Ernest Puyfourcat fil & Cie., 1927), p. 291.

28. William A. Byrd, "The Color-Line in Art," *New York World* (April 30, 1923): np.

29. Eugene Kinkle Jones, "Miss Augusta Savage" [a three-page, unpublished biographical summary] (November 11, 1928), Rosenwald Archives, Fisk University (hereafter RA/FU).

30. Savage to Du Bois (September 22, 1929), DP/LC.

31. Savage to Arthur (June 15, 1930), RA/FU.

32. Paulette Nardal, "Une femme sculpteur noire," *La dépêche africaine* (August–September 1930): 3–4.

33. Archibald Dalzel, *The History of Dahomey, an Inland Kingdom of Africa, Compiled from Authentic Memoirs* (1793) (London: Frank Cass, 1967), p. 55.

34. Ibid., opp. p. 54.

35. Stanley B. Alpern, *Amazons of Black Sparta: The Women Warriors of Dahomey* (New York: New York University Press, 1998), p. 11.

36. Ibid., p. 27.

37. Richard F. Burton, *A Mission to Gelele, King of Dahome,* ed. C. W. Newbury (New York, 1966), 111, quoted in Alpern, *Amazons,* p. 37.

38. Alpern, *Amazons,* pp. 47, 73.

39. Ibid., pp. 11–12.

40. Ibid., pp. 12, 68.

41. Ibid., p. 8.

42. Edward Fells, Savage's father, was a deeply religious, fundamentalist man who, upon seeing his daughter's "graven images" of clay ducks "almost whipped all the art out of me." As quoted from an unidentified newspaper clipping in Romare Bearden and Harry Henderson, *A History of African-American Artists: From 1792 to the Present* (New York: Pantheon Books, 1993), p. 169.

43. Ibid., p. 34. For further documentation of beheadings, see also pp. 45, 65, 77, 103, 107, 172, 177, 194, 195.

44. Using an elusive article from the *Chicago Whip* as their source (the clipping has since disappeared from the Schomburg Center for Research in Black Culture), several authors write that Savage executed an African figure in conjunction with the exposition (possibly a work from in the Amazon series), but disagree on whether the work received a medallion itself or whether it was selected for medallion reproduction. Hope Finkelstein, "Augusta Savage: Sculpting the African American Identity" (M.A. thesis, City University of New York, 1990), p. 21 and Bearden and Henderson, *History of African-American Artists,* p. 172.

45. Arthur to Savage (May 28, 1930), RA/FU.

46. Savage to Arthur (June 15, 1930), RA/FU.

47. Ibid.

48. Nardal, p. 3.

49. Locke, "The Legacy of the Ancestral Arts," in *The New Negro,* p. 267.

50. Nardal, p. 3.

51. Wilson, p. 33.

52. See *New Negro Artists in Paris,* pp. 132–136.

53. Ibid., pp. 156–158.

54. Ibid., pp. 98–104.

55. Ibid., pp. 235–238.

SELECTED BIBLIOGRAPHY

Nancy Elizabeth Prophet

"Along the Color Line," *Crisis* 38 (September 1931): 308.

"Anne Elizabeth Prophet Wins R. S. Greenough Prize," *New York Times* (July 9, 1932): 8:4.

"Art: Woman Artist," *Crisis* 39 (August, 1932): 259.

"Awarded Greenough Memorial Prize: Miss Prophet's Picture 'Silence' Judged Best in Art Association Exhibit," *Newport Daily News* (July 8, 1932): 3.

"Beth Prophit [*sic*] is Hailed in Paris as Real Artist," *The Afro-American (Baltimore)* (Saturday, August 3, 1929): 8.

"Can I Become a Sculptor? The Story of Elizabeth Prophet," *Crisis* 39 (October, 1932): 315.

Cochrane, Albert Franz. "A Sculptress Who Carves Her Own at Vose's," *Boston Evening Transcript* (November 2, 1932): 4.

Cullen, Countee. "Elizabeth Prophet: Sculptress," *Opportunity* 8 (July, 1930): 204–205.

"Elizabeth Prophet, Artiste Américaine," *L'Art contemporain* (ca. 1929–1931): page unknown.

"Elizabeth Prophet, Sculptor," *Crisis* 36 (December, 1929): 407, 427.

"Elizabeth Prophet, Sculpture Prize Winner," *Providence Evening Bulletin* (February, 1930): page unknown.

"Elizabeth Prophet Wins Prize for Head of Negro," *New York Times* (January 12, 1931): 26:1.

Kirschenbaum, Blossom S. "Nancy Elizabeth Prophet, Sculptor," *SAGE* IV: 1 (Spring, 1987): 45–52.

Leininger, Theresa. "Elizabeth Prophet (1890–1960)," in Jessie Carney Smith, ed., *Notable Black American Women.* Detroit: Gale Research Inc., 1992, pp. 890–897.

"Nancy Prophet Wins Success As Sculptress/Calls Courage Real Requisite for Achieving," *Providence Evening Bulletin* (Friday, July 8, 1932): 10.

"Negress Wins the First Prize at Newport," *The Art Digest* (August 1, 1932): 14.

"Newport Exhibition Marks Twenty-Fifth Year of Group," *New York Herald Tribune* (July 10, 1932): page unknown.

"Newport Ready for Art Show," *Providence Sunday Journal* (July 3, 1932): D:6.

Occomy, Nell. "Art Corner," pub. date, and page unknown.

Patézon, Jean. "Elizabeth Prophet, artiste américaine," *Le rayonnement intellectuel* (ca. 1930): page/s unknown.

Prophet, N. Elizabeth. "Art and Life," *Phylon: The Atlanta University Review of Race and Culture* 1 (Third Quarter, 1940): 322–326.

Sélig, Raymond, Jules de Saint-Hilaire, and Jean d'Humovain, "Les Salons des Artistes Français, de la Nationale et des Indépendants (Elisabeth Prophet)," *Revue du Vrai et du Beau* (August 10, 1929): 7.

Société du Salon d'Automne: Catalogue des Ouvrages de Peinture, Sculpture, Dessin, Gravure, Architecture et Art Décorative. Paris: Imprimerie Ernest Puyfourcat fil & Cie., 1927, p. 291.

"Woman Artist," *Crisis* 39 (August, 1932): 259.

"Women Artists' Work to Fore in Annual Exhibit at Newport: Opening Marked by Award to R.I. Girl Sculptress," *The Providence Sunday Journal* (July 10, 1932): E:8.

Augusta Savage

"Augusta Savage," *Chicago Whip* (August 15, 1931): page unknown.

"Augusta Savage Gets Fellowship," *New York Amsterdam News* (May 29, 1929): page unknown.

"Augusta Savage Studies Under Master in Paris," *New York Amsterdam News* (November 13?, 1929): page unknown.

Bibby, Deirdre. *Augusta Savage and the Art Schools of Harlem.* New York: The Schomburg Center for Research in Black Culture, The New York Public Library, 1988.

Byrd, William A. "The Color-Line in Art" (letter to editor), *New York World* (April 30, 1923): page unknown.

"Colored Sculptress Tells Story of Life," *American* (Waterbury, CT) (December 2, 1935): page unknown.

"Famous Artists Draw Color Line Against Student," *Negro World* (Saturday, May 5, 1923): 3.

Finkelstein, Hope. "Augusta Savage: Sculpting the African American Identity." M.A. thesis, City University of New York, 1990.

"Harding Asked to Intercede in Exclusion Case," *New York World* (May 10, 1923): page unknown.

Nadral, Paulette. "Une femme sculpteur noire," *La dépêche africaine* (août-sept., 1930): 3–4.

"Negro Artist Fight Moves to France," *New York World* (May 12, 1926): page unknown.

"Noted Sculptress Expects Distinct, But Not Different, Racial Art," *Pittsburgh Courier* (Saturday, August 29, 1936): 1:5.

Occomy, Nell. "Who Is Who—Augusta Savage," *New York News* (June 1, 1929).—page unknown.

Poston, T.R. "Augusta Savage," *Metropolitan Magazine* (January, 1935): 28–31, 51, 66–67.

Savage, Augusta. "Augusta Savage on Negro Ideals" (letter to the editor), *New York World* (May 20, 1923): page unknown.

Savage, Augusta. "Augusta Savage: An Autobiography," *Crisis* 36 (August, 1929): 269.

"Sculptress Makes Good in France," *The Afro-American* (Saturday, February 14, 1931): 10.

"Sculptress to Study Abroad: Talented Augusta Savage Awarded Rosenwald Fellow-ship," *Chicago Defender* (June 1, 1929): 2:6.

Smith, Jessie Carney. "Augusta Savage (1892–1962)," in Jessie Carney Smith, ed., *Notable Black American Women.* Detroit: Gale Research Inc., 1992, pp. 979–983.

"$300 Purse for Augusta Savage," *The Afro-American* (Saturday, August 10, 1929): 7.

Walrond, Eric D. "Florida Girl Shows Amazing Gift for Sculpture," publication un-known (ca. 1922): page unknown.

Walton, Lester A. "Negro Girl Gets Fund to Study Art Abroad," publisher unknown (1926): page unknown

Additional Sources

Alpern, Stanley B. *Amazons of Black Sparta: The Women Warriors of Dahomey.* New York: New York University Press, 1998.

Bearden, Romare, and Harry Henderson. *A History of African-American Artists: From 1792 to the Present.* New York: Pantheon Books, 1993.

Burton, Richard F. *A Mission Guide to Gelele, King of Dahome.* New York: 1966.

Dalzel, Archibald. *The History of Dahomey, an Inland Kingdom of Africa, Compiled from Authentic Memoirs* (1793). London: Frank Cass, 1967.

Janson, H.W., compiler. *Catalogues of the Paris Salons 1673–1881.* New York: Garland Publishing, Inc., 1977.

Leininger, Theresa. "The Transatlantic Tradition: African-American Artists in Paris, 1830–1940" (translated by Lydia Rand as "La Tradition Transatlantique: Les Artistes Africains Américans à Paris, 1830–1940,") in Asake Bomani and Belvie Rooks, eds., *Paris Connections: African American Artists in Paris.* San Francisco: Q.E.D. Press, 1992.

Leininger-Miller, Theresa. *New Negro Artists in Paris: African American Painters and Sculptors in the City of Light, 1922–1934.* New Brunswick, NJ: Rutgers University Press, 2001.

Locke, Alain. *The New Negro.* New York: Atheneum, 1968.

Reynolds, Gary R., and Wright, Beryl J. *Against the Odds: African-American Artists and the Harmon Foundation 1923–43.* Newark, NJ: Newark Museum, 1989.

Wilson, Judith. "Sargent Johnson: Afro-California Modernist," in *Sargent Johnson: African American Modernist.* San Francisco: San Francisco Museum of Modern Art, 1998, pp. 27–40.

Archival Resources

The Archives of American Art, Smithsonian Institution.

Carnegie Foundation, New York.

Guggenheim Foundation, New York.

Harmon Foundation Papers, The Library of Congress, Washington, DC.

Harry Henderson, private files and taped recorded interviews, Croton-on-Hudson, New York.

National Archives, Harmon Foundation Records, Washington DC.

Rhode Island College. Documents on Nancy Elizabeth Prophet. Providence, Rhode Island.

Rosenwald Archives, Fisk University, Nashville, Tennessee.

Schomburg Center for Research in Black Culture, New York Public Library, New York.

Yale University, The James Weldon Johnson Memorial Collection of Negro Arts and Letters, Beinecke Rare Book and Manuscript Library, New Haven, CT.

7

The Mexican Murals of Marion and Grace Greenwood

James Oles

INTRODUCTION

Between 1933 and 1936, two American women, sisters Marion (1909–1970) and Grace Greenwood (1902–1979) painted five separate murals in true fresco in Mexico, first working independently on relatively minor projects in the provincial cities of Taxco and Morelia and then collaborating on the most spectacular commission of their careers, the decoration of an immense twin stairwell in Mexico City's new Abelardo L. Rodríguez Market.[1] This range of practice distinguishes them from most of the other Americans who created murals in Mexico in the 1930s (Howard Cook, Ryah Ludins, Philip Guston and Reuben Kadish, Isamu Noguchi), each of whom worked on only a single project and none of whom achieved equivalent fame within the Mexico City art world.[2] Only Pablo O'Higgins (born Paul Higgins in Salt Lake City in 1904) had a greater impact as an American-born muralist, but he was a true expatriate: After arriving in 1924 to serve as an assistant to Diego Rivera, he remained in Mexico until his death in 1983.[3]

The Mexican frescos of the Greenwood sisters have never been fully discussed, mainly because they do not fit within standard views of 1930s mural painting, which privilege the New Deal projects, the historical epics of the Regionalists, or the prolific careers of Mexico's "tres grandes" (Diego Rivera, José Clemente Orozco and David Alfaro Siqueiros). But for these same reasons, they provide important insight into the broader processes and meanings that shaped public art during the Depression years. Their story not only highlights the dependency of certain New Deal muralists on the Mexican model, but also confirms that Mexican muralism itself was more than just a monolithic "renaissance" led by a few heroic figures under the aegis of the Ministry of Public Education. By the 1930s, it was a heterogeneous force (rather than a

defined "movement") marked by competing and overlapping strategies played out by a wide range of participants. But although the Greenwoods worked for different patrons, in different locales, and under different conditions, creating murals that merit attention in and of themselves, they still had to negotiate prior aesthetic and political models, particularly those established by Rivera (contrary to some sources, however, neither ever studied with Rivera or worked as his assistants). Indeed, throughout their period of residence in Mexico, Rivera's style and themes would be hard for either sister to ignore.

Although Marion and Grace Greenwood, as two American sisters, certainly stood apart from the crowd, there is scant evidence that they (or any of the other American muralists in Mexico) ever faced discrimination as outsiders: A year after arriving, Marion Greenwood even observed that "like in France, you are more appreciated if you are a foreigner."[4] Rather, their commitment to local audiences and their engagement with local subjects was seen as admirable, and their very situation as Americans working in Mexico ratified the international importance of Mexican muralism, just as Rivera, Orozco and Siqueiros had when they brought their techniques and messages to the United States earlier in the 1930s. But the Greenwoods were not just Americans, they were women, and their success forces a reconsideration of the largely ignored role of women in the history of Mexican mural painting. Although they benefited from the fact that other women had worked as assistants on earlier mural projects, the Greenwoods were the first women of any nationality to create important works of public art in Mexico.

If the Greenwoods' first murals were limited by the relative conservatism of their patrons, their Mexican context ultimately allowed and even encouraged them to create monumental and radical images that would never have been permitted in the United States. Their embrace of Marxist rhetoric may have been tentative (both were affiliated with Popular Front organizations, like the American Artists' Congress, but neither joined the Communist Party, or made any attempt to pursue left-wing imagery after returning home in 1936) and was certainly shaped by their colleagues and a difficult, if exciting, historical moment. Yet even as fellow travelers, in the Rodríguez Market they created among the most powerful antifascist and proletarian murals ever painted by American artists. Together with their conquest of the technical and compositional difficulties of fresco, these works would set them far apart from most of their contemporaries. Marion Greenwood found her subsequent experience as a New Deal muralist "anti-climactic and inhibited by the bureaucracy."[5] It would be hard to equal the euphoria of these years spent south of the border.

FROM BROOKLYN TO PROVINCIAL MEXICO

The early careers of Marion and Grace Greenwood provide scant evidence of their future dedication to the radical possibilities of public art. Born in Brooklyn to a middle-class family that fully supported their artistic inclinations, both sisters attended the Art Students League in New York in the

mid-1920s. Marion also took classes at the artists' colonies in Woodstock and Yaddo. She studied briefly with artist Winold Reiss, who had worked in Mexico in 1920 and who, as a key figure in the Harlem Renaissance, may have sensitized her to the vitality of cross-cultural influences. Later in the decade, both sisters shared a studio in Paris, and enrolled briefly in the Académie Colarossi; Grace went on to Italy to study murals, as Rivera had done in 1920. Marion was, from the beginning, the more famous of the two. At first known primarily as a portraitist, her undistinguished early work reveals a loose affiliation with the figurative school of American painting of the first quarter of the century, and only a fleeting interest in more modernist currents.

In 1931, a brief trip to New Mexico (a gateway for many American artists who ended up in Mexico, including Paul Strand and Marsden Hartley) provided Marion Greenwood with an introduction to Hispanic and Native American culture. Then, in late December 1932, she was the first of the two sisters to cross the border. As she later wrote: "Like a good many of the younger American artists, I was attracted to Mexico because it seemed to offer an inspiration and an opportunity that was vital and American. American, that is, in the big sense of the New World, as against the European influence that pervaded most painting at that time."[6] Greenwood also had a more personal reason for undertaking the journey. After a serious operation, she had accepted an invitation to accompany the radical writer and journalist Josephine Herbst and her husband, John Hermann, on their escape from New York. The two women had met in the summer of 1932 and began an intense sexual affair that continued in Mexico.[7] This intimate relationship had a master-protégé component as well (Herbst was 17 years older), and helps explain Herbst's financial and critical support for Marion Greenwood's Mexican experience. Through published articles, personal conversations and letters, Herbst not only lauded Greenwood's work, but also encouraged her to take an increasingly radical path. Pablo O'Higgins, a member of Mexico's Communist Party since 1927, was also an important catalyst, both in practical and ideological matters. Greenwood met O'Higgins soon after her arrival in Mexico City, and he eventually taught her the rudiments of mural composition and technique and helped her obtain commissions. Even more important, he was an insider who served as an important model for the success that a committed American could find in the Mexico City art world.[8]

Refugees from modern urban life, Herbst, Hermann and Greenwood quickly fled the noisy capital for Taxco, a picturesque colonial town in the mountainous state of Guerrero. Taxco was just emerging as an important tourist destination, mainly due to the promotional skills of the American architect and writer William Spratling. In January 1933, after creating a few conventional easel paintings, Greenwood received her first mural commission from the American owners of the Hotel Taxqueño, the town's only sophisticated hotel. This was not only a case of Americans helping a fellow citizen, but a sharp marketing strategy. If the mural "renaissance" was a major reason for tourist interest in Mexico, then why not create frescos expressly for tourists?[9] Assisted first by Hermann, and then by O'Higgins and Ramón Alva Guadarrama (another Rivera

assistant), Greenwood finished her fresco in April, knowing she was "the first woman who has ever done a fresco in Mexico."[10]

Taxco Market covers a small and irregular space measuring about six square meters on one wall of the hotel stairway, a constricted site that Greenwood used to her advantage. The mural features activity (and inactivity) in the shaded plaza in front of Taxco's parish church of Santa Prisca. Seated women in the foreground sell pottery, fruits and vegetables, while other peasants carry bundles or merely watch and wait in the sharply receding distance. By successfully integrating the stairway itself into the lower margin, and packing the mural with figures, Greenwood encouraged her viewers to recall the treacherous local topography and the inescapable crowds on market day.

Because of their picturesque difference from the modern forms of retailing familiar to residents of urban America, market scenes were common subjects for visiting American artists, and had also been featured in the murals and easel paintings of Rivera and other Mexicans. Despite Greenwood's avoidance of explicit political discourse Herbst argued that the mural was indeed socially relevant in *Mexican Life,* a leading Mexico City cultural magazine:

These larger than life figures appear somehow aware of the tragic quality of their history. The clash between their submission and resistance resolves itself in the patient folds of the rebozo and the bold uprightness of the male figures against the wall. This is not the mellow drunken happy-go-lucky scene that is such a favorite with Northamerican [*sic*] writers singing their way back home. These people are not dreaming, are not mystic; they are surrounded with concrete objects, products of their toil.[11]

One could argue that there is more "submission" than "resistance" in these stoic faces. And though not inaccurate, Greenwood's emphasis on traditional costumes and her elimination of any signs of modernization configured Mexico as timeless, devoid as a postcard of any evidence of political or social progress. Here, then, is the tourist's first impression, a reserved fascination with Mexico's difference already foreshadowed in a letter she sent home soon after crossing the border: "We've been going through the most gorgeous mountains and country I've ever seen in my life, full of these wonderful Indian descendants of the old Aztecs, with bamboo huts and thatched roofs. I would give anything to paint these people but they are so strange and aloof it would be quite difficult."[12] Indeed, few individuals in the Taxco mural interact directly with the viewer, who remains a mere observer surveying the market from behind an invisible barrier of language and class.

Perhaps Herbst could not have avoided interpreting Greenwood's first mural as a "distinct social art" (even though it was only nominally public) for such a reading ratified her efforts, and those of Hermann, to push Greenwood further to the left (unlike Herbst, Hermann was a member of the Communist Party). The results appear in Greenwood's own increasingly politicized discourse. In part inspired by Mexican communal life, she argued that American individualism was especially dangerous in the context of the Depression: "The world is in a terrible mess, and when people begin to have a group feeling instead of worrying about their own little lives things will begin to straighten themselves

out."[13] She also began to connect this new political awareness to her practice as an artist: "In making frescos I have to study history and the Indians here, for the subject and themes have to be significant, not playing around with easel pictures—Herbst is teaching me all about communism which gives one a wonderfully hopeful slant on life and it's something you can grasp, it's tangible and useful. Someday I may even be able to go to Russia and paint revolutionary frescos."[14] This, however, is the stridency of a recent convert. When problems developed during her next mural commission, she easily slipped from her radical soapbox: "There are people made to serve and people born to boss—and if the world is ever under the control of these inferiors then God help us."[15] Rather than attempt to nail down Greenwood's political beliefs with any precision, or see her as merely naïve or opportunist, it might be best to view such ambiguities as a part of an ongoing self-definition, evidence of continuing negotiations with her colleagues, her public and her patrons: a process rather than a position.

Marion Greenwood's second fresco, *Landscape and Economy of Michoacán,* painted in 1933–1934 for the prestigious Universidad Michoacana de San Nicolás de Hidalgo in Morelia, the state capital of Michoacán, reveals a subtle but important transition in her understanding of the purpose of public art. Although the mural also emphasizes local customs in a pre-modern setting, her subjects are less passive and more explicitly located within a reformist discourse than in Taxco. Greenwood was commissioned directly by the University's rector, Gustavo Corona, who provided expenses and lodging, but no salary for the city's first public muralist.[16] She enthusiastically reported home that Corona "feels like Sforza, and wants to get a lot of painters here including Rivera to cover the walls of Morelia and thus go down in history as a patron of the arts."[17] She might have mentioned his more direct model: José Vasconcelos, minister of education in the early 1920s and sponsor of the first modern murals in Mexico City. Though her prior experience and radiant looks together may have persuaded Corona to give her this more important commission, the fact remains that any artist willing to make the trip to Morelia would probably have been welcomed with open arms. Indeed, in the mid-1930s four other Americans—Grace Greenwood, fellow New Yorker Ryah Ludins, and Californians Philip Guston and Reuben Kadish—all obtained important commissions from cultural and political leaders in Michoacán eager to establish a provincial renaissance but unable to lure Mexican artists to do the job.

Landscape and Economy of Michoacán covers a large horizontal space (about 3.3 meters high by 21.7 meters wide) on the second story of an open patio in the university's main building (Figure 13). This larger and more public site caused Greenwood some anxiety at the start of the project, prompting a self-justifying letter to Herbst (who had returned to the States in May 1933):

I'm afraid I have nothing to say, which has not been said before in the way of social significance and political attitudes by Orozco and Rivera and many others. I am simply going to paint these people as I feel them in all their sadness, their apathy, and beauty. Hammers and sickles, and historical periods and personalities have been done to death. I have only become class-conscious in the last year; it would be an affectation for me to

paint the usual propaganda at this period when I have nothing original to offer, whereas if I paint something I *feel* it might have much more significance.[18]

The Mexicans, often thought of as purely inspirational for younger American artists, could also block creativity, especially when one was working more or less on their home turf. Ultimately, however, Greenwood followed an example set by Rivera in the Patio of Labors at the Ministry of Public Education. She addressed the region's geographic and cultural characteristics, focusing on three aspects of the rural economy she had observed around Lake Pátzcuaro: fishing and repairing nets, the harvest of wheat and corn, and the manufacture of utilitarian folk crafts, specifically reed mats and pottery.

As in Taxco, Greenwood emphasized Mexico's timeless folkways, but this time she did not ignore the daily labors of peasant workers, as did so many visitors (including Strand, who also worked in Michoacán in 1933). Rather, labor is the central theme of the mural, and whether intended or not, served to refute persisting racist opinions on Indian "laziness."[19] The mural also includes her first attempt to shift scale for symbolic purposes: Above a central doorway Greenwood placed an enormous Indian with his chin resting on the upper edge of the doorframe, as if otherwise unable to support the pressure of a stone he carries on his back. According to Herbst, who reworked Greenwood's ideas in a statement designed for Corona: "No student can enter that library door without passing under the burden and the privilege of the historical past of the Tarascan [Indian]."[20]

Less explicit, but more illuminating, Greenwood intentionally placed her signature over the skirt of a female potter grinding pigments on the right side of the fresco. Partly an allusion to the fact that fresco painters engage in a similarly grueling task, this "signing" can also be seen as a sort of "labeling." Since the early 1920s, most Mexican muralists had sought to ally themselves with members of the working class, whether through equivalent wages, union organization, placing hammers and sickles next to their signatures, or wearing overalls. In Morelia, notwithstanding her different nationality and class affiliation, Greenwood made a similarly public (and even feminist) statement, identifying herself directly with an indigenous woman painter working for the community for little remuneration.

Nevertheless, as in Taxco, the local population is stoic, suffering the pains of its labors silently, far removed from political upheavals. Greenwood's unwillingness to allow a move beyond the symbolically discursive is further suggested by her rejection of several titles proposed by Herbst because they sounded "too much like cartoon propaganda. I notice neither of you would name your books in that fashion it does *not* have to have a revolutionary or hopeful viewpoint to live as a work of art—in my opinion—as long as it is a strong vital interpretation of living realities painted with *sincerity* and love for the beauty of line, rhythm, and sound structural composition."[21] This resistance to overt left-wing rhetoric, with a concomitant emphasis on form over meaning, reflects not only her anxieties that everything had "been said before," or her own tentative political consciousness, but also political complexities in Michoacán. For much

of 1933, the state was marked by conflicts between those loyal to the revolutionary policies of former governor Lázaro Cárdenas (including Greenwood's patron, Gustavo Corona) and those allied with current governor Benigno Serrato, a devout Catholic accused of "counterrevolutionary" tendencies. These tensions, which caused a strike at the university while she was working, did not encourage risk-taking: She feared students might vandalize her work; as others had at the National Preparatory School in the 1920s, and may have toned down her subject to avoid confrontation. But Greenwood weathered the storm: When Cárdenas visited Morelia in January 1934, during his campaign for the presidency, he viewed the fresco and thanked Greenwood for devoting a year of her life to his native state.[22]

Greenwood concluded her project with a feeling of confidence. She had gained technical experience although, despite the continued assistance of O'Higgins, she had to repaint sections of the mural several times (leaving spectators amazed at her perseverance). And because she used black river sand (rather than purer mine sand) for part of the plaster surface, the fresco quickly darkened. Her greatest complaints about the months spent in Morelia related not to technical or political difficulties, however, but to the tribulations of living in an exceedingly provincial city in a nation where women where still largely consigned to home and family. Working in public, she found her gender a hindrance primarily because she attracted several suitors, among them a prominent lawyer, and feared their advances would compromise her reputation, sexual as well as artistic: "The Mexican woman has no more freedom than in the harem—naturally being an American girl here I have to keep to myself or get talked about."[23] But she also felt her body restricted her as a muralist: "I wish my breasts and hips would disappear, they're in the way, and I look awful in pants."[24] In a comment that alludes to both these social and physical ordeals, she angrily confessed to Herbst: "If I was a man everything would be easier."[25]

Herbst, again writing in *Mexican Life,* made no reference to the problems Greenwood faced as a woman on the scaffolds, instead focusing on the fresco's deeper symbolic meanings:

The Mexican Indian has never gone down [but] his ways of life are doomed also to disappear before the onslaught of the machinery age which is slower in Mexico than in the States. Roads will come, gasoline stations sprout along the way, burros disappear. But now, while there is still time, when ways of life are almost as ancient as the Indian himself, Marion Greenwood brought it down, in imperishable color, the method, the feeling, the burden and beauty of this Indian life which is a cultural heritage not to be lost, as many of the Aztec idols and cities were lost forever.[26]

For Herbst, rural Mexico provided a reminder of what Americans had given up in the race for progress. Similar fears for the annihilation of tradition in the face of modernity deeply informed contemporary discourse in both Mexico and the United States. More remarkable is that, despite her sensitivity to cultural loss and a dedication to the proletariat, Herbst's preservationist impulse (which Greenwood shared) was essentially conservative, since in the defense of tradition it consigned rural populations to a pre-industrial age, isolated from the

technological and social advances of the modern world. She (like many artists, anthropologists and writers of the time) allowed the local population no agency (or means to achieve agency, such as education) to accept or reject change: It was only through an outsider's representation that the Tarascans' heritage could be saved.

Greenwood's murals became a tourist attraction, and her success quickly prompted commissions for other visitors. Ryah Ludins, whom Greenwood had known in New York, arrived in June 1933; Marion's sister Grace followed in September after a summer spent traveling with her husband elsewhere in the country.[27] Through the intercession of O'Higgins, Corona assigned Grace Greenwood a vertical panel (about 8.4 x 3 meters) on the second story of the nearby Museo Michoacano, which also housed the main offices of the university administration. In late November, Marion took time off to teach her sister the requisite skills.

Grace Greenwood's allegorical fresco, titled *Men and Machines* (1934), ironically hailed the very modernity that threatened the rural folkways Marion Greenwood memorialized (Figure 14).[28] Five male workers, surrounded (or trapped) by enormous metal gears, seem to push and pull against unseen forces. The arms of the largest figure press against the margins as if to break out of the confining space; those of another are crossed as if in agony. Their positions mimic the imagined movement of pistons, levers and gears, though they perform no identifiable function. The machine plays an ambiguous role here, as a force with which *and* against which the proletariat must struggle. Although Marion reported that her sister's sketches were "quite communistic in feeling, the workers mastering the machine instead of the machine mastering them as in the capitalistic countries," there is no clear visual evidence that these proletarians have control over anything.[29] Grace's mural is also notable for its clichéd emphasis on the exclusively male realm of industry, unlike her sister's fresco, which acknowledged the importance of both genders in the rural workforce.

Few previous murals in Mexico were as devoid of nationalist referents; Rivera's depictions of industry in the Ministry of Education were not only more geographically and culturally specific, but showed workers as unambiguously dominated by capital. Although Grace may have been influenced by Rivera's *Detroit Industry* program, then in progress (and easily familiar through press photographs), José Clemente Orozco provided a more direct formal source. In a later interview, Grace recalled that she had read a book on Orozco before leaving for Mexico, and that she "felt drawn towards Orozco's work."[30] In fact, the upright thrust of the arms in the center left of her mural specifically recalls Orozco's *The Trench* (National Preparatory School, 1926). By selecting an industrial theme and using Orozco as a model, Grace Greenwood perhaps hoped to differentiate her work from that of her more established sister, though there remains little evidence of sibling rivalry in surviving documents.

REVOLUTIONARIES IN THE CAPITAL

The murals completed by the Greenwoods in Taxco and Morelia avoided explicit references to current political debates or conflicts, featuring instead subtle allusions to peasant or working-class concerns. These murals reflect not only hesitant personal politics, and the relative conservatism of their patrons and intended audiences, but the fact that they were basically working in provincial isolation. These constraints were significantly lifted, however, as they embarked upon their final Mexican murals, designed for a new working-class market in Mexico City known initially as the Mercado del Carmen, and later renamed in honor of President Abelardo L. Rodríguez.

The Greenwoods first learned of the plans to decorate the market through Pablo O'Higgins in early 1934, while the building itself was still under construction. Revealing that her willingness to paint "social" themes did not mean she saw herself as a mere worker, Marion Greenwood complained to Herbst that O'Higgins had "made arrangements that we would only get paid 4 pesos a day, just like other workers. It may be alright [*sic*] for him but not for me. He's so afraid that I won't be proletarian enough."[31] Other clouds may have been lurking on the horizon, for she also noted that certain individuals (probably younger Mexican artists) thought she was "trying to step in where others should be."[32] If such objections from Marion Greenwood's colleagues related to her status as an American or a woman, they stand alone: It is more likely that by working in the provinces she had lost her proverbial place in line, or that her two previous murals (and her sometimes less than proletarian attitude) were seen as insufficiently radical in the political climate of the capital.

While waiting for the Rodríguez Market project to coalesce, the Greenwoods returned together to the United States in March 1934, and immediately joined the Public Works of Art Project (PWAP) in New York. Although their previous murals belie the complaint, Marion Greenwood wrote to Herbst that she and her sister were "both getting so class-conscious that it's hard to work."[33] It may have been a similar outburst that prompted the artist Edward Biberman to sympathize: "I realize what a problem you are up against—for to return from Mexico, where the problem was how to be *revolutionary enough,* to New York, where the job seems to be one of treading lightly so as not to offend any one of a hundred different people."[34] Biberman surely referred to the pitfalls of working as a muralist in the United States, where from the beginning of the New Deal arts projects, both federal bureaucrats and the public were constantly on guard against images that went beyond specific political or moral boundaries, and where artists generally had to compete for commissions rather than await appointment by an independent patron. If the Greenwoods expected their Mexican experience to translate into major projects upon their arrival home, as their letters suggest, they were surely disappointed. Their projects for the Immigration Building at Ellis Island remained mere sketches, since the PWAP, a temporary measure designed to alleviate unemployment, drew to a close in June before they could begin work: Not until much later in the decade would they get the chance to finish murals in the United States.[35] The loss did not go unnoticed

by PWAP official Edward Rowan, who regretted publicly that budget curtailments had forced Marion Greenwood to find work abroad.[36]

With a sure commission awaiting them in Mexico City, Marion and Grace Greenwood returned to Mexico in October 1934, and soon found themselves embroiled in an ever-more complex artistic and political situation. By 1934, new positions were being drawn among Mexican muralists. Siqueiros and several younger radical artists now vehemently attacked the murals of the previous decade as insufficiently revolutionary. In their view, these works had praised the peasant and worker through historical epics and utopian visions, ignoring or whitewashing continuing class conflicts and social inequities. Rather than call for social and political change, such murals had tended to consolidate the rule of the current regime by supporting the status quo.[37] Though critics chiefly had in mind Rivera's famous 1920s frescos in the Ministry of Education and the National Palace, not to mention his work for the leaders of American capitalism, their analysis applied equally to the Greenwoods' recent work.

Siqueiros' position emerged partly in reaction to the continuing hegemony of Rivera, partly to discredit Rivera's "errant" dedication to communism, and partly to revitalize the discourse of muralism. In an influential critique of the early years of Mexican muralism published in *New Masses* in 1934, Siqueiros laid out his platform, attacking Rivera as a "snob" and "mental tourist."[38] This article, as well as an earlier condemnation of Rivera's exhibition at the Museum of Modern Art, written by Siqueiros's ally Joseph Freeman for the same magazine, launched a quarrel between Rivera and Siqueiros that culminated in their famous debate of August 1935 at the Palace of Fine Arts in Mexico City.[39] Though couched in terms of a struggle between Stalinists (headed by Siqueiros) and Trotskyites (led by Rivera), both sides were marked by inconsistencies that reveal personal as well as political motives. For example, Marion Greenwood publicly demonstrated her allegiance to Rivera when she challenged Siqueiros during the debate for not practicing what he preached. The latter responded that "the penetration of imperialist influence in the arts made it impossible for him to live any other way than by turning out commercial products for the bourgeoisie," forcing a sympathetic reporter for the *New Masses* to admit that "this was a pretty weird kind of resignation from one who had functioned so long as a professional revolutionary."[40] The August debate, as well as the shift in Communist Party politics, manifested by the call for a Popular Front against war and fascism at the Seventh Comintern that same month, left artists, including the Greenwoods, searching for new solutions in muddied waters.

Not surprisingly, this controversy emerged just as mural commissions in Mexico began to increase at the close of the Maximato (1928–1934), a six-year political period so called because former president Plutarco Elias Calles (known as the "Jefe Máximo" [Supreme Leader] of the Revolution) exerted control over three relatively weak successors. The political conservatism of the Maximato years had sent Rivera, Orozco and Siqueiros to seek opportunities in the United States. Although still somewhat dominated by Calles, the new administration of Abelardo L. Rodriguez (1932–1934), facing the effects of the world economic depression, was forced to search for ways to ameliorate growing social protest;

one strategy was the revitalization of government–sponsored murals. Artists too young or inexperienced to have participated in the 1920s found official mural commissions through two progressive campaigns to improve Mexico City's infrastructure: the new primary schools built under Narciso Bassols, head of the Ministry of Public Education (and a devout socialist), and the Abelardo L. Rodríguez Market, sponsored by the Departamento del Distrito Federal (Department of the Federal District, or DDF), a branch of the federal government charged with running the capital.

The Rodríguez Market, a bulky neocolonial edifice covering two square blocks, was a linchpin in the revitalization of a working-class district in downtown Mexico City. From an early stage, murals were considered integral to the vast building, which included a theater, day care center, and offices of the Departamento de Acción Cívica (Department of Civic Action), the cultural wing of the Mexico City government and direct patron of the murals. Although 10 muralists eventually obtained walls in the structure's interior, the art was less important than the propaganda value of the market itself: At the inauguration, Aaron Sáenz, the head of the DDF and a Calles ally, insisted that its very modernity disproved the "calumnies thrown at the Government, at an administration dedicated to the Revolution."[41] Such dedication, however, was already in question.

The story of the murals in the Rodríguez Market is extraordinarily complex. Though they worked separately on their individual projects, the Greenwoods and their fellow muralists jointly discussed relevant subjects and aesthetic solutions. Thus, despite stylistic differences, the murals share many of the same concerns and are partially unified by repeated images, although some are much more didactic than others. Despite this collaborative context, however, bureaucratic delays, contractual disputes and political upheavals plagued the artists from the time negotiations to decorate the building began in early 1934.[42] From the start, the authorities in charge feared that the young artists' inexperience and political leanings would lead to "inappropriate" murals. Such fears were not groundless, since while the patrons encouraged progressive themes directly related to nutrition and food distribution, most of the muralists soon shifted their attention to current political events such as labor disputes, antifascist rallies, and Depression-era "readjustments" in the workforce. In part, this reveals the influence of the Liga de Escritores y Artistas Revolucionarios (League of Revolutionary Writers and Artists, or LEAR), founded by O'Higgins and others in 1933.[43] Like the U.S. John Reed Clubs, the LEAR was at first closely affiliated with the Communist Party, which may have dictated particular themes despite the reticence of the official patrons. Given the anticommunism of the Rodríguez administration, however, the LEAR kept their involvement out of the press. To qualm official anxieties, poet Antonio Mediz Bolio, head of the cultural wing of the Mexico City government, supervised the political content of all preliminary sketches, while Diego Rivera was charged with approving their visual content. Although some of the muralists, like O'Higgins, scorned Rivera's rebellious "Trotskyism," few could avoid the visual codes he had previously established.[44] In any event, Rivera seems to have been a bit lax in his

supervisory role, and for the most part, the muralists were more or less allowed
to do as they pleased, provided all work was completed within the time frame
of their contract. This was less a sign of government sympathies with such rad-
ical content than a toleration of the muralists' rhetoric as a smokescreen for the
conservative politics of the regime.

The official contracts drawn up in early 1934 mention neither Greenwood sis-
ter, but O'Higgins fought from the beginning to bring them into the project, in part
because they had more experience than some of the other participants. After their
return from the States, the Greenwoods obtained official work permits and were
assigned a complex arrangement of walls covering almost 300 square meters in
the northeast corner of the building, but they did not begin painting until Febru-
ary 1935. The space is dramatic: Small panels face each other across a foyer that
opens out in one direction to the street and in the other to the market interior. Two
large stairwells rise from this foyer to a second floor, where they meet in a single
shared wall: Together, the richly colored compositions lure visitors up the stairs,
despite competition from the sights and smells of the nearby stalls.[45] In their stair-
wells, the Greenwoods used Rivera's stairwell mural in the Ministry of Education
(1923–1928) as a model. Like him, each began with images conceptually related
to the ground floor (canals, mines), and then—just as Rivera moved up through
the Mexican landscape—so the Greenwoods created a vertical progression em-
phasizing increasing industrialization and class consciousness. At the top of the
stairs, at a point where the murals are best seen as a whole, a single wall that con-
nects the separate murals underlines the purpose of the entire endeavor, inscribed
in Spanish with the slogan "Workers of the World, Unite!"

In the ground floor foyer, Marion Greenwood painted a naturalistic rendition
of the Jamaica terminal, where produce arrived by canal from agricultural zones
to the south of the city. Like the canals, themselves zones of transit and move-
ment, this panel serves as a disembarkation point for the rest of her project. It
also conformed to the original request by the DDF that the artists choose "pro-
gressive" (but not radical) themes related to health, sanitation and food distri-
bution. By making loose reference to the DDF's ongoing restoration of the Ja-
maica Market and nearby canals, it presented the city government as an active
force in improving urban food transportation and sales. In the remainder of the
mural, however, Marion Greenwood (like most of the other artists working in the
market) quickly shifted attention to particular struggles affecting Mexico's rural
and urban workforce, including the threatening allegiance of fascism and capi-
talism. Even before the sisters had returned to Mexico, O'Higgins had insisted
that they "get immediate demands up on the walls with as little allegory as pos-
sible."[46] In a later letter to Herbst, Marion Greenwood clarified the issue: "Pro-
paganda in art is most difficult these days because if you paint revolution the peo-
ple think its already taken place. All the government buildings have the most
radical posters in them—"down with Imperialism, Fascism"—Workers of the
world unite, etc—The result is the most hopeless confusion in the minds of the
people—The only way to solve it in painting is to state the present miserable
conditions but you don't dare paint the way out—if you don't want to fool the

people."[47] Such comments reflect the ongoing debates over the function of public art in a nation where the promises of the Revolution had yet to be fulfilled. Although both did eventually include "radical posters" in their murals, they are justified by their placement within a much more complex revolutionary discourse. Yet despite the internationalism of the communist slogan at the top of the stairs, both sisters depicted easily identifiable Mexican types and events, surely to make the works personally relevant to their working-class audience.

The three walls in Marion Greenwood's stairwell are generally known by the title *The Industrialization of the Countryside,* which barely captures their complex content.[48] On the east wall, peasants at work are juxtaposed with capitalist authorities (foreman, monopolist, bookkeeper) to reveal the continuing hierarchy of classes and the social problems lurking behind an otherwise blissful market scene. Greenwood reinforced the contemporaneity of her scene through detail (modern trucks and overalls) and specific reference to current events. Her focus on sugarcane may refer to the sugar monopoly partly controlled by the Sáenz family, and was based on her own research trip to sugar plantations in Veracruz: (both she and her sister followed Rivera's model of careful onsite visits to ensure the "authenticity" of their subject).

The landing wall, the focal point for her entire cycle, includes both generalized political commentaries and tragic vignettes of individual suffering (Figure 15). Here, Greenwood moved far beyond the naturalistic spaces of her earlier murals. Different scales are dramatically juxtaposed, and disparate activities and locales are piled up in a relatively shallow field. This sophisticated play between interrelated forms and actions, which conceal the underlying compositional structure, was one of the most important skills she learned from Rivera's frescos. Greenwood framed this wall with expanded treatments of the farmer (harvesting and processing sugar) and the worker (in a steel mill), the twin foundations of socialist society. Above, two oversized and particularly Rivera-like fists of a capitalist hold a ticker tape: This sinuous emblem of capital floats above a banker, defended by a line of soldiers. In a call to arms, however, a group of four workers threaten this display of financial authority.

On the west wall, a collapsing bank facade and a tilted, cramped perspective create an unstable composition in keeping with ensuing scenes of social strife (Figure 16). Greenwood transformed a circular window into an enormous gear that appears to spin clockwise towards the center of the wall, almost propelling a line of marching soldiers forward. A Nazi flag, gun barrels, and a tank complete her thesis: Fascism, emerging from economic and social traumas, supported by the church and technology, means war. To the right, stevedores strike against shipment of petroleum in an industrial port, perhaps Tampico. Scenes like this further demonstrate her desire to make reference to her precise historical moment: Mexico saw an explosion of organized strikes throughout 1935, as inflation seriously eroded wages. Through inscribed red banners, Greenwood also encouraged working-class resistance to war and fascism through the boycott of oil exports and even sabotage. By tracing a progression from the ancient tranquillity of the canals to the modern violence of working-class protests,

Marion Greenwood summarized the complexities of Mexico's political and economic situation in the mid-1930s.

Grace Greenwood's mural cycle, known by the general title *Mining,* follows much the same trajectory, although her focus is on the extraction, production and use of mineral resources.[49] The ground floor panel depicts a mining tragedy set deep within the earth, and refers to Rivera's *Death of the Peon* in the Ministry of Education (and by extension, to Renaissance images of the entombment of Christ). More explicitly proletarian than her sister's canal scene, the panel rallies market visitors to commiserate with distant comrades. Other workers in this inventory of mining tasks push upwards, rising just as the viewer climbs the stairs (Figure 17). In the distance looms the mining town of Real del Monte, Hidalgo, where the artist had gone on a research trip. On the remainder of the wall, ore is transformed into molten silver, while a foundry foreman counts ingots. Like the seated accountant counting bundles of sugarcane in her sister's mural (one of many iconographic parallels that unite the two stairwells), this figure symbolizes the watchful presence of capitalism.

Grace Greenwood divided her landing wall into two horizontal sectors. Above, money is coined at a mint. Two men representing local and foreign bankers dip their hands into a bin of coins (equivalents of the ticker tape held at roughly the same point in Marion's mural) while a worker below looks on in anger. Like her sister, she too exposed the starvation wages of the working class, made grimmer by the contrast with gleaming wealth. Surprisingly, the most prominent figure, a worker in overalls in the foreground, remains passive, although others gesture aggressively towards the bankers. On the south wall, Grace too moved from the depiction of latent class conflict to that of actual revolt, placed within the context of a munitions factory. Outside, clusters of "white guards," or strikebreakers, subdue the workers with poison gas. Inside, the tedium of factory labor is revealed by two lines of workers, whose repeated bent backs resemble the tiers of shell casings before them. At the far left of the wall, a hint of triumph is indicated by a group of armed workers who have entered the factory space itself. This focus on the munitions factory completes her survey of the life cycle of metals, moving from the extraction of precious metals to the destructive power of iron and steel. Indeed, both sisters conclude their cycles with equally strong condemnations of war and fascism, the twin evils to be defeated by the Popular Front.

Despite differences between the two women's styles, the completed frescos (together with the concrete relief by Isamu Noguchi that faces them) form the most successfully integrated set of murals in the entire building. They are further complemented by adjacent spaces, which the sisters worked on together. Unlike any of the other muralists in the Mercado, the Greenwoods kept their ceilings free of didactic images, which allowed them to cover additional square meters at a rapid pace. Fields of blue (as if open to the sky) are surrounded by red *trompe l'oeil* girders, incorporating actual support beams. The small panel at the top of the stair, though inscribed "Marion Greenwood 36," may have been painted by both women.[50] An urban worker and a campesino cooperate in hanging and decorating a red banner bearing the Communist Party slogan. The wall serves as

a concluding metaphor not only for the murals themselves (which visually unite peasants and urban workers, and suggest further alliances among working-class spectators), but for the Greenwoods' own practice. The two workers can be read as equivalents of the two young Americans, artists who had adopted the overalls and wages of the working-class to bring their message directly to the people. In fact, Rivera had included his own self-portrait at the top of the stair in the Ministry of Education. But whether due to the requisites of social realism, the modest rejection of self-portraiture, or their reluctance to fully identify themselves with the proletarian subjects of their murals, the Greenwoods made their proxies men—perhaps an overtly feminist statement here at the conclusion of their greatest endeavor would have questioned the very spirit of equality that had given them this opportunity. In fact, men are the leading actors in both stairwells, further evidence that the tropes of proletarian art were hard to avoid.

Marion and Grace Greenwood successfully completed their murals in the Rodríguez Market in early 1936, squeaking past the contractual deadline of December 31, 1935, imposed by the DDF from an early stage. Some of their colleagues, including O'Higgins, were not so lucky. Political transformations resulting from Cárdenas' final break with the conservative political control of Calles in mid-1935 had left the muralists with new bureaucratic patrons, hardly committed to their predecessors' glory. The violent political content of several of the murals may also have contributed to the withdrawal of official support: According to *Frente a Frente,* the LEAR magazine, the new head of the DDF declared that the government not only lacked funds to complete the murals, but labeled them "subversive."[51] Perhaps more revealing, a more general change in government policy concerning propaganda was underway. One journalist noted that it had become essential "to use every possible means to fight off a counter-revolutionary coup which the Cardenistas thought was imminent as a result of the renewed Calles agitation in 1936. The press, the radio, the poster became the favored mediums. Funds were withdrawn from mural work and shunted toward the more direct publicity."[52] Radio programs, magazines, conferences, films, and "revolutionary posters," orchestrated by the regime's Department of Press and Propaganda (DAPP), would all take precedence over more geographically fixed, if less ephemeral, fresco paintings. Indeed, despite its liberal reputation, the Cárdenas regime sponsored comparatively few murals (Rivera, Orozco and O'Higgins each obtained just one federal commission between 1934 and 1940): New times called for new and more effective tactics.

After completing their murals in the Rodríguez Market, the Greenwoods asked Manuel and Lola Alvarez Bravo to photograph their walls: The prints would not only record the work in case of destruction (as Rivera's experience in New York had shown, censorship was always a possibility) but, more important, serve as evidence of their achievements for audiences back home. Their projects were widely covered in the national and foreign press, from the mainstream (*The New York Times'* Mid-Week Pictorial) to the far left (Moscow-based *International Literature*), although Herbst remained publicly silent on this, her friend's most radical mural.[53] But with no confirmed mural commissions in sight, the Greenwoods returned to the United States, press clippings, notebooks

and sketches in hand, where they quickly sought work on the various New Deal art projects, ready to build on the reputations they had established south of the border.

CONCLUSION

In April 1936, soon after Marion and Grace Greenwood returned to the United States, the *Washington Post* reported that Rivera had named them "the greatest living women mural painters."[54] Rivera had a tendency to make such definitive proclamations, which situated him as the leading arbiter of emerging talent, whose opinion could make or break a career.[55] His personal ranking of the Greenwoods may not be that surprising, given that both were deeply inspired by his work and that he had just supervised their murals in the Rodríguez Market. But in 1936, there were not that many female muralists, and none in Mexico of greater importance than these two American sisters.[56] Yet no scholar has ever fully addressed the issue of why so few women worked as muralists in Mexico, or why American women were given the first important commissions.

Even in post-revolutionary Mexico (where women were not given suffrage until 1952), the female sphere was still largely domestic. Though one could become an artist, it was difficult to leave home to work in public.[57] Women muralists, by violating expected standards of dress and by adopting a public role, had an even more difficult struggle, as Marion Greenwood's experience in Morelia testifies. Beauty was an also double-edged sword, facilitating professional connections but sometimes leading to awkward and compromising situations. Art historian Edward Sullivan has argued that the "tres grandes" were unwilling to cede wall space to women (citing their "censorship" of a mural proposed by María Izquierdo in 1945), but the success of the Greenwoods contradicts this: The limits were more internal than external.[58]

Women muralists first needed physical energy (which may explain why Frida Kahlo never attempted a mural of her own). Surely writing after a long day at work in Morelia, Marion Greenwood lamented that mural painting was "pure labor—there will never be many women fresco painters because they can't stand the grind."[59] And along with physical perseverance, women needed ambition. Lola Alvarez Bravo may have put it best when she recalled the beginnings of her career as an independent photographer after her separation from Manuel Alvarez Bravo in 1934: "In the mid-thirties, we women who were trying to get respect for our work and efforts, were very few. Not because you needed to be brave, because there really wasn't any persecution of women—though we did cause a bit of a scandal—but because what you really needed was decisiveness: to really know that you wanted to create important or beautiful things, and that you had the ability to do it."[60] But along with talent, energy, and ambition, it may also have been that *as Americans* the Greenwoods expected to be given an opportunity to work. Their background—a supportive family, early careers in New York and Paris—had provided a liberal and bohemian context in which they had come to believe that artistic success was dependent less on gender than on talent. Marion Greenwood may have complained about her

paint-splattered overalls, or that it would have been easier to be a man, but she never seems to have doubted that, as a woman, she would ultimately triumph. Equally important, both sisters were in the right place at the right time: eager to work in a provincial capital whose cultural officials were unable to attract leading Mexican artists; close allies of the well-connected and talented Pablo O'Higgins; and living in Mexico at the crest of the second wave of mural commissions following the glory days of the early 1920s.

The Mexican experience of the Greenwoods also reminds us of the crucial interrelationship between mural painting in the United States and Mexico, perhaps the only time in history when the art of the former was significantly dependent on the achievements of the latter. Like all of the Americans who worked as muralists in Mexico in the 1930s, the Greenwoods returned home to undertake new commissions under the federal arts projects of the Roosevelt administration, bringing direct experience with the Mexican model to audiences in the United States. And yet their uplifting American murals of the late 1930s and early 1940s, in keeping with the restrictions of their New Deal patrons, are not only smaller in scale, but entirely (and not surprisingly) devoid of revolutionary rhetoric. Their content is beyond the scope of this essay, but it might suffice to recall that *Blueprint for Living* (1940), Marion Greenwood's most famous American fresco, painted for a Brooklyn community center under the WPA's Federal Art Project, pales in every way when compared to her great stairwell cycle in Mexico City. Had the Greenwoods done anything similar to those market frescos in the United States (an unlikely proposition given their overt left-wing stance), no doubt they would both have long since entered the pantheon of American muralists currently dominated by Thomas Hart Benton, John Steuart Curry and Ben Shahn, among others.

After the 1940s, Grace Greenwood practically disappeared from the artistic scene, having enjoyed much less critical and financial success than her sister. Marion Greenwood achieved continuing recognition for her paintings of the American South and China, but with the rise of abstraction in the postwar decades, her representational style and conservative subjects left her in the margins. At the time of her early death in a car accident near Woodstock in 1970, few remembered that at a specific historical and cultural moment, Mexico had offered these two American sisters the chance to push their talents to the limits, and a space to explore the possibilities of a radical public art that would never be permitted in the United States.

ACKNOWLEDGMENTS

Many friends, colleagues and institutions have helped in the elaboration of this essay. In particular, I would like to thank Esther Acevedo, who generously shared her research on the Rodríguez Market, and Robert Plate, who provided indispensable documentation and advice on Marion Greenwood. The insightful comments of Mary K. Coffey, Diana L. Linden and Rebecca Bedell, readers of

earlier drafts, helped refine many of my arguments and ideas. Thanks also to Laura Cohen, Francisco Reyes Palma and Sal Sirugo.

NOTES

1. Given the lack of a suitable alternative, the adjective "American" is used in this essay to refer to the United States. For additional illustrations of the Greenwoods' Mexican murals, see James Oles, *Las hermanas Greenwood en México* (Mexico City: Círculo de Arte, Conaculta, 2000); and James Oles, *South of the Border: Mexico in the American Imagination, 1914–1947* (Washington, DC: Smithsonian Institution Press, 1993), p. 193.

2. "Never before or after have any American painters received such overwhelming praise or left behind such vivid memories." Verna Carleton Millan, *Mexico Reborn* (Boston: Houghton Mifflin, 1939), p. 175.

3. For a full discussion of these artists and their commissions, see James Oles, "Walls to Paint On: American Muralists in Mexico, 1933–1936" (Ph.D. dissertation, Yale University, 1995).

4. MG to her mother, April 6, 1933. Marion Greenwood Archive, courtesy Robert Plate (hereafter, MGA).

5. Cited in Greta Berman, *The Lost Years: Mural Painting in New York City under the WPA Federal Art Project* (New York: Garland, 1975), p. 75.

6. "My Murals in Mexico and the United States," mss. (c. 1941), p. 4, MGA.

7. The affair is documented in letters in the Josephine Herbst Papers, Yale Collection of American Literature, Beinecke Rare Book and Manuscript Library, Yale University (JHP). See also Elinor Langer, *Josephine Herbst* (New York: Warner Books, 1985), pp. 140–45.

8. On O'Higgins, see Elena Poniatowska and Gilberto Bosques, *Pablo O'Higgins* (Mexico City: Fondo Editorial de la Plástica Mexicana, 1984); Oles, "Walls to Paint On," Chapter 3.

9. Howard Cook painted another mural (*Fiesta Taxco*) in the same hotel later that year. The building was later converted into a school. In subsequent years, many other hotel owners saw similar benefits in commissioning murals.

10. MG to her mother, February 24, 1933, MGA. Two students, Margarita Torres and Juana García de la Cadena, completed minor murals in the late 1920s. Their medium is unknown, but it is unlikely they worked in fresco (the murals are now lost). See "Las escuelas libres de pintura," *¡30–30! Organo de los pintores de México,* no. 1 (July 1928): 6–7.

11. Josephine Herbst, "Marion Greenwood," *Mexican Life* 9:7 (July 1933): 19. Two oil paintings completed in Taxco, as well as a sketch for the mural, are illustrated here.

12. MG to her mother, December 27, 1932, MGA.

13. MG to her mother, April 30, 1933, MGA.

14. MG to her mother, May 8, 1933, MGA.

15. MG to JH, November 19, 1933, JHP.

16. Marion Greenwood, interview with Dorothy Seckler, Woodstock, New York (January 31, 1964). Archives of American Art, Washington, DC (AAA).

17. MG to JH, October 26, 1933, JHP.

18. MG to JH, June 22, 1933, JHP.

19. According to a local historian, "the mural provoked the ironic comments of one teacher who taught here in the 1930s, who said that what he most liked about it was that it showed, for the first time in his life, that the Tarascans actually worked." Xavier Tavera

Alfaro, *Paseo por Michoacán: guía para el turista,* 2nd ed. (Morelia: Fimax Publicistas, 1976), p. 15.

20. Josephine Herbst, "Project: Fresco University of Michoacán," mss. (c. 1934), p. 2, JHP.

21. MG to JH, January 7, 1934, JHP. Emphasis in the original. Herbst's list of titles does not survive.

22. S.L.A. Marshall, "Two Pretty American Sisters Find Adventure Painting Pictures on Mexican Walls," *Detroit News,* Feature Section (March 29, 1936): 1, MGA. This sensational article includes reference to a mob that chased Marion Greenwood after she asked a local woman to pose naked. There is no confirmation of this story in Greenwood's letters.

23. MG to her mother, August 16, 1933, MGA. One American journalist, and a friend of the Greenwoods, later noted that the sisters, although dressed "in blue jeans and men's shirts, with wet paint smudged upon their cheeks, are always the center of a group of admiring males." Verna Carleton Millan, "Montparnasse to Mexico," *Brooklyn Daily Eagle* (March 1, 1936): F8.

24. MG to JH, December 3, 1933, JHP.

25. MG to JH, September 13, 1933, JHP.

26. Josephine Herbst, "The Artist's Progress," *Mexican Life* 11:3 (March 1935): 24.

27. In some publications and official documents, Grace Greenwood used her married name Grace Ames (or Grace Greenwood Ames).

28. On the murals in the Museo Michoacano by Ludins (*Modern Industry,* 1934; destroyed) and Guston and Kadish (*The Workers' Struggle For Liberty,* 1934–1935), see Oles, "Walls to Paint On," pp. 167–184 and 335–358.

29. MG to JH (November 3, 1933), JHP.

30. Grace Greenwood, interview with Joseph Trovato, Woodstock, New York (January 29, 1965), AAA. The book was Alma Reed's *José Clemente Orozco* (New York: Delphic Studios, 1932).

31. MG to JH, February 23, 1934, JHP. The muralists ultimately earned 13.5 pesos (about $3.75 US) per square meter, but they had to pay for materials, scaffolds and assistants out of pocket. Esther Acevedo, "Dos muralismos en el mercado," *Plural* 11:121 (October 1981): 47.

32. MG to JH, February 23, 1934, JHP.

33. MG to JH, May 11, 1934, JHP.

34. Edward Biberman to MG [September 23, 1934], MGA.

35. The Greenwood sisters worked together on the following projects in the U.S.: Immigration Building, Ellis Island (1934; PWAP; not completed); Westfield Acres Housing Project, Camden, New Jersey (1936–1938; TRAP); community center designed by Oscar Stonorov (1937; National Society of Mural Painters; not completed). Grace Greenwood planned a mural for Bellevue Hospital, New York City (1939; WPA/FAP; not completed) and completed another for Lexington, Kentucky, post office (1939; TSFA). Marion Greenwood painted murals in the Crossville, Tennessee, post office (1939; TSFA) and the Red Hook Community Center Building, Brooklyn (1940; WPA/FAP). She also painted murals at the University of Tennessee (1955) and Syracuse University (1965).

36. "Sees Artists Here in Serious Straits," *New York Times* (September 21, 1934). Scrapbook, MGA.

37. Acevedo, "Dos muralismos en el mercado," p. 46.

38. David Alfaro Siqueiros, "Rivera's Counter-Revolutionary Road," *New Masses* 11:9 (May 29, 1934): 17.

39. See Robert Evans [Joseph Freeman], "Painting and Politics: The Case of Diego Rivera," *New Masses* 7:9 (February 1932): 22–25; Emanuel Eisenberg, "Battle of the Century," *New Masses* 17:11 (December 10, 1935): 18–20; and Francisco Reyes Palma, "Diego y Trotsky," *La Jornada Semanal* 102 (August 31, 1986): 3–5.

40. Eisenberg, p. 19.

41. La metrópoli cuenta con el primer mercado de América," *El Nacional* (November 25, 1934): sec. 1, p. 2. Along with the Greenwoods and O'Higgins, Ramón Alva Guadarrama, Angel Bracho, Raúl Gamboa Cantón, Antonio Pujol, Pedro Rendón, and Miguel Tzab painted murals in the market. Isamu Noguchi, the last to join the project, created a colored-cement relief immediately adjacent to the Greenwoods' murals; see James Oles, "International Themes for a Working Class Market: Noguchi in Mexico," *American Art,* Vol. 15, No. 2, (Summer 2001): 10–33.

42. For details, see Acevedo, "Dos muralismos"; Oles, "Walls to Paint On," pp. 226–247.

43. See Millan, *Mexico Reborn,* p. 174; also Francisco Reyes Palma, "La LEAR y su revista de frente cultural," *Memoria* 71 (October 1994): 25–31, 35–38. I have found no evidence (like ID cards) that the Greenwoods were formal members of the LEAR. The organization was disbanded in 1938.

44. An official Communist Party attack unfairly accused Rivera of controlling the decoration of the Rodríguez Market. Mary Randolph, "Rivera's Monopoly," *Art Front* 2:8 (December 1935): 12–13. On the sketches, see Oles, *South of the Border,* pp. 190–91.

45. To calculate her pay rate, Marion Greenwood recorded the wall dimensions and completion dates in a notebook, now in the MGA. No similar record survives for Grace's walls, although it can be assumed her dimensions and progress were roughly the same. Foyer wall (February 16, 1935): 17 m^2; first rising wall (May 18): 39 m^2; landing wall (July 22): 25 m^2; ceiling (September 26): 35.1 m^2; second rising wall with window (December 31): 24.48 m^2; shared wall at top of stairs (January 1936): 8.95 m^2. This gives a total of 140.58 m^2 for each sister's mural, ceiling included. Together with the shared panel, that brings the total area decorated by both sisters to 290 m^2.

46. O'Higgins to GG and MG, June 12, 1934, MGA.

47. MG to JH, December 15, 1934, JHP.

48. This title appears in Esther Acevedo, ed., *Guía de Murales del Centro Histórico de la Ciudad de México* (Mexico City: Universidad Iberoamericana, 1984), p. 88, which I have followed. This is the same name given to a panel in Rivera's Ministry of Education stairwell. I have found no evidence of the original title (if Greenwood even applied one). An earlier publication titles the east and landing walls "The Exploitation of the Peasant," [Carlos Mérida, *Frescoes in Rodríguez Market by Various Artists* (Mexico City: Frances Toor Studios, 1937)], while "Fruits and Vegetables," was used in "Mexican Market," *Time* 26:4 (July 22, 1935): 25.

49. The cycle was titled "Money" in the 1936 *Time* article.

50. Mérida, *Frescoes in Rodríguez Market,* n.p.

51. "¡¡Protesta!!," *Frente a Frente* 2 (April 1936): 23.

52. Plenn, *Mexico Marches,* p. 339.

53. See "Two Young Americans in Mexico's Renaissance," *New York Times,* Mid-Week Pictorial (April 18, 1936); "The Mexican Murals of Grace and Marion Greenwood," *International Literature* 4 (1936): 92–96. They were also favorably reviewed by Howard Philips, the editor of *Mexican Life.*

54. "Marion Greenwood Applauded for Steady Rise to Mural Fame," *Washington Post* (April 12, 1936). Scrapbook, MGA.

55. In fact, Rivera promoted several other women artists, among them María Izquierdo, his American assistants Ione Robinson and Lucienne Bloch and, of course, Frida Kahlo.

56. The only other women who had completed significant murals in Mexico by this time were Ryah Ludins and the Mexican Aurora Reyes (*Attack on the Rural School-teachers,* 1936, Centro Escolar Revolución, Mexico City). For further details, see Oles, *Las hermanas Greenwood,* pp. 7–12.

57. See also Edward Sullivan, *La mujer en México/Women in Mexico* (Mexico City: Centro Cultural/Arte Contemporáneo; New York: National Academy of Design, 1990), pp. XLVII–LIII.

58. Ibid., p. LIII. It could be argued that Izquierdo's mural was rejected for its poor design, not for her gender.

59. MG to her mother, November 21, 1933, MGA.

60. Lola Alvarez Bravo, *Lola Alvarez Bravo: Recuento fotográfico* (Mexico City: Penélope, 1982), p. 95.

SELECTED BIBLIOGRAPHY

Acevedo, Esther, ed. *Guía de murales del Centro Histórico de la Ciudad de México.* Mexico City: Universidad Iberoamericana, 1984.

———. "Dos muralismos en el mercado," *Plural* (Mexico City) 11:121 (October 1981): 40–50.

Carr, Barry. *Marxism and Communism in Twentieth Century Mexico.* Lincoln: University of Nebraska Press, 1992.

Debroise, Olivier, ed. *Modernismo y modernización en el arte mexicano, 1920–1960.* Mexico City: Museo Nacional de Arte, 1992.

Delpar, Helen. *The Enormous Vogue of Things Mexican: Cultural Relations between the United States and Mexico, 1920–1935.* Tuscaloosa: The University of Alabama Press, 1992.

Edwards, Emily. *Modern Mexican Frescoes.* Mexico City: Central News Co., 1934.

———. *Painted Walls of Mexico from Prehistoric Times to Today.* Austin: University of Texas Press, 1966.

Garner, Bess Adams. *Mexico: Notes in the Margin.* Boston: Houghton, Mifflin, 1937.

Herbst, Josephine. "Marion Greenwood," *Mexican Life* 9:7 (July 1933): 19–21.

———. "The Artist's Progress," *Mexican Life* 11:3 (March 1935): 24–26.

Kalaidjian, Walter. *American Culture Between the Wars: Revisionary Modernism & Postmodern Critique.* New York: Columbia University Press, 1993.

Leal, Fernando. "Marion Greenwood: Una artista norteamericana," *El Nacional,* rotogravure section (September 15, 1935): 3.

"Los frescos de Grace Greenwood," *Todo* 3:128 (February 11, 1936): 20–21.

"Marion Greenwood Applauded for Steady Rise to Mural Fame," *New York Post* (April 12, 1936).

Marshall, S.L.A. "Two Pretty American Sisters Find Adventure Painting Pictures on Mexico Walls," *The Detroit News,* feature section (March 29, 1936): 1+.

Mérida, Carlos. *Frescoes in Rodríguez Market by Various Artists.* Mexico City: Frances Toor Studios, 1937.

"Mexican Market," *Time* 26:4 (July 22, 1935): 24–25.

"The Mexican Murals of Grace and Marion Greenwood," *International Literature* (Moscow) 7 (July 1936): 92–96.

"Mexico a través de una pintora de los Estados Unidos," *Todo* 3:127 (February 4, 1936): 20–21.

Millan, Verna Carleton. "Montparnasse to Mexico," *Brooklyn Daily Eagle* (March 1, 1936): F8–F9.

————. *Mexico Reborn.* Boston: Houghton Mifflin, 1939.

Nochlin, Linda, and Helen A. Harrison. *7 American Women: The Depression Decade.* Poughkeepsie: Vassar College Art Gallery, 1976.

O'Connor, Francis V. "The Influence of Diego Rivera on the Art of the United States during the 1930s and After," in *Diego Rivera: A Retrospective.* Detroit: Founders Society, Detroit Institute of Arts, 1986.

Oles, James. *South of the Border: Mexico in the American Imagination, 1917–1947.* Washington, DC: Smithsonian Institution Press, 1993.

Plenn, J.H. *Mexico Marches.* Indianapolis: Bobbs, Merrill, 1939.

Rivas, Guillermo [Howard Phillips]. "Mexican Murals by Marion Greenwood," *Mexican Life* 12:1 (January 1936): 24–25+.

————. "The Murals of Grace Greenwood," *Mexican Life* 12:12 (December 1936): 28–30.

————. "American Women Painters in Mexico," *Mexican Life* 17:11 (November 1941): 25–30.

Rodríguez, Antonio. *A History of Mexican Mural Painting.* London: Thames & Hudson, 1969.

Salpeter, Harry. "Marion Greenwood: An American Painter of Originality and Power," *American Artist* 12:1 (January 1948): 14–19.

Shapiro, David, ed. *Social Realism: Art as a Weapon.* New York: Frederick Ungar Publishing Co., 1973.

"Sister Act in Art," *New York Woman* (March 31, 1937).

Star-Hunt, Jack. "Brooklyn Girls Delight Mexico with 8 Murals," *New York Herald Tribune* (March 4, 1934).

————. "Two American Girls Figure in Mexican Art Movement," *Kansas City Star* (April 4, 1935).

Suárez, Orlando S. *Inventario del muralismo mexicano (Siglo VII a. de C./1968).* Mexico City: UNAM, 1972.

Sullivan, Edward. *La mujer en México/Women in Mexico.* Mexico City: Centro Cultural/Arte Contemporáneo; New York: National Academy of Design, 1990.

"Two Sisters Paint Out Precedents; Are as Attractive as Their Work," *Brooklyn Eagle* (February 5, 1939).

"Two Young Americans in Mexico's 'Renaissance'," *New York Times,* Mid-Week Pictorial (April 18, 1936).

Whiting, Cécile. *Antifascism in American Art.* New Haven: Yale University Press, 1989.

Wolfe, Bertram D. *Diego Rivera: His Life and Times.* New York: Alfred A. Knopf, 1939.

8

Fashioning Nationality: Sam Francis, Joan Mitchell, and American Expatriate Artists in Paris in the 1950s

Michael Plante

The issue of national identity arose in reference to the works of American expatriate artists living in Paris during the 1950s, specifically the ways in which European audiences regarded their paintings. Artists such as Sam Francis and Joan Mitchell managed to present themselves to Parisian audiences as *demi-françaises,* that is, as partly French and partly American in character. It is curious to note the success of artists such as Mitchell and Francis, who operated, or were perceived to operate, within the discourse of the tradition of French painting. They were perceived to be less American in their point of reference, hence more successful as artists within the highly nationalistic art world of postwar Paris. Significantly, this nationalistic revival of the French tradition—in particular the renascent interest in the late works of Claude Monet—allowed the expatriate Americans to carry an arguably legible "Frenchness" that elevated them in the eyes of French critics to the status of *demi-françaises.* Yet, the issue was further complicated by the fact that while the work of Sam Francis was read, at times, as operating within the French tradition, he was also regarded (paradoxically, at times) as the primary example of contemporary American painting. It is the way that nationalism seemed to be legibly indexed and fluid in the work of Francis and Mitchell—shifting between what Serge Guilbaut has termed the "rough" and the "slick," or the "American" and the "French"—that is the subject of this chapter.[1]

Sam Francis and Joan Mitchell were part of a broad community of American expatriates who lived in Paris during the 1950s. In the period between 1946 and 1958, France witnessed a wave of American artists arriving on its shores seeking to educate themselves in the visual arts. This second "occupation" of Paris, this time by Americans, was of such a large scale that it must be regarded as a broad-based cultural phenomenon. At the height of this Paris revival in 1953, one

French critic claimed that he knew of three hundred American painters living in the French capital.[2] Yves Michaud's study of Americans in Paris estimates as many as six hundred artists had passed through the French capital by 1965.[3] The presence of museums and monuments, as well as the heritage of European culture, was a powerful attraction to young American artists. As well, there existed the myth of bohemian Paris, a myth that had grown fat on a similar invasion of Paris that had developed among American artists and *literati* during the 1920s.[4]

The late 1940s was an ironic moment in the history of American art for artists once again to discover Paris. Assisted by the European war refugees, New York had developed a painting culture during the war that challenged Paris as the center of artistic activity. But it is perhaps equally ironic that many of the painters and sculptors who journeyed to France during the first years after the war would emerge as important contributors to American painting during the late 1950s and early 1960s. The most significant and frequently cited reason for the Paris pilgrimage was the desire to assimilate the French modernist tradition. This was partly a nostalgic desire for the prewar "high life," but there was also a genuinely felt need in America, after a long period of artistic isolation (particularly outside of New York), to incorporate the lessons of recent European art into American painting culture. The existence of an expatriate French community in New York—refugees from Hitler's onslaught—is frequently cited as an important influence on the development of American painting. Certainly, the presence of such great figures as André Masson and Piet Mondrian proved influential to New York painting. However, there were other ways in which the significance of the French tradition of painting was communicated to a broader New York and American audience.

The development and influence of American artists living and exhibiting their work in Paris is one facet of the complex network of linkages that united Paris and New York during the first postwar decade. The definitions of what exactly constituted American style, or identity, shifted considerably with the impact of exhibitions of American painting that began in 1952. Additionally, this shifting perception of American painting had a considerable impact on the reception of the work of American expatriates, especially those, like Sam Francis and Joan Mitchell, who were longtime residents of the French capital. Americans students and artists who traveled to Paris in the late 1940s found a very different situation there than the "gay Paris" of the 1920s. France had many interior problems during the postwar years; in addition to the problem of repatriating the prisoners of war and the deportees, there were issues of prosecuting the collaborators, regulating the black market, and the imposition of severe rationing of food and heat that continued well into 1947. Yet Fourth Republic prosperity and expansion came at a price: France had to accept economic dependence on the Western alliance, particularly the United States. From the first entry of Americans into France—the Allied landing at Normandy—the French had to cope with military dependence: French soldiers were placed on American troop lists and subject to American military regulations. In a sense this was a metaphor for the character Franco-American diplomacy would develop during the late 1940s and 1950s. It was during this

early period that the French began to refer to the U.S. military presence as the "second occupation."[5]

Within the context of Cold War politics and the tense relationship between France and the United States, Francis' work will be examined with particular attention to the extent to which it was interpreted as "American," on the one hand, and "French," on the other. An argument can also be made for noting similar strategies in the work of Joan Mitchell during this time. Mitchell and Francis were part of the same crowd in Paris, but they did not set out to accomplish the same things. In fact, these artists adopted very different strategies to resolve the nationalistic context of their works. Francis actively engaged himself within the discourse of the revival of French traditionalism in his painting during the 1950s. Mitchell, it would seem, tried to consciously distance herself from the Paris scene, disavowing any interest in Monet's work, while her paintings increasingly were viewed, by the Americans and French alike, as fitting neatly within the context of contemporary French painting. These artists accomplished what French critics had been demanding for years: They brought the most advanced ideas in American painting to the feet of the École de Paris.

SAM FRANCIS AND THE FRENCH TRADITION

Sam Francis achieved the greatest level of both critical and popular success of any of the American expatriate artists in Europe. This is ironic, given his absence from New York, since Francis embodied the New York "style" for art viewers outside the U.S. By the mid-1950s, his popularity had spread beyond Paris to other parts of Europe, particularly to England and Switzerland. Arnold Rüdlinger, the director first of the Kunsthalle in Bern and later, the Kunsthalle in Basel, became one of Francis' ardent supporters, and through Francis' example came to comprehend the accomplishment of the New York School. Franz Meyer, another of Francis' Swiss patrons from the 1950s recalled, "To Rüdlinger as to many European art lovers who have been guided by him, Francis meant the real intermediary to America. Rüdlinger's experience with Francis' art led the way to Still, Kline, Rothko, and Newman."[6]

Francis' accomplishment during the 1950s was to manage to bypass the complicated contemporary art scene in Paris—the social realists, the geometric abstractionists who had descended from Mondrian, and the Cercle et Carré group—and develop a stylistic practice that was located in the French tradition of optical color, yet informed by contemporary American painting. Although Francis' work from the 1950s exhibits parallel concerns with the Abstract Expressionists in New York (many of whom, though much older, were nonetheless developing simultaneously with Francis), Francis' painterly preoccupation with issues of surface and color rendered his art more palatable to French tastes than New York School painting. And it was his fundamental employment of many of the same formal issues that the New York School engaged (particularly the Field painters) that allowed him to function as a mediating link between New York and Europe. His formal similarity to New York School painting is stressed because, like most of his generation (Ellsworth Kelly, Jules Olitski, etc.), Francis never addressed content-related issues such as

myth, and what Michael Leja called the "modern man discourse" that occupied the first generation of the New York School during these years.[7]

After receiving his M.A. degree from Berkeley in 1950, Francis decided to use the rest of his G.I. Bill funding in Paris. Upon arriving in the French capital, he registered for classes at the Académie Fernand Léger. Beyond his appeal as a master of modern painting, Léger had also taught painting at Mills College in Oakland, California, though he evidently spoke very little English. Francis later remembered Léger with great affection, but the French artist had a certain amount of antipathy toward Francis' work. An early acquaintance with Canadian expatriate Jean-Paul Riopelle provided a means of introduction to many of the leading intellectuals and promoters associated with contemporary art in Paris, including Michel Tapié and Georges Duthuit. Through these connections, Francis began exhibiting from as early as 1950, when one of his paintings was included in the prestigious Salon de Mai. The next year, in 1951, he is listed in the section designated "Participation étrangères" under the "U.S.A." for a painting titled *Beyond the Mask*.[8] It was most likely at the Salon de Mai that Riopelle first saw Francis' work and decided he wanted to meet the American artist. Also in 1951, Francis was included in several group exhibitions, including Michel Tapiés "Un art autre," and had a one-person exhibition at the Galerie du Dragon. Tapié meant the term *art autre* to encompass the range of art forms that emerged in Europe and America after World War II, while disregarding the respective nationalist agendas. Tapié used the term *autre* to mean more than the literal translation "other," implying an art that was defined reactively against previous artistic traditions. Tapié's agenda was to champion individualism within the context of an "international style" of postwar art. By assembling artists of differing nationalities, each of whom employed the Informal or Abstract Expressionist style (however loosely), Tapié thwarted any grouping of these artists into a traditional collective avant-garde organized around nationality.[9]

By all accounts, Francis' one-person exhibition at "la Dragonne" was a smashing success. Through Riopelle and Duthuit, Francis had become acquainted with most of the prominent contemporary art figures in Paris. Culturally speaking, Francis' exhibition launched the three-pronged American invasion of Paris in 1952. Francis' exhibition was hung in February 1952; "Regards sur la peinture américaine," the survey of contemporary Abstract Expressionism, was on view at the Galerie de France from February 26–March 15, 1952; and "Jackson Pollock" was presented at the Studio Paul Facchetti in March 1952. These three exhibitions provided a thought-provoking view of contemporary American painting, though the attention given to Pollock and Francis meant that the gestural component of American painting was slighted (however, Paris had already seen a solo exhibition of Hans Hofmann's work at the Galerie Maeght in 1949). Because of these three exhibitions, contemporary American painting was accessible to the French in 1952. The French could choose to ignore it, but it was impossible to avoid.

Francis included the paintings he had executed since arriving in Paris in his exhibition. In *Red and Pink* of 1951 (Figure 18), he accelerated the fragile subtlety of his earlier with more color. *Red and Pink* makes use of a variety of

stained red, pink and yellow hues that hang like a veil over a spread of gray cells, or corpuscles (as they are regularly described). Essentially, what Francis has constructed is an Impressionist palette of prismatic colors. These paintings—strange, cloud-like discursions into color—caught the art world off guard. The critic for the Paris *Herald Tribune* noted his surprise at encountering this new approach toward abstraction that Francis embodied:

> I have seen nothing that quite resembles his painting either in Paris or elsewhere. Whereas non-objective artists strive chiefly for a greater concentration of plastic essences, Mr. Francis merely wants to harmonize the various smoke-like formations in his canvases into an essentially monochromatic composition.[10]

This exhibition was the first opportunity many Europeans had to see several examples of Francis' work—or that of any young American artist—in one place. Franz Meyer recalled his own response to Francis' work and the difficulty he felt in placing Francis into a ready category of contemporary art:

> I remember my own stupefaction in front of the paintings of his first exhibit in Paris in 1952 with Nina Dausset in the Galerie du Dragon. The Paris avant-garde at that time meant Bazaine and Manessier, Vasarely and Poliakoff, either loose, painterly or constructive form in a closed compositional space. Obviously the young painter had something completely different in mind. For never did the square of the frame in his white or reddish tinted paintings block the constant movement of cloud packs and shreds.[11]

The large scale of Francis' work made a significant impact, while seeming completely foreign, to the contemporary art world in Paris. Robert T. Buck has noted that at this early date, only the canvases of Jackson Pollock and Barnett Newman extended to larger sizes than what Francis was then working with.[12]

The Sam Francis exhibition at the Galerie du Dragon was reviewed by *Arts*. In contrast to other reviews of American painting, the response to Francis was unqualified in its praise. The critic worked to associate Francis' work with that of Bonnard, which is a measure of the degree to which Francis' paintings were readily interpreted within the tradition of French modernism:

> This is, among the exhibitions that I visited this week, the most astonishing, the most deeply moving. Before the large canvases of this young Californian painter in Paris a year now, one feels a shock, an emotion, as though perched on the edge of a new world. One feels drawn as by an abyss, spellbound. Did Sam Francis pass through the boundaries of the inexpressible? What then are these paintings? At first, they seem emptied: a kind of clotted fog, whitish or red. Jules Verne in his interstellar journeys or at the center of the earth must have crossed similar spaces. Sometimes, but not necessarily, the colorful masses (drawn from a palette often very close to Bonnard's), appears as if the material were melting, were introduced by dyes. Pictures of the scenes which play under closed eyelids in full sun light? Maybe, but that doesn't matter. Is it necessary to rank Sam Francis among those whom Michel Tapié called "Les Signifiants de l'informel"? Maybe. It seems good in any case that the boundaries of the Informel are once in a while dismissed. To what depths will we reach? One could look for some components of the answer in the drawings and the texts of Henri Michaux. The paintings of Sam Francis are worthy of just so great a comparison.[13]

Peuchmaurd viewed Francis as an Autre art painter who pushed against the limits of that category. An argument might be made that Francis' work was optically too striking, overly delicate in its expression to be viewed within Tapié's Autre category. And though Tapié included Francis in all of the 1952–1953 exhibitions and catalogues (and sponsored his work later at the Galerie Rive Droite), Francis' work did not fully embody the Autre art sensibility. Francis' paintings did continue the tradition of decorative surfaces, and lush color that had been forged by Renoir, and continued with Vuillard, Bonnard and Matisse.

Sam Francis was the center of a loosely organized group of artists and writers who met almost daily. Central to the group were Canadian painter Jean-Paul Riopelle, writer and critic Georges Duthuit, and American artists Norman Bluhm, Paul Jenkins and Joan Mitchell. Georges Duthuit was a generation older than the others (born in 1891), and had established himself as a major art historical voice with the recent publication of his book *Les Fauves* in 1949 (English edition published in 1950). Immediately after the war he founded the American review *Transition,* which had ceased publication by 1950. His most lengthy work was the three-volume *Le Musée inimaginable* (1956), which was a response to André Malraux's *Le Musée imaginaire* (1947). Duthuit had married Matisse's daughter Marguerite, and it was through them that the American artists—particularly Norman Bluhm, Sam Francis and Jean-Paul Riopelle—had access to both the French master and his work. Francis spent the summers of 1951 and 1952 with the Duthuits at their summer house in Aix-en-Provence. Presumably, some of the other Americans went also. The Duthuit-Matisse family proved very supportive of the Americans, purchasing pictures and assisting with exhibitions. They purchased several of Francis' paintings. Duthuit came to call the art they produced *abstrait chaud,* in reference to its high-key color and loose handling, in opposition to the geometric abstraction, or *abstrait froid,* inherited from Mondrian that constituted an important stylistic practice in postwar Paris. Francis remembers that they were uninterested in the work of Picasso, or any of the newer stylistic French trends. Significant to their experience, though, was the art of Claude Monet, which was at that moment undergoing something of a revival.

A new examination of the late works of Claude Monet—the works executed in his garden at Giverny, and consisting mostly of the oversized panels of *Nymphéas*—occurred in both Europe and the United States during the second half of the 1950s. In his seminal essay "'American-Type' Painting" from 1955, Clement Greenberg discussed the importance that Monet's late paintings had in repudiating of Cubist pictorial structures, as well as the influence they exerted over the Abstract Expressionists, particularly Clyfford Still and Barnett Newman:

Until a short while ago Monet, who had gone furthest in the suppression of value contrast, was pointed to as a warning in even the most adventurous circles. It was maybe a dozen years ago that some of Monet's later paintings began to seem "possible" to people like myself, which was at about the same time that Clyfford Still emerged as one of the original and important painters of our time. And as it turned out, Still, along with Barnett Newman, was an admirer of Monet.[14]

Greenberg wrote this essay in the same year that The Museum of Modern Art in New York acquired its first major *Nymphéas* panel. Greenberg stressed in his article of the following year, "The Later Monet" (1956), that the influence of the late water lilies upon the Abstract Expressionists was accomplished through reproductions, as there were no opportunities to see the actual paintings in New York.[15]

In October 1956, Knoedler's mounted the first New York exhibition of several of the late Monet water lilies in a show titled "Les Nymphéas, serie de paysages d'eau." These paintings had been shown earlier that year in Paris, at the Galerie Katia Granoff. This exhibition and the criticism it generated—the essay by Greenberg, for example—resulted in an extremely agile reevaluation of Monet's late work that was mediated (perversely enough) by the contemporary paintings of the New York painters. In other words, the late Monet became comprehensible through Abstract Expressionist eyes. It must be noted that this "revival" of Monet's paintings in New York occurred after an entire generation's disregard for the Impressionist painter's last statement. Cubism exerted a compositional hegemony over avant-garde painting between the two world wars that viewed the late Monet as unstructured, diaphanous and sugary sweet. As Greenberg wrote, "Never before or after the 1900s, apparently, did the precious so quickly become the banal. By 1920, Monet's later art had acquired a period flavor even for eyes not offended by what the avant-garde found wrong with it."[16]

The Monet revival in France encompassed all of New York's issues, but with a few more twists. Monet fit snugly into the category of the "French tradition" that the more conservative French critics were championing, and nationalistic pride—particularly after the discouragement of the Occupation—was certainly part of renewed interest in the Impressionist painter. The advantage that Parisians gained in rediscovering Monet, of course, was the presence of the artist's long-unkempt house at Giverny, and the forgotten murals installed at the Musée de l'Orangerie on the Place de la Concorde. It is hard for us today to believe how infrequently seen these murals had become, particularly as they were located in the center of modern Paris. But it was not until the early 1950s that artists began to visit the installation at the Musée de l'Orangerie and consider the accomplishment of the murals.

The outpouring of commentary on Monet's work in 1952 indicates that the revival of his reputation began at least three to four years earlier in Paris than in New York.[17] If the Orangerie installation represented the public-minded Monet, the gardens and studio at Giverny presented a different view of the French master to the artists who visited there. The house and gardens were not officially opened to the public, but visitors were allowed to wander through the gardens, even to go through the contents of the vast studio that Monet had built to paint the *Nymphéas*. More than any other of the American artists in Paris, Francis identified himself and his work with Monet's achievements. Francis declared his attachment to Monet shortly after he arrived in Paris at dinner one night at the home of Nina Kandinsky, the master's second wife. According to one of the

other guests that night, when asked what sort of art he made, Francis replied: "I make the late Monet pure."[18]

By mid-decade, Sam Francis was "the hottest American painter in Paris," according to *Time* magazine.[19] He had become instantly famous in Paris after Madame Matisse purchased one of his paintings out of the Galerie du Dragon exhibition. He had exchanged a painting with Alberto Giacometti. And he had one-person exhibitions in 1955 and 1956 at the Galerie Rive Droite, the prestigious modernist gallery owned by Jean Larcade and supervised by Michel Tapié. In a review of the 1956 exhibition, Julien Alvard clearly comprehended the degree to which Francis had accessed the French tradition, and Alvard understood these paintings in those terms:

The exhibition of Sam Francis will confirm all the hopes that we could have placed on painters this personal and original. The breath of Impressionism, that of Monet mainly, banishes all human presence from his canvases.
 But the romanticism of the water succeeds, after an almost total eclipse of some thirty years. This is a romanticism of the atmosphere whose rhythm travels through the canvases of Sam Francis.[20]

Francis had always received critical support in Paris, but by the mid-1950s he was also enjoying the proceeds from the sale of his paintings. In 1957 he wrote to John Hultberg of a sale: "I have just sold the biggest painting I have so far done here. A stroke of luck as it was bought one afternoon by a man who came by chance & bought it after about five minutes deliberation for 1,000,000 francs—about $3,000."[21]

Francis also became the only member of the circle of Americans living in Paris to begin developing a reputation back in the States without leaving Paris. Alfred Barr purchased Francis' *Black in Red* (1953) for the Museum of Modern Art, New York, out of the first of the Rive Droite exhibitions in 1955. Later that year, Dorothy Miller visited his studio in Paris and selected canvases for her upcoming exhibition at the Museum of Modern Art, *12 Americans.*[22] In 1955 Francis also exhibited at the Pittsburgh International at the Carnegie Institute. And early in 1956, he had his first one-person exhibition in New York, at the Martha Jackson Gallery.

Joan Mitchell was one of the last of the American artists to move to Paris.[23] After her initial expatriation in 1948, she moved to Paris gradually, going back and forth between New York and the French capital for four years. She arrived in Paris (for the second time) in the summer of 1955. She had been living in New York since her return to the U.S. in 1949, very much a part of the Abstract Expressionist milieu. She showed at the Ninth Street Show in 1951 and at the Stable Gallery in 1953. After her psychiatrist suggested a trip to France in 1955, she wrote her friend Shirley Jaffe that she was going abroad. From 1955 until 1959 when she moved to Paris permanently, she spent her summers in France and her winters in New York. Jaffe introduced her to the circle around Francis and Duthuit, and she began what would become a 24-year relationship with Jean-Paul Riopelle.

After five years in New York, Mitchell found that it took her some time to develop a taste for what was being done in Paris. For example, it took her quite a while to like Sam Francis' paintings. It was "like acquiring a taste for olives or beer."[24] The *abstrait chaud* crowd had already congealed and was beginning to come apart by the time Mitchell arrived in 1955.[25] Mitchell exchanged her St. Mark's Place studio in New York for Paul Jenkins' studio in the 14th arrondissement. Perhaps because of the fragmentary nature of the Pacifique group and the *abstrait chaud* group (and their various overlappings) at this late date, Mitchell claims that it was never a "group," just "Americans clinging to Americans."

Ironically, Joan Mitchell arrived in France in 1955 with the most impressive Abstract Expressionist pedigree of any of the Americans who moved to Paris. Because she chose to stay in France—she eventually bought a country house in Vétheuil that included the house Monet occupied prior to his move to Giverny—she seemed more French with each successive exhibition. There is a quality in her paintings that seems more finished and more resolved than in her New York paintings. Some of this has to do with the issue of "white," which can be located in her work and in paintings by Francis as well.

The prominently displayed "white" of Sam Francis' *The Whiteness of the Whale* is not merely ground. In Francis' paintings, it is never "ground" in the Abstract Expressionist sense. White functions in a highly symbolic way for Francis, which is partially indicated by his choice in naming this painting. "The Whiteness of the Whale" is the title of a chapter from Herman Melville's *Moby Dick* in which the author discusses the symbolic meaning of white throughout history. Francis takes his cue from Melville and views white as "ringing silence an endless, ultimate point at the end of your life. Ahab had to get at the whiteness, strike it, bring up the blood, the red."[26]

During this period white also becomes a significant component of Joan Mitchell's paintings. Mitchell has strong negative associations with white: "It's death. It's hospitals. It's my horrible nurses. You can add in Melville's, *Moby Dick,* a chapter on white. White is absolute horror; just horror. It is the worst."[27] Mitchell began to make a dramatic use of white in her paintings upon her return to Paris in 1955. Her reliance on white as a spatial device was rooted in her admiration for de Kooning, which began shortly after her return to New York in 1950. In her painting *August, Rue Daguerre* (1956) (Figure 19), white is used as both form and background, engaged in an endless tension between depth and flatness, in much the same way as de Kooning used it in his *Woman* series. By 1958, Mitchell's painting is closer to the Frenchman Mathieu in sensibility than to the American de Kooning, as Mathieu had a greater tendency to "compose" his gesturalism, and to work it in toward the center of the painting.

Although I have grouped Mitchell and Francis together as artists who had strong roots in American avant-garde painting, yet seemed to successfully cross over into the French art market, they did not set out to accomplish the same. Francis actively engaged himself in the discourse of the revival of French traditionalism in postwar Paris, a discourse formulated, at least partially, by the conservative ideology of Bernard Dorival, curator of the Musée National d'Art Moderne and other officials in the museum system. Francis also exhibited his

paintings actively in Paris, as well as Germany and Switzerland, becoming in Hilton Kramer's words "the most renowned American painter in Europe."[28] Mitchell, it seems, tried to consciously distance herself from the Paris scene. She did not have a one-person exhibition of her paintings in Paris until 1960, at which point her New York exhibitions became less frequent. She distanced herself—at least in her interviews—from the French tradition, even while her gardener lived in Monet's house, all the while remaining one of the most successful artists in Europe. Francis explained the paradox of his American reputation to a French journalist: "In the United States," he said "I am 'successful,' but they don't take me seriously. I have two serious faults: to have lived in Paris during the 1950s and to be a Californian. When they say of the work of a painter "it's far too European" the Americans have said it all. For some Americans, this summarizes my painting: it is too European."[29]

Certainly, "Frenchness" was not a positive attribute with American critics, particularly Clement Greenberg, even for French art. Greenberg had little tolerance for gestural art by the late 1950s, whether it was American or European. Already, fairly early in the decade, he had established the criteria that distinguished American from European painting, mostly concerning the idea of a painting's "finish."

There is a certain crucial difference between the French and American versions of so-called abstract expressionism despite their seeming convergence of aims. In Paris they finish and unify the abstract picture in a way that makes it more acceptable to standard taste. For all the adventurousness of their "images," the latest generation in Paris still go in for "paint quality" in the accepted sense. If "abstract expressionism" embodies a vision all its own, that vision is tamed in Paris—not, as the French themselves may think, disciplined.[30]

Greenberg could well have been—and may have been—speaking as much about Sam Francis in this quotation, as any painter of the French avant-garde. It was precisely Greenberg's certainty on this issue—a certainty he shared with like-minded critics—that guaranteed that the expatriates of the mid to late 1950s could not really come home. What had worked so well in Paris simply wouldn't play in New York.

NOTES

1. See Serge Guilbaut, "Postwar Painting Games: The Rough and the Slick," in *Reconstructing Modernism: Art in New York, Paris and Montreal 1945–1964,* ed., Serge Guilbaut (Cambridge, MA: The MIT Press, 1990), pp. 30–79.

2. Michel Seuphor, quoted in "Editorial: French Critic Reacts," *Art Digest* 27: 11 (March 1, 1953): 9.

3. Yves Michaud, "Américains à Paris: Première Approche," in *Des Américains à Paris.1950/1965,* exh. cat. (Pyrenees-Orientales: L'Oeil et Demi Fondation du Chateau de Jau, 1988), p. 6.

4. For an account of this period, see Elizabeth Hutton Turner, *American Artists in Paris, 1919–1929* (Ann Arbor, MI: UMI Research Press, 1988).

5. Jean-Pierre Rioux, *The Fourth Republic, 1944–1958,* trans. Godfrey Rogers (Cambridge: Cambridge University Press, 1987), p. 8.

6. Franz Meyer, "Sam Francis in Europe," in *Sam Francis: Paintings, 1947–1972,* ed., Robert T. Buck, Jr., exh. cat. (Buffalo: Albright-Knox Art Gallery, 1972), pp. 8–9. Rüdlinger was later one of the organizers of "The New American Painting" exhibition that was circulated throughout Europe by The Museum of Modern Art, New York in 1958–1959.

7. See Michael Leja, *Reframing Abstract Expressionism: Subjectivity and Painting in the 1940's* (New Haven, CT: Yale University Press, 1993).

8. *VIIième Salon de Mai* (Paris, 1951), p. 5. *Beyond the Mask* is listed as catalogue number 366. Every catalogue on Francis cites his inclusion in the Salon de Mai of the previous year, thus I have listed it. However, Sam Francis is not listed in the 1950 Salon de Mai catalogue, and if he did exhibit, he would have had to send the picture from California, as he did not arrive in Paris until later in the year.

9. For a discussion of the relation of Autre art to the idea of "individualism," see Yule F. Heibel, "New Unravellings of the Real? *Autre* Art's Threadbare Subjects Meets the New Universalism," *Rutgers Art Review* 7 (1986): 75–103.

10. "Art and Artists," (Paris) *Herald Tribune* (February 27, 1952); quoted in Peter Selz, *Sam Francis* (New York: Harry N. Abrams, 1982), p. 39.

11. Franz Meyer, "Sam Francis in Europe," quoted in Buck, *Sam Francis,* p. 8.

12. Buck, *Sam Francis,* p. 17.

13. Jacques Peuchmaurd, "Sam Francis (Galerie Nina Dausset) *Arts* (Paris) no. 396 (February 15, 1952): n.p.

14. Clement Greenberg, "American-Type' Painting" in *Art and Culture: Critical Essays* (Boston: Beacon Press, 1961), p. 221.

15. Clement Greenberg, "The Later Monet," in *Art and Culture,* p. 45.

16. Ibid., p. 38.

17. See also Gaston Bachelard, "Les Nymphéas ou les surprises d'une aube d'été," *Verve* VII, no. 27–28 (December 1952).

18. Bernhard Schultze to Anneliese Hoyer, August 1967, quoted in Anneliese Hoyer, *Sam Francis: Exhibition of Drawings and Lithographs* exh. cat. (San Francisco: San Francisco Museum of Art, 1967): n. p.

19. Selz, *Sam Francis,* p. 51.

20. Julian Alvard, "Sam Francis, Galerie Rive Droite," *Cimaise* 3, no. 7–8 (June–July–August, 1956), p. 42.

21. Sam Francis to John Hultberg, undated (c. 1957), John Hultberg Papers, Archives of American Art.

22. *12 Americans* was on display at The Museum of Modern Art, New York, from May 29 until September 9, 1956. The other 11 artists included were Ernest Briggs, James Brooks, Fritz Glarner, Philip Guston, Raoul Hague, Grace Hartigan, Franz Kline, Ibram Lassaw, Seymour Lipton, José de Rivera and Larry Rivers. Sam Francis was the only artist who did not include a statement in the catalogue.

23. Joan Mitchell was born in Chicago in 1926. She attended Smith College for two years, and graduated from the Art Institute of Chicago. She eventually earned an MFA from the Art Institute, though she had also studied in New York, at both Columbia and NYU during this period. She first lived in Europe during 1948–1949, returning to New York until 1955. She had one-person exhibitions at the Stable Gallery in New York annually from 1953–1958. She was included in the Whitney Annuals in 1951 and 1955. She did not exhibit in Paris until 1959.

24. Joan Mitchell, interview with Linda Nochlin, April 16, 1986, Archives of American Art, Smithsonian Institution, Washington, DC.

25. The departure of Joan Mitchell and the arrival of Norman Bluhm in New York was immortalized in Frank O'Hara's poem, "Adieu to Norman, Bon Jour to Joan and Jean-Paul."

26. Selz, *Sam Francis,* p. 64.

27. Judtih E. Bernstock, *Joan Mitchell* exh. cat. (New York: Hudson Hills Press, in association with the Herbert F. Johnson Museum of Art, Cornell University, 1988), p. 39.

28. Hilton Kramer, "Francis: 'The Mallarmé of Painters?,'" *New York Times* (December 24, 1972): 25.

29. Georgina Oliver, "Les 'Extra Terrestres' de Sam Francis," *Les Nouvelles Litteraires* (July 13–21, 1978).

30. Clement Greenberg in "Symposium: Is the French Avant-Garde Overrated?," *Art Digest* (September 15, 1953): 12.

SELECTED BIBLIOGRAPHY

Agee, William C. *Sam Francis: Paintings 1947–1990.* Los Angeles: The Museum of Contemporary Art, 1999.

Bernstock, Judith E. *Joan Mitchell.* New York: Hudson Hills Press, 1988.

Buck, Robert T. *Sam Francis: Paintings, 1947–1972.* Buffalo, NY: The Albright-Knox Art Gallery, 1972.

Francis, Sam. *Saturated Blue: Writings from the Notebooks.* Santa Monica, CA: Lapis Press, 1995.

Guilbaut, Serge et. al. *Reconstructing Modernism: Art in New York, Paris and Montreal 1945–1964.* Cambridge, MA: The MIT Press, 1990.

Kertess, Klaus. *Joan Mitchell.* New York: Harry N. Abrams, Inc., 1997.

Leja, Michael. *Reframing Abstract Expressionism: Subjectivity and Painting in the 1940s.* New Haven and London: Yale University Press, 1993.

Michaud, Yves and Robert Storr. *Joan Mitchell.* Paris: Galerie Nationale de Jeu de Paume, 1994.

Michaud, Yves. *Des Américans à Paris: 1950/1965.* Pyrennes-Orientales: L'Oeil de Demi Fondation du Chateau de Paris, 1982.

Sam Francis: The Fifties. Washington, DC: The Phillips Collection, 1980.

Selz, Peter. Am Francis. New York: Harry N. Abrams, Inc., 1975, revised ed., 1982

Turner, Elizabeth Hutton. *American Artists in Paris, 1919–1929.* Ann Arbor, MI: UMI Research Press, 1988.

9

R.B. Kitaj:
Painting as Personal Voyage

Carol Salus

Travel is intrinsic to the art of R. B. Kitaj; his work reflects his belief that a painter, as his life has shown, is a voyager with a baggage of ideas who mentally travels in his studio. His art, as will be demonstrated in this chapter, is an expression of his identity as an American, born in Cleveland in 1932, who has lived in London for four decades and as a Jew, whose upbringing was shaped by stories of the atrocities of the Nazis. While much of his working life was spent in London, his vision, curiosity, and attachment to American and European culture have propelled his travels, thought, and art. Of equal importance in the formation of these later elements are his deep bonds with his Jewish roots. His accomplishments both overseas and in the U.S. indicate his stature; yet, because of the historically specific circumstances of his life, Kitaj, the expatriate, has a sense of ambivalence about his feelings of homeland.

It is attempted here to explore in abbreviated form aspects of Kitaj's life as he chose to study and live abroad. Select examples of his work, accomplishments, and statements reveal the different milieus to which he belongs and the powerful issues he confronted and important attractions he found overseas. The complexity of his identity makes his work and thought so interesting. William Lieberman, curator of twentieth-century art at the Metropolitan Museum of Art has hailed him as "the greatest living American artist."[1] The English art scene since 1960 cannot be understood without mention of his strong presence, yet Kitaj's greatest preoccupations are his Jewish identity and his compassion for victims of the Nazis. His powerful Holocaust art, one of the most moving bodies of work on this topic, reveals both attachment to family history and awareness of horrors that occurred at various sites he saw while living and traveling in Europe. His mother, Jeanne Brooks, was an American-born daughter of Russian-Jewish immigrants. His stepfather, Dr. Walter Kitaj, was forced to flee his native Vienna during the Third Reich. His paternal grandmother, Helene Kitaj, whose family was exterminated,

found refuge in Sweden and could only join the Kitaj family in America after World War II.[2] The artist grew up among family friends many of whom were refugees from Nazi Europe.

Kitaj also belongs to a distinguished tradition of American artists and writers who chose to live in England, including James McNeil Whistler, John Singer Sargent, Jacob Epstein, Henry James, Ezra Pound, and T. S. Eliot. The self-imposed exile feels connected to them as he stated, "London is home in the sense that it was for Henry James, Eliot, Whistler, and Sargent."[3] His identification with these esteemed Americans goes further, as he explained his move to England was not only to study at the Ruskin School in Oxford but also "because James and Eliot and Pound had gone there 50 years before."[4]

Kitaj's art, which draws on history, film, poetry, novels, sex, philosophy, social and political figures and issues, is in the collections of many major European and American museums. His consistent exhibition record further indicates numerous galleries and museums showing his work.[5] The inheritor of many traditions and identities, Kitaj's art for over the past 30 years has constituted one of the most distinctive bodies of work within the British art world, where it has been correspondingly influential. Moreover, he remained one of the most visible figures in the European painting scene after the mid-1960s.

Among notable tributes from his adopted country is Kitaj's election in 1985 to the Royal Academy of Arts: He is the only American since Benjamin West in the eighteenth century and John Singer Sargent in the nineteenth century to have achieved this recognition; he is among only nine Americans ever to be elected to the Royal Academy of Arts. In 1994 The Tate Gallery held a Kitaj retrospective, a great tribute for a living artist that was attacked by London critics with devastating reviews.[6] Kitaj's reaction to the overwhelmingly hostile response to the London retrospective was passionate and enraged. He blamed the unexpected death of his wife, an American artist, Sandra Fisher, on his critics saying, "They tried to kill me and they got her instead."[7] Yet great successes followed in spite of his furor directed at the English art critics. The retrospective received positive reviews in its American venues at The Metropolitan Museum of Art and the Los Angeles County Museum of Modern Art. His international achievements since then include the Golden Lion Painting Award at the XLVI Venice Biennale (1995) where he was a British representative. In addition to honorary doctorates and numerous awards, he became a Chevalier des Arts et Lettres in Paris bestowed by President Chirac (1996). Kitaj's commissions include the following: in 1995 an invitation to the White House to draw a portrait of President Clinton, for which he was selected by University College, Oxford, where his pastel portrait of the American president now hangs alongside the faces of other notable alumni; in 1997 a portrait commission, also pastel, of Gustav Mahler for the State Opera in Vienna; a major tapestry based on his painting *If Not, Not* to hang in the British Library among others.

His transnational vision reflects his education and his travels; Kitaj studied at the Cooper Union for the Advancement of Science and Art, New York (1950), and the Akademie der Bildenden Künste, Vienna (registered there 1951–1954), and

graduated from the Ruskin School of Drawing and Fine Art, Oxford (1959), and the Royal College of Art, London (1962).

Significantly, since 1957, Kitaj has approached the artistic life he found in Europe with a sense of passion. He participated in many exciting developments in the English art scene. In the early 1960s he was counted among the British Pop artists; since the mid-1970s, Kitaj, whose art from the beginning has been figurative, was regarded as the major spokesperson for this tradition.[8]

Kitaj associated in his adopted city with a loosely knit group of other well-known artists—Lucien Freud, Leon Kossoff, Frank Auerbach, Michael Andrews, and the late Francis Bacon. School of London was the term he dubbed for these colleagues who, he felt, were doing some of the most interesting painting in the world today.[9] The members of the School of London were attractive for Kitaj in that they all shared with him similar ideas about painting. Though each worked in extremely different styles, most quite radical and abstract, they all were intensely involved with subject matter and particularly devoted to painting centered on the figure. Like Kitaj, these artists held a passion for the painterly tradition of Rembrandt, Goya, Manet, Van Gogh, and Cézanne, among others, and were committed to build upon their foundations. The artist explained his happiness in finding a group of painters who absorbed and respected the same kind of past leaders:

These London guys have been studying the masters as a religious devotion since teenage and they'd entered into the very lives and paint of the great painters, you can take it from me. That's one of the main things that make London painting so powerfully good now, it ignores trends, which is a good trend here and unusual elsewhere.[10]

Kitaj, who felt connected to the distinguished group of American artists and writers who chose to live in England, considered his presence in London as a foreigner to be part of a long and influential heritage, especially in the history of twentieth-century art:

History is full of artists who lived out their lives in places far from their origins. But there is a more unusual pattern in the outstanding modernist schools. At the risk of being a real bore, I would submit that the entire milieux in New York, Paris, London, etc. have been profoundly affected by the Alien in their midst and drew infinite aesthetic, even tragic power there from. Consider key pictures like Picasso's *Gertrude Stein* and Matisse's grand experimental portraits of outsider women (G. Prozor, Y. Landberg, E. Mudocci, S. Stein, the Cones, etc.). There's a pattern, as I said, a social history of art as a function of cosmopolitan refuge. These great cities are wondrous safe havens for a transient, alien, vulnerable modern aesthetic.[11]

Yet, in spite of his stature and his awareness of the great tradition of expatriates to which he belonged, Kitaj felt a sense of being an outsider. His belief in the important role of the artist who works and lives in a foreign country was also tempered by ambivalent feelings. After living in Europe for 25 years, he expressed this sense of apartness. When asked whether he felt self-conscious about being an

American in Europe, he replied: "Are we used to it? Kitaj asked. No, I don't think so. I think it was never ours for the having. It was and is an alien culture in which I had and have no business. Were Hemingway and all kidding themselves in their affair with Europe? I don't know."[12]

Kitaj's periodic statements about his adopted homeland reveal his mixed emotions: In 1986 he said: "We are trying now to invent a way to divide the year. I'm very homesick for America. I always have been.[13] And a letter written in 1990 again indicates a sense of ambivalence: "I do like to watch people who are un-at-home. Is that not a possible subject or trait in pictures as in people? I don't leave London easily, nor do I stay here with any ease."[14] In an interview in 1994 he stated: "Sometimes I feel at home in London and sometimes not when I get homesick for various fantasies."[15]

Established as a foreigner, an émigré, in another country, it is through Kitaj's paintings and his words that insights are gained into his thoughts and the lines of descent in which he sees himself. The works to be discussed here reflect a deep commitment to place, as he travels both into the past and into the present; Kitaj's imagination was stirred by his life abroad.

For Kitaj, painting is a form of self-expression, it is a personal voyage that charts his identity, interests, and concerns. This is perhaps foremost seen in an emblematic self-portrait *The Jew* (Figure 20) (1976), in which he presents himself as the modern-day passenger, singular, in progress, in a shifting place—a train. On one level, this charcoal and oil painting on canvas, one of his pictorial personae, functions by virtue of the explicitness of its title as indicative of his strong identification with being a Jew. Like the fictive traveler with his hearing aid, Kitaj is hard of hearing. The hearing aid also functions symbolically to identify the Jew as Other. Sander Gilman points out that there is an old trope in European culture regarding details of the differences of the Jew's body, even the Jew's ear, as a sign of difference of Jewish character. It can be found in the anti-Semitic literature of the *fin-de-siècle* as well as a major subtheme of one of the great works of world literature, Heinrich Mann's *Man of Straw* (1918).[16]

Kitaj's self-portrait with its pathological ear can be interpreted on various levels. On a most rudimentary level, the seated passenger can refer to the transports taking Jews to the death camps. On another level, Kitaj represents the twentieth-century version of the legacy of the Wandering Jew, who travels from place to place due to persecution. Dressed in his suit and wearing his hat, he leans forward in his seat, remains unsettled, between two places—never really at home because of his history.

On another level, this self-portrait in transit recalls Kitaj's ideas on painting and its expressive role for him; it is an important part of understanding his desire to travel and live overseas. He wrote down his thoughts as follows: "Painting is a great idea I carry from place to place. It is an idea full of ideas, like a refugee's suitcase a portable Ark of the Covenant."[17] Kitaj, as embodied in his characterization *The Jew,* is a wishful escapee who prowls with a critical intelligence to various sites, both imaginary and real, in a search for his own roots. The simple, direct depiction serves as metaphor as he collects experiences to be recalled in the isolation of his studio.

While Kitaj has been both inspired by the cosmopolitan nature of his life in London and able to travel easily to other European capitals and further develop his broad interests, he has a growing sense of himself as an outsider, a Jew. He coined the term Diasporism to describe the exilic condition he felt in spite of his successful career and wrote his *First Diasporist Manifesto,* a short text on the subject published in 1989. Here Kitaj extended the historical definition of Diaspora, a Greek word meaning scattering or dispersion of the Jews after the fall of the Second Temple in C.E. 70, and felt it encompassed far more than the question of Jewish experience. For him, the Diasporist feels both a part of his society and alienated from it at the same time. Diasporism, Kitaj believes, is a common plight not only of the Jews. He also applies this thesis to all classes outside the mainstream of power in their society, including women, foreigners, homosexuals, and those of non-Caucasian racial origins. In his text, the Diasporist, over and beyond the diversity of concrete situations, shares a single unequivocal character, a similar and unchanging trait—as marginalized, as outsider from the dominant culture. The artist shows understanding for those who feel uncomfortable, mistrusted, or perhaps only tolerated by parts of the community at large.

Kitaj refers to himself in his text as a Diasporist who is "utterly American, longingly Jewish, School of London."[18] He draws from all of these identities, yet discusses in depth the Jewish experience as one of dislocation, fragmentation, and rootlessness. The American expatriate identified with the plight of the Jews as a people repeatedly forced to flee by historical circumstances. Set on foreign soil, whether in England or America, Kitaj bonds with the Wandering Jew whose sense of isolation and nomadic existence is secured by his past.

Kitaj's writing and his painting indicate in particular how the Holocaust and the subsequent experience of suffering, loss, and dispersal have come to mean for him a sense of apartness in the modern world. By living and studying in Europe, Kitaj, the artist, the self-imposed exile, the Diasporist, discovered firsthand the realities of the Holocaust—conversations he had and sites he saw profoundly affected him. His exposures to the realities of the fate of the Jews were particularly traumatic for him. From his experiences, he came to realize that even a nonpractising, agnostic Jew like himself was conditioned and defined by the fate of other Jews in the twentieth century. He saw sites where Jews had been rounded up for deportation and met survivors. Some of his experiences, particularly in Paris and Vienna, became moments he would never forget. While studying at the Akademie der Bildenden Künste in Vienna in 1951, Kitaj was reminded of the horrors that had taken place there only six years earlier. Aware of how the Nazis operated, he recalled in a 1990 interview, "Even in my Vienna days, I shuddered to think of my kind in those very streets a few years before."[19]

Kitaj, who also visited concentration camps in Poland and France, revealed similar emotional responses to being in Paris only a few years after the war. During a year-long stay in Paris in 1982–1983, he explained some of his motivation in expatriation and the feelings he experienced when he first passed through the city for a few days as a 19-year-old student in autumn, 1951 on his way to Vienna. David Plante, a writer, recounted his conversation with Kitaj,

he told me he wanted to come to Europe because of writers he'd read who had found Europe a revelation of creativity, and one of those writers was of course Hemingway. He knew that a great creative flowering, equal to that of 5th century Greece or Renaissance Florence, had occurred in Paris over a period of, say, a hundred years, and he wanted to go where so many of his compatriots had gone and, there, produced amazing works. When he got here he found something else: Paris only seven years removed from German occupation; And imagine what it felt like, he said, to walk down a street and know that people there had been pulled out by the Gestapo and sent off to concentration camps. It was, really, my first awareness of being a Jew.[20]

Kitaj developed an extensive treatment of the Holocaust through paintings, drawings, prints, and a book, all of which reveals his deep bond to his Jewish roots.[21] Powerful statements indicate further his preoccupation as he stated in an interview: "a central condition for me has been the murder of the European Jews. Winston Churchill wrote, "This is probably the greatest crime in the whole history of the world."[22]

Selection of one of his many Holocaust-related paintings shows both the compassion and importance these years of persecution held for him. In *Self Portrait as a Woman* (1984) Kitaj mentally traveled back in time to the period of the Third Reich and cast this canvas in a distinctly personalized light; he reenacted one of the punishments forced upon women who did not comply with the regime's racial laws forbidding Aryan women to have relations with Jewish men. The painting was based on an actual event Kitaj learned about from his landlady in Vienna. She told Kitaj, who was then a 19-year-old student at the art academy, that she had been caught in bed with a Jew. The Nazis had forced her to parade naked through the streets of her suburb wearing a placard that announced her "crime" and shouting the same message. Kitaj, who became her lover, went with her to the actual streets where they had marched her, and he made some drawings in his sketchbook of the buildings and the church in this section of Vienna.

Kitaj, who was labeled by Robert Hughes as "the best history painter of our time,"[23] transformed himself into a female role. He appears from the back with a placard hanging on his chest. Kitaj's female characterization, with this sinister placard around his neck, is stripped of human identity. Archival photographs show German women, who violated the *rassenmischung* (statutes of racial purity) by virtue of their relations with Jewish men, forced to display such signs in public stating *Ich bin am Ort das grösste Schwein und lass mich nur mit Juden ein* (I'm the biggest pig in town I only have sexual relations with Jews). Kitaj recast this scene with both historically accurate props and site as a token of his empathy for his landlady and other women similarly treated. In his textual Preface for the painting he writes in his Viennese landlady's voice and reveals his degree of identification with her ordeal. He includes how she saw this painting of his in a book 40 years after the event and wrote to him in London saying she had "no idea he felt close enough to my humiliation to have put himself in my place as it were, to have put himself in the picture."[24] These Prefaces, extensive written texts to accompany paintings, often with wall texts next to the canvases, were one of the most attacked

aspects of Kitaj's art at his infamous 1994 retrospective. Yet his written texts to accompany paintings, one of the most problematic elements of Kitaj's painting for art critics, have been a part of his art since the 1960s.

Certain sites, experiences, and great art he encountered abroad fueled Kitaj's imagination. Important artistic influences and a strong commitment to the figurative tradition were strengthened by his various trips to Paris. In 1975, during a visit to the Petit Palais, Kitaj was inspired by Edgar Degas' work and became determined to use pastel. He even purchased "the very expensive Roché pastels still made in the Marais by two old ladies whose grandfather made pastels for Degas."[25] The significance of this trip to Paris culminated in an intense renewed interest in life drawing of the human figure as evidenced in his work. His *Degas* (1980), a richly colored pastel and charcoal drawing, shows the master draftsman, who he believed drew the human form better than anyone ever did, on his deathbed.[26] While living in Paris with Sandra Fisher in 1982–1983, Kitaj worked with Picasso's master printer Aldo Crommelynck and created a group of soft-ground etchings, and he did a substantial amount of life drawing using both professional models and friends. Kitaj said of his time in Paris, "This was the happiest year of my life for a hundred crazy reasons. I felt hidden away in time and romance and I found or invented some of the lost Paris which people said was gone—the Paris of Henry Miller and René Clair. I should have stayed put in that dreamworld I stumbled into."[27]

Cecil Court, London WC2 (The Refugees) (1983–1984) (Figure 21) is perhaps one of Kitaj's most impressive statements of the roots he found overseas. This painting is a tribute to this well-known alley, near Leicester Square Underground Station, linking Charing Cross Road and St. Martin's Lane that Kitaj frequented after his arrival in London. Close reading of his carefully selected imagery tells about the peripatetic artist's attachments, interests, and memories. Kitaj is surrounded by figures and symbols appropriate to retrospective assessment in his fantasy version of this pedestrian alleyway of rare and second-hand books and fine art prints, many of that have provided sources for imagery in his art over the years. Kitaj placed himself in the foreground of this vivid theater-like scene of antiquarian bookshops that serves as a backdrop for the animated characters. Although streetlights are missing, it appears to be night as shop windows are brightly lit. The artist who reclines on his own LeCorbusier chaise lounge conjures up the dream-like setting, filled with imaginative and real figures. While he seems to be reading a book, with another book lying on the pavement, Kitaj is in deep concentration as if mentally traveling. While working on *Cecil Court* in 1983, Kitaj married Sandra Fisher at London's oldest synagogue in Bevis Marks. In the painting he wears his wedding outfit.

Kitaj's imagination for *Cecil Court, London WC2 (The Refugees)*, the bustling street scene with its clear perspective and colorful characters, drew upon various literary, artistic, and personal sources. Identification of the major characters in the foreground reveals that *Cecil Court* is a gathering of significant people. On the right, Kitaj's recently deceased stepfather, Dr. Walter Kitaj, a research chemist from Vienna, who fled his homeland when Hitler took power in Austria, looks back at him as if in a memory. On the left, the late Mr. Seligmann, whose name appears

behind him, written in script on his shop's window shade, holds a bouquet of flowers. The bookshop owner, who had sold Kitaj over the years many art books and prints, was, like the artist's stepfather, as stated in the subtitle of the painting, also a refugee from the Nazis. Kitaj, on his couch between his stepfather and Seligmann, is portrayed among images of importance to him.

Cecil Court, Kitaj's first major work upon his return to London after seeing the 1983–1984 Balthus retrospective during his brief honeymoon in Paris, is a response to the master's *La Rue* (1929) with a later version of this painting, which has been in the collection of the Museum of Modern Art in New York since his youth.[28] Inspired by this well-known genre scene of the even tinier Passage du Commerce Saint-André on the Left Bank in Paris, various elements from the Paris shop fronts, shop signs, and bright facades to some of the characterizations appear; Kitaj's recasting of Balthus' work transforms the French painter's haunting mood into a state of bustling activity. Kitaj, who approached Europe and the intellectual life he found overseas as a passionate explorer, was inspired by the great exhibitions he could see in Paris and in London in which two Venetian Renaissance paintings seen in an exhibition at the Royal Academy influenced two of Kitaj's characterizations.[29]

Analysis of other figures depicted in *Cecil Court, London WC2 (The Refugees)* reveals that a number of the characters share with Kitaj an identification with the outsider, the marginalized man, the Jew. The street sweeper is appropriated from a character in the same body position in an advertisement for *The Green Millionaire,* a circa 1910 play in New York City's Yiddish theater that told of another expatriate, a greenhorn, in his new land, America.[30] Kitaj has given his character, based on this preexisting image of a Jewish immigrant from Eastern Europe, the site of many turn-of-the-century anti-Semitic pogroms, a new costume and a broom as he cleans the alleyway.

The spirit of Kitaj's lively figures and some of his shop signs, Gordin, Löwy, and Kalb, who are designated as shop owners, stem from his reading of Kafka's *Diaries* in which the great Czech novelist wrote over one hundred pages about his fascination with the troupes of traveling Jewish theater companies, Central European characters, who performed in Prague from 1911 to 1913.[31] Joe Singer, another bookshop owner whose name appears on the right, is a fictive character that appears in a number of his Holocaust paintings and functions as a survivor, an expatriate because of historical circumstance.[32] Just like Mr. Seligmann, Joe Singer, this novelistic figure, is significant because, as a Holocaust refugee, he forms a link with Kitaj's own family.

The theme of displacement unites the histories of many of these colorful characters in *Cecil Court.* Kitaj, the expatriate, placed himself among real and fictive expatriates. These exiles that found refuge in various countries, are placed in the city of *his* choice, London. It is in Cecil Court, an area world famous among bibliophiles, that Kitaj selected to be his home; here, he envisioned his stepfather along with others who found a new life in their adopted countries, and here that he found stimulation for his painting.

Kitaj kept strong ties to his country of origin as found in both his work and his words. His attachment to things American is apparent as he visited his homeland in

his paintings. *John Ford on his Deathbed* (1983–1984) and *Baseball* (1983–1984), each amusing paintings, affirm and declare his American identity from London. The portrayal of John Ford on his deathbed is a vision of Kitaj's favorite film director, filled with a distinctly filmic ambiance, complete with a "THE END" sign framed on the bedroom wall. This witty portrait of the great American film director, which was based on a 1970 visit by Kitaj and his older son Lem, a screenwriter, is shown in accurate synoptic form. Various identifying characteristics and emblems of his life and career animate his bedroom; the images Kitaj presents serve as a sampling of memories he had of the great director. Ford is shown twice seated—he is on his deathbed as well as in action in his younger years. On the upper right, he is seen sitting up, with his eyeglasses on, smoking a cigar in bed, wearing an admiral's cap, and holding rosary beads.[33] Kitaj added a picture on the wall, a still from Ford's *The Sun Shines Bright,* a postwar tearjerker, which appears near where his rosary beads were actually hanging. In the upper-left corner of his bedroom, Ford looks across the room at a painted representation of a clip from one of his films in which the silver screen is replaced by a large colorful wooden frame. Typical of the dance numbers in so many films Ford directed, a man and woman holding hands swirl about in a circle in this framed clip. Behind the frame a uniformed man stands in place with his white-gloved fist held firmly against his chest as if playing a role. Elements of his past directing are seen also as the young Ford appears in the lower left in a chair, in his prime; wearing his cap and sunglasses and using a megaphone, he directs a man and a woman, at the lower right, who sit at the foot of his bed—these characters based on an archival photo from *Tobacco Road* (1941). Kitaj got the idea for all these "corny ghosts" reappearing at Ford's deathbed from the last scene in Huston's Moulin Rouge, when all his past characters reappear at Lautrec's death bed.[34]

Kitaj's roots are again revealed with humor in *Baseball.* A vast landscape is filled with activated toy-like baseball players in various positions—hitting, pitching, and running. John Russell alludes to this painting, which is a playful pastiche of Velázquez' *Philip IV Hunting Wild Boar* (1640), a Spanish royal commission Kitaj saw in London in the collection of the National Gallery, in his discussion of Kitaj as "remaining in many ways an archetypal American."[35] Baseball was a part of his childhood recollections of Ohio and upstate New York. Kitaj explained his attachment to the sport: "the Velázquez setting reminded me of the low hills of home which often framed the playing fields where we toiled at pick-up ball long after dusk blinded up."[36]

These boyhood memories live on his own photograph collection of baseball players; in fact, in 1965, Kitaj was commissioned to draw baseball players for *Sports Illustrated.* He returned to America for the first time in nine years. During this visit, in which he had his first one-man exhibition in New York, he went to St. Petersburg where he had a "glorious time in Florida" drawing at the baseball spring training camps for the magazine. Here he both drew and painted portraits of Stengel, Barra, Spahn, and others.[37]

Kitaj, a former Clevelander, has maintained a passion for the sport and the city's team through his many years of living in London. *The Cleveland Indian,* a near

life-size painting of a Cleveland Indians ball player, which he painted in London in 1995, indicates his lasting interest in this quintessential American sport. This imaginary portrait, in which the character wears a contemporary outfit complete with red socks, was one of the first he started after an 18-month hiatus in work following the sudden death of his wife, Sandra. Kitaj explained, "I've been a Cleveland Indians nut since I was a small child. Even though I've lived much of my life in Europe, I've followed the Indians every day."[38] The artist was aware of the successes of the Indians after their move to the newly built ballpark, Jacobs Field, in 1994. The pose of Kitaj's character, a right-handed batter preparing for a pitch, is inspired by a ballplayer in a watercolor by the great American master Thomas Eakins painted in 1875. The player wears a contemporary uniform complete with red socks. Also *Self Portrait as a Cleveland Indian* (1994), a pastel and charcoal drawing on paper, undoubtedly amused him.[39] Both works appear to express his yearning for the United States after 40 years in London.

Kitaj has been to the U.S. several times as visiting professor at various colleges and universities and has lived here for short times.[40] Yet the painter-traveler, who remained for more than half of his life in London, felt himself to be an American in many ways:

My sense of national belonging is both confused and not confused. I feel very American and always will. The American language and culture and one's childhood secures that belonging and it is sustained by deep American friendships and interests and always renewed contact with America; nothing much in American life escapes my notice one way or another. I seem to belong, now, to England and to London after all these years but I can say without hesitation that I don't fit in here and never will in any comfortable way. I've noticed that some exiles do become very English and Some Do Not. I won't name names. The Jewish Thing is also so complex; it will have tempered much for me the life, the art, the American times, the English passage, even those periods in my youth when I didn't *feel* like a Jew, of course.[41]

Kitaj's words regarding his expatriate status in London after many years of living in English society affirm his repeated feelings of ambivalence. His bond to his Jewish roots, fortified by experiences he had overseas, remains strong. His identification with and interest in American issues and culture indicate a strong attachment to a country he chose to leave. Furthermore, his art reveals his enthusiasm for his homeland. Beyond numerous baseball and film works, other paintings deal with political and social issues touching the United States. *Erie Shore* (1966) is inspired by a newspaper account in which the artist read about the death by pollution of Lake Erie. Two of his paintings, which document major events of the past few decades, *Dismantling the Red Tent* (1964), a response to the assassination of President Kennedy, and *Juan de la Cruz* (1967), an icon to the Vietnam War, further indicate his feeling for contemporary American tragedies and history. His *Walter Lippmann* (1966) is a tribute to the famous journalist and political pundit he remembers from his high school days in America. *Superman* (1973) and *Batman* (1973) are his amusing interpretations of these American comic heroes.[42]

Examination of the confessional nature of his art reveals the complexity of this expatriate's identity. He perceives himself as an outsider belonging to and caught between different cultures. Kitaj's attachments to his different roots remain fascinating to consider; even his painting style has been described as indicative of one of these heritages. "Many years ago in London, Clement Greenberg [renowned American art critic] told me that my pictures could only have been painted by an American."[43] Whatever American qualities Greenberg saw, Kitaj's work was also greatly influenced by the many stimuli he found in Europe. Both Kitaj's life as a voyager and its reflections in the works selected indicate that place, both contemporary and past, is critical to his identity and purpose. The intellectual and personal demands of his art are only satisfied by these kinds of voyages. Elements of time, history, family, geography, fantasy, and reality were gathered in his studio in London as he traveled.

The polarities Kitaj felt, as American and English, and as Jew living on the margin, form the shape and power of his art. The paintings and drawings discussed provided him with a kind of record and personal odyssey into his roles, interests, and roots. In his search for self-definition, these works and his words indicate the contradictory states of being settled and being rootless. Furthermore, in his pain and anger over his 1994 disastrous retrospective at The Tate Gallery and the simultaneous sudden death of his wife from an aneurysm, he did a series of paintings treating the theme of the art critic as her killer. Significantly, he was honored with the prestigious Wollaston Award for the best painting in the Royal Academy summer exhibition in 1997 for his multi-part work *Sandra Three, The Killer Critic,* in which sensitive portraits of Sandra Fisher and their son Max are linked to the controversial central panel, *The Killer-Critic Assassinated by his Widower, Even.* With its title, a Duchampian spoof, and its image, based on Manet's *Execution of Maximilian,* Kitaj and other artists are shown firing at a monstrous "critic" in whose tongue curls the words "yellow press, yellow press, kill, kill, kill." *Sandra One/The Critic Kills* (1996), in which a portrait of Sandra Fisher is juxtaposed with stark and fragmentary, largely abstract panels, emblazoned with the words *The* Critic *Kills,* was exhibited at the Royal Academy summer exhibition in 1996. In *Sandra Two,* a brochure published on the occasion of an exhibition of his work in Paris in 1996, he refers several times to Sandra's death under fire.[44]

The significant relationship between Kitaj's art and biography underlines the importance of identity in his life. The death of Sandra seemed to be a turning point for the artist, "London just died for me when she died."[45] The yearning and romanticism for study and life in Europe and its great art after four decades no longer had its appeal for Kitaj. In spite of recognitions he received following the post-1994 battle pursued by the English art critics and their insulting response to his Tate retrospective, Kitaj decided to return to America. The artist, who enriched the British art world, who became a highly visible figure in the European painting scene, and who defended such hallowed traditions in art as drawing from the figure, felt more at home in America. Only in 1997, following these honors, and events, did he finally decide to permanently leave London with his younger son Max to join

his older son Lem and his grandson. He lives now in Los Angeles with an old movie palace at the corner of his street.

NOTES

1. William S. Lieberman, quoted in "Thoroughly Modern Met," by Sylvia Hochfield, *Art News* 86 (February 1987): 117.

2. For information on Helene Kitaj's plight, see my article, "R.B. Kitaj's *Murder of Rosa Luxemburg: A Personal Metaphor,*" *Jewish Art* (Jerusalem: Center for Jewish Art: Hebrew University), Volumes 16–17, 1990–1991, pp. 130–138.

3. R.B. Kitaj, quoted in "The Fugitive Passions of R.B. Kitaj," by Jerome Tarshis, *Art News* 75:8 (October 1976): 42. See also, Dan Hofstadter, "Annals of Art: Dungeon Masters (on the School of London)," *The New Yorker* (November 12, 1990): 54.

4. Kitaj, quoted in Tarshis, p. 42.

5. Richard Morphet, editor, *R.B. Kitaj: A Retrospective,* exhibition catalogue (Millbank, London: The Tate Gallery, 194), pp. 230–233.

6. Janet Wolff, "The Impolite Boarder: 'Diasporist' Art and its Critical Response," in *Critical Kitaj,* eds. James Aulich and John Lynch (New Brunswick: Rutgers University Press, 2001), pp. 31–34, 203, ns. 13–16.

7. Ibid., p. 33.

8. For Kitaj's beliefs on the figurative tradition, see R.B. Kitaj and David Hockney, "R.B. Kitaj and David Hockney Discuss the Case for the Return to the Figurative," New Review 3 (January–February 1977): 75–77. Also see James Faure Walker, "R.B. Kitaj Interviewed by James Faure Walker," *Artscribe* 5 (February 1977): 4–5.

9. R.B. Kitaj, *The Human Clay: An Exhibition Selected by R.B. Kitaj,* introductory essay, exhibition catalogue (London: The Arts Council of Great Britain, 1976). Exhibition held at the Hayward Gallery, London, and toured to three other English cities. In the text he advocates his passionately held views on the figure, pp. 5–8. See also Dan Hofstadter, "Annals of Art: Dungeon Masters (on the School of London)," *The New Yorker* (November 12, 1990): 53–92.

10. Kitaj, in Morphet (ed.), *Kitaj,* p. 45.

11. Ibid.

12. R.B. Kitaj, quoted in Paris 1983 (interview), by David Plante, *Sulfur: A Literary Tri-Quarterly of the Whole Art* (Los Angeles, CA) 9 (1984), p. 108.

13. R.B. Kitaj, quoted in "Always against the Grain," by Israel Schenker, *Art News* 85:3 (March 1986): 83.

14. R.B. Kitaj quoted in "Annals of Art: Dungeon Master," by Dan Hofstadter, p. 54.

15. Kitaj, in Morphet, ed., *Kitaj,* p. 43.

16. Sander L. Gilman, "R.B. Kitaj's 'Good Bad' Diasporism and the Body in American Jewish Postmodern Art" in *Complex Identities and Jewish Consciousness in Modern Art,* eds., Matthew Baigell and Milly Heyd (New Brunswick: Rutgers University Press, 201), p. 234. See especially p. 237 n. 32 on the question of reading of Jewish ears.

17. R.B. Kitaj, *First Diaporist Manifesto* (New York: Thames and Hudson, 1989), p. 22. See this text for further understanding of Kitaj's thoughts on being an outsider. The artist's comments reveal the inseparable relationship between his ideas and paintings.

18. Ibid., p. 41.

19. R.B. Kitaj, quoted in "The Viennese Inspiration: In Search of Self," by David Cohen, *Royal Academy Magazine* 29 (Winter 1990): 34–36.

20. R.D. Kitaj, quoted in "Paris, 1983," by David Plante, p. 104.

21. Marco Livingstone, *R. B. Kitaj,* rev. ed. (New York: Thames and Hudson, 1992). The following plates from this book reveal the artist's interest in the Holocaust (i.e., its perpetrators, its victims, and its aftermath in the modern world) see figs. 30, 44, 57, 91, 94, 113, 114, 143, 146, 155, 161, 154, 169. Also in *Kitaj,* Morphet, ed., see figures 75, 76. See also the artist's *First Diasporist Manifesto,* which contains numerous discussions of his thoughts on the Holocaust and how he has translated them into his work. The test includes many illustrations of his work on this historic epoch, including a photograph her took in 1972 in Warsaw of a Gestapo prison, p. 52. See also text by Anne Attic and R. B. Kitaj, Drancy (London: Victoria Miro, 1989). This collaborative effort was the result of their visit to the camp that served as a transit station for those departed to Auschwitz and concentration camps farther east. The book, which has text and illustrations, was published in a limited edition of 300-signed copies.

22. R. B. Kitaj, quoted in "A Return to London interviewed by Timothy Hyman," *London Magazine* 19 (February 1980): 21.

23. Robert Hughes, "Singular and Grand Britons," *Time* 6 (April 1987): 83.

24. Kitaj, in Morphet, ed., *Kitaj,* p. 144.

25. R. B. Kitaj quoted in Marco Livingstone, *R. B. Kitaj* (New York: Rizzoli International Publications, Inc., 1985), p. 30.

26. See R. B. Kitaj, *The Artist's Eye: Pictures Selected by R. B. Kitaj,* introductory essay, exhibition catalogue (London: The National Gallery, 198). For this exhibition, which Kitaj curated, he selected figurative works from the collection and included a few of his own works. Significantly, at the entrance to the exhibition was his *Degas,* a pastel of the great Impressionist figurative artist in his deathbed.

27. Kitaj, in Morphet, ed., *Kitaj,* p. 63.

28. The two versions of Balthus' *La Rue,* dated 1929 and 1933, had been known to Kitaj "all my life," particularly as the later was on display at the Museum of Modern Art, New York, during his growing up years. They are reproduced in Sabine Rewald, Balthus, exhibition catalogue (New York: Metropolitan Museum of Art: H.N. Abrams, 1984), see cat. nos. 2 and 8, respectively. Exhibition traveled from Centre Georges Pompidou, Musée Nationale d'Art Moderne (November 15, 1983–January 23, 1984) to The Metropolitan Museum of Art.

29. While working on *Cecil Court* Kitaj made repeated visits to the exhibition *The Genius of Venice: 1500–1600,* which was on view during the winter of 1983–1984 at the Royal Academy, London. Pinned to his wall were reproductions of two pictures from the exhibition, Titian's *Flaying of Marsyas* and Tintoretto's *The Washing of the Feet.* The position of Titian's character informed the legs of the woman with green hear spread out in the street, and the figure at the far left of Tintoretto's painting was appropriated for the had of Seligman See Jane Matinee and Charles Hope, eds., *The Genius of Venice: 1500–1600,* exhibition catalogue (London: Royal Academy of Arts in association with Weidenfeld and Nicolson, 1983), cat.nos. 132 and 101, respectively.

30. Nahma Sandow, *Vagabond Stars: A Word History of Yiddish Theater* (New York: Harper and Row, 1977), p. 100.

31. For references to Jacob Gordin, a well-known playwright, see *The Diaries of Franz Kafka, 1910–1913,* ed. Max Brod. trans. Joseph Keresh (New York: Schocken Books, 1949), pp. 111–112; for information on Löwy, a major actor, pp. 110–111, 114–115; Kalb is taken from *Yoshe Kalb,* a play by I.J. Singer. Also, see Evelyn Torton Beck, *Kafka and the Yiddish Theater: Its Impact on His Work* (Madison: University of Wisconsin, 1971).

32. The name Joe Singer was taken from an actual family friend Kitaj vaguely

remembered from his childhood. For more information on Kitaj's fictional character Joe Singer, see Morphet, p. 132. The artist here refers to the emblematic figure in *The Jew* as Joe Singer. Also see Marco Livingstone, *R. B. Kitaj* (New York: Rizzoli Publications International, Inc., 1985), p. 9, fig. 1, pp. 38–42. In this monograph, Joe appears in the following paintings: figs. 113, 114, 117, 165.

33. For a photograph of Ford with admiral's cap, eyeglasses and pipe, see Dan Ford, *Pappy: The Life of John Ford* (Englewood Cliffs, NJ: Prentice-Hall, Inc., 1979), plate 16.

3. Kitaj, in Morphet (ed.), p. 148.

35. John Russell, "An American Abroad Undertakes a Self-Excavation," *New York Times* (Sunday, 30 July 1989): sec. H, p. 31.

3. Livingstone, rev. ed., p. 171.

37. For baseball photo by the artists, see John Willett, "Where to Stick It," *Art International* (14:4 (November 1970): 35. Both paintings and drawings of ballplayers' portraits were done. For paintings, *Kitaj,* Morphet, ed. p. 60. Also R. B. Kitaj, texts by John Ashbery, Joe Shannon, and Jane Livingston. Republished from retrospective exhibition held at Hirschorn Museum and Sculpture Garden, Smithsonian Institution, Washington DC in 1981. New York: Thomas and Hudson, 1983), fig. 32. For drawings of baseball players, see *R. B. Kitaj,* exhibition catalogue (Hannover: Kerstner-Gesellschaft, 1970), figs, 22, 23, 25. Baseball is referred to in the print series, *Mahler Becomes Political, Beisbol* (1976).

38. Steven Litt, "Art Museum Acquires a Couple of Heavy-Hitters," *The Cleveland Plain Dealer* 25 (November 1998: sec. A, 1, 15. See front page, sec. A-1 for *The Cleveland Indian.*

39. For this *Self Portrait as a Cleveland Indian,* see *R. B. Kitaj: Recent Pictures,* exhibition catalogue (New York: Marlborough Gallery, 1995), fig. 42.

40. Kitaj, in Morphet, ed., pp. 57–64.

41. R. B. Kitaj, quoted in Livingstone, rev. ed., p. 18.

42. See Livingstone, rev. ed., for these paintings with American-inspired themes, figs. 19, 40, 43, 61, 67, 68. Also there are prints that attest to Kitaj's awareness of events in American even though he was away for so many years before his first return to this country. See James Aulich, "The Difficulty of Living in an Age of Cultural Decline and Spiritual Corruptions: R. B. Kitaj 1965–1970" *Oxford Art Journal* 10:2 (1987): 44, 47, 56 notes 10, 22.

43. Kitaj, in Morphet (ed.), p. 43.

44. Wolff, p. 33.

45. R. B. Kitaj, quoted in Litt, p. 15.

SELECTED BIBLIOGRAPHY

Aulich, James and John Lynch, eds. *Critical Kitaj.* New Brunswick: Rutgers University Press, 2001.

Kitaj, R. B. *First Diasporist Manifesto,* New York: Thames and Hudson, 1989.

———. Introduction to *The Artist's Eye: Pictures Selected by R. B. Kitaj.* London: The National Gallery, 1980

———. Introduction to *The Human Clay.* London: The Arts Council of Great Britain, 1976.

Livingstone, Marco. *R. B. Kitaj.* Rev. ed., New York: Thames and Hudson, 1992.

Morphet, Richard, ed., *R. B. Kitaj: A Retrospective.* Millbank, London: The Tate Gallery.

10

Global Citizen: Beverly Pepper

Laura Felleman Fattal

Expatriatism is an anachronism; expatriatism is a mindset as well as a physical circumstance according to Beverly Pepper. Since the 1950s, Ms. Pepper has worked professionally as a sculptor in Rome and Todi, Italy, and in New York City, underlining the sentiment that she has never lived exclusively abroad. Her allegiance is American but she has an affection for Italy. Explicating her American aesthetic, Pepper states that she feels more American when she leaves the country. Her sense of democracy and politics and her belief in the necessary separation of church and state are based on her upbringing in the United States. Her large-scale sculptures have been described as personal, elegant and cosmopolitan.[1]

Modernist, in the ideology of the collectivity of a spiritual aesthetic, Pepper's sculptures reference the power of the expression of the abstract. Searching for pictorial equivalents of universal experiences, she, like other members of the generation of Abstract Expressionists appropriated ancient myths, symbols and signs. Often these symbolic forms were simplified to stand for such Manichaean oppositions as light versus darkness, good versus evil, celestial versus chthonian.[2] Dramatizing space, Pepper strategically places her sculptures to evoke a heroic historical present. Memory and a continuity with the past are omnipresent in her work. Rosalind E. Krauss relates an experience with Pepper that encapsulates the artist's vision.

It was a brilliant July day in 1980, and Beverly Pepper was in Siena, with friends. During the thirty years that she had lived in Italy she had constantly returned to Siena, to feel the majestic security of its campo, to renew the shock of insistent ferocity of its cathedral, striated everywhere—on columns, on piers, on the walls of the nave-with running bands of black and white that seemed to armor the building's interior, to sheath its stones as though for battle, to give to their clustered mass a crystalline sharpness and

clarity so that each pillar, each architectural profile, seemed to leave the imprint of its
weight on the brain. Two sets of impossible contradictions come together in the image of
this enormous, useless screen. It is at once an inside and an outside surface; and it is a struc-
ture working to support nothing. On the piazza swarming with tourists heading toward the
Duomo, Beverly Pepper stood facing the other way, stunned by the vision of this huge,
derelict remnant, effortlessly transcending gravity in front of the impassive witness of the
sky. One day, she said, one day, I will use this extraordinary thing.[3]

The continuum of civilization, so apparent in Italian small towns and large
cities with their castle walls, church facades, and large piazzas with obelisks
and columns, are the setting for many of Pepper's tall bronze columnar sculp-
tures in Todi (1979) and Narni (1991). She frequently organizes sculptures con-
trapuntally to combine several independent melodies, in this case, sculptures
or markers into a single harmonic composition. The contrasting pieces direct
human movement, creating a type of outdoor theatrical setting. Pepper under-
stands her placement of monumental sculptures also has an internal logic. The
influence of sacred and ancient sites with their staged rituals is both implicit
and explicit in the work of Pepper.

Cy Twombly, the American Abstract Expressionist painter, who has lived in
Italy for over 30 years, balances in his paintings the weight of antiquity with
an engagement in the "raw life of the street." In the 10-panel series of *Fifty
Days at Iliam* (1979), Twombly's scratched and worked surfaces reference
Homer's two major works, the *Iliad* by depicting the battle where Achilles'
boyhood friend and lover, Patrocles, dies, and the *Odyssey,* by recounting the
exploits of a prolonged homecoming, thereby attempting to hold the past and
present simultaneously.[4] Twombly, like Pepper, travels back and forth to the
United States, encouraging remembrances of his childhood and young adult-
hood in his layered painted mythology. Pepper's pitted iron and cast bronze
sculptural surfaces have a weathered affinity suggestive of a collective history
and human presence within and outside the circumscribed walled medieval
towns of central Italy.

Pepper's work transcends time, in part, by creating totemic columns in inte-
rior and exterior installations, by embedding forms in the land and by placing
monumental work in historical settings. The myth of creation itself became an
important metaphor for artistic innovation for Pepper, in particular, and the Ab-
stract Expressionists, in general. Pepper sees her trip to the half-hidden mud
and vine-covered stone palace and sculptures at Anghor Wat in Cambodia as
seminal in her development. The land became integral to the necessary pas-
sage of time in reacting to her sculptures. Pivotal in her signature "earthworks"
of the 1980s and 1990s is the cinematic sequencing of viewing her work. Ti-
tles and ideas reoccur in her work, again informing the cyclical nature of her
inspirations. The naming of pieces as sentinels, altars and markers reverber-
ates with the telltale image of cultural universality. There is a predisposition
for mythic semblances invigorated by other post-World War II artists' attitudes
that reappears significantly in Pepper's work in the 1990s.

The gleaming elegance of the stainless steel surfaces of cascading squares in *Fallen Sky* (1967) hugging the land are reinvented in the eclectic mounded surface of the hills in Cel Caigut—meaning fallen sky in Catalan—in the Sol I Ombra Park in Barcelona (1989–1992). Located in the city, Pepper has built earth mounds covered with pieces of ceramic tile in pale colors. The monumental scale of Pepper's sculptures/earthworks reemerges in this installation; the undulating land created by her mounds and reflective tile alludes to and mirror the borderless sky and its infinite waves of light and shadow.

Dichotomies of voids and solids punctuate Pepper's mid-career work in *Totlec Market* (1981) and *Vertical Presences—Grass Dunes* (1985). The wedges of concave and convex shapes reappear in the AT&T headquarters in Bedminster, New Jersey, *Amphisculpture* (1974–1976) recalling a Roman amphitheater. On the open fields of New Jersey, Pepper first employed the form of concentric circles. Its historic and natural reference is one of an ancient sundial and the sun's shifting light. In *Amphisculpture* seven skewed circular tiers of concrete and grass, two hundred feet in diameter, sink 14 feet into the ground, forming a sunken area adjacent to the corporate headquarters of AT&T: Corporate employees are invited to seek refuge in an environment that is both partially constructed and illustrative of nature.

An early awareness of an eco-aesthetic is evident in *Venezia Blue* (1968). These monumental four rectangular structures, which are two forms placed upright side-by-side on the ground and two similarly atop them, recall in their grandeur portals found at the entrances to ancient towns. Pepper's bold metallic elements are designed to capture a portion on the expansive sky. This eco-aesthetic becomes pervasive by her use of sun and shade in her environmental installations of the 1980s through 1990s. Her commitment to color in sculpture is seen in her variegated use of natural forms and fabricated sculpture. The use of trees, grass, dirt, wood, concrete, cast iron, and steel, concomitantly, enlivens Pepper's palette, while reinforcing her expansive scope in contrasting installations.

Palingenesis (1992–1994) (Figures 22, 23) is a continuum of successive moments that are manifested through the separation of 17 cast iron sculptures—varying in height from 7 to 16 feet—that move away from an arc-shaped textured cast iron wall relief that is 220 feet long and 15 feet high at its apex. It was originally made in plaster, then cast in iron. Sophisticated in its mythic allusions, the sculpture's tonal contrast is apparent in the divergent planes of rust iron wall embedded in the earth, recalling Etruscan artifacts and columns/stele and the encircling fields of green grass. Intended to be a meditation on time, the connective work can be read from left to right as an awakening, or from right to left as a memory. *Palingenesis,* one of Pepper's most important works, is a profound coupling of a lifetime of ideas. The earthwork/sculpture requires viewings from numerous vantage points of the long relief wall fronted by watchful sentinels as icons of past cultures set in a vast rolling grassy field.

Beverly Pepper came to Paris as an art student at the École Grande Chaumière after World War II. With her roots in the Flatbush section of

Brooklyn, she sees herself as part of a generation with post-World War II opportunities such as the G.I. Bill of Rights to study and live in Europe. She is defensively and aggressively Jewish, which she feels stems from the terror of living through World War II, even at the safe distance of New York. For Pepper, Judaism is equated with a kind of metaphysicality. She does not purposefully imbue a spirituality in her work related to her Jewishness, but she is pleased if it is evident. Her non-Jewish son-in-law named the linear multi-rod sculpture *Shaddai* (1977)—meaning God in Hebrew—since the pile of random angular pickup stick composition suggested Hebrew letters. Pepper recognizes that she is not a religious person, but feels one has to have that other dimension in life that one does not understand so one can keep feeling trust and courage.[5]

Pepper is most interested in making art and has arranged her life, as a mother and wife, to enable her to work long hours in the studio. Energetic and practical, Pepper has divided her time since 1951 between Rome and Todi, Italy, and New York City. She is the first to note that one needs talent to succeed as an artist but also one needs luck. She feels one must work very hard to make one's luck: Fate does not always take care of you. She freely expounds upon the ready experience of living in Rome in the 1950s and 1960s and joining the Marlborough Gallery branch in Rome in 1960, and later being handled by their New York office. In 1974, she joined the Andre Emmerich Gallery in New York and has stayed with them until recently. Her work has moved both inside and outside of gallery settings. She does not fabricate work particularly for gallery shows, so there is a fluidity between what is shown in public spaces and what is exhibited in an interior space.

Her celebrity at times is understated, perhaps due to her international community where critical voices are dispersed. Pepper has complained of being "invisible" because of her expatriatism.[6] At other times she states, "I was on the outside and I was making it. I was an American living abroad, very well known, and written about a great deal. A lot of critics didn't love me. The American art world of the 1960s was very chauvinistic, very xenophobic. And I was here [Rome].[7] The public has seen an evolution in Pepper's work from Abstract Expressionism, to minimalism, to earthwork, while maintaining not a local but an individual course. Pepper's work bridges stylistic moments, not movements. She sees her work as transcending nationality—possessing a universal outlook, yet reflecting the self—not as indulging an ego, but an expression of experience, hopefully evoking contemplation. The seed for each sculpture is in the past sculpture and in the next sculpture. She recognizes that she is the ever-present factor in each sculpture, not affected by nationality or geography.

In her earlier pieces such as *Venezia Blue* (1968), it has been observed that Pepper has used highly polished stainless steel surfaces to act as a smokescreen of reflections. Under certain conditions and from certain angles the reflectivity picks up the sculpture's environment and causes the work to almost disappear.[8] In the next decade, the land limns a more integral connection to the sculptures as in *Dallas Land Canal and Hillside* (1971–1975) in Dallas, Texas, *Thel* (1976–1977) at Dartmouth College in Hanover, New Hampshire, and in *Sand Dunes*

(1985) at New Smyrna Beach, Florida. The aesthetic of re/emerging from the land is evident in these sculptures of sequenced parts. It could be envisioned that the undulating patterns of emerging and dissolving of sculptural surfaces are metaphors for personal transformations. The personality of the artist is exposed through her quotidian paces and incendiary revelations in creating the works of art. "To be a real artist, you have to take risks, you have to get on a higher diving board each time you take a leap. You have to go somewhere that you haven't been before."[9]

American sculptors in the nineteenth century flocked to Italy because of the quality of the marble and the craftsmanship of the artisans. Pepper, who has worked in foundries around the world—Santa Fe, Trenton, San Francisco, Pistoia, Frostinone, Barcelona, and upstate New York—finds American fabricators today far more talented than any others. Pepper perceptively notes that American foundries now employ artists. The American artists are more inventive and flexible and make the impossible, possible. The patinas that the Americans use are far better than what the Italians use. She does not feel it is less expensive to work in Italy than elsewhere. Though she has lived in Todi for over 30 years, she does not work with artisans and is not dependent on Italy to do her work. She has a hands-on approach and must be near her latest project. She had to finish three huge outdoor installations in 1994–1995 in Switzerland, New York City, and Jerusalem, so she situated herself geographically for an extended period of time, in the middle, in the Umbrian hills.[10]

Associated with her globe-trotting mobility are her worldliness and the cosmopolitan characteristic of mitigating the core and periphery of cultural experiences. Pepper is never detached from her surroundings but situated with a true sense of "belonging" to parts of the world other than a singular nation. She prides herself on her long-term friendships and easy demeanor with strangers. Bruce Robbins has suggested that not enough imagination has gone into the different modalities of situatedness-in-displacements.[11] A literal interpretation of displacement can be viewed in Pepper's *Moline Markers* (1981) and *Tarquinia Plaza Sculpture* (1983). In these pieces one can think of three slender trees standing in close proximity. The spaces between the trunks have discernable form only because the trees act as boundaries that define and shape them. Remove the trees, and these shapes disappear in the void.[12] In a critical review of Pepper's work at the Brooklyn Museum in 1987, her sculptures were seen as functioning as punctures in the entirety of the space, even where boundaries are arbitrary constructions. A graduated understanding of cosmopolitanism reflects the self-referential aspects of Pepper's work requesting "a state of readiness, through listening, looking, intuiting, and reflecting" by the visual participant. Pepper's cosmopolitanism can be seen as a condition, as a state of mind, protean a mode of managing meaning.[13]

Pepper recounts how CNN is in every small town around the globe and that one will find American plumbing in nearly every kitchen and American newspapers available everywhere. She continues her enthusiasm for the world community by effusing that even the Japanese are drinking American coffee,

eating at McDonald's and pizza parlors, and recognizing that blue jeans are the international style. She questions how can one feel expatriatism is a valid term, when a computer and the Internet will connect you with the global village that, by definition, transcends borders.

All comments not footnoted derive from an interview on March 26, 1995, between Laura Fattal and Beverly Pepper.

NOTES

1. Robert Hobbs, "Beverly Pepper: Sculpture in Place," *Women's Art Journal* (fall 1991/winter, 1992): 38.

2. Barbara Rose, *American Art Since 1900* (New York: Praeger Publishers, 1967), p. 164.

3. Rosalind E. Krauss, *Beverly Pepper, Sculpture in Place* (New York: Abbeville Press, 1986), pp. 23–24.

4. Kirk Varnedoe, *Cy Twombly, A Retrospective* (New York: MOMA, 1994), p. 36.

5. Kay Larson, "Hot Pepper," *New York Magazine* (June 8, 1987): 56.

6. Barbara Rose, "A Monumental Vision," *Vogue Magazine* (March, 1987): 535.

7. Barbara Grizzuti Harrison, "She's Gotta Have Art," *Mirabella* (July 1990): 113.

8. Rosalind E. Krauss, *Passages in Modern Sculpture* (New York: The Viking Press, 1977), p. 178.

9. Barbara Grizzuti Harrison, p. 113.

10. Ibid.

11. Bruce Robbins, "Comparative Cosmopolitanism," in *Secular Vocations* (New York: Verso Press, 1993), p. 173.

12. Walter Thompson, "Beverly Pepper Dramas in Space," *Arts Magazine* (June 1988): 52.

13. Ulf Hannerz, "Cosmopolitans and Locals in World Culture," in Mike Featherstone, ed. *Global Culture, Theory, Culture and Society,* 7 (London: Sage, 1990), p. 239.

SELECTED BIBLIOGRAPHY

Barrie, Brooke, "Beverly Pepper," Trenton, NJ: *Grounds for Sculpture,* October 9, 1999–April 16, 2000.

Bryson, Norman, Holly, Michael Ann and Moxey, Keith, *Visual Culture: Images and Interpretations:* Hanover and London: University Press of New England, 1994.

Hannerz, Ulf, "Cosmopolitans and Locals in World Culture," in Mike Featherstone, ed., *Global Culture, Theory, Culture and Society.* London: Sage, 1990.

Harrison, Barbara Grizzuti, "She's Gotta Have Art," New York, *Mirabella* (July 1990): 113–114.

Hobbs, Robert, "Beverly Pepper: Sculpture in Place," *Woman's Art Journal* (fall, 1991/winter, 1992): 38.

Katz, Janet B. *Artists in Exile:* New York: Stein and Day, 1983.

Kline, Katy, "Beverly Pepper: An Autobiography in Form," *List Visual Arts Center,* Massachusetts Institute of Technology, March 3–July 2, 1989.

Krauss, Rosalind E., *Beverly Pepper: Sculpture in Place.* New York: Abbeville Press, 1986.

———. *Passages of Modern Sculpture.* New York: The Viking Press, 1977.

Larson, Kay, "Hot Pepper," *New York Magazine* (June 8, 1987): 113–114

Prose, Fanine, "Expatriate Games," *New York Times* (Sunday, March 3, 1996): 33.

Robbins, Bruce, "Comparative Cosmopolitanism," in *Secular Vocations.* New York: Verso Press, 1994.

Rogoff, Irit, "The Discourse of Exile: Geographies and Representations of Identity," *Journal of Philosophy and the Visual Arts* (1989): 70–75.

Rose, Barbara, *American Art Since 1900.* New York: Praeger Publishers, 1967.

Stebbins, Theodore E. ed. *Lure of Italy: American Artists and the Italian Experience, 1760–1914.* Boston: Boston Museum of Fine Arts, 1992.

Stowe, William W. *Going Abroad: European Travel in Nineteenth Century American Culture.* Princeton, NJ: Princeton University Press, 1994.

Thompson, Walter, "Beverly Pepper Dramas in Space," *Arts Magazine* (June 1988): 52–53.

Varnedoe, Kirk, *Cy Twombly, A Retrospective.* New York: Museum of Modern Art, 1994.

Ward, Meredith, *Adventure and Inspiration: American Artists in Other Lands.* New York: Hirschl and Adler Galleries, 1988.

Index

Abstract Expressionism, 137, 138,
140, 141, 142, 143, 161, 162, 164

Baudelaire, Charles, 25, 31, 33
Bloomer, Hiram, 37, 38, 40, 45, 60
Bonheur, Rosa, 69, 70, 72, 73, 74, 75,
76, 77, 78; *The Horse Fair*, 71;
Ploughing at Nivernais, 72
Boston, 73, 77, 78, 86, 87, 88, 90, 98,
107, 108
Bridgman, Frederick, 40, 41, 61
Bruce, William Blair, 45, 55

Carolus-Duran, Emile Auguste, 35,
36, 37, 38, 40, 50, 56, 59, 85
Cassatt, Mary, 23, 25, 26, 27, 28, 29,
30, 31, 32, 81, 82, 85, 88; *Lydia
Crocheting in the Garden at Marly*,
88; *Offering the Panale to the
Bullfighter*, 23, 28; *On the Balcony*,
23, 25, 26, 27, 28, 29, 30; *Susan on
a Balcony Holding a Dog*, 28;
Toreador, 23, 28
Chadwick, Francis, 42, 45, 50, 55,
56, 57, 62
Chile, 12, 13, 17, 18, 19; Valparaiso,
11, 12, 13, 14, 15, 16, 17, 18, 19,
20, 21, 22
Class, 13
Coffin, William A., 42, 43, 46, 64;
After Breakfast, 43
Corot, Camille, 35, 37

Cox, Kenyon, 40, 41, 42, 45, 47, 48,
61, 62, 63, 64; *Grez Seen Across an
Open Field*, 45; *Thistledown*, 47
Cullen, Countee, 95, 97, 99, 107, 108

Degas, Edgar, 23, 27, 32, 152, 158
De Kooning, Willem, 143
Diasporism, 150, 151, 157, 158, 160
Donoho, G. Rugero, 41; *La Marcel-
lerie*, 42; *Shepherd,* 48
Douglass, Frederick, 98
Du Bois, W.E.B., 95, 96, 98, 99, 106,
107

Eaton, Wyatt, 36, 59
Eliot, T.S., 148
England, 11, 12, 16, 20; London, 147,
148, 149, 150, 151, 152, 153, 154,
155, 156, 157, 158, 159, 160

Feminism, 69, 70, 75, 76, 77, 78, 79
France, Barbizon, 35, 36, 37, 38, 39, 40,
41, 42, 45, 46, 50, 55, 57, 58, 59, 63,
69, 70, 72, 76, 77, 79, 85, 87, 93, 94,
95, 96, 97, 99, 100, 102, 104, 106,
110; Bois d'Arly, 35; Brittany, 38,
39, 42, 45, 49, 50, 51, 84; Giverny,
40, 45, 50, 53, 55, 57, 66, 140, 141,
143; Grez, 35, 36, 37, 38, 39, 40, 41,
42, 43, 44, 45, 46, 47, 48, 49, 50, 51,
52, 53, 54, 55, 56, 57, 58, 59; Paris,
11, 13, 20, 36, 37, 38, 40, 41, 42, 44,

45, 48, 49, 50, 51, 52, 53, 54, 55, 56,
 57, 58, 59, 61, 62, 63, 70, 71, 72, 73,
 77, 79, 80, 83, 85, 86, 87, 88, 90, 93,
 94, 95, 96, 98, 99, 100, 101, 102, 104,
 105, 106, 107, 108, 109, 110, 111,
 135, 136, 137, 138, 139, 140, 141,
 142, 143, 144, 145, 146, 148, 149,
 151, 152, 153, 157, 158
Francis, Sam, 135, 136, 137, 138,
 139, 140, 141, 142, 143, 144,
 145, 146; *Beyond the Mask*, 138;
 Black and Red, 142; *Le Musée
 inimaginable*, 140; *Red and Pink*,
 138; *The Whiteness of the Whale*,
 143
Franzen, August, 50, 52, 56, 65

Gardner, Isabella Stewart, 86, 87, 90,
 91
Gautreau, Virginie, 86, 87, 90
Goya, Francisco de, 25, 26, 27, 28,
 31, 32, 33, 149
Greenwood, Grace, 113, 114, 115,
 117, 120, 122, 126, 127, 128, 129,
 131, 132, 133, 134; *Men and Ma-
 chines*, 120; *Mining*, 126
Greenwood, Marion, 113, 114, 115,
 117, 119, 120, 121, 122, 124, 125,
 126, 127, 128, 129, 130, 131, 132,
 133, 134; *Blueprint for Living*, 129;
 *The Industrialization of the Coun-
 tryside*, 125; *Landscape and Econ-
 omy of Michoaca*, 117; *Taco Mar-
 ket*, 116

Harrison, Alexander, 40, 42, 44, 48,
 49, 64; *Enfants jouant, Grez-sur-
 Loing*, 49; *In Arcadia*, 49; *La Soli-
 tude*, 50
Harrison, Birge, 37, 38, 41, 42, 48,
 49, 60, 62, 64; *The Appointment*,
 48, 49; *Jeune fille dans un pré*, 49;
 Landscape Painting, 42; *The Mir-
 ror*, 48; *November*, 48
Hawthorne, Nathaniel, 35

Impressionism, 23
Irving, Washington, 25, 31, 82
Italy, 41, 61, 81, 85, 87, 161, 162,
 164, 165, 167; Rome, 35

James, Henry, 82, 85, 86, 148

Kitaj, R.B., 147, 148, 149, 150, 151,
 152, 153, 154, 155, 156, 157, 158,
 159, 160; *Baseball*, 155; *Batman*,
 156; *Cecil Court, London WC2
 (The Refugees)*, 147, 153, 154; *The
 Cleveland Indian*, 155; *Disman-
 tling the Red Tent*, 156; *First Dias-
 porist Manifesto*, 151; *If Not, Not*,
 148; *The Jew*, 150; *John Ford on
 His Deathbed*, 155; *Juan de la
 Cruz*, 156; *The Killer-Critic Assas-
 sinated by his Widower, Even*, 157;
 Sandra Three, The Killer Critic,
 157; *Self Portrait as a Cleveland
 Indian*, 156; *Self Portrait as a
 Woman*, 152; *Walter Lippmann*,
 156
Klumpke, Anna, 69, 70, 71, 72, 73,
 74, 75, 76, 77, 78; *Rosa Bonheur,
 savie et son oeuvre*, 70

League of Revolutionary Writers and
 Artists (LEAR), 123, 127, 132
Lee, Vernon, 83, 87, 90
Low, Will, 37, 39, 43, 46, 47, 61

Manet, Edouard, 26, 32, 33, 149, 156;
 Le balcon, 26, 27; *Matador*, 29
Masson, André, 136
Matissse, Henri, 140, 141, 149
Melville, Herman, 143; *Moby Dick*, 143
Mexico, 113, 114, 115, 116, 117, 118,
 119, 120, 121, 122, 123, 124, 125,
 126, 128, 129, 130, 131, 132, 133
Micas, Natalie, 71, 74
Millet, Jean-François, 35, 36, 58, 59,
 63, 65
Mitchell, Joan, 135, 136, 137, 140,
 142, 143, 145, 146; *August, Rue
 Daguerre*, 143
Mondrian, Piet, 136, 137, 140
Monet, Claude, 40, 50, 51, 52, 53, 57,
 58, 135, 137, 140, 141, 142, 143,
 145
Morisot, Berthe, 26, 27, 28, 32
Murillo, Bartolomé, 24, 26, 27, 28,
 32; *Immaculate Conception of the
 Escorial*, 24

New Deal, 113, 114, 121, 128, 129

Odenheimer, Mary, 40, 41

O'Higgins, Pablo, 113, 115, 121, 129, 130
Osbourne, Fanny, 37, 38, 40

Pennie, Robert M., 44, 63; *The Weaver*, 44
Pepper, Beverly, 161, 162, 163, 164, 165, 166, 167; *Amphisculpture*, 163; *Dallas Land Canal and Hillside*, 164; *Fallen Sky*, 162; *Moline Markers*, 165; *Sand Dunes*, 164; *Shaddai*, 164; *Talquinia Plaza Sculpture*, 165; *Thel*, 164; *Totlec Market*, 163; *Venezia Blue*, 163, 164; *Vertical Presences—Grass Dunes*, 163
Pound, Ezra, 148
Prophet, Nancy Elizabeth, 93, 94, 95, 96, 97, 98, 99, 100, 103, 104, 105, 106, 107, 108, 109, 111; *Bitter Laughter*, 94; *Congolais*, 93, 96, 97, 98, 100, 104, 105; *Discontent*, 94; *Head in Ebony*, 96; *Head of a Negro*, 95, 96; *La volonté*, 94; *Le pélerin*, 94; *Peace*, 94; *Poise*, 94; *Prayer*, 94; *Silence*, 94
Public Works of Art Project (PWAP), 121, 122, 131

Renoir, Pierre-Auguste, 140
Rivera, Diego, 113, 114, 115, 116, 117, 118, 120, 122, 123, 124, 125, 126, 127, 128, 132, 133
Robinson, Theodore, 36, 40, 41, 47, 61
Rodin, Auguste, 95, 97

Saint-Simonians, 70, 71, 75
Sargent, John Singer, 36, 38, 60, 65, 81, 82, 83, 84, 85, 86, 87, 88, 89, 90, 91, 148; *Arab Gypsies in a Tent*, 89; *Bedouin Camp*, 89; *Doorway of a Venetian Palace*, 87, 88; *Grand Canal, Venice*, 88; *Madame X*, 86; *Mending a Sail*, 89; *Simplon Pass: The Green Parasol*, 88; *Simplon Pass: The Lesson*, 88; *Simplon Pass: The Tease*, 87; *Venetian Doorway*, 88
Savage, Augusta, 93, 96, 98, 99, 100, 101, 102, 103, 104, 105, 106, 107,

108, 109, 110; *The Amazon*, 93, 100, 101, 104, 105, 107; *Bathing Boy*, 99; *Bust of a Woman*, 99; *The Call*, 102; *Danseur nu*, 99; *Divinité negre*, 103; *Fern Frond*, 103; *Gamin*, 98, 103; *Green Apples*, 98, 103; *La Citadelle — Freedom*, 99; *Martiniquaise* 100; *Mourning Victory*, 100, 101, 102; *The New Negro*, 98; *Nu*, 99; *Tete de jeune fille*, 100, 101, 103
Sears, Charles Payne, 44, 56, 63
Spain, 23, 24, 25, 26, 28, 29, 30, 31, 32, 87; Madrid, 24, 25, 26, 27, 31, 44, 63; Seville, 24, 27, 31
Stevenson, Robert A.M., 35, 36
Stevenson, Robert Louis, 35, 36, 38, 39, 40, 43, 59, 60, 62

Twombly, Cy, 162, 166, 167; *Fifty Days at Iliam*, 162

Verlaine, Paul, 25, 31, 34
Vonnoh, Robert, 51, 52, 53, 54, 55, 56, 58, 62, 65, 67; *Edge of the Pond*, 52; *Jardin de Paysanne*, 52; *November*, 52; *Poppies in France*, 53; *Spring in France*, 52; *Sunlit Hillside*, 52; *Winter Sun and Shadows*, 52

Waugh, Frederick Judd, 42, 44, 47, 48, 62, 63; *Family Resting Under a Tree*, 48; *Grez*, 47
Wharton, Edith, 85, 90; *A Backward Glance*, 85
Whistler, James Abbot McNeill, 11, 12, 13, 14, 15, 16, 17, 18, 19, 20, 21, 22, 81, 82, 85, 148; *Crepuscule in Flesh Color and Green*, 15, 20, 21; *The Golden Screen*, 19; *Morning After the Revolution*, 16, 20, 15, 21; *Nocturne: Blue and Gold— Old Battersea Bridge*, 18, 21; *Nocturne in Blue and Gold: Valparaiso Bay*, 15, 17, 20, 21; *Nocturne: The Solent*, 13, 14, 20; *Peacock Room*, 14, 20; *A Street at Saverne*, 16, 21; *Symphony in Grey and Green: The Ocean*, 14, 21
World War II, 138, 147, 162, 163

About the Editors and Contributors

M. ELIZABETH BOONE, Ph.D., associate professor of art history at Humboldt State University in Arcata, California, received her doctorate in art history from the Graduate Center of the City of New York and her M.A. from the University of California, Berkeley. She has lectured and published on many aspects of nineteenth- and twentieth-century art, including "'Brilliant Sunlight and Wonderful Color': Mathias Alten and Spain," Mathias Alten: Journal of an American Painter. Exh. Cat., Grand Rapids and Seattle: Grand Rapids Art Museum in association with Marquand Books. "Jewish History, Mural Painting, and Bernard Zakheim in San Francisco," Crónicas: El muralismo, producto de la Revolución Mexicana, en América (Universidad Nacional Autónoma de Mexico, núm 5–6, 2001. She presented "Surrealist Travel and Exploration in the Art of Remedios Varo" at the International Alexander von Humboldt Conference, Humboldt State Univesity, Arcata, California. Her essay entitled "'Why Drag in Velázquez?' Realism, Aestheticism, and the Nineteenth-Century American Response to *Las Meninas*" appeared in an anthology of essays on Velázquez's *Las Meninas* edited by Suzanne Stratton-Pruitt for Cambridge University Press, 2002. In 1998 Dr. Boone curated and wrote the exhibition catalogue for *Espãna: American Artists and the Spanish Experience,* held in New York at the Hollis Taggart Galleries and in Connecticut at the New Britain Museum of American Art. She is currently working on an anthology of writers and artists who visited the Spanish city of Toledo, to be published in Spain by Ediciones Antonio Pareja, and *Vistas de Espãna,* a book about the vogue for Spain among American artists in the nineteenth century. She has been the recipient of numerous awards and fellowships, including those from Humboldt State University, City University of New, Chester Dale, Jane and Morgan Whitney, and Henry Luce Foundations.

KATHLEEN L. BUTLER, Ph.D., assistant director of the Phoebe A. Hearst Museum of Anthropology and an independent scholar, received her doctorate in the history of art from University of California, Berkeley. An independent scholar, her research area includes American visual and literary travel and travelers. She wrote "Independence for Western Women through Tourism" for the *Annals of Tourism Research* (1994), contributed "John Singer Sargent," "Timothy O'Sullivan," "Samuel Coleman," and "William Henry Jackson" to *American National Biography* (1999), "John James Audobon," "Thomas Cortin," "Thomas Sully," "John Trumbull," and "Travel Writing: United States" to the *Encyclopedia of the Romantic Era* (2002). She presented "The Virtue of the Fly: Angling the 'The Patient and Honest Man's and *Woman's* Recreation,'" one of whose underlying themes was travel, at the 1996 national conference of the American Studies Association. She is currently co-curating an exhibition on nineteenth-century American expedition photography in the U.S. Southwest, and co-authoring an accompanying exhibition catalogue for The Bancroft Library, U.C. Berkeley.

BRITTA C. DWYER, Ph.D., is an art historian at the University of Pittsburgh, specializing in American art. She is the author of Anna Klumpke, *A Turn-of-the Century Painter and Her World* (Northeastern University Press, Boston, 1998). She is a regular contributor of book reviews to *The Woman's Art Journal* and has presented numerous lectures at national and international conferences on topics ranging from painting and Civil War politics to the art of the Renaissance. She also teaches at the University of the Third Age (U3A) in Cambridge, UK.

LAURA FELLEMAN FATTAL, Ph.D., co-editor of this volume, is an arts educator, art historian and independent curator. She has curated the five-site museum exhibition *Veiled Time: Contemporary Artists and the Holocaust.* As director of the New Jersey School of the Arts, Dr. Fattal assists high schools throughout the state of New Jersey in fulfilling national and state standards by administering an artists-in-residency program. She received her doctorate from the University of Texas in Austin in comparative approaches to teaching art history at the postsecondary level.

WILLIAM H. GERDTS, Ph.D., is a professor emeritus of art history at the Graduate School of the City University of New York, where he continues to teach on an annual basis. He received his Bachelor of Arts degree from Amherst College and his Master's and Ph.D. degrees from Harvard University. He received an honorary doctorate in humane letters from Amherst College in 1992 and an honorary doctorate in fine arts from Syracuse University in 1996. Dr. Gerdts is the author of 25 books, including *American Still-Life Painting,* with Russell Burke, (1971); *American Neoclassic Sculpture, Art Across America,* (1990); *Monet's Giverny: An Impressionist Colony,* (1993); *Impressionist New York,* (1994); *Alice Schille, Foremost American Woman Watercolorist,* (2001); and *American Impressionism,* revised and expanded edition, (2001).

ROBERT H. GETSCHER, Ph.D., is emeritus professor, John Carroll University. Dr. Getscher has been a Smithsonian Fellow to study Whistler in Washington and Glasgow (1968–1969). He was recipient of the 2000 Distinguished Faculty Award at John Carroll University. Among his many publications are: *James Abbott McNeill Whistler: Pastels,* with Paul G. Marks, (George Braziller, 1991), *James McNeill Whistler and John Singer Sargent: Two Annotated Bibliographies* (Garland, 1986), *The Stamp of Whistler,* exhibition catalogue for the Museum of Fine Arts, Boston, Philadelphia Museum of Art, and Oberlin College (1977). His lecture "Whistler: Flesh, Fabrics, and Facades: The Pastels" was by invitation at The Whistler Symposium, Washington DC at The Freer Gallery, the National Portrait Gallery and the National Gallery, June 1–3, 1996. Also his "Whistler's Puritanical Nudes" was an invitational lecture at The Graphic Arts Council of Los Angeles, 1984. Dr. Getscher, who received his doctorate from Western Reserve University, was also president (1995–1997) of the Midwest Art History Society and has been a member of the Print Council of America since 1978, a position held by invitation only. He is one of only a handful of academics in the professional organization for museum curators of prints and drawings.

THERESA LEININGER-MILLER, Ph.D., is associate professor and director of Graduate Studies in art history at the University of Cincinnati (U.C.). She is the author of *New Negro Artists in Paris: African American Painters and Sculptors in the City of Light, 1922–1934* (Rutgers University Press, 2001). Her writings are in *Paris Connections: African-American Artists in Paris* (winner of a 1993 American Book Award), *American National Biography, Notable Black American Women,* Books I and II, *Notable Black American Men, Epic Lives: One Hundred Black Women Who Made a Difference, Gumbo Ya Ya: Anthology of Contemporary African-American Women Artists, the Encyclopedia of African-American Culture and History, CAA Reviews,* and the *Art Journal.* Dr. Leininger-Miller, who received her doctorate from Yale University, is the recipient of numerous fellowships and awards, including those from the Smithsonian Institution, Centre d'Études Afro-Américaines et des Nouvelles Littératures en Anglais, Université de la Sorbonne Nouvelle, University of Cincinnati, Carter G. Woodson, Samuel Kress, and Henry Luce Foundations. She is currently working on a critical biography of Augusta Savage.

JAMES OLES, Ph.D., is an assistant professor of art history at Wellesley College, where he lectures on the history of Mexican art from the ancient through modern eras. He received his doctorate from Yale University. Oles teaches at Wellesley in the spring semesters and resides in Mexico City for the remainder of the year, where he works as an independent art historian and is a regular art critic for the daily newspaper *Reforma.* He is the author and curator of *South of the Border: Mexico in the American Imagination, 1914–1947* (Smithsonian Institution Press, 1993); *Helen Levitt: Mexico City* (W.W. Norton, 1997); "The Gelman Collection of Mexican Art in Context," in Frida Kahlo, Diego Rivera, and Mexican

Modernism from the Jacques and Natasha Gelman Collection, San Francisco Museum of Art, 1996: *Las hermanas Greenwood en México,* Consejo Nacional para la Cultura y las Artes, Mexico City, 2000, as well as essays in museum catalogues and journals. He has also co-curated exhibitions of the work of David Alfaro Siqueiros and Lola Alvarez Bravo, and recently curated "Art in Post-Revolutionary Mexico" section of *Making Sense of Modern Art,* an interactive computer program/CD for the San Francisco Museum of Modern Art.

MICHAEL PLANTE, Ph.D., is associate professor, who holds the Jessie J. Poesch Professorship in Art History, Newcomb Art Department, Tulane University. He is the author of *Paris' Verdict: American Art in France, 1946–1958* (Cambridge University Press, 2002). He is also author of a book on the Abstract Expressionist painter Ida Kohlmeyer titled, *Signs and Symbols: The Abstract Language of Ida Kohlmeyer* (Hudson Hills Press, 2002). This book is being published in conjunction with an exhibition of Kohlmeyer's work in New Orleans for which Dr. Plante is the curator. Dr. Plante was curator of *Deborah Kass: The Warhol Project,* Newcomb Art Gallery, Woldenberg Art Center, Tulane University plus venues, 1998. He was editor and contributor to *Deborah Kass: The Warhol Project* for Distributed Art Publishers, 1999. Additional authors include Maurice Berger, Linda Nochlin, Robert Rosenblum, and Mary Ann Staniszewski. His involvement with American art in the U.S. embassy in Paris is seen in his "Pilgrmage and the High Life: The American Artist in Paris," in *American Artists in the American Ambassador's Residence in Paris,* intro. by Felix G. Rohatyn, American Ambassador (Washington, DC: The Art in Embassies Program, United States Department of State, 1998), 30–43. Additional essay written by Robert Rosenblum. He will also be writing an essay for a forthcoming exhibition catalogue on the African-American artist Beauford Delauney that is being organized by the Minneapolis Institute of Arts tentatively for 2004. His focus will be on Delauney's Paris period when he was close to and traveled with James Baldwin. Among his many fellowships, grants, and awards are National Museum of American Art, Smithsonian Institution, Visiting Scholar, Kress Fellowship, Lily Endowment Teaching Fellowship, NEH Summer Seminar, "War and Memory," Harvard University, Harvard College Merit Scholarship for Academic Distinction. Dr. Plante received his Ph.D. from Brown University.

CAROL SALUS, Ph.D., co-editor of this volume, is associate professor in the division of art history at Kent State University. Her writings are in *National American Biography, Art Bulletin, Jewish Art, Printmaking Today, Journal of Comparative Literature and Aesthetics, Schatzkammer der Deutschen Sprache, Dichtung und Geschichte, Analecta Husserliana,* and others. She has twice been an invited speaker at the American Institute of Medical Education. Her topics have been "The Effects of Aging on Picasso's Last Years and His Art" (1997) and "Picasso, His Father and His Pigeons: A Transitional Object" (2001). She received her doctorate from The Ohio State University.